The Changing Image:

Prints by Francisco Goya

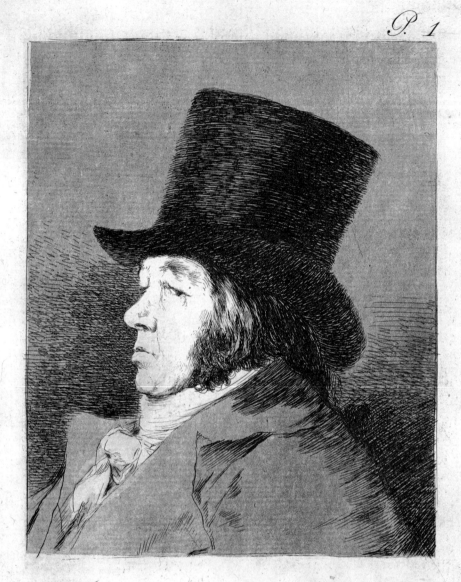

Fran.co Goya y Lucientes
Pintor.

The Changing Image:
Prints by Francisco Goya

ELEANOR A. SAYRE

AND THE DEPARTMENT OF PRINTS AND DRAWINGS

DISTRIBUTED BY NEW YORK GRAPHIC SOCIETY, BOSTON

Museum of Fine Arts, Boston

Copyright 1974 by Museum of Fine Arts
Boston, Massachusetts
Library of Congress catalogue card no. 74-19964
ISBN 0-87846-085-3
Printed in the U.S.A.
by the Meriden Gravure Co., Meriden, Conn.
Typeset by Wrightson Typographers, Boston
Designed by Carl F. Zahn

Dates of the Exhibition:
Museum of Fine Arts, Boston
October 24 — December 29, 1974

The National Gallery of Canada
Ottawa
January 24 — March 14, 1975

Back cover:
34
Caprichos 1 (Frontispiece)
Self-Portrait: Franꞯ⁰ Goya y Lucientes, Pintor
Preparatory drawing. Red chalk
Lent by the Estate of Walter C. Baker

Front cover:
36
Caprichos 1 (Frontispiece)
Self-Portrait: Franꞯ⁰ Goya y Lucientes, Pintor
Working proof. Etching, aquatint, drypoint, and burin
Biblioteca Nacional, Madrid

Frontispiece:
37
Caprichos 1 (Frontispiece)
Self-Portrait: Franꞯ⁰ Goya y Lucientes, Pintor
Completed state, pre-publication impression. Etching, aquatint, drypoint, and burin
The Art Institute of Chicago. The Clarence Buckingham Collection

To all those friends in Spain
who helped me learn about Goya.

Lenders

THE ART INSTITUTE OF CHICAGO
Chicago, Illinois

BIBLIOTECA NACIONAL
Madrid, Spain

BIBLIOTHÈQUE NATIONALE
Paris, France

BOSTON ATHENAEUM
Boston, Massachusetts

BOSTON PUBLIC LIBRARY
Boston, Massachusetts

BRITISH MUSEUM
London, England

DAVISON ART CENTER
WESLEYAN UNIVERSITY
Middletown, Connecticut

FUNDACIÓN LÁZARO GALDIANO
Madrid, Spain

GRAPHISCHE SAMMLUNG ALBERTINA
Vienna, Austria

HAMBURGER KUNSTHALLE
GRAPHISCHE SAMMLUNG
Hamburg, West Germany

METROPOLITAN MUSEUM OF ART
New York, New York

MUSÉE DU PETIT PALAIS
Paris, France

MUSEO DEL PRADO
Madrid, Spain

MUSEUM OF ART
RHODE ISLAND SCHOOL OF DESIGN
Providence, Rhode Island

MUSEUM OF FINE ARTS
Boston, Massachusetts

NATIONAL GALLERY OF ART
ROSENWALD COLLECTION
Washington, D.C.

NATIONAL GALLERY OF CANADA
Ottawa, Ontario

THE NEW YORK PUBLIC LIBRARY
New York, New York

THE NORTON SIMON FOUNDATION
Los Angeles, California

RIJKSMUSEUM
Amsterdam, The Netherlands

STAATLICHE MUSEEN PREUSSISCHER KULTURBESITZ,
KUPFERSTICHKABINETT
Berlin, West Germany

Preface

The Changing Image: Prints by Francisco Goya is the third in a series of exhibitions devoted to the work of master printmakers. The two preceding ones, *Rembrandt: Experimental Etcher* (1969) and *Albrecht Dürer: Master Printmaker* (1971), like the present exhibition, showed several impressions of the same image in order to illustrate the artist's working methods and to explore matters of quality and connoisseurship.

The present exhibition has come about as the result of the museum's acquisition of a major group of Goya's graphics. With the generous help of a number of friends, we were able to purchase 126 etchings, many of them working proofs, and seven drawings. Added to works already in the collection, these new acquisitions offered the opportunity to review Goya's graphic work with a breadth and depth not possible earlier. As this exhibition so clearly illustrates, the artistic process of bringing an idea to its fullest realization is often as illuminating and fascinating as the final print. Since Goya's graphic work has not been shown in this way or with such comprehensiveness before, the museum's new acquisition seemed to demand this kind of presentation.

The exhibition would not have been possible without the many significant loans from private and public collections both here and abroad. We are especially grateful to the Spanish government, its ministers in Spain, and its representatives in this country for their cooperation in arranging the very generous loans from the Spanish collections. And to all others who have helped in so many ways, we extend our most sincere thanks.

MERRILL C. RUEPPEL
Director

Donors
Goya acquisition, 1974
Museum of Fine Arts, Boston

ANONYMOUS DONORS

HAZEN H. AYER

MRS. RUSSELL W. BAKER

MR. AND MRS. PAUL BERNAT

SARGENT BRADLEE

ROBERT BURLEN & SON, INC.

MR. AND MRS. MAXWELL BURSTEIN

VICTORIA MAXWELL CASS, M.D.

DAVID CHEEVER

LANDON T. CLAY

WILLIAM A. COOLIDGE

RUTH P. CUNNINGHAM

MR. AND MRS. CHARLES C. CUNNINGHAM, JR.

BARBARA DANIELSON

DOWS DUNHAM

MRS. MARSHALL DWINNELL

MRS. G. W. EASTERBROOK

MR. AND MRS. JOSEPH P. EDINBURG

PROFESSOR AND MRS. S. LANE FAISON, JR.

LINCOLN AND THERESE FILENE FOUNDATION, INC.

MR. AND MRS. G. PEABODY GARDNER

MR. AND MRS. JOHN L. GARDNER

MR. AND MRS. KENNETH GERMESHAUSEN

DOROTHY AND SAMUEL GLASER

DAVID R. GODINE

MR. AND MRS. MORTON GODINE

MR. AND MRS. ELLIS L. GORDON

MRS. ISABELLA GRANDIN

MRS. WILLIAM HARRINGTON

BRÜDER HARTMANN, *West Berlin*

MISS INGEBORG HOLLWOEGER

FREDERICK J. KENNEDY MEMORIAL FOUNDATION

KEYLITHO LTD., *Montreal*

MR. AND MRS. E. ANTHONY KUTTEN

MRS. HERBERT C. LEE

MR. AND MRS. PHILIP D. LEVIN

WILLIAM LILLYS

LITHO ASSOCIATES, *St. Laurent, Quebec*

HENRY CABOT LODGE

MRS. CORNELIA LOMBARD

MR. AND MRS. ANDRÉ MERMINOD

T. O. METCALF CO.

MOHAWK PAPER MILLS, INC.

MRS. RICHARD C. PAINE

MR. AND MRS. ROBERT PIRIE

MR. AND MRS. IRVING W. RABB

MR. AND MRS. JOHN S. REED

MR. AND MRS. HARRY REMIS

MRS. LINDA MAKANNA SAWYER

ELEANOR A. SAYRE

MRS. FRANCIS B. SAYRE

GEORGE C. SEYBOLT

MR. AND MRS. BERNARD S. SHAPIRO

PAUL SINGER AND HENRY LUSARDI

MARTIN H. SLOBODKIN

RUSSELL B. STEARNS

MR. AND MRS. BURTON S. STERN

MISS ELLEN STILLMAN

ROBERT STORR

TECHNO-COLOUR CO. INC., *Montreal*

MRS. MILDRED C. TITCOMB

MRS. CHRISTOPHER TUNNARD IN HONOR OF ELEANOR SAYRE

MR. AND MRS. ARTHUR E. VERSHBOW

FREDERIC B. VIAUX

JEPTHA H. WADE

MR. AND MRS. GUY W. WALKER, JR.

RICHARD W. WALLACE

MR. AND MRS. JAMES O. WELCH

IAN WOODNER FAMILY FOUNDATION

WRIGHTSON TYPOGRAPHERS

MRS. MAURICE YOUNG

Acknowledgements

Authorship of the Catalogue:

Sue W. Reed, Stephanie L. Stepanek, and Clifford S. Ackley drafted the entries for the catalogue and Barbara S. Shapiro the glossary. The curator wrote the introductions and except for 231–232 completed the entries through number 247. Due to illness the curator was unable to proofread the catalogue or to examine the final proof. The catalogue was completed by Mr. Ackley, who wrote the introduction to the Disparates, and, on the basis of the curator's publications and notes, by Mrs. Reed, who wrote the remaining introductions, entries 231–232, 248–268, and the acknowledgments. This part was not seen by the curator before publication.

Many people have helped make this exhibition and its catalogue possible. It is a pleasure to have the opportunity to thank the individuals from whose collections the loans have been drawn:

Jean Adhémar, Jacob Bean, Jean S. Boggs, Karel G. Boon, Janet Byrne, Adeline Cacan, Enrique Pardo Canalís, José Camón Aznar, Etienne Dennery, Richard S. Field, John Gere, Guillermo Guastavino Gallent, Sinclair H. Hitchings, Darryl E. Isley, Jack Jackson, Harold Joachim, Diana Johnson, Walter Koschatzky, John Maxon, John McKendry, Stephen E. Ostrow, Elena Páez, Alfonso E. Pérez Sanchez, Andrew Robison, Lessing J. Rosenwald, Elizabeth Roth, Xavier de Salas Bosch, Eckhard Schaar, Mary C. Taylor, and Matthias Winner. Several private collectors who wish to remain anonymous have generously lent objects of importance from their collections. The vital loans from Spanish collections were made possible by the approval of the Spanish government. From the Ministry of Foreign Affairs we are indebted to José Luis Messía, Marqués de Busianos, to Rodolfo Arévalo, and to Luis Sagrera; from the Ministry of Education and Science, Joaquín Pérez Villanueva, Florentino Pérez Embid, and Joaquín de Alba. These ministries, as well as the Ambassador to Canada, His Excellency Dr. José María Moro, and his staff have enabled the exhibition to be shown in Ottawa. Both Ambassadors to the United States, the late Angel Sagaz and His Excellency Jaime Alba, as well as the cultural attaché Luis J. Casanova, have supported the exhibition. We have received much help and encouragement from the Spanish consuls in Boston, Juan Lugo and his predecessor José María Campoamor.

This exhibition was conceived in the first months of Merrill C. Rueppel's directorship of the Boston Museum and has benefited from his continuing support. The museum's recent acquisition of a large group of fine Goya prints and drawings was a major impetus to the exhibition. Without the extraordinary support of the Trustees, especially George Seybolt and John Coolidge, and the extensive donations of many individuals, foundations, and corporations, an acquisition of such major proportions would not have been possible. We are proud to strengthen our collection with these works of art, and

to the donors who appear on a separate list, we are profoundly grateful.

Cornerstones of the collection are the working proofs purchased in 1951 by Henry P. Rossiter from the Stirling-Maxwell collection, brought to his attention by Philip Hofer. In addition to this group of prints, other gifts, such as the Bullard and W. G. Russell Allen bequests, have contributed to the importance of Boston's collection.

To undertake an exhibition and catalogue of major proportions in a short time required much assistance from fellow staff members of the Boston Museum. Designed by Carl Zahn, the catalogue was edited by Lynn Salerno; Jennifer Davis assisted. Linda Thomas and Allison Gulick capably negotiated the complex arrangements necessary for international loans. Our paper conservator, Francis W. Dolloff, readied the objects for exhibition. The installation was designed by Tom Wong.

Other individuals have devoted time to the project. For the exhibition Michael Mazur coordinated a section dealing with Goya's techniques, for which Tamara Hochbaum executed a copper plate. Stephen Andrus of Impressions Workshop, Boston, offered his services in the area of lithography, and Paul Maguire executed a lithograph using techniques akin to Goya's. We were assisted with translations from the Spanish by Leonor Hushfar and Teresa Lugo, whose knowledge of bull-fighting was extremely useful.

We could not wish for more enthusiastic cooperation from an institution sharing the exhibition than we have received from the National Gallery of Canada. To Jean S. Boggs, Mary C. Taylor, Sherrill Mosely, and others, our deep appreciation.

We are especially indebted to the Meriden Gravure Company, in particular to William Glick and Roger Bartlett, for their fine reproductions and careful printing of the catalogue.

In undertaking this extensive project we have been generously aided by a grant from the National Endowment for the Arts, Washington, D.C., a federal agency.

Contents

How to use the catalogue

ABBREVIATIONS

B. A. de Beruete Moret, *Goya grabador*,
 Madrid, 1918.

D. Loys Delteil, *Francisco Goya*, 2 vols., Paris,
 1922. (*Le peintre graveur illustré*, vol. 14)

H. Tomás Harris, *Goya, Engravings and
 Lithographs*, 2 vols., Oxford, 1964.

Hof. Julius Hofmann, *Francisco de Goya, Katalog
 seines graphischen Werkes*, Vienna, 1907.

Gassier Pierre Gassier and Juliet Wilson, *The Life
and Wilson and Complete Work of Francisco Goya*,
 New York, 1971.

In this catalogue, the measurements for the prints are those of Harris, who measured the copper plates wherever possible. The drawing measurements are of the sheet unless otherwise stated. The reproductions are reduced unless indicated as actual(full) size. The presence or lack of watermarks has been indicated whenever the sheet has been examined. For techniques and terminology related to drawing and printmaking, see the Glossary at the back of the catalogue.

In this catalogue the term *working proof* is used to designate an impression taken for or by Goya in the course of executing a plate. A *trial proof* is one that is taken from the completed plate before the printing of an edition; in this catalogue it indicates one taken after the artist's death in preparation for a posthumous edition. *A preliminary drawing* is one that serves as the source for the design or subject of a print. A *preparatory drawing* is made expressly for a print.

Point of View of the Exhibition

"The Changing Image: Prints by Francisco Goya" explores Goya's methods of working and development of an idea from drawing to print throughout his career as a printmaker. For this reason several impressions of the same print in different stages of development are often shown. The drawings have been selected on the basis of their relation to the evolution of the design or imagery of a print. Two of Goya's most important series, the *Desastres* and the *Disparates,* were not published during his lifetime. The majority of impressions of Goyas' prints in circulation today are posthumous. Since these posthumous impressions give very little notion of Goya's original intentions, an unusually large number of impressions printed during his lifetime are exhibited. For each series, a small number of posthumous impressions have been included for comparison of quality.

Goya is often viewed as a fantasist. He was, in fact, a man of the Enlightenment, a moralist who looked with a sardonic eye at the follies, vices, and superstitions of his time. In the series concerned with the Peninsular War, the *Desastres,* he made specific reference to the political and social chaos of his time. But there are also veiled satires and allegories directed against the evils of church, state, and nobility to be found in the *Caprichos* and the *Disparates.*

The Early Prints

In eighteenth century Spain printmaking was not considered a flourishing art. In 1790 Don José de Vargas Ponce, historian and naval officer, looking for the reason, rightly observed that throughout the preceding century Hapsburg kings had made it their policy to patronize Netherlandish engravers. Nor was the concurrent lack of royal encouragement for Spaniards tempered by the nation's collectors, for as Vargas Ponce also noted: "Spain has been more fertile in producing artistic talent than in helping artists live. I refer particularly to the scarcity and poverty of collecting."[1]

In 1700 the Bourbon dynasty replaced the Hapsburgs. But for decades northern prints and illustrations continued to exert their influence, and although some interesting Spanish works appeared, no important centers of printmaking developed in the kingdom. Only religious prints were plentiful, if not always inspiring as art. The critic Ponz wrote in 1776: "Time, money, and copper have been wasted in representing ridiculous carved altars, images which because of their ugliness should be removed from the sight of worshippers."[2]

It was not until 1750 that Fernando VI began to take measures that were to change both the character and the quality of prints in Spain. That year he named a Frenchman as court painter and engraver, Charles Joseph Flipart (1721–1797), who had studied both arts in Venice.[3]

In 1752 the king inaugurated the Real Academia de San Fernando for the "noble arts" of painting, sculpture, and architecture. Printmaking was taught from the beginning, the first professor being an energetic and dedicated Cordovan, Juan Bernabé Palomino (1692–1777).[4] Fernando VI was succeeded in 1759 by Carlos III, who also took an active interest in the fine arts. He had first-hand knowledge of engraving, since he practiced it himself.[5] Statutes of the Academia show that at least by 1757 there were scholarships available for those who wanted to learn etching and engraving. Advanced students were not sent to Rome, like those who pursued the noble arts, but to Paris, where they could remain as *pensionados* (pensioners) for six years at the king's expense.[6] Some of them flourished there, notably Manuel Salvador Carmona (1734–1820), who received an appointment as engraver to the king of France. Salvador Carmona's French engravings were excellent, but as the years passed his work slowly deteriorated in quality. Nonetheless he was a major figure. For we are told that on his return to Spain in 1763: "Not only did he revive engraving, but he regulated the presses used for printing, the manufacture of paper, the composition of inks for the same; and he managed all this so that it then spoiled foreign commerce in prints to the benefit of our industriousness."[7] In general

1. "España ha sido más fecunda en producir talentos artísticos que en ayudarlos a vivir; me refiero especialmente a la escasez y pobreza de nuestro coleccionismo." Excerpt from *Distribución de los premios . . . hecha por la Real Academia de Bellas Artes de San Fernando* (Madrid, 1790), quoted by Enrique Lafuente Ferrari in his answer to Teodoro Miciano Becerra's *Breve historia del aguatinta* (Madrid: Real Academia de Bellas Artes de San Fernando, 1972), p. 55.

2. "Se ha gastado el tiempo, el dinero, y el cobre en representar ridículos altares de talla, imágenes, que por su fealdad debian apartarse de la vista de los fieles." Antonio Ponz, *Viage de España*, vol. 6, 2nd ed. (Madrid, 1782), p. 131 (Madrid: Aguilar reprint, 1947, ed. Casto María del Rivero, p. 555).

3. Flipart went to Venice at sixteen, where he studied engraving with Wagner and painting with Amiconi and G. B. Tiepolo. Anton Maria Zanetti published Tiepolo's *Capricci* by 1749, the year before Flipart came to Spain; on Flipart's life see Juan Agustín Ceán Bermúdez, *Diccionario historico de los mas ilustres profesores de las bellas artes en España,* (Madrid, 1800), vol. 2, pp. 119–121; on the date of the *Capricci* see H. Diane Russell, *Rare Etchings by Giovanni*

Battista and Giovanni Domenico Tiepolo, exhibition catalog, National Gallery of Art, Washington, D.C., 1972. Flipart was a very capable reproductive engraver, capable of executing an effect of sparkling brilliance in his prints in which he combined etching with engraving. He published his work in Venice and later in Madrid. In technique his prints have much in common with the mainstream of fine Venetian prints and very little with Tiepolo's etchings.

4. On Palomino see Ceán Bermúdez, *Diccionario* (1800), vol. 4, pp. 27–29.

5. On Carlos III as engraver see the 1772 quotation translated by Ceán Bermúdez, *Diccionario* (1800), vol. 1, pp. 256–257.

6. *Estatutos de la real academia de S. Fernando* (Madrid, 1757), pp. 41, 51–54.

7. "no solo fue el restaurador del grabado, sino que arregló los tórculos que sirven para estampar, la fabricacion del papel, la composicion de tintas para lo mismo, y todo lo dispuso de modo que aniquiló por entonces el comercio estrangero de estampas en beneficio de nuestra industria." From Salvador Carmona's obituary in *Distribución de los premios* (Madrid: Real Academia de Bellas Artes de San Fernando, 1832), p. 79.

the *pensionados* returned home well disciplined in the skilful, sophisticated use of printed lines. They were less interested in engraving original prints than in making excellent translations of other artists' designs. In the 1760's one can observe an infusion of their work; in the 1770's the changes that they and their pupils had effected in fine Spanish book illustrations and prints are striking. In Madrid printmakers working in the French manner were apt to describe a new plate advertised for sale in the *Gazeta de Madrid* as an *estampa fina* (fine print).

Goya had access to a print collection when he was still a boy. He was by birth Aragonese, born fortuitously, it would seem, in his mother's native village, rather than his father's city, Zaragoza, where his four brothers and sisters were baptized.[8] We may suppose that a certain measure of tough hardiness of mind and spirit was bred into Goya, for it was the citizens of Zaragoza who were later to defend themselves with heroic stubbornness against the armies of Napoleon.

Certainly Goya was never one of eighteenth century Spain's starveling children. His father was a respected master gilder, who was described as owning his house.[9] He sent his eldest son when he was thirteen to learn the profession of art under José Luzán y Martinez (1710–1785).[10] It is customary to dismiss this painter rather scornfully, but his contemporaries were less harsh, and it is from them that we learn that he was far from being a mere provincial painter. He had had five years in Naples, bringing back with him, we are told, a fine sense of color and a breadth and rapidity of execution that would have appealed to a pupil of Goya's temperament. He knew Madrid and maintained contact with artists there, among them outstanding students of his own. Luzán was equally esteemed for his patience, kindness, and extraordinary concern for the young people who entered his studio. They were taught first to draw from prints, casts, and live

models and later to paint from their own invention.[11]

We read of these prints long afterwards in a brief note written by Goya for the 1828 catalogue of the Prado. It is worth quoting not only the particular passage but the full text, since it contains the artist's summary of those aspects of his life that he considered important.

"He was born in Fuendetodos, the kingdom of Aragon in 1746; he was named Court Painter to the king in 1780, and later first among them; now he is retired because of his advanced age.

"He was a pupil of don José Luzan in Zaragoza with whom he learned the principles of drawing, making him copy the best prints he owned; he was with him four years, and began to paint from his own invention until he went to Rome; having had no other master than his observations of the tricks of the celebrated painters and pictures of Rome and Spain which is wherein he gained more knowledge. (Article communicated by the same.)"[12]

There is no mention there of another Zaragozan, Francisco Bayeu (1734–1795). Yet we know from one of the tantalizing fragments of documentary evidence on the early part of Goya's career that he went to Madrid and studied under Bayeu. When Goya was in Italy in 1771 it was Bayeu, and not Luzán, whom Goya cited as

8. Rita (1737), Tomás (1738), Jacinta (1745), Mariano (1750), and Camillo (1753); see E. Lafuente Ferrari, *Antecedentes, coincidencias e influencias del arte de Goya* (Madrid, 1947), pp. 285–294.

9. Lafuente, ibid., p. 285.

10. See Goya's obituary, *Distribución de los premios* (Madrid: Real Academia de Bellas Artes de San Fernando, 1832), pp. 91–92.

11. On Luzán, see Ceán Bermúdez, *Diccionario*, vol. 3, pp. 55–57. See also note by Larrca quoted in part by Ricardo del Arco, "El círculo de pintores aragoneses en torno de Goya," *Revista de ideas estéticas*, 4, 1946 [Goya issue] (Consejo superior de investigaciones científicas, Instituto Diego Velázquez, Madrid), pp. 379–387.

12. "Nació en Fuendetodos, reino de Aragon, en 1746, fué nombrado pintor de Cámara del Rey en 1780, y despues primero de los mismos; ahora jubilado por su abanzada edad.
Fué discípulo de don José Luzan en Zaragoza, con quien aprendió los principios de dibujo, haciendole copiar las estampas mejores que tenia; estuvo con él cuatro años, y empezó á pintar de su invencion hasta que fué á Roma; no habia tenido mas maestro que sus observaciones en las cosas de los pintores y cuadros célebres de Roma y de España, que es donde ha sacado mas provecho. (Artículo comunicado por él mismo.)" *Noticia de los cuadros que se hallan colocados en la Galería de Museo del Rey* (Madrid, 1828), pp. 65–66. In the notes on modern painters the catalogue differentiates between information on an artist compiled by a cataloguer, obtained from the family, or, as in Goya's case, submitted by the artist.

his master when he entered a competition.[13] Goya stayed in Rome about a year, paying the cost in part through his own effort and in part with help from his family.[14] Doubtless in that city he saw and admired Piranesi's etchings, although he may not then have been able to afford the "collection" of his prints that would be mentioned forty years later in an inventory of Goya's household goods.[15] He returned to Spain by October and for the next two years was occupied with commissions in or near Zaragoza, including a fresco for the cathedral and wall paintings for the Cartuja de Aula Dei. In the summer of 1773 he married Bayeu's sister Feliciana and in 1774 settled in Madrid.

What must be emphasized is the closeness of Goya's relationship with Francisco and his younger brother Ramón (1746–1793), who was Goya's age. They may well have shared the same studio. Goya and his wife lived in Francisco's house at least until the birth of his first son in December 1775.[16] In 1779 Goya wrote to his best friend Zapater in Zaragoza (to whom he sent many of his oil sketches): "The design of the little sketch you have is by Francisco, the execution is mine, and the whole isn't worth three snails; it is not worthy of being either mine or yours; it isn't even worth a snail's horn."[17]

Bayeu did much to further Goya's career, and the relationship lasted until their famous disagreement on principles in 1781. The paintings and drawings of those years by Goya and the two Bayeus are often so similar that we can attribute them to one or another artist only through minor stylistic differences. One might be tempted to attribute the conjunction of style to the influence of Goya were it not that Francisco Bayeu, ten years older and trained by Mengs, was an artist of considerable talent. In 1765 he had been made a deputy head of painting at the Real Academia de San Fernando, and two years later a court painter. Goya, genius though he was, developed slowly as an artist; and it must be observed that the elongated, Italianate, somewhat sprightly figures of his Zaragozan style were replaced in Madrid by solid, more naturalistic figures, very much like those painted by his brothers-in-law. In Goya's case, there is a perceptible divergence in viewpoint. He had by then an inherent straightforwardness and an almost total disinterest in unnecessary detail.

His earliest known print, *The Flight into Egypt* (cat. no. 1), extremely simple in technique, may have been etched while he was still in Zaragoza, for it is closely related to the figure style of the 1772 painting in the cathedral there. However, since Goya was to prove capable of working in a variety of styles in the same year, no isolated print or drawing can be absolutely dated on stylistic grounds alone. It is hardly surprising that it is a religious subject. The advertisements in the *Gazeta de Madrid* from 1770 to 1780 define for us the character of public taste. Well over half the prints were religious. Most of the rest might be classified as useful: portraits of sovereigns, an occasional general, maps, and technical innovations, with a slight leavening of regional costume, exotic animals, and monstrous humans.

Some artists designed as well as executed their prints. Yet it does not seem to have occurred to them to describe such work as "original" nor did they ask a price higher than was current for reproductive work.

Goya etched five more early, undated prints, among them *Un ciego cantando con su guitarra, San Francisco de Paula,* and *San Isidro el Labrador.* Here, too, there is a relationship with the Bayeus, but in this side of their work it has yet to be determined who was the initial leader and dominant figure.

We know from the art historian, Goya's friend Juan Augustín Ceán Bermúdez, that Francisco etched at

13. "M. François Goja [sic], romain, élève de M. Vajeu [sic] . . ." from the *Mercure de France,* January 1772, quoted by Valentín Sambricio, *Tapices de Goya* (Madrid, 1946), p. 19.

14. Pedro Beroqui, "Una biografía de Goya escrita por su hijo," *Archivo Español de Arte y Arqueología* 3 (Madrid, 1927), 99.

15. In 1812 Goya made a settlement with his son. The prints named are: *Una colección de marinas; Diez estampas de Rembrant; Dos paises de Perelle; Fredericus de Kers; Don Guillermo Pit; Quince estampas diferentes; Una colección del Piranesi; Uno de Flipar; Quatro estampas de Wouverman.* The entire document was published by F. J. Sánchez Cantón in "Como vivía Goya," *Archivo Español de Arte* 19 (Madrid, 1946), pp. 73–109.

16. On this relationship see Sambricio, *Tapices,* pp. 23, 27–28, and note 69.

17. "El borroncito que tu tienes es de Francisco la invención y mia la execución y todo ello importa tres caracoles que no merece la pena de que sea mio ni tuyo, no vale ni un cuerno." January 9; quoted by Sambricio, *Tapices,* p. 23.

least one print: "Graved in etching, very lightly, a print of the Virgin, Saint Joseph and the Child half length and five *pulgadas* high."[18] The print is not signed, but it can be identified because an impression in the Biblioteca Nacional, Madrid, bears Francisco's name in writing of the period.[19] The execution of this print (cat. no. 3), with its very free, delicate, sketchy lines, is somewhat in the manner of Goya's *San Isidro el Labrador*. Ramón tried this technique too, but with heavy-handed results.

It is in those of his etchings that are technically similar to Goya's that Ramón is an interesting and effective printmaker. The work of both artists shows the influence of the Tiepolos, Ramón's if anything more strongly than Goya's. In this respect both are unusual, for in the decade of the 1770's their contemporaries worked primarily in the academic French print tradition and to a lesser extent in the academic Italian.

Giovanni Battista Tiepolo's (1696–1770) etchings and those of his sons Domenico (1727–1804) and Lorenzo (1736–1776) were known in Madrid, although they may not have been widely available, since they were issued for the most part in Venice. Giovanni Battista's prints were certainly not fashionable. The Tiepolos had arrived in Madrid at the invitation of Carlos III in 1762, the year after Anton Raphael Mengs had been brought from Italy to be the king's first court painter. Unlike Mengs, Giovanni Battista Tiepolo did not master the politics of patronage of the 1760's. Furthermore it was Meng's classicism, not Tiepolo's freedom and originality, that found favor with the king's influential artistic advisor and confessor, the Franciscan Joaquín de Eleta. Tiepolo died at Madrid in 1770. Not long afterward paintings executed for San Pascual at Aranjuez were replaced with work by Mengs, Francisco Bayeu, and Maella.[20]

Except for the etchings after Velázquez, Goya did not date his early prints. It is frustrating therefore not to find a dated print by Ramón Bayeu, since, in addition to

being influenced by the Tiepolos, Ramón and Goya at times used surprisingly similar technical means. In Ramón's *Immaculate Conception of the Virgin*, after a painting by his brother, and Goya's *Un ciego cantando con su guitarra*, based on his own tapestry cartoon of 1778 (cat. no. 6), the paper itself is used to suggest both light and aerial perspective, and shadows and volumes are defined with very similar blends of stipple and brief, quivering lines. Ramón's *Saint Jerome* after Ribera (cat. no. 15) and Goya's *Seated Dwarf* after Velázquez, dated 1778 (cat. no. 14), are so close in their manner of etching that, should one have happened on an impression of *Saint Jerome* lacking its inscriptions, one might quite convincingly have attributed it to Goya.

Perhaps we might imagine that in those years the two brothers-in-law experimented together, learning etching "tricks" from one another. But it is likely that Goya, with his intuitive feeling for hidden potentialities in the process of etching, inevitably would have come to be the leader in the field of prints.

18. "grabó al agua fuerte muy ligeramente una lámina de la Vírgen, S. Josef y el Niño de medio cuerpo, y de cinco pulgadas de alto." Ceán Bermúdez, *Diccionario,* vol. 1, p. 100.

19. Bottom margin, pen and brown ink: *Grabada al agua fuerte/por D. Francisco Bayeu;* Bib. Nac. 40817, 11–18.

20. F. J. Sánchez Cantón, *J. B. Tiepolo en España* (Madrid, 1953), pp. 10–13, 18–21.

1
The Flight into Egypt
D. 1, H. 1, not in B., Hof. 227
130 × 95 mm.

Harris I (only state)
Etching
Lower right in the plate: *Goya inv^t et fecit*
Coll.: Boix
Kupferstichkabinett, Staatliche Museen Preussischer
Kulturbesitz, Berlin. 777–1906

It has been suggested that this print may be as early as
1771 and possibly etched in Italy. But it appears that the
print is less closely related to the group of mythological
paintings of 1771 with their greatly elongated figures
than to the slightly more solid figures in the fresco
The Adoration of the Name of God, completed in the
summer of 1772 for Zaragoza's cathedral, El Pilar.[1]

The graphic means are simple. The figures and
foreground are relatively deeply bitten, whereas the back-
ground, sky, and landscape are lightly etched. The
shading consists of simple parallel lines or crosshatching,
and the pronounced shadows form a strong visual pattern.
Only six or seven impressions of this etching, Goya's
earliest known print, are recorded by Harris.

1. Repr. *Goya revista de arte,* no. 100, 1971, pp. 201 ff., 207, 218 ff.

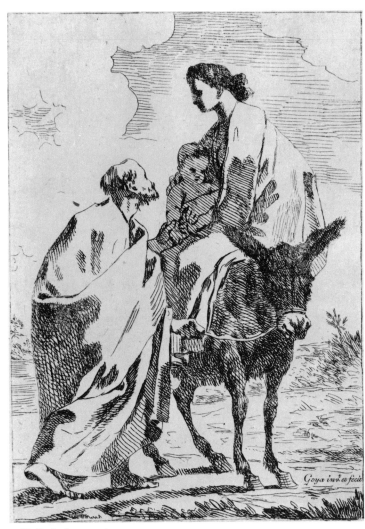

1 (full size)

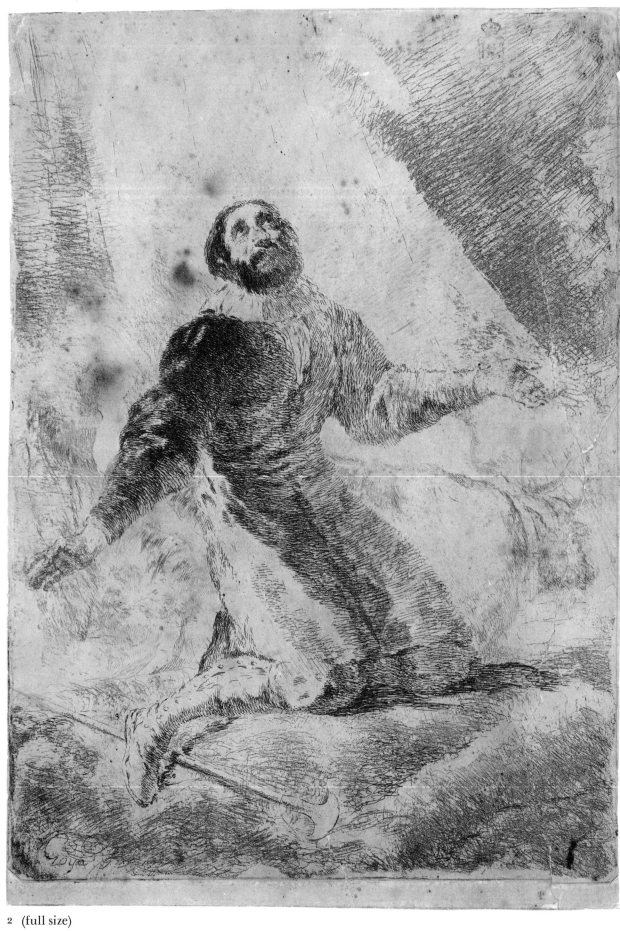

2 (full size)

2–3
San Isidro el Labrador
D. 3, H. 2, B. 3, Hof. 229
230 × 168 mm.

2
Unique proof. Harris I
Etching
Lower left in the plate: *Goya*
Sheet laid down
Coll.: Carderera
Biblioteca Nacional, Madrid

FRANCISCO BAYEU. Spain, 1734–1795
3
La Virgen, S. Josef y el Niño
(The Virgin, Saint Joseph and the Child)
Etching. 106 × 78 mm.
Museum of Fine Arts, Boston. Gift of Mr. and Mrs.
Benjamin A. Trustman. 68.763

This is the only known impression of Goya's etching of
San Isidro, the farmer, patron saint of Madrid, who died
in 1170. The sheet is in poor condition and mounted
down in order to mend several tears at the right side, and
a false margin has been added at the bottom.

Goya represents San Isidro in much more human
terms than the hieratic statue in the cathedral at Madrid,
where he stands richly dressed in brocaded peasant
clothes. In the etching, the saint kneels beside his ox, his
agricultural tool fallen to the ground, as he is bathed
in heavenly light.

Dots describe the flesh, a traditional practice that
Goya used until about 1814. The lines are very finely
etched, and drawn freely in short strokes or shallow loops.
This graphic language is not unlike that in Francisco
Bayeu's only known print, *The Virgin, Saint Joseph
and the Child* (cat. no. 3).[1]

The etching also bears comparison with prints by
the Tiepolos (see for example cat. no. 5) as well as with
Goya's prints after Velázquez, *San Francisco de Paula,*
and *The Garroted Man* (cat. nos. 11–26, 4, 7–10). Goya's
single prints should be dated with caution, but it is worth
observing that the figure of the saint has much in com-

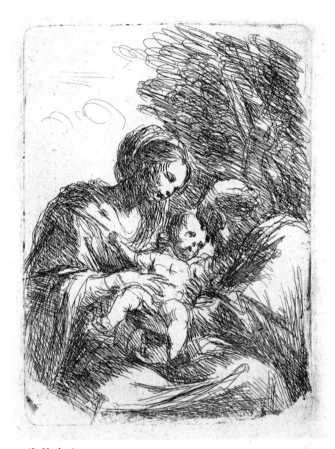

3 (full size)

mon with his painting of San Bernardino of Siena and
its three preliminary oil sketches, all executed between
1781 and 1783.[2] The foul biting in the background prob-
ably caused the plate to be abandoned. An event in 1779
may have been the impetus for this print; on November
15, according to the *Gazeta de Madrid* (p. 906), San
Isidro's body was moved to the Iglesia del Sacramento.

1. See introduction p. 3.
2. Gassier and Wilson, nos. 184–187.

4–5
San Francisco de Paula (Caritas)
D. 2, H. 3, B. 2, Hof. 228
130 × 95 mm.

4

Eighteenth century impression from the completed
plate, Harris I, 2
Etching and drypoint
Lower left, in the margin, etched: *Goya ft*
No watermark
Museum of Fine Arts, Boston. Gift of H. L. Pierce.
M9810

Giovanni Battista Tiepolo. Italy, 1696–1770
5
Saint Joseph Carrying the Child Jesus
Etching. 95 × 88 mm.
DeVesme 2, first state
Museum of Fine Arts, Boston. Gift of W. G. Russell
Allen. 46.1248

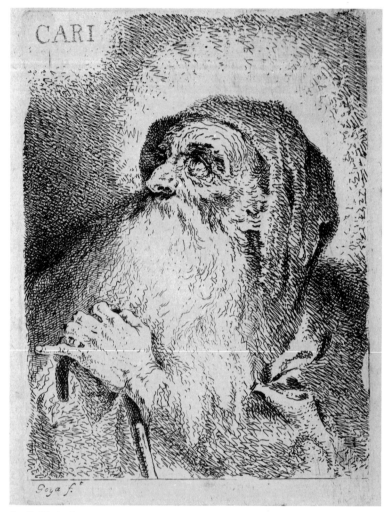

4 (full size)

5 (full size)

The Italian San Francisco di Paola (1416–1507) was a
hermit who founded the Minim friars. Two impressions
of the first state have been preserved, with the letters
CARI reversed. Both are touched to indicate changes;
one in pen (British Museum), the other in chalk (Biblio-
thèque Nationale). This impression is of the second state,
with the letters CARI corrected to read in the right direc-
tion and with drypoint additions to the saint's beard
and top of his hood.

The graphic means used to create the print are very
close to those of *San Isidro,* but in this case the plate was
successfully etched. A small print by Giovanni Battista
Tiepolo is here included to show the similarities between
the two printmakers. Neither has any trace of academic
rigidity. Both use broken contour lines and short, curv-
ing, parallel strokes and rounded zigzags for shading,
although there are a few longer parallel lines in the
deeper shadows. Both artists allow the paper itself to
play an important role in the design as well as to sug-
gest light. Because the white paper is half seen between
the etched lines a sense of vitality is given to both the
figures and the atmosphere around them. Only a small
number of contemporary impressions of this print seem
to have survived. The plate was acquired by the Calco-
grafía in Madrid and continued to be printed after
Goya's death.

No external evidence has yet come to light that
would fix the date of this etching with certainty. It is
worth noting, however, as Harris did, that in 1780 Goya's
son was born, and on August 22, he was christened
Francisco de Paula Antonio Benito.

6

Un ciego cantando con su guitarra y su Lazarillo
(A blind man singing with his guitar, and his
Lazarillo [boy guide])
D. 20, H. 20, B. 251, Hof. 232
395 × 570 mm.

Harris I
Etching
On rock, lower left: *Goya*
No watermark
Coll.: Beurdeley
Metropolitan Museum of Art, New York. Schiff Fund,
1922

Goya submitted a tapestry cartoon of this subject to the Fábrica de Tapices on April 27, 1778. In his bill of May 1 he describes it as "a blind man singing with his guitar and his *Lazarillo* . . . On the other end there is a Murcian with a cart and oxen . . . there is a perspective of a street with houses and in it a new building which is being constructed."[1] On October 26 Goya acknowledged an order of the director of the tapestry works, Cornelio Vandergoten, to correct and complete parts of the design that the Fábrica alleged could not be copied by the weavers.[2] The existing painting (Prado 778) shows that Goya made changes. At the left, a fisherman under a huge tree replaced the peasant from Murcia with his cart and oxen, and the buildings on the right are simpler than the "perspective" described by Goya.

It is conceivable that Goya etched the plate later that autumn, intending to preserve and circulate his earlier design. However, the print, the largest executed by Goya, does not quite reproduce the cartoon in its original state, for the Murcian and his oxen have no cart, and the buildings on the right do not seem to be under construction. In addition, the central figures in the print do not repeat the informal assembly of the cartoon but are contained within a triangle. In the etching Goya was able to give strong characterization to each face so that the intent listeners seem drawn together by the power of the blind man's song.

1. "un Ciego canttando con su guittarra y su Lazarillo . . . Ay en ottro termino un Murziano con una Carretta con Bueyes . . . hay una prespettiba de Calle con Casas y una Obra qẹ se fabrica en ella." Valentín de Sambricio, *Tapices de Goya,* documento 44 and 47.

2. Sambricio, doc. 48.

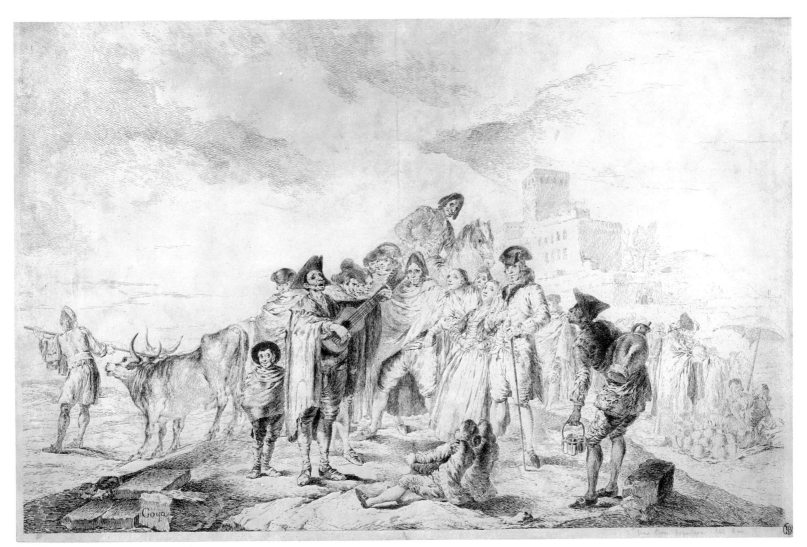

6

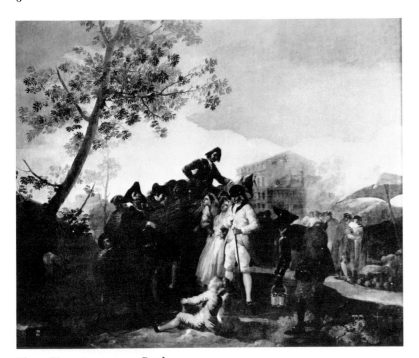

Fig. 1. Tapestry cartoon, Prado

7–10

The Garroted Man

D. 21, H. 21, B. 252, Hof. 230

330 × 210 mm.

7

Preparatory drawing

Pen and brown ink over chalk sketch. 265 × 202 mm.

Incised for transfer; verso rubbed with black chalk

No watermark

British Museum, London. 1850-7-13-11

8

Working proof, printed in blue

Harris I, 1 (unknown to Harris)

Etching

Metropolitan Museum of Art, New York

Rogers Fund, 1920

9

Completed plate, Harris III, 1

Etching and burnishing

Biblioteca Nacional, Madrid. 45607

10

Late impression, Harris III, 2

Etching, burnishing

Wove paper

Museum of Fine Arts, Boston

Bequest of W. G. Russell Allen. 1974. 236

Although the subject of this print has sometimes been described as a prisoner of the Inquisition, there is no evidence that Goya intended to represent such an execution. Indeed, Llorente, who headed the Madrid Inquisition, or Holy Office, wrote that there were no more than four such executions during Charles III's reign, 1759–1788.[1] The prisoner is not dressed as the Inquisition garbed its prisoners, nor does he display the symbols of any crimes in which the Inquisition interested itself. Instead he wears a Carmelite scapulary such as were given by religious orders to lay devotees.[2]

Garroting was rarer in Spain than we might suppose. For one thing, as various contemporary travelers pointed out, "In Spain they let live a great number of scoundrels who would be executed elsewhere. If they are young, vigorous, well set up, they send them off to Mexico, to the Antilles, to Chile, to work in the mines; if they are old they keep them in prison."[3] Of the wretches whose crimes made capital punishment inevitable, the number garroted was smaller still; for this particular death was considered a privilege. More gentlemanly than hanging, it could be claimed by *Hidalgos* (people entitled to the rights of nobility) who had committed civil crimes.

From a Spanish clergyman living in exile we have the following account: "The relations of the *Hidalgo* . . . had been watching the progress of the trial, in order to step forward just in time to avert the stain which a cousin, in the second or third remove, would cast upon their family, if he died in mid-air like a villain; presented a petition to the judges, accompanied with the requisite documents claiming for their relative the honours of his rank, and engaging to pay the expenses attending the execution of a *nobleman*." He describes the scaffold, the garrote, the cortège of priest, notary, soldiers, and convict "dressed in a loose gown of black baize" and how at length "The sentence being executed, four silver

1. Juan Antonio Llorente, *Histoire critique de l'Inquisition d'Espagne* (Paris, 1818), pp. 269 f.

2. P. Joseph Francisco Isla, *The History of the Famous Preacher Friar Gerund,* Baretti transl. (London, 1772), vol. 1, pp. 90 f. See also Manuel Trens, *María iconografía de la Virgen en el arte español* (Madrid, 1946), p. 378, figs. 231–3.

3. J. M. J. Fleuriot, *Voyage en Espagne,* 6th ed. (Paris, 1803), p. 53.

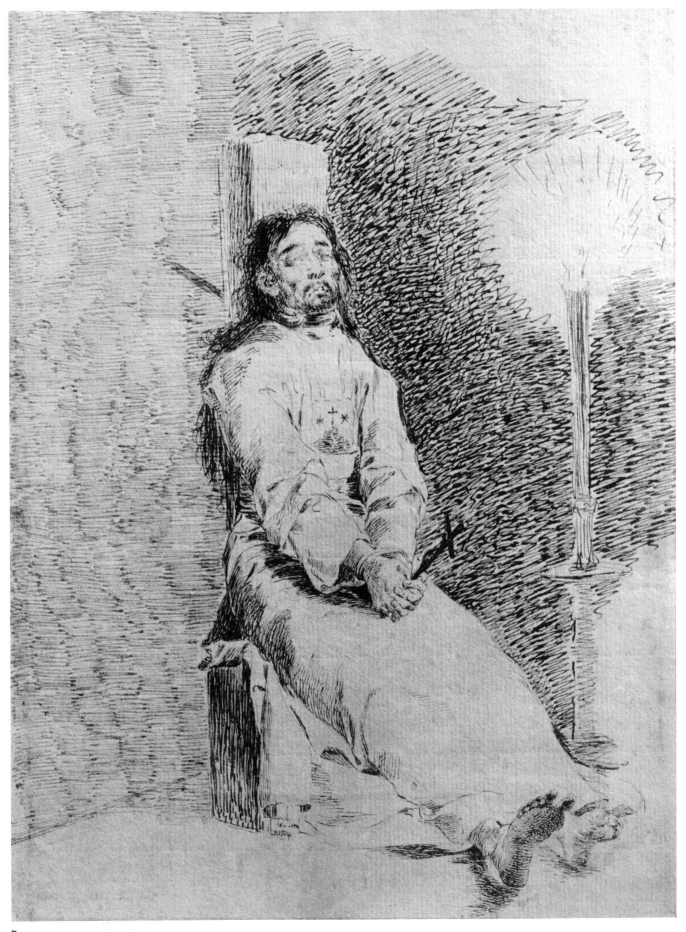

7

candlesticks, five feet high, with burning wax-candles of a proportionate length and thickness, were placed at the corners of the scaffold; and in about three hours, a suitable funeral was conducted by the *posthumous* friends of the noble robber . . . these honours being what is called *a positive act of noblesse*, of which a due certificate is given to the surviving parties, to be recorded among the legal proofs of their rank."[4]

No print remotely resembling this one in subject matter was advertised during the 1770's in the *Gazeta de Madrid*. Goya treats the subject with a sympathy and understanding that foreshadows much of his later graphic work.

The drawing is close in style to the study for *Aesop* (cat. no. 11). It was transferred to the plate by tracing the design with a stylus, a practice Goya rarely used. The image is thus reversed in the print.

The unique working proof, printed in blue ink, is worth comparing with *San Isidro* (cat. no. 2), partly for the intensely expressive faces of the condemned man and the saint and partly for the similarity of the lines. Here too, Goya had technical difficulty with the biting so that a number of small white patches were left in the area at the right of the face.

In the brilliant impression of the completed state, new lines have been added to the hair to cover the patches. However, the new etching caused two dark strips of foul biting, one above the head, the other below the handle of the screw. Goya tried burnishing to reduce this disfigurement, but this weakened some etched lines of the hair.

In the nineteenth century impression the deeply bitten rework on the hair stands out strongly against the original lines, which have become weaker. The entire image is weak, and its gray, speckled appearance is caused by minute pits of corrosion on the plate. The impression was printed on wove paper before the plate was bevelled.

4. Joseph Blanco White, *Letters from Spain,* 2nd ed. (London, 1825), pp. 36–38.

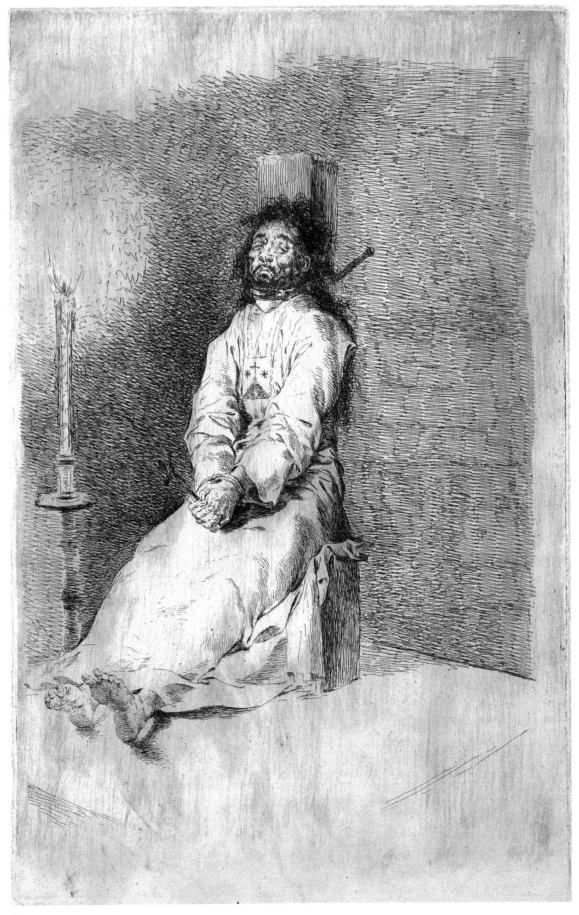

8

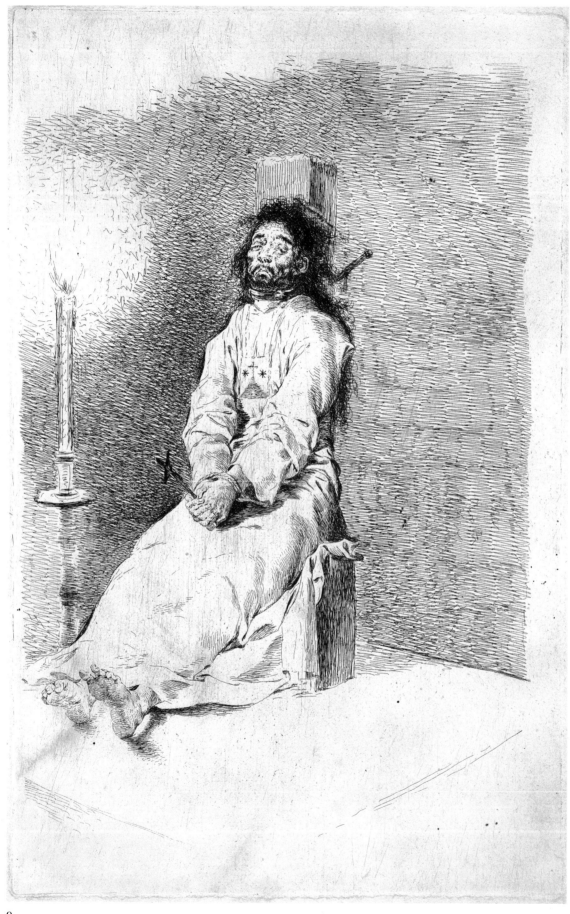

9

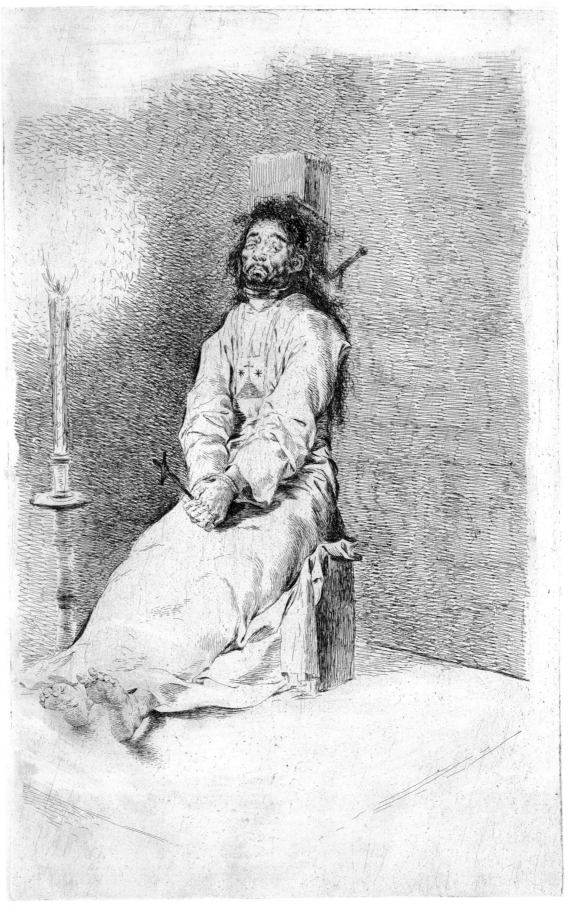

10

The Prints after Velázquez

In 1773 Antonio Ponz Piquer (1725–1792), following the dauntless encyclopedic tradition of his century, published the first volume of letters of his *Viage de España* (Travels through Spain). His aim was to note everything that would interest a cultivated traveler, including virtually every work of art. He died long before his undertaking was finished, the eighteenth volume being published posthumously in 1794. Ponz's book is remarkably good, probably because of his extraordinary qualifications for such an undertaking. He had been educated for the church by the Jesuits and then turned to art instead. In 1751, after he had studied painting for five years with some of the men who were to found the Real Academia de San Fernando, he went to Italy, where he stayed for nearly a decade, painting, studying works of art, and assembling a library of books on art. On his return to Spain he spent five years painting portraits for the Escorial Library. With characteristic energy he took full advantage of the library's rich collection of manuscripts and books to pursue his study of art history. His return to Madrid in 1765 coincided with the expulsion of the Jesuits from Spain and the sequestration of their goods. Ponz was sent to Andalucía to choose and describe those of their paintings that might be useful to students at the Real Academia de San Fernando. He came back with what was required, but he also had the scheme for his book and the first sheaves of copious notes on all the matters the book was to contain. In 1771, when Ponz began his work in earnest, he was a genuinely learned man who had what is rare in an art historian, the particular insights of a painter.[1]

Goya is mentioned in volume 5, the first of two needed to describe Madrid. Ponz names José Castillo (1737–1793), Goya, and Ramón Bayeu as artists who, under the direction of Francisco Bayeu and Mariano Maella, were producing very creditable tapestry designs for the Real Fábrica de Tapices de Santa Bárbara. The subject matter was contemporary, representing, Ponz says, "the amusements and costumes of the present day" ("las diversiones y trajes del tiempo presente").[2]

1. On Ponz's life see Casto María del Rivero, introduction to the Aguilar reprint of *Viaje de España* and *Viaje fuera de España* (Madrid, 1947), pp. xxiv–xxviii.

2. Antonio Ponz, *Viage de España*, 2nd ed. (Madrid, 1782), vol. 5, pp. 234–235 (Aguilar reprint, p. 479).

The Madrid volumes were advertised for sale in the *Gazeta de Madrid* on May 7, 1776,[3] and it is a tribute to Ponz's thoroughness that Goya appears at all, for he was not then attached to the Real Fábrica, but was paid by the piece. He had painted only nine cartoons, all of them in 1775 for a set of hunting tapestries commissioned for the crown prince's dining room in the Escorial,[4] a project on which Castillo and Ramón Bayeu were also engaged.

On the grounds of sheer human vanity it is difficult not to suppose that he saw Ponz's pleasing reference to himself. But it is almost certain that Goya read further. Ponz describes in considerable detail the impressive royal collections housed in the Palacio Nuevo, the Casa de Reveque, and the Buen Retiro. He then interjects an impassioned plea: "Europe knows very vaguely that there are wonderful works in Madrid and particularly in the royal palaces and in the Escorial; but few people have any idea of what they are because they have scarcely seen one miserable print of any of them . . . What is there, good or mediocre in France and Italy, and in a thousand other places, which has not been made known to the world through prints, to the honor of those who possess the originals and with no small profit to those who publish the reproductions . . . Formerly this lack was less to be wondered at because of the scarcity of engravers here . . . but now that we have a sufficient number of professionals who could set about accomplishing this project, it is disgraceful not to see them applying themselves to this."[5]

3. p. 168.

4. Goya submitted five to the Real Fábrica on May 24, and by December 23, four more. See Valentín Sambricio, *Tapices de Goya* (Madrid, 1946), docs. 6–13.

5. Sabe la Europa muy en confuso, que en Madrid, y señaladamente en los Reales Palacios, y en el Escorial, hay obras estupendas; pero pocos tienen idea de lo que son, porque apenas han visto una miserable estampa de alguna de ellas . . . ¿Qué hay en Francia, en Italia, y en otras mil partes de bueno, ó de mediano, que no se haya comunicado al mundo por medio de estampas, con crédito de los que poseen las obras originales, y no poco lucro de los que publican las copias? . . . En lo pasado era menos de extrañar dicha falta, por la escasez que aquí habia de Grabadores; . . . pero ahora que ya tenemos un número competente de tales profesores, que podian ir desempeñando esta empresa, es desgracia no verlos aplicados á ella. Ponz, *Viage*, vol. 6, pp. 130–132 (Aguilar reprint, pp. 555–556).

Ponz's plea was heeded. Among those who were moved to do likewise were Goya and probably also the two painters with whom he had worked on the hunting cartoons. Among Ramón Bayeu's etchings are reproductions of paintings by Ribera, Guercino, and Francisco Bayeu. Two triangular etchings, *The Assumption of the Virgin* and *The Attributes of the Virgin,* reproduce compositions painted by his brother in 1778 for a royal chapel at Aranjuez.[6] José Castillo's etchings were celebrated during his lifetime for their painterly quality, his *Supper at Emmaus* after Cerezo dated 1778 being one of those mentioned by a contemporary biographer.[7]

Goya's set of prints published in 1778 was ambitious both in scope and in the size of some of the etchings. All of them were after secular paintings by Velázquez that were hanging in the Royal Palace. The choice of painter may represent a predilection on Goya's part, for in the rough draft of Goya's obituary written by his son Xavier for the Real Academia de San Fernando, we are told that Goya was a "scrutinizer, with veneration, of Velázquez and Rembrandt" ("observador con veneración de Velázquez y de Rembrant").[8] However, it is possible that Ponz's *Viage de España* provided the initial impulse. The neoclassical painter Anton Raphael Mengs (1728–1779), as interested in antiquities as Ponz, probably knew the art historian in Rome. From 1761 until his death Mengs spent much of his time in Spain as first court painter to Carlos III. For inclusion in the *Viage* Ponz asked Mengs for a letter on the principal paintings of the Royal Palace. The letter was finished in 1776 and inserted by Ponz in volume 6 of the *Viage* at the end of his account

of the royal collections in Madrid. Mengs, like almost every eighteenth century foreigner who obtained access to the Palacio Nuevo, was profoundly impressed by the paintings of Velázquez.

An English translation of the letter was published in 1796: "What knowledge and truth of clare obscure [light and shade] do we not find in Velasquez! How well he understood the effect which the air has when interposed between the objects, to make appear distant the one from the other! And what study for any professor who would wish to consider the paintings of that author existing in the said hall (executed at three different times;) and the manner which shows the way held by him to arrive to such excellence in the imitation of nature!"[9] Mengs' account of the royal paintings interested and impressed his contemporaries, who examined Velázquez's work with renewed care.

Goya etched nineteen prints after paintings by Velázquez. He also made drawings after an additional five for which no etchings are known. It is plain that he intended to reap the profit suggested by Ponz, for the prints were advertised in the *Gazeta de Madrid,* on Tuesday, July 28, 1778, as follows: "Nine prints drawn and graved in etching by Don Francisco Goya, Painter, of which the life sized originals painted by Don Diego Velázquez exist in the collection of the Royal Palace in this Court. They represent the equestrian figures of the Kings Felipe III and Felipe IV and the Queens, Doña Margarita de Austria and Doña Isabél de Borbón and of Don Gaspar de Guzmán, Conde Duque de Olivares; the standing figures of Menippus and Aesop and two seated

6. The etchings measure 293 × 97 mm. and 294 × 96 mm. respectively. The paintings were for the vault of the *Capilla de la plantabaja del Palacio de Aranjuez;* the oil sketches are owned by the Prado. For their identification and date I am grateful to Sᵗᵃ Rocío Arnaez at the Prado, who is a specialist on Francisco Bayeu.

7. "Se celebran las estampas que grabó al agua fuerte con gusto pintoresco: la cena de Emaus, pintada por Cerezo . . . ," Juan Augustín Ceán Bermúdez, *Diccionario historico de los mas ilustres profesores de las bellas artes en España,* vol. 1 (Madrid, 1800), p. 286. *The Supper at Emmaus* was advertised in the *Gazeta* for January 19, 1779, together with three of his etchings after Luca Giordano.

8. Pedro Beroqui, "Una biografía de Goya escrita por su hijo," *Archivo español de Arte y Arqueología* 3 (1927), 100.

9. ¡ Quánta verdad, é inteligencia de claro, y obscuro no se observa en los quadros de Velazquez! ¡ Cómo entendió bien el efecto que hace el ayre interpuesto entre los objetos para hacerlos comparecer distantes los unos de los otros! ¡ Y qué estudio para qualquier profesor, que considerase en los quadros, que de este autor exîsten en la referida sala (executados en tres diversos tiempos) el modo como enseñan el camino que tuvo para llegar á imitar con tanta excelencia la naturaleza!

Carta de D. Antonio Rafael Mengs, primer pintor de cámara de S. M. al Autor de esta obra, Ponz, *Viage,* pp. 197–198 (Aguilar reprint, p. 574). The English translation is here taken from Joseph Nicholas d'Azara, *The Works of Anthony Raphael Mengs,* vol. 2 (London, 1796), pp. 82–83. José Nicolas de Azara, the Spanish minister at Rome, divided the letter into two sections.

dwarfs. They are for sale in the bookshops of D. Antonio Sancha in the old Custom-house and of D. Manuel Barco, Carrera de San Gerónimo. The prices are, the equestrian figures at 6 *reales* and the four portraits at 3; they can be had together or separately."[10]

On Tuesday, December 22, two more were offered to the public, obtainable like the others at the same two Madrid bookshops: "Two new prints one of which represents the Prince, Don Baltasar Carlos on horseback, and the other a false Bacchus crowning some drunkards; paintings by Don Diego Velázquez extant in His Majesty's Royal Palace, drawn and graved in etching by Don Francisco Goya, Painter . . ."[11]

The paintings in question (as well as five others that Goya reproduced in aquatint[12]) were all hanging in the Palacio Nuevo at Madrid. Although they were shifted from time to time by their royal owners, we know, thanks to detailed accounts by visitors to the palace in the years immediately preceding 1778, the very rooms in which Goya probably saw them.[13]

Goya's choice of paintings is interesting. Of the five large equestrian paintings, only two, precisely the two given entirely to Velázquez by modern art historians, were singled out by eighteenth century writers. *Las Meninas* and *Baco* were almost universally mentioned; but hanging in the same chambers to which he had been given access were other paintings that Goya does not seem to have considered, possibly because the problems of translating them successfully into graphic terms then seemed to him too great. Thus we do not know what he would have done with *Mercury and Argus,* with *Vulcan's Forge,* the *Spinners,* or with the *Surrender at Breda.*[14]

We should not expect that any man of enormous, innate creativity would make meticulous, faithful copies of another artist's work, however much he might admire it. Nor did Goya. The divergence is already apparent in the drawings after the paintings. The specific shapes of a tree, a bush, or a mountain ridge did not interest him in the least, and he characteristically simply indicated that Velázquez painted something or other of the kind in that spot. In the drawing of the *Infante Don Fernando as*

10. Nueve estampas dibuxadas y grabadas con agua fuerte por *Don Francisco Goya* Pintor; cuyos originales del tamaño del natural pintados por *D. Diego Velazquez* exîsten en la coleccion del Real Palacio de esta Corte. Representan las figuras eqüestres de los Reyes *Felipe III.* y *Felipe IV.* y de las Reynas *Doña Margarita de Austria* y *Doña Isabél de Borbón,* y la de *Don Gaspar de Guzmán* Conde Duque de *Olivares;* las figuras en pie de *Menipo* y *Esopo* y de dos enanos sentados. Se venden en la Librería de *D. Antonio Sancha* en la *Aduana vieja,* y en la de *D. Manuel Barzo* [sic] Carrera de *S. Gerónimo.* Sus precios son, las 5 figuras eqüestres á 6 rs. y las 4 restantes á 3; y se darán juntas ó separadas (p. 300). Advertisements from 1770–1778 show the Librería de Antonio Sancha selling prints illustrating Bible passages, monstrous animals, and Joaquín Josef Fabregat's prize print executed for a Real Academia de San Fernando competition. In September 1777 Sancha had two prints by Fernando Selma after paintings by Luca Giordano in the Madrid palace. The Librería de Manuel Barco was a recent entry in print selling. On July 7 he was selling three prints by Manuel Salvador Carmona's brother Juan Antonio.

11. Dos estampas nuevas que representan, la una al Príncipe D. Baltasar Carlos á caballo, y la otra á un fingido Baco coronando á algunos borrachos: pinturas de D. Diego Velazquez exîstentes en el Real Palacio de S. M. dibuxadas y grabadas al agua fuerte por D. Francisco Goya Pintor, *Gazeta de Madrid,* p. 640. In a copy in the British Museum *fingido* is misspelled *frigido.* It has been typset correctly in the Harvard University Library copy.

12. An aquatint of the *Niño de Vallacas* survived in a unique impression belonging to the statesman and collector of drawings, Goya's friend, Gaspar Melchor de Jovellanos. It was preserved in the Instituto Jovellanos he founded in Gijón. The collection was destroyed during the Spanish Civil War. For a reproduction see Alfonso E. Pérez Sánchez, *Catalogo de la coleccion de dibujos del Instituto Jovellanos de Gijon* (Madrid, 1969), pl. 143, as well as Pierre Gassier and Juliet Wilson, *The Life and Complete Work of Francisco Goya* (New York, 1971), no. 112.

13. The five large equestrian portraits of *Felipe III, Margarita de Austria, Felipe IV, Isabel de Borbón,* and *Gaspar Guzmán, Conde Duque de Olivares* all hung in the king's dining room. *Las Meninas* was in a room described by Ponz as the king's supper room and by most writers as his conversation room; in the king's dressing room were *El Trionfo de Baco* (The Triumph of Bacchus), the buffoon *Francisco Bazan* (now ascribed to Carreño), and perhaps, although they cannot be certainly identified, the two dwarfs *Don Sebastian de Morra* and *Don Diego de Acedo.* In the queen's large salon customarily hung the buffoon *Barbarroxa;* the crown prince and princess had in their large salon *Baltasar Carlos, Menippus,* and *Aesop.*

14. See Henry Swinburne, *Travels through Spain in the Years 1775 and 1776* (Dublin, 1789), p. 378 and Ponz, *Viage,* vol. 6, pp. 28–52 and pp. 197–199 [written by Mengs] (Aguilar reprint, pp. 524–531 and 574–575) and [Jean François Peyron] *Nouveau voyage en Espagne fait en 1777 & 1778,* vol. 2 (London, 1782), pp. 16–25.

Hunter (cat. no. 25) one can see that Goya was equally high-handed with the cut of the Infante's cap, with the seventeenth century pattern on his undersleeve, with the folds of his coat, and with the rosette at his royal knee. Yet looking at those of the drawings that have survived, one sees that there is often a translation into graphic terms of Velázquez's extraordinary sense of envelopping atmosphere. Invariably, the figures in Goya's drawings have a vitality of spirit, if not the majestic superiority the seventeenth century artist gave his sitters.

The drawings are, in short, works of art in their own right and were appreciated as such during Goya's lifetime by his friend Juan Augustín Ceán Bermúdez. In his *Diccionario historico* Ceán mentions *Las Meninas,* or as he expresses it, "that celebrated painting described as The Family, and better known under the title given it by Giordano, the 'Theology of Painting.' " In a footnote he remarks that the statesman Jovellanos owned the original oil sketch, "and I the red chalk drawing which D. Francisco de Goya made in order to grave it in etching which despite its not being by Velázquez's own hand could not be held in greater esteem."[15]

Ceán specifies eighteen paintings by Velázquez as having been reproduced by Goya and again in a footnote adds that he owns the majority of the drawings for the etchings.[16] Since at least nine of the surviving drawings are neatly lettered in the same fashion in pen and brown ink below the image with both artists' names and sometimes the title, it is possible that these were among the drawings owned by Ceán.[17]

The drawings occupy an intermediary position between Velázquez's originals and Goya's completed etchings, conforming neither to the one nor to the other but having elements of both. By this means one can separate them from eighteenth and nineteenth century drawings by other artists after Velázquez's paintings or after Goya's prints. Of the thirteen drawings presently known, nine are executed in red chalk, three in black (one being over a red chalk sketch), and one in pen with two tones of ink. The twelve examined by me are all on good, strong, Netherlandish paper that Spanish eighteenth century draughtsmen preferred to the thinner papers made in their own country. There are prints for which no drawings are known to have survived and drawings not known to have been etched.

Goya's method of transferring his drawing to the copper plate was an unusual one. The paper was dampened and rolled through the press with the grounded copper plate. Sufficient chalk adhered to the waxy ground to indicate the design. Signs of this procedure are visible on some of these drawing sheets in the form of printing creases or of indentations made by the edges of the copper plates. As Goya worked on the copper plates he continued to make changes. One can observe the process by comparing a working proof with a finished print. The unfinished proof of *Margarita de Austria* (cat. no. 20) still has a delicate restraint that is reminiscent of the sobriety of the painting. Then Goya changes the outline of the Queen's riding habit with its distinctly eighteenth century elegance of pattern and gives the composition

15. "aquel célebre quadro llamado de la Familia y conocido mas bien con el título, que le puso Jordan, de la *Teología de la pintura.*" Ceán Bermúdez, *Diccionario,* vol. 5, pp. 171–172. "y yo el dibuxo de lápiz roxo que sacó D. Francisco de Goya para grabarle al agua fuerte, que á no ser de mano del mismo Velázquez no le tendria en mas estimacion" (footnote, p. 172).

16. "(1) hasta (11) D. Francisco de Goya grabó al agua fuerte los quadros señalados con estos números; de los quales conservo la mayor parte de sus dibuxos." Ceán Bermúdez, *Diccionario,* vol. 5, p. 178, note 1. The numbers refer to *Las Meninas,* the five large equestrian prints, two buffoons, *Barbarroxa,* the equestrian *Baltasar Carlos,* the *Infante Don Fernando, Aesop, Menippus, Bacchus, Ronquillo,* the two dwarfs, and the *Water Carrier of Seville.* No print of this last has survived, but there is a drawing of the subject with the characteristic pen inscription in the Kunsthalle, Hamburg.

17. Félix Boix, in his article "Los dibujos de Goya," *Gaceta de Bellas Artes,* 1928, vol. 19, no. 329, p. 6, described three drawings after Velázquez as having belonged to Ceán Bermúdez: *Las Meninas; Felipe III,* now in the Museo Lázaro Galdiano and having the characteristic inscription (repr. José Camón Aznar, "Dibujos y grabados de Goya sobre obras de Velázquez," *Goya revista de arte,* no. 100. Jan.–Feb. 1971, p. 264); and *Isabel de Borbón* (now lost). Boix also states that some of the group were bought by Lefort from the heirs of Ceán Bermúdez. The 1869 Lefort sale catalogue (Hôtel Drouot, Jan. 28–29) claims that drawings annotated in Ceán Bermúdez's hand had been acquired from his collection by Lefort (pp. 5–6). Included in the sale were two drawings of dwarfs, no. 107 *El Primo* (Victoria and Albert Museum) with the characteristic pen inscription, and no. 108 in red chalk (present whereabouts unknown).

freshness and vitality by adding his own dark accents (cat. no. 21).

Velázquez's balance of tonal areas was not at all respected by Goya. Light areas in the paintings were darkened, and dark ones lightened in the prints. The freedom with which Goya altered them to conform to his own authoritative tonal balance is nowhere more striking than in the working proofs in which he added aquatint. The completed print of the *Infante Don Fernando* (cat. no. 29) became almost a negative image of the painting.

There is one respect in which Velázquez's contemporaries understood his paintings better than did Goya's. In the 1636 inventory of the Alcazár in Madrid the picture was described as "a painting of Bacchus" (*una pintura de Baco*).[18] The concept that Bacchus, a god, should be painted surrounded by seventeenth century country Spaniards can have seemed no more remarkable than the widespread notion that the representation of Christ's birth would be more vivid if one saw ordinary people whom one might know attending him. But in 1776 Ponz, with his knowledge of Greek and Roman art, could not accept Velázquez's half-naked figure as the incarnation of a god sojourning in the world. In the *Viage* he describes the painting as "one who plays the role of Bacchus with diverse figures who form a kind of bacchanal" (*uno que hace el papel de Baco, con diversos figuras, que forman una especie de Bacanal*).[19] In Mengs' letter, the artist, passionately devoted to classical art, gives as his title "the painting of the false Bacchus who crowns some drunkards" (*el quadro del fingido Baco, que corona á algunos borrachos*).[20] It is Mengs' text that Goya used almost literally in his inscription *representa un BACO fingido coronando algunos borrachos* (cat. no. 23).

Much more significant than the text is the intellectual influence Ponz and Mengs exerted on Goya's understanding of the subject. In the painting Bacchus' nakedness has the poetic perfection one might expect of the early seventeenth century; and the god performs his ritual act for human beings with manifest earnestness. In Goya's etching Bacchus' body has the muscularity of a man accustomed to physical labor. But the most striking change Goya makes is in the face of the god. His features have an unexpected kinship with the peasant beside him, and as Bacchus places the wreath his face is alight with a hearty grin. In short, what Goya has depicted is not what Velázquez painted, but precisely that country masquerade Ponz and Mengs suggest. In this respect Goya's etching contrasts strongly with Manuel Salvador Carmona's faithful, careful engraving, and it is interesting that the latter adheres to the traditional title, *Baco coronando á los borrachos* (cat. no. 24). Goya's prints after Velázquez, like the preliminary drawings, are creative works of art.

Ponz cannot but have been aware that Goya's etchings were not accurate reproductions, yet he must have perceived that Goya had managed to convey at least a painterly essence of Velázquez. In volume 8 of the *Viage* he wrote that Goya had undertaken to etch the notable paintings of Velázquez in the Real Palacio and was doing so with talent and intelligence.[21] In the same section Ponz urged Spanish artists to invent their own designs, as had such artists as Mantegna, Dürer, Salvator Rosa, and José de Ribera.[22] He can have seen only the first group of etchings while Goya was still at work on them, for that volume was advertised in the *Gazeta* on July 7, three weeks before Goya advertised the prints.[23]

The etchings of *Baco* and *Don Baltasar Carlos* were offered for sale just before Christmas in 1778. As we saw, nine others were advertised five months earlier. Goya probably began with the four plates that are of a more modest size. Proofs of the two philosophers, *Aesop* and *Menippus*, and one of the seated dwarfs, *Sebastian de Morra*, indicate that Goya's first idea had been to inscribe the painter's name and, rather modestly, his own initials

18. Bernardino de Pantorba (pseud. for José López-Jiménez) *La vida y la obra de Velázquez* (Madrid, 1955), p. 95.

19. Ponz, *Viage*, vol. 6, p. 31 (Aguilar reprint, p. 525).

20. Ibid., p. 198 (Aguilar reprint, p. 574).

21. ... ha tomado á su cargo D. Francisco Goya, profesor de pintura: este se ha propuesto grabar de agua fuerte los insignes quadros de D. Diego Velázquez, que se encuentran en la coleccion del Real Palacio; y desde luego ha hecho ver su capacidad, inteligencia, y zelo en servir á la Nacion, de que le deben estar agradecidos los aficionados á Velázquez, y á la pintura. Ponz, *Viage*, vol. 8, p. ii (Aguilar reprint, p. 666).

22. Ibid., p. iii (Aguilar reprint, p. 666).

23. Tuesday, July 7, p. 268. Vols. 7 and 8 were advertised together with the reprints of vols. 1 and 2.

in drypoint. But this information was almost immediately recognized as insufficient. Therefore it is not surprising to find impressions of the three prints in that state neatly lettered in pen to identify the painter, the subject, the collection, and the etcher himself. The tedious hand lettering was soon abandoned and the inscriptions corrected and engraved in the margins of the plates (see cat. nos. 12–14).

No proof of the second dwarf or of the five large equestrian prints has been recorded with drypoint inscriptions. Such pen inscriptions as appear in the lower margins seem to be written by Goya himself. As Harris observed, the numbers of letters in each line has been counted and jotted down for the use of a professional engraver.[24]

It was the practice in the 1770's to advertise parts of a set of prints as they were finished. Goya seems to have had the same intention. There are six etchings after Velázquez, all of them undated, that were undoubtedly executed for a part 2. This group of prints is in a different technique, etching with tones of aquatint added over the lines as a means of suggesting painted surfaces, a process that neither of Goya's brothers-in-law seems to have tried.

Aquatint was not much known until late in the eighteenth century, and the questions that have yet to be resolved are how, when, and through whom the medium was transmitted to Madrid. It may have come through one or another of the king's *pensionados* at Paris. Jean-Baptiste Leprince (1734–1781) is usually credited with its perfection. However he claimed to have kept his process a secret, and it was only made public in 1782.[25] But he had been etching with aquatint for more than a decade before his death. There are aquatints by Leprince signed and dated 1768, and the following year he submitted a group of them to the Académie. Despite

Leprince's secrecy, the abbé, Jean-Claude Richard de Saint-Non (1727–1791), learned about the process from the engraver and printseller De La Fosse, learned it in confidence and seems to have respected his promise.[26] As early as 1766 he had executed a group of signed and dated aquatints.[27]

France was not the only nation where aquatints could be seen. In 1775 Giovanni David of Genoa (1743–1790) published a set of satirical costume prints that are surprisingly close in point of view and technique to Goya's *Caprichos,* published in 1799. Also in 1775 the English artist Paul Sandby aquatinted part of his set of *Views of South Wales.* The source of his knowledge was the Honorable Charles Greville, who had obtained the secret from Leprince.[28]

If aquatinting reached Madrid as it had come to Italy and England, Goya's aquatints may have immediately followed the publication of the etched group in July and December 1778. Otherwise they cannot be earlier than 1782, when Leprince's process was made public.[29]

The early aquatinters were interested in the speed and ease with which tones could be made on the copper plate. We are told that Saint-Non invited Benjamin Franklin to breakfast, during which he made a charming plate of Franklin crowned by Liberty that his guest had the pleasure of printing.[30]

Goya's initial interest in aquatint may well have been that reputed rapidity and economy of effort by

24. See Tomás Harris, *Goya, Engravings and Lithographs,* vol. 2, (Oxford, 1964), nos. 5, 7, 10.

25. In need of money in his last years, Leprince tried unsuccessfully to sell the process in 1780. The manuscript was actually purchased from his niece in 1782 by the Académie and a copy provided to any academy member who desired one. Apparently it was not published until 1791. Jules Hédou, *Jean Le Prince et son oeuvre* (Paris, 1879), pp. 75–78.

26. Roger Portalis and Henri Béraldi, *Les Graveurs du dix-huitième siècle,* vol. 2 (Paris, 1881), p. 672.

27. There was another artist in Paris, a Swede, P. G. Floding (1741–1791), who may have been working on the process independently, since he reproduced two compositions by Boucher in 1762, the year before Leprince returned to Paris after a five-year stay in Russia. Ibid., p. 203.

28. S. T. Prideaux, *Aquatint Engraving* (London, 1909), p. 98.

29. Elena Páez, Curator of Prints, Biblioteca Nacional, Madrid, very kindly looked through that collection for dated Spanish aquatints. The earliest she could find was *Diversion Española,* inscribed *P. de Machy hijo lo Grabo en Madrid 1790.* Machy, who was in Madrid from 1787 to 1791, was the son of a French academician, Pierre Antoine de Machy, himself an aquatinter.

30. Louis Guimbaud, *Saint-Non et Fragonard* (Paris, 1928), pp. 166 f.

which a range of tones could be produced.[31] Initially he seems to have embellished the etched lines with aquatint in compositions that were already legible. Goya's difficulties with the unfamiliar medium are all too apparent. In one plate, *Las Meninas,* after the most admired of Velázquez's paintings, Goya must have striven for a brilliant success, but the copper plate was in the end severely damaged while the aquatint tones were being bitten (cat. no. 31). There is only one of the six, *Don Juan de Austria* (cat. no. 33), where line and tone play separate but equal parts in the composition.

The Real Calcografía was set up in 1789 under the jurisdiction of the government press to provide artists with experts to print their plates.[32] By 1796 the five equestrian etchings were advertised by the Calcografía together with eight prints by Castillo and Goya, also after paintings in the royal palace.[33] The chalcography also came to own the plates for eight more of the etchings after Velázquez as well as two of the early etchings, *San Francisco de Paula* and *The Garroted Man.* They continued to print these plates as customers wanted them, continued when the sparkling delicacy of the very early impressions had vanished, continued when what they had to offer could please only the least discerning but still eager purchaser.

31. Prideaux, *Aquatint Engraving,* p. 98.

32. See Enrique Lafuente Ferrari in his answer to Teodoro Miciano Bercerra's *Breva historia del aguatinta* (Madrid: Real Academia de Bellas Artes, 1972), p. 57.

33. Lista de las estampas que se hallan de venta en la Real Calcografía establecida en la misma Imprenta Real. Siete estampas de pliego de marca mayor de los caballos de Velazquez grabadas por Goya al agua fuerte, en 42 rs. Ocho estampas de diferentes pinturas del Palacio, grabadas por Goya y Castillo, en 24 rs. *Diario de Madrid [?],* p. 19. [The volume from which this reference was taken has disappeared and could not be verified.]

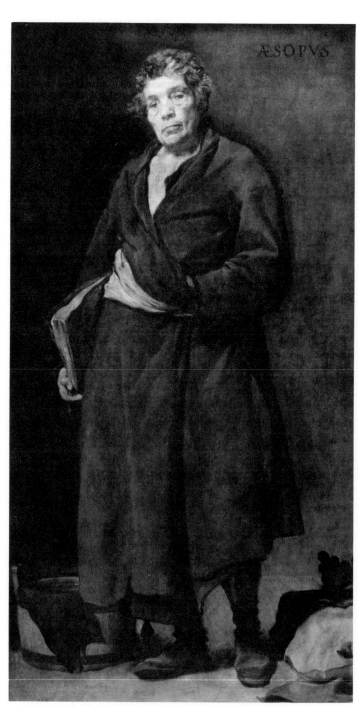

Fig. 2. Velázquez, *Aesop,* Prado

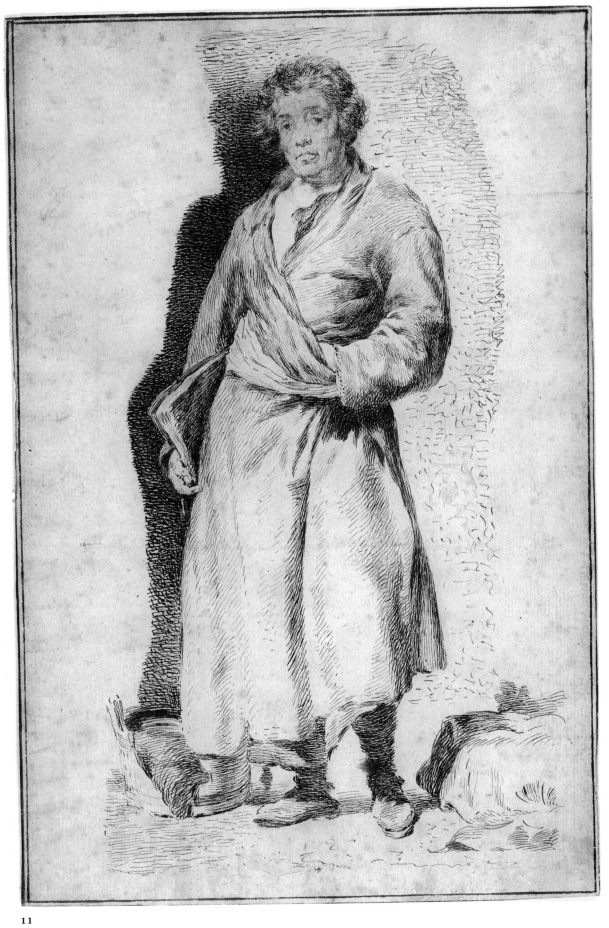

11

11–13

Aesop

By July 1778

After the painting by Velázquez (Prado 1206)

D. 16, H. 13, B. 17, H. 259

300 × 215 mm.

11

Preparatory drawing for the etching (1777–78)

Pen and black and brown inks

310 × 208 mm.

No watermark

Coll.: Stirling-Maxwell; Mr. and Mrs. Philip Hofer

Museum of Fine Arts, Boston. Gift of the Frederick J. Kennedy Memorial Foundation, 1973.695

12

First published state; Harris I, 2

Etching; in drypoint, lower left: *Diego Velazquez;* lower right: *FG*

Inscribed in pen and brown and black inks and dated 1778

No watermark

Coll.: Stirling-Maxwell

Museum of Fine Arts, Boston. 1951 Purchase Fund. 51.1715

13

Second published state; Harris III

Etching; inscription engraved and dated 1778

No watermark

Museum of Fine Arts, Boston. Bequest of William P. Babcock. B1747

This is the only known drawing for the series executed in pen. It was begun in black ink, which delineates Aesop's head, right shoulder, and lapels, and perhaps completed in brown ink. (It is possible that both inks were originally the same color, and that one has changed.) Goya makes Aesop a stockier figure than in the painting, and because his face is more fleshy and his lips thicker and less firm, Aesop's face loses its original expression of disciplined intelligence. Furthermore, the philosopher's robe is light rather than dark, and there is no tonal differentiation between the robe and the sash. The strong column of shadow in the painting, running from Aesop's waist to his foot, is interrupted in Goya's drawing. The shadow behind Aesop that repeats the profile of his body at the left is Goya's invention. The accessories, a bucket and a bundle, are summarily sketched.

In the etching the shape of the shadow is altered, giving a new sense of balance to the design. Aesop's face is gaunter and his hair considerably shorter. His figure becomes more monumental because Goya has now etched his own version of the long, columnar shadow. The folds of drapery across Aesop's chest and on his skirt have been freely altered, and the ambiguous, foliate form rising behind the bundle at the right has disappeared. In this print the graphic means are unusually restrained. The etching has fewer loops, flicks, and curves than appeared in the drawing or in Goya's other etchings after the seventeenth century painter.

The earliest proofs were unsigned. Then Goya added to the plate in drypoint *Diego Velazquez* and his own initials, *FG*. The impression shown here is not strictly speaking a working proof. Goya realized that buyers would require more information. Impressions in this state are known with pen inscriptions. These are carefully lettered on ruled or incised guide lines. This laborious procedure was soon abandoned in favor of an inscription engraved in the plate. This particular impression bears two sets of pen and ink inscriptions. The first, in black ink, over the drypoint name and monogram reads: *ESOPO, EL FABVLADOR./Pintura de D. Diego Velazquez qͤ esta en el Palazio Rᶫ de Maᵈ grabada pͬ D. Francᵒ Goya Pintor ãͦ 1778.* (Aesop, the Fabler, Painting by Don Diego Velázquez which is in the Royal Palace of Madrid, graved by Don Francisco Goya, Painter, the year 1778.) A second inscription, in brown ink, written in the margin, adds information to be found in the engraved inscriptions, although not in that exact form: *Sacada y gravada del Quadro Original de Dⁿ Diego Velazquez que está en el Rᶫ Palacio de Madrid por D. Francisco Goya Pintor. ano 1778.* (Copied and graved from the original painting by Don Diego Velázquez which is in the Royal Palace of Madrid by Don Francisco Goya, Painter, the year 1778.)

The second impression, early and fine, is printed on paper identical to the preceding. The title has been engraved.

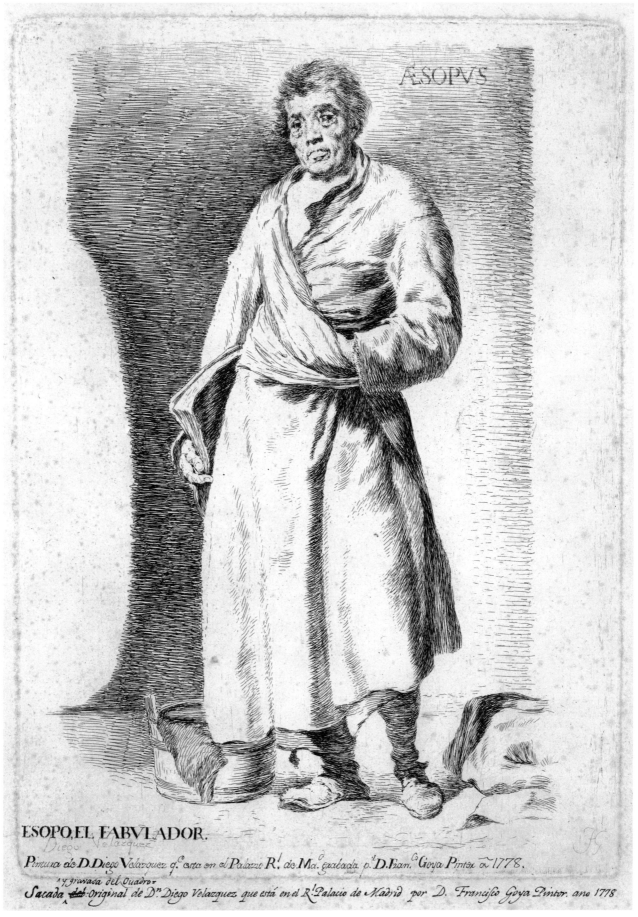

ESOPO, EL FABVLADOR.

Diego Velázquez

Pintura de D. Diego Velazquez q.e está en el Palacio R.l de Ma.d grabada p.r D. Fran.co Goya Pintor añ 1778.

y gravada del Quadro
Sacada ~~del~~ Original de D.n Diego Velazquez que está en el R.l Palacio de Madrid por D. Francisco Goya Pintor. ano 1778

12

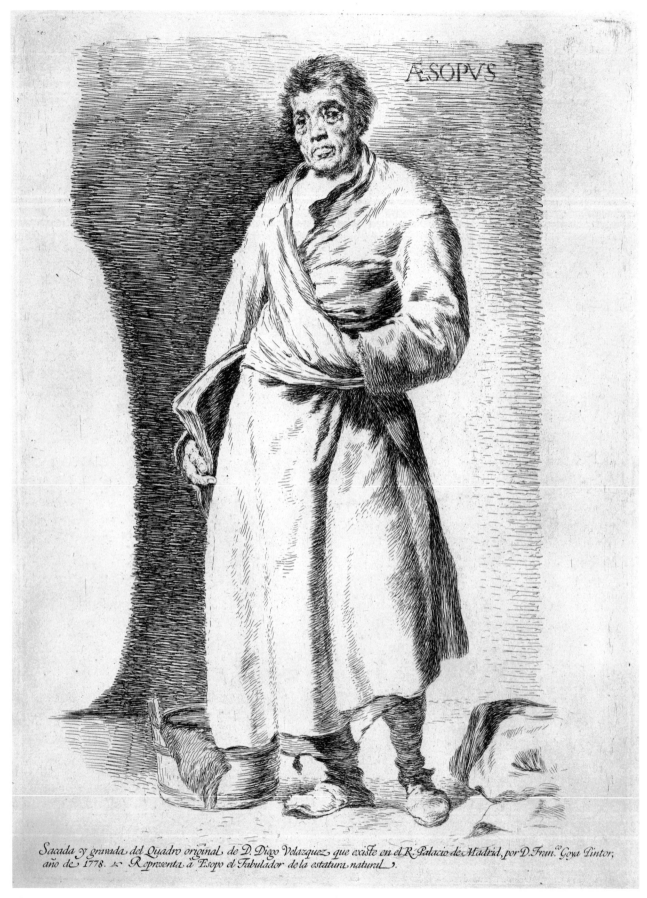

AESOPVS

Sacada y grauada del Quadro original de D. Diego Velazquez que existe en el R. Palacio de Madrid, por D. Fran.co Goya Pintor, año de 1778. Representa á Esopo el Fabulador de la estatura natural.

13

14–15

Un enano (Sebastian de Morra)
(A Dwarf). By July 1778
After the painting by Velázquez (Prado 1202)
D. 18, H. 15, B. 19, Hof. 263
205 × 155 mm.

14

First published state, Harris I, 2
Etching; in drypoint, lower left: *Diego Velazquez;*
lower right: *FG*
Inscribed in pen and black ink
No watermark
Coll.: Stirling-Maxwell
Museum of Fine Arts, Boston. 1951 Purchase Fund.
51.1719

RAMÓN BAYEU. Spain 1746–1793
15

Saint Jerome
(After the painting by José Ribera)
Meyer 9
Etching. 227–230 × 194 mm.
No watermark
Museum of Fine Arts, Boston. Gift of Mr. and Mrs.
Benjamin A. Trustman. 68.803

Both prints are after seventeenth century Spanish paintings; Goya's after the Velázquez painting in the Prado and Ramón Bayeu's after a Ribera in the Fogg Art Museum, Cambridge, Massachusetts. Both prints reveal their indebtedness to Giovanni Battista Tiepolo. Unlike Tiepolo, Goya and Bayeu use a dense variety of short strokes applied in different directions in the background. Goya's tend to be overlapping, short curving lines that are essentially parallel. Bayeu, however, uses longer and more even strokes of crosshatching somewhat like those in Tiepolo's *Saint Joseph and the Child Jesus* (cat. no. 5). Yet if Bayeu's print had not been inscribed with his name, one might easily and convincingly have attributed it to Goya.

The fine early impression of *A Dwarf* is on the same paper as *Aesop* (cat. nos. 12, 13). It too bears a hand-lettered inscription in pen and black ink over the drypoint name of Velázquez and the initials of Goya, and is also an example of the print in its earliest published state. At least four other hand-lettered impressions exist in which the lettering seems to grow increasingly careless.[1] One impression, in the Biblioteca Nacional, has, like *Aesop* (cat. no. 12), a further inscription in the lower margin.

1. Compare, for example, the Berlin Kupferstichkabinett and Rosenwald collection examples, repr. (Berlin) Valerian von Loga, *Francisco de Goya* (Leipzig n.d.), Meister der Graphik IV, Pl. 6 and (Rosenwald) Hoffman Pl. 16.

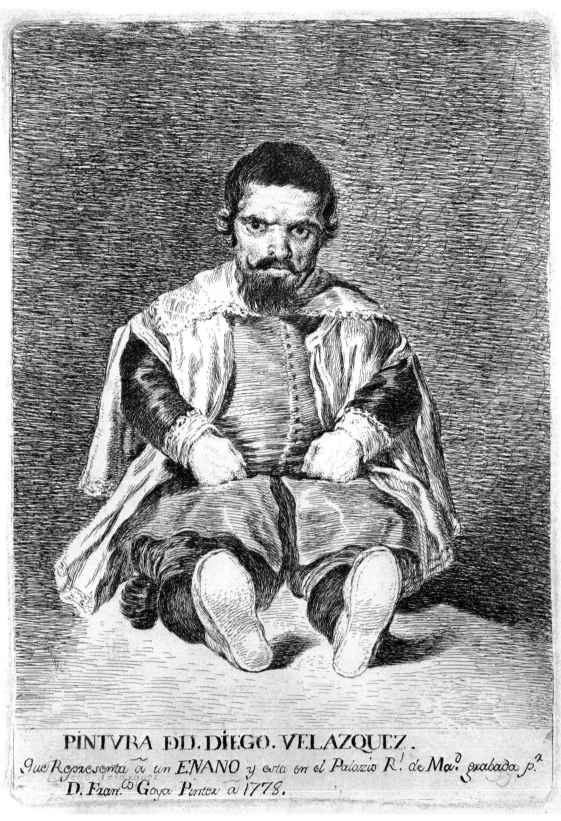

14 (full size)

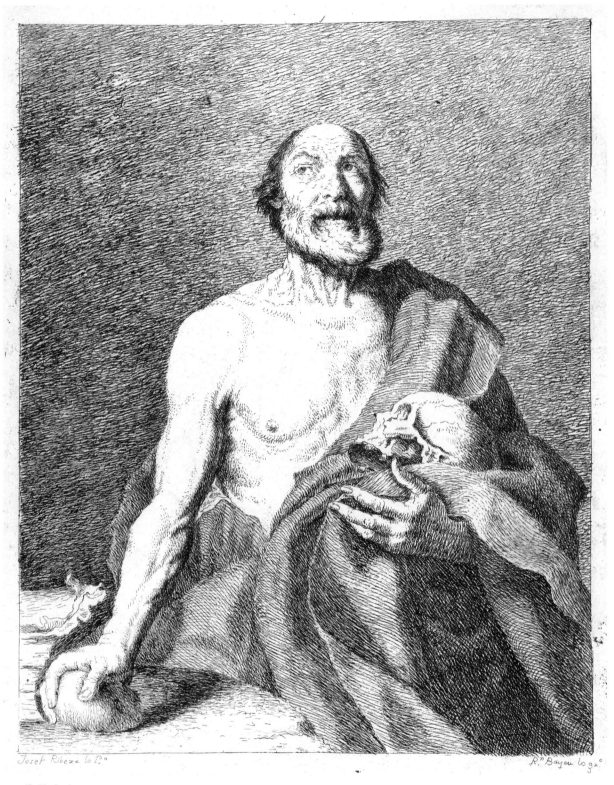

Josef Ribera lo Po Rn Bayeu lo gx

15 (full size)

16–19
Felipe III
By July 1778
After the painting by Velázquez and an unknown
painter (Prado 1176)
D. 6, H. 5, B. 7, Hof. 249
370 × 310 mm.

16
Working proof, Harris I, 1
Etching. Inscribed in pen and brown ink
Watermark: R ROMANI and coat of arms
Museum of Fine Arts, Boston. 1951 Purchase Fund.
51.1700

17
Impression from completed plate, Harris III
Etching; inscription engraved and dated 1778
Sheet laid down
Museum of Fine Arts, Boston. Bequest of W. G.
Russell Allen. 1974.225

18
Impression from completed plate, Harris III
Etching; inscription engraved and dated 1778
Laid paper without watermark
Museum of Fine Arts, Boston
Gift of William Norton Bullard. 21.1037

19
Impression from completed plate, Harris III
Etching; inscription engraved and dated 1778
Wove paper
Museum of Fine Arts, Boston. 1951 Purchase Fund.
51.1701

This working proof is the only known impression
before additional etching. The lines are very fine, cleanly
etched, and laid close together. The white paper shows
around this work, and together they create a pale, silvery
tonality and a sense of shimmering light similar to that
found in the etchings of G. B. Tiepolo (cat. no. 5). The
proof is inscribed in the margin, probably in Goya's
hand: *Felipe III Rey de España. | Pintura de Dꞥ Diego
Velazquez, del tamaño del natural en el Rᴵ Palacio de
Madrid, dibujada y | grabada por Dꞥ Francᵒ Goya, Pintor
año de 1778.* (Felipe III, King of Spain, Painting by Don
Diego Velázquez, of life size, in the Royal Palace of
Madrid, drawn and graved by Don Francisco Goya,
Painter, the year of 1778.) As Harris noted, the numbers
21, 74, and 40 in pen and black ink that appear at the
ends of the lines are a count of the letters for the engraver.

In the published state, the new inscription is
engraved in almost exactly the same form. New etched
work darkens the king's hat, and defines the volume, and
intensifies the shine of his armor. It accents the horse's
mane and tail, and his trappings, and clarifies the shape
and pattern of the saddle blanket. The new dark tones
also serve to unify the composition. The condition of the
sheet is only fair; nevertheless this is an early impression,
taken when the plate was in perfect condition, and is
probably one of those offered for sale by Goya in 1778.

In the third impression the fine lines appear paler as
the plate had begun to show signs of wear from repeated
printings. Therefore, the heavier new lines added on the
hat and saddle cloth become more prominent than
they should be.

The fourth impression was printed by the Calcografía
Real, probably in the nineteenth century, since it is on a
wove paper. Although it makes a good appearance, the
copper plate was, in fact, quite worn. The areas of second
etching are even more prominent, since the finer lines
in the plate could no longer hold much ink, but print
with a broad, grayish effect. A film of ink was left on the
plate to compensate for its condition.

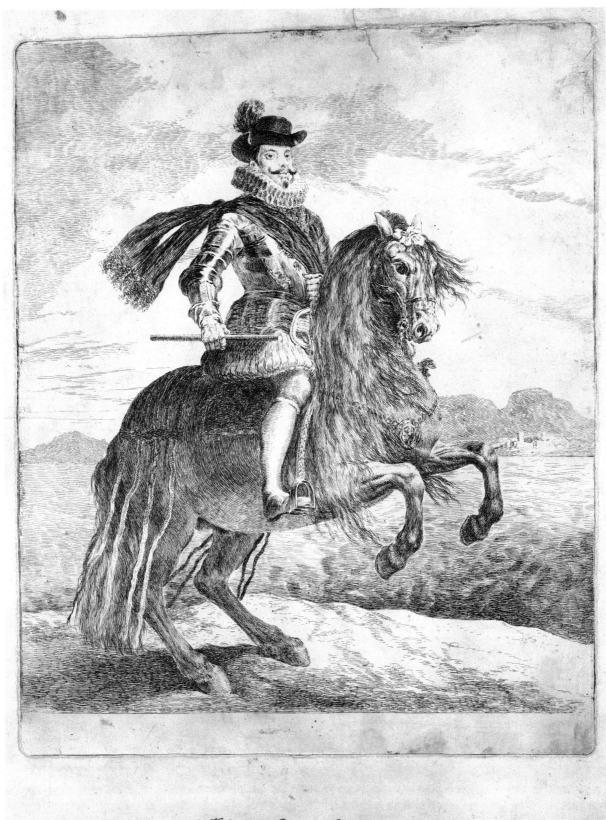

Felipe III Rey de España.

Pintura de D.n Diego Velazquez, del tamaño del natural en el R.l Palacio de Madrid, dibujada y
grabada por D.n Fran.co Goya, Pintor año de 1778.

74
4.o

16

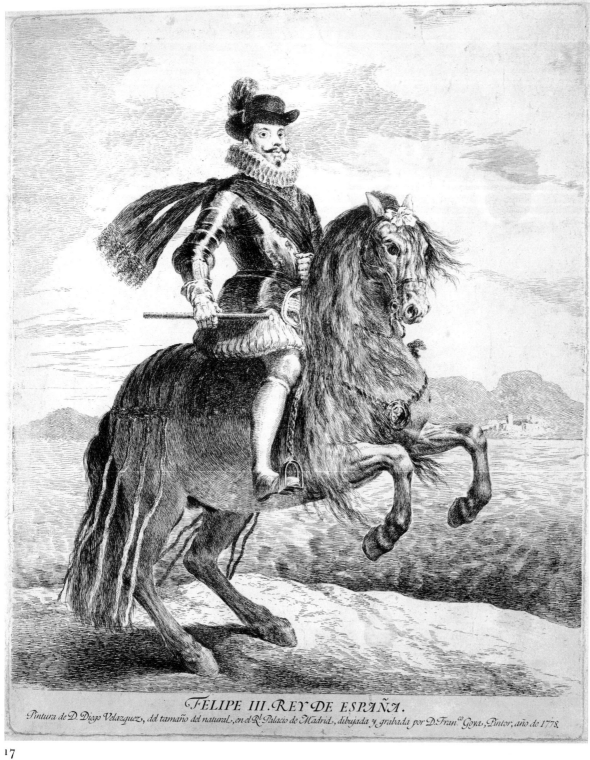

FELIPE III. REY DE ESPAÑA.
Pintura de D. Diego Velazquez, del tamaño del natural, en el Rl. Palacio de Madrid, dibujada y grabada por D. Fran.co Goya, Pintor, año de 1778.

¹⁷

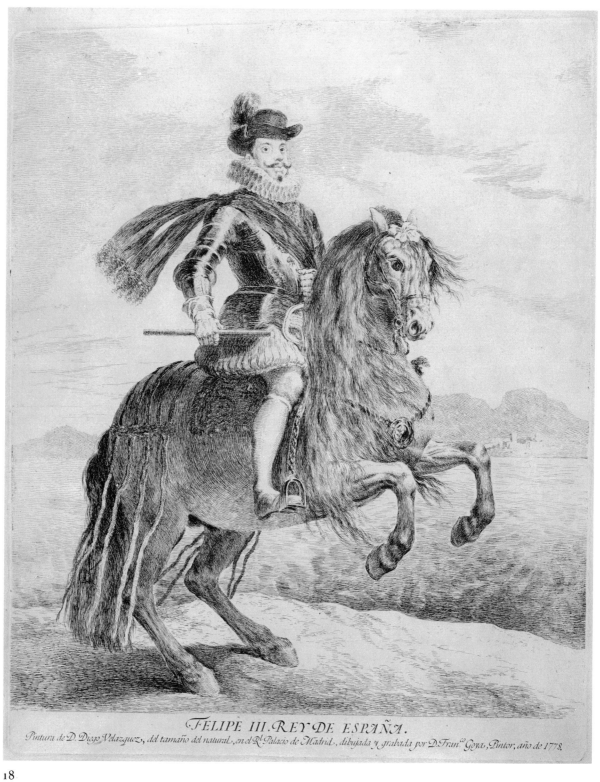

FELIPE III. REY DE ESPAÑA.
Pintura de D. Diego Velazquez, del tamaño del natural, en el Rl. Palacio de Madrid, dibujada y grabada por D. Franco Goya, Pintor, año de 1778.

18

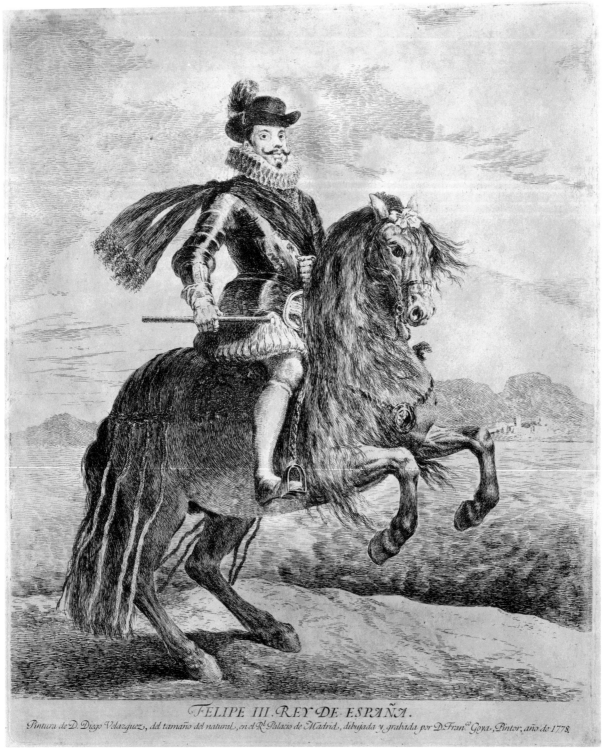

FELIPE III. REY DE ESPAÑA.

Pintura de D. Diego Velazquez, del tamaño del natural, en el Rl. Palacio de Madrid, dibujada y grabada por D. Franco Goya, Pintor, año de 1778.

19

20–21

Margarita de Austria. By July 1778
After the painting by Velázquez and an unknown
painter (Prado 1177)
D. 7, H. 6, B. 8, Hof. 250
370 × 310 mm.

20
Working proof, Harris I, 1
Etching; touched with pen and black ink; inscribed in
pen and brown and black inks.
Watermark: R ROMANI and coat of arms
Coll.: Stirling-Maxwell
Museum of Fine Arts, Boston. 1951 Purchase Fund.
51.1702

21
Impression from completed plate, Harris III
Etching and drypoint; inscription engraved and
dated 1778
No watermark
Museum of Fine Arts, Boston. Harvey D. Parker
Collection. P18305

Neither the painting of Felipe III nor that of his wife,
Margarita de Austria, was among those most admired by
Goya's contemporaries, and scholars today attribute both
works to Velázquez working with an assistant. Neverthe-
less, Goya himself was proud of this etching. For, in
1797, when he drew a title page with self-portrait, he
placed an earlier work at his side, the copper plate for
this print (see cat. nos. 70–76).

This impression, the only one known from the
unfinished plate, is printed on the same Romani paper
as the proof of *Felipe III* (cat. no. 16) and is also lightly
etched. There are numerous retouches in pen and black
ink: on the queen's bodice and along the right edge and
border of her gown, and along the fringe of the horse's
blanket, as well as on its mane and trappings. The title is
written in the lower margin, probably by Goya: (in
brown ink) *D. Margarita de Austria Reyna de España
Muger de Phelipe* IV [crossed out] *III* / (in black ink)
*Pinttura de Dⁿ Diego Velazquez del Tamaño del natural
en el Rˡ Palazio de Madᵈ, dibujada grabada* / *pᵗ Dⁿ Francᵒ
Goya Pinttor año 1778.* (Doña Margarita de Austria,
Queen of Spain, Wife of Felipe III, Painting by Don
Diego Velazquez of life-size in the royal palace of Madrid,
drawn [and] graved by Don Francisco Goya, Painter,
the year 1778.)

In the finished state of the etching the areas indi-
cated with pen on the proof impression are retouched in
very fine drypoint lines. In addition drypoint is used to
darken the queen's hair and lightly shade a large area of
her skirt. The new work adds life and sparkle to this
delightful eighteenth century image of a seventeenth
century queen.

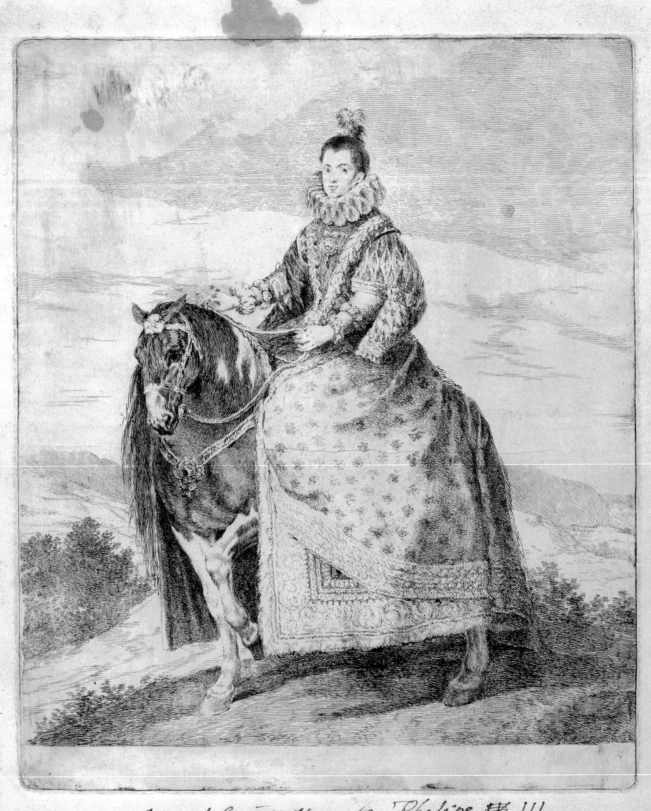

D. Margarita de Austria Reyna de España Muger de Phelipe III

Pintura de D.n Diego Velazquez del tamaño del natural en el R.l Palacio de Mad.d dibujada grabada

p.r D.n Fran.co Goya Pintor año 1778

20

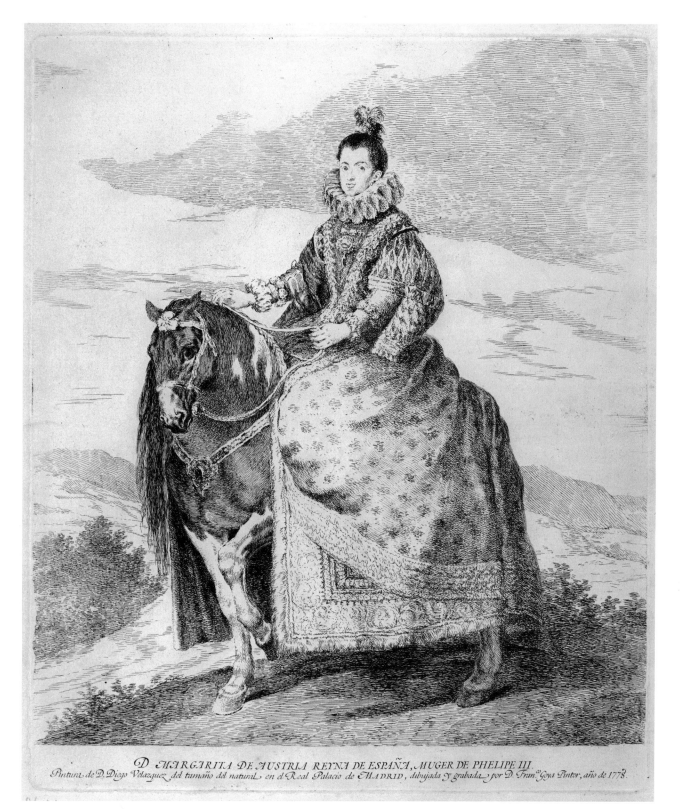

D. MARGARITA DE AUSTRIA REYNA DE ESPAÑA, MUGER DE PHELIPE III.
Pintura de D. Diego Velazquez del tamaño del natural, en el Real Palacio de MADRID, dibujada y grabada por D. Fran.co Goya Pintor, año de 1778.

21

Baltasar Carlos. By December 1778
After the painting by Velázquez (Prado 1180)
D. 10, H. 9, B. 11, Hof. 253
350 × 220 mm.

22
Working proof, Harris I, 1, printed on the verso of
a working proof of *Aesop*
Etching
No watermark
Coll.: Stirling-Maxwell
Museum of Fine Arts, Boston. 1951 Purchase Fund.
51.1714

Goya also made etchings after Velázquez's paintings of
Felipe IV and his wife, Isabel de Borbón; the Infante
Baltasar Carlos was their son.

Velázquez painted a small, aristocratic prince, riding
his barrel-shaped pony with great regality across a spa-
cious stretch of his father's realm. In the etching Goya
reproduced faithfully only the image of the pony.
Velázquez's landscape apparently impressed him not at
all, for he altered it to a rather barren and insubstantial
background. He adhered even less to Velázquez's con-
ception of the little *infante*. From the canvas the child
gazes with great reserve, and the original position of the
painting over a doorway must have added to his high-
born remoteness.[1] But the boy etched by Goya perches
on his steed with the reins held awkwardly in his hand.
He has the bright, knowing eyes of the thin, sharp-faced
children so often found in Goya's paintings.

This impression of the lightly etched, unfinished
plate, the only one known of this state, is printed on the
back of a working proof of *Aesop*. In the following state,
new etching would be added on the prince and his pony,
and the semicircular gap at the lower left edge partially
filled in with drypoint.

Fig. 3. Velázquez, *Baltasar Carlos,* Prado

1. Museo del Prado, *Catalogo de los cuadros,* (Madrid, 1952), p. 698.

22

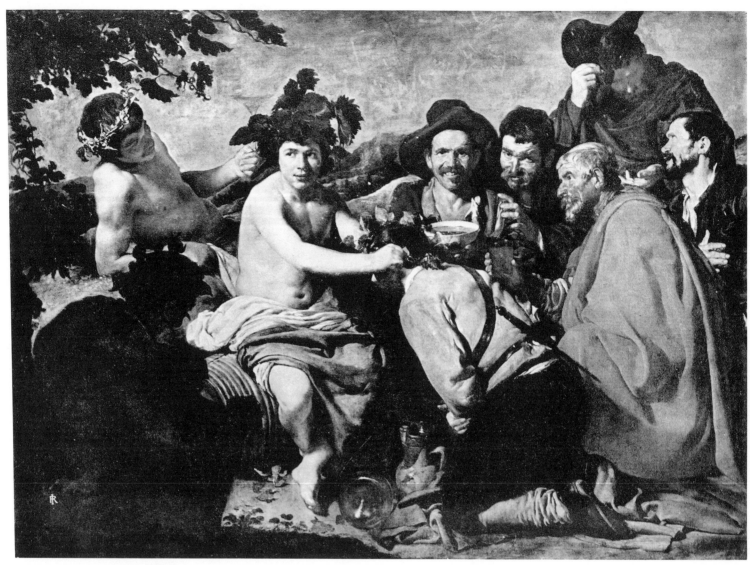

Fig. 4. Velázquez, *Bacchus,* Prado

23–24
Un Baco fingido coronando algunos borrachos.
(A false Bacchus crowning some drunkards)
By December 1778
After the painting by Velázquez (Prado 1170)
D. 4, H. 4, B. 4, Hof. 256
315 × 430 mm.

23
Impression from the completed plate, Harris III
Etching
Watermark: JOAN
Coll.: Burty
Museum of Fine Arts, Boston. Harvey D. Parker
Collection. P19367

Manuel Salvador Carmona. Spain, 1734–1820
24
Baco coronando á los borrachos
(Bacchus crowning the drunkards) after Velázquez
Etching and engraving
Museum of Fine Arts, Boston. Bequest of William P.
Babcock. B823

In neither his prints nor the drawings on which they
were based did Goya feel confined by what Velázquez had
painted. In general, the differences were confined to
Goya's own intuitive sense of the proper balance of a
composition or to his tendency to view royalty and
philosopher alike as human beings.

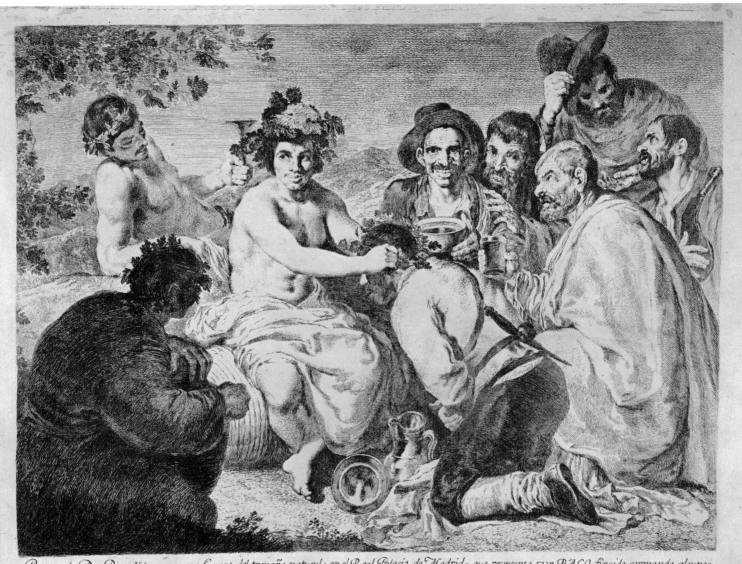

Pintura de Don Diego Velazquez con figuras del tamaño natural en el Real Palacio de Madrid, que representa un BACO fingido coronando algunos borrachos: dibujada y grabada por D. Francisco Goya, Pintor. Año de 1778.

23

23, detail, full size

detail of Fig. 4

43

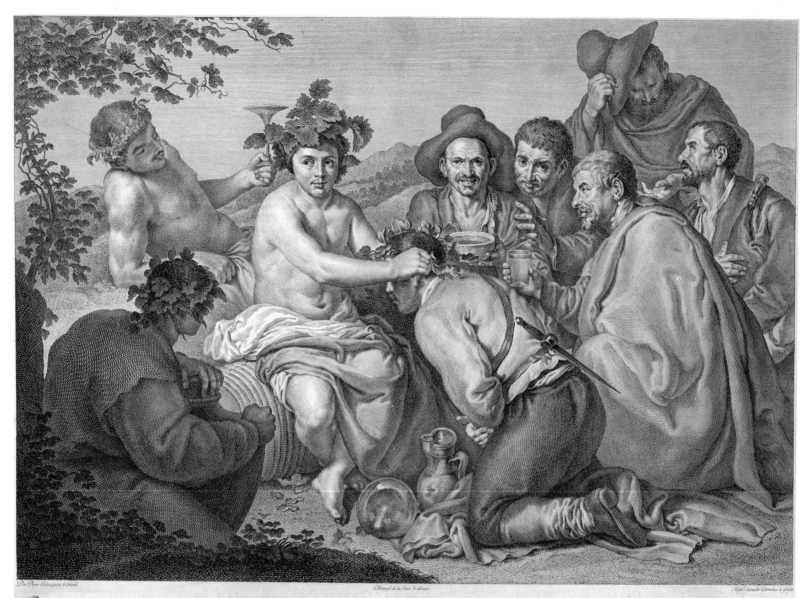

Baco coronando á los Borrachos, pintado por D. Diego Velazquez de Silva, natural de Sevilla, Caballero de la Órden de Santiago, Primer Pintor,
Ayuda de Cámara, y Aposentador mayor del Rey D. Felipe IIII°: admirable en la imitacion de la verdad y en la soltura y libertad de su estilo: Este
Quadro, que es de su tiempo medio, tiene de ancho siete pies de rey, y de alto cinco y pulgada y media: está en el Real Palacio de Madrid.

24

Goya's understanding of this painting was influenced by two texts in the *Viage de España* by Antonio Ponz and Anton Raphael Mengs, both of whom saw the central figure not as a god, but as a man playing the part of Bacchus in a country masquerade.[1]

The earnestness of Bacchus' face in the painting, the beauty of his body, and the solemnity of his attendant are in part retained in a drawing by Goya in the Prado (474). However, in the print, Goya etches a sturdy, muscular peasant with knowing face, while the attendant toward whom he glances looks on with tolerant amusement. The drunkards have become even more rough-looking. It is not a coincidence that Goya's title is almost identical with Mengs' text. This is the first of the series to be entirely etched, including even the inscription.

Carmona's copy of the painting was begun in etching and completed with the burin as in the French academic tradition. Carmona brought to his plate considerable technical ability and the intention of translating Velázquez's painting into black and white as faithfully as possible. The traditional title is preserved in his inscription, which informs us that Velázquez was "admirable in the imitation of truth and in the looseness and freedom of his style" and that the painting "is from his middle period."

Goya's print, however distant from the original, is a work of art in its own right.

1. See the introduction to this section for further discussion of the painting's meaning.

25–29

Infante Don Fernando
After the painting by Velázquez (Prado 1186)
D. 12, H. 11, B. 13, Hof. 257
280 × 170 mm.

25
Preparatory drawing for the etching (1777–78)
Red chalk
272 × 151 mm.
No watermark
Coll.: F. B. Cosens, London (?); B. Quaritsch, 1891
Kunsthalle, Hamburg. inv. 38538

26
Working proof, Harris I, 1
Etching
Biblioteca Nacional, Madrid. inv. 45568

27
Working proof, Harris I, (noted as 3 but actually 2)
Etching; toned with black chalk
Inscribed in pencil: *Felipe IV* . . .
Biblioteca Nacional, Madrid. inv. 45570

28
Working proof, Harris I, 4
Etching, burnishing, and roulette
British Museum, London. 1851-12-13-19

29
Working proof, Harris I, 5
Etching, burnishing, roulette, and aquatint
No watermark
Inscribed in pen and brown ink: *Un Ynfante* . . .
Biblioteca Nacional, Madrid. inv. 45571

There are five working proof states of the *Infante Don Fernando*, more than for any other of the plates after Velázquez. As Goya worked on the plate, trying to produce a more painterly tone, he seems to have felt it necessary to check the progress of the plate more frequently than usual. In the drawing and four of the progressive proofs, one can see how Goya deals with

Velázquez's image, first changing principally the forms, then the tonality.

There is no reason to believe that the drawing was made any later than those for the eleven etchings advertised in July and December 1778. As usual, Goya freely adapts Velázquez's painting, giving the drawing a narrower format. Goya reduced the landscape to a minimum and changed details such as the shape of the hat and the baroque pattern of the Infante's sleeve. He is more thickset and less aristocratic. The dog is reduced in size, altering the relationship between the slender prince and his magnificent beast.

The first working proof looks complete. The etched lines are fine, and there is the same light tonality and delicate surface sparkle as in the first eleven published prints. In the second working proof horizontal etched lines shade the sky and ground.[1] The prince's clothing has been darkened by broadly etched lines of a character not found in the eleven earlier etchings. In this respect Goya has moved away from the etchings of Tiepolo. Similar work was to appear in various plates of the *Caprichos*. Chalk has been rubbed over much of the sheet to indicate where areas should be darkened.

The London impression is a later working proof. In this fourth state, Goya, like other printmakers before him, tried adding a tone over most of the background by means of a spiked roulette wheel.

It is not until the fifth and final working state that a fairly dark aquatint is added that covers the entire background and much of the Infante's clothing. Just above the mountains the sky has been burnished to lighten it. Changes in the Infante's face, begun in earlier states, are here noticeable. The aquatint tone is primarily contained within the areas already etched. In this respect Goya's print differs little from the work of such early practi-

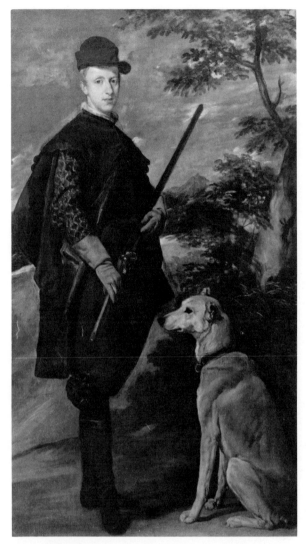

Fig. 5. Velázquez, *Infante Don Fernando,* Prado

tioners as Leprince and St. Non. This proof is inscribed: *Un Ynfante de España- / Pintura de Dⁿ Diego Velazquez de el tamaño natural en el / Rⁱ Palacio de Madrid debujado y grabado por / Francᵒ Goya pintor . . .* (A prince of Spain, painting by Don Diego Velázquez, life size, in the Royal Palace of Madrid, drawn and graved by Francisco Goya, painter . . .) An engraved title with much the same wording was later added to the plate.[2]

1. In our opinion Harris' order of impressions is not correct. There are two impressions of a later state, one at the Biblioteca Nacional, Madrid (inv. 45569) and another at the Bibliothèque Nationale, Paris (repr. in Delteil), in which the etched lines of the shrubbery leaves above the dog's head have been extended so that they almost touch the Infante's breeches. The dog's head and collar and the horizontal lines in the left background have been burnished. Since the Madrid touched proof precedes these changes, it is in reality a second state, while the other two are a third state.

2. Harris records a 1778 edition of thirteen plates. There are, however, not enough eighteenth century impressions of this print nor of *Barbarroxa* to suggest an actual edition.

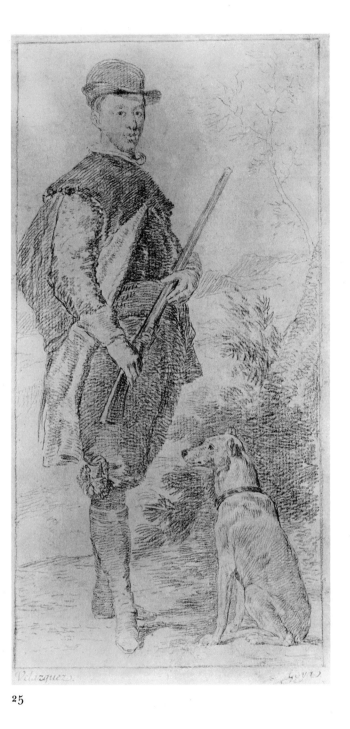

25

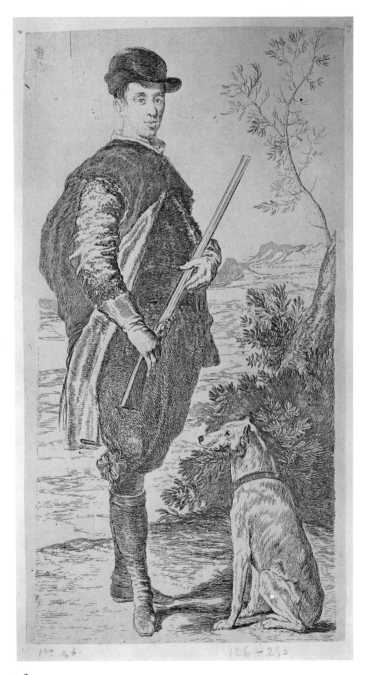

26

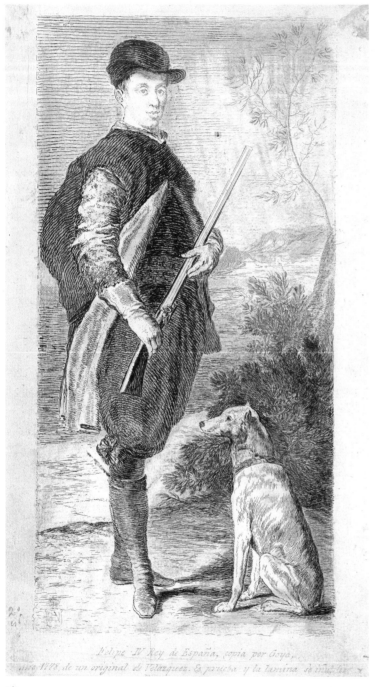

Felipe IV Rey de España, copia por Goya,
año 1778, de un original de Velázquez. Es prueba y la lámina de

27

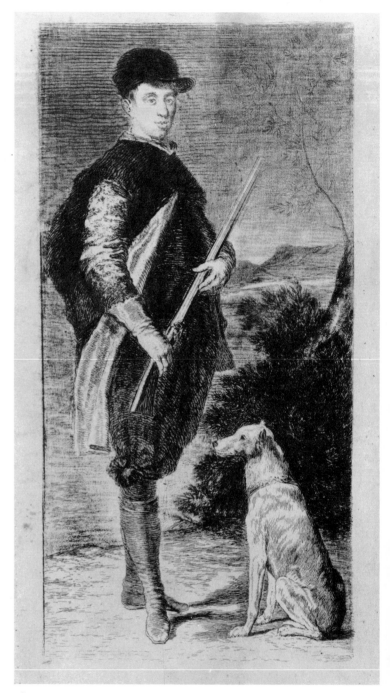

28

48 *The Prints after Velázquez*

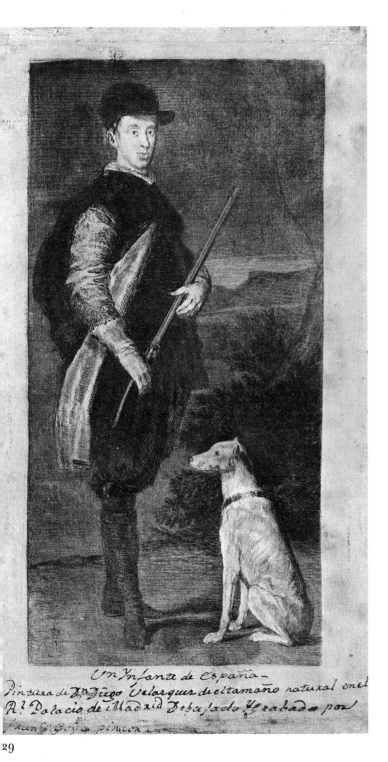

Un Ynfante de España—
Pintura de D.ⁿ Diego Velasquez de tamaño natural en el
R.ˡ Palacio de Madrid Debaxado Y grabado por
Fran.ᶜᵒ Goya pintor en...

29

1. El quadro historiado, en que se ve la Infanta (que despues fué Emperatríz de Alemania) Doña Margarita María de Austria, aun niña, asistida de algunas Meninas de su edad, y de diferentes personages, con dos figuras de Enanos, y detras D. Diego Velazquez retratando á dicha Infanta, ha sido tenido, y se tiene en el mayor aprecio. Ponz, *Viage*, vol. 6, p. 29 (Aguilar reprint p. 525).

30–31

Las Meninas

(The Ladies-in-Waiting)

After the painting by Velázquez (Prado 1174)

D. 5, H. 17, B. 6, Hof. 255

405 × 325 mm.

30

Working proof, Harris I, 1

Etching and drypoint

Petit Palais, Paris. 5381

31

Working proof, Harris I, 4

Etching, drypoint, roulette, and aquatint

Coll.: Meade; Stirling-Maxwell

Museum of Fine Arts, Boston. 1951 Purchase Fund.

51.1699

In 1776 the painting was described as follows: "The historical painting in which is shown the Infanta (who later became Empress of Germany), Doña Margarita Maria of Austria, when still a child, tended by various ladies-in-waiting of her own state and other persons; with two figures of dwarfs, and in back, Don Diego Velázquez painting a portrait of the said Infanta, the which has been and still is held in the highest esteem."[1] *Las Meninas* remains to this day the best known of Velázquez's paintings; Picasso is not the only twentieth century artist to use it as a theme.

It is impossible to believe that Goya did not take especial pains with this print, and yet it is no closer to Velázquez's painting than any of the etchings advertised for sale. The first working proof (not recorded by Harris) is executed in etching with many small touches of drypoint on the figures. Although it has the sparkle and vitality of the equestrian portraits, Goya continued to

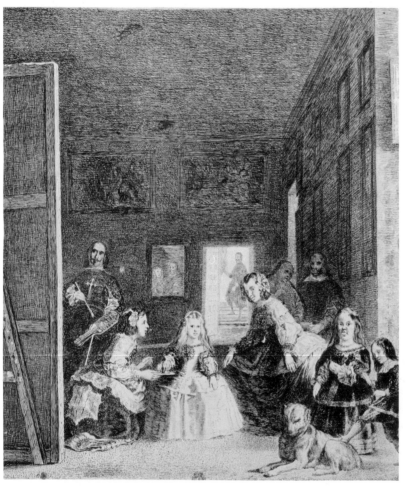

30

work on the plate. Eight working proofs are recorded that have pale tones of aquatint on background, floor, and figures. Some roulette work to suggest painted tone was also added, as in the *Infante Don Fernando* (cat. no. 28), and remained visible on the Infanta's skirt and the shoulder of the kneeling lady at the left.

The Boston Museum impression, the last state known, is unique. Two new tones of very fine-grained aquatint, one extremely pale, have been added over most of the plate, leaving very little of it untouched. The paper remains white only in small highlights on the faces and hands of the five foreground figures and on the dresses of the Infanta and her attendant ladies. The aquatint has been applied with a greater freedom than in the *Infante Don Fernando* (cat. no. 29). Instead of being restricted by the etched lines, it occasionally escapes these boundaries and suggests new shadows (the Infanta's waist) or gives new modeling to a face (lady-in-waiting on the right). The two new tones do not have the proper relationship to each other, so that the darker tone of aquatint is visible as disturbing, complex shapes that overlie the original design. The new biting required for the aquatint weakened the etched lines of the copper plate, leaving a number of areas that print as lighter, cloudy patches. Carderera (1796–1880), the great collector of Goya's work, referred to this particular impression as the last and only one from the over-bitten plate.[2] The plate never received an engraved inscription and was not acquired by the Calcografía.

2. Paul Lefort, *Francisco Goya* (Paris, 1877) p. 119; first appeared in the *Gazette des Beaux-Arts* (1867), vol. 22, p. 191 f.; (1868), vol. 24, 169 f., vol. 25, 165 f.

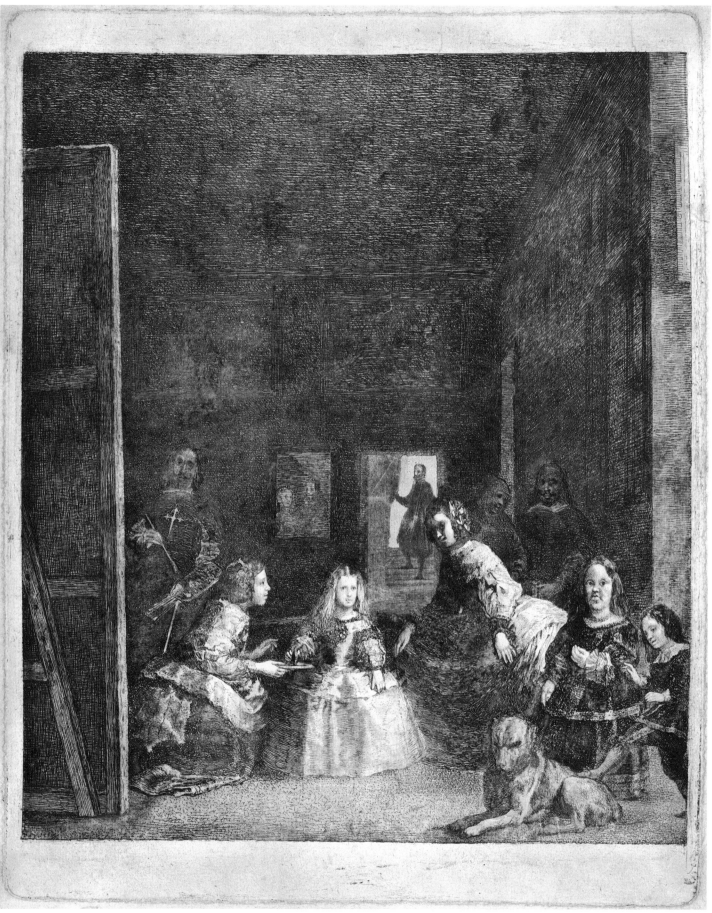

31

32–33

Don Juan de Austria, A Buffoon
After the painting by Velázquez (Prado 1200)
D. 14, H. 18, B. 14, Hof. 261
280 × 170 mm.

32
Working proof, Harris I, 1b
Etching; with colored washes
Laid down
Coll.: Stirling-Maxwell
Museum of Fine Arts, Boston. 1951 Purchase Fund.
51.1713

33
Working proof, Harris I, 2
Etching and aquatint, printed in red
British Museum, London

It is uncertain whether Goya understood that the sitter was a court fool or buffoon as did Ponz, or whether he believed him to be a military figure as the royal inventories of 1772 and 1794 describe him. Goya's "Don Juan" has been given a knowing and self-confident air not present in Velázquez's painting. Moreover, Goya has almost entirely dispensed with the carefully receding tiled floor and barely indicated the naval battle that raged in the distance.

The Boston Museum's is one of two etched impressions executed economically in very fine lines except for the broad ones that darken vest and hat. This latter work is similar to that on the *Infante Don Fernando* (cat. no. 27). This impression is a hitherto undescribed state with additional etching.[1] New work describes shading on the right side of the cloak and below both hands. The print is colored with pale blue, pink, and yellow watercolor washes.

Of the final working proof, the third state, only two impressions are known, each printed in red. Tones of

1. The earlier of the two etchings, that in the Biblioteca Nacional, has pen touches and a chalk tone rubbed onto the background and costume to indicate areas to be darkened or aquatinted, like the *Infante Don Fernando* (cat. no. 27).

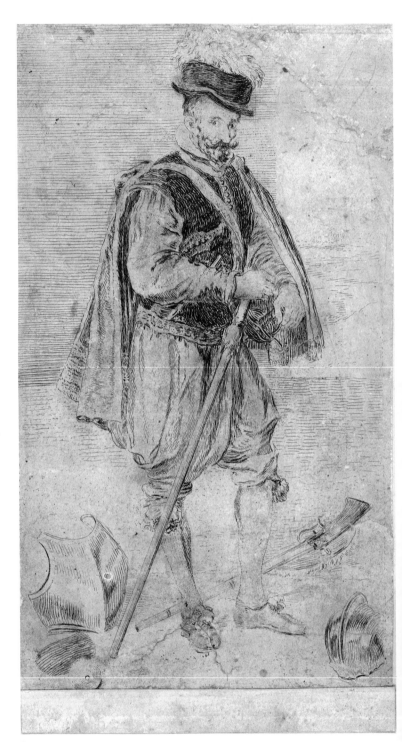

32

aquatint have been added over all but a few highlights on the figure and the armor, and one small area of the background. The setting has disappeared, and an almost abstract background has been substituted. In the *Infante Don Fernando* (cat. no. 29) or *Las Meninas* (cat. no. 31) aquatint had embellished and made more painterly a design that was already essentially complete. Here the aquatint is used as an independent and important element of the composition. In this respect *Don Juan de Austria* foreshadows the *Caprichos* of 1799.

No impression with an engraved inscription exists, nor was the plate acquired by the Calcografía.

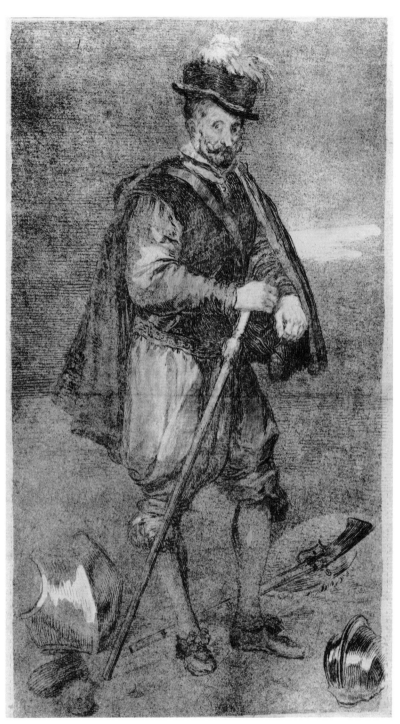

33

The Caprichos

The *Caprichos* have always fascinated those who saw them. The young Delacroix filled a number of sheets with drawings after expressive faces from the prints. Baudelaire found in some of the aquatints the quintessence of the nightmare fantasy. Art historians have cited the work as one of the sources of modern art, and sociologists and would-be psychiatrists have subjected them to analysis.

At first glance the prints may seem as easy to understand as Goya's etchings after Velázquez: monks devour their fare with relish (cat. nos. 48–49); witches fly about their business on a moonlit night (cat. no. 87); an old woman, rosary in hand, bends protectively toward a pretty young woman, who stretches out her shapely legs while her hair is combed (cat. nos. 64–65). One might think this pair to be that staple of literature and art, the young lady with her faithful family nurse. It is only when one looks carefully at the print that one sees that the old woman has a wicked face and the girl a sly, seductive expression. In the margin is an engraved title, *Ruega por ella* (She prays for her). The roles of the old and evil praying over the young and wanton can only be played by bawd and prostitute; and the content of the procuress' prayer as the girl is readied for work may easily be surmised. It is these layers of meaning in the *Caprichos* that form an essential part of their fascination.

On the whole Goya's contemporaries understood the set better than do most of us today. One of the best, brief summaries of the work appeared in 1831 in a review of a travel book on Spain by Alexander Slidell, an American naval lieutenant.[1] The reviewer thought Slidell's work superficial, and to give point to his criticism devoted two pages to the *Caprichos* on the grounds that Goya was the only person who had given a true picture of Spain.[2] "In his harsh, biting spirit, he has profoundly understood the vices which gnaw at Spain; he painted them as though he hated them . . . a Spanish Rabelais in deadly earnest, whose humor makes one shudder . . . the mockery written in his magnificent sketches . . . gives you gooseflesh and makes you shiver. One drawing by Goya has said more about Spain than have all travellers; but his work is very little known."[3]

Today it is those scholars who are knowledgeable about the social and political conditions of the eighteenth century, particularly in Spain, and who have read the diaries, journals, and literature of the day who will have the clearest understanding of these satires.[4]

The *Caprichos* were etched in the years 1797–1798 after the American and French revolutions had taken place and while the ideas of the Enlightenment were still a force. Spanish intellectuals were not alone in questioning the utility to a nation of a large body of nobles, many extremely wealthy and most of them idle. Ecclesiastical personnel were widely criticized in those nations where the church was supported by the state and where there were richly endowed monastic foundations or parish livings; laziness, greed, ignorance, and a wide spectrum of offenses against morality were noted. Men saw poverty, widespread and without remedy, as the cause of the frightening degree of brigandage and the great prevalence of prostitution. They blamed this poverty on governments that failed to promote agriculture and industry or to educate the poor and teach them useful trades. The dead weight of outworn traditions was universally deplored. So, too, were hypocrisy, pride, and an obstinate refusal to open one's eyes and ears to the truth.

1. [Lieut. Alexander Slidell], *A Year in Spain* (Boston, 1829). After 1839 the author was known as Slidell Mackenzie.

2. The review by "Ad. M.," appeared in *Revue encyclopédique*, vol. 50, 1831, pp. 328–331. The portion relevant to Goya was reprinted in Enrique Lafuente Ferrari, *Antecedentes, coincidencias e influencias del arte de Goya* (Madrid, 1947), Appendix II, 1.

3. "Dans sa verve âpre et mordante, il a profondément compris les vices qui rongent l'Espagne, il les a peint comme il les haïssait . . . un Rabelais espagnol, sérieux, et dont la plaisanterie fait frémir . . . le ridicule qu'il écrit dans ses magnifiques esquisses . . . vous donne la chair de poule, et vous fait frissonner. Un dessin de Goya en dit plus sur l'Espagne que tous les voyageurs; mais son oeuvre est très-peu connue." *Revue encyclopédique,* pp. 328–329.

4. See F. J. Sánchez Cantón, *Los Caprichos de Goya y sus dibujos preparatorios* (Barcelona, 1949), and Edith Helman, *Trasmundo de Goya* (Madrid, 1963).

Travelers coming to Spain were struck by the widespread poverty and misery of the Spanish peasant laborers. There was little land for an enterprising farmer to buy, because of the vast holdings, most of them entailed, of the Spanish Church and certain nobles.

The Inquisition still held power and persisted until 1834. By the end of the eighteenth century, although executions were rare, the secret trials continued. The summary damning evidence forced from the prisoner was read at an *auto da fé* and used as the justification for sentencing (cat. nos 58–59). To pay the costs of the trial the prisoners' worldly goods were confiscated. This institution, the *Santo Oficio* (Holy Office), resisted political, social, and even religious changes and exercised a powerful and repressive censorship.

Carlos III, who maintained progressive policies toward culture, commerce, and industry, died in 1788 and was succeeded by his son, Carlos IV. This amiable man, who had such a passion for hunting that even sparrows were game to him, had little interest in governing and small awareness of the history of his own time. As late as 1803 he seems not to have been aware that the United States had become a nation and still referred to her minister in Madrid as the Minister of the Colonies (*El Ministro de las Colonias*).[5] In 1792 the Queen María Luisa had her lover, the twenty-five-year-old Manuel Godoy, made prime minister. Into his hands was given the government of Spain. He had already been made a general and a *Duque,* and by the time Goya's *Caprichos* appeared had fathered the youngest Infante and been created Prince of Peace (*Príncipe de la Paz*). He had ability, but lacked experience, and had none of the integrity of the late king's prime minister. On March 28, 1798, Godoy resigned his office. He was replaced by two men, Francisco de Saavedra and Gaspar Melchor de Jovellanos, whom Goya knew. The latter was one of the great eighteenth century figures in Spain, learned, exceptionally talented, superior in mind and character, and totally incorruptible. In the meantime the queen had taken a new lover. Within months both ministers became extremely ill, the widespread assumption being

that they had been poisoned. In August they were exiled and replaced. Godoy began to be seen frequently in the palace, exercising his former influence and power.[6]

In Spain there were countless attacks on these and other ills, published when the subject matter was safe and, when it was not, handed around in manuscript form among trusted friends. The content of the *Caprichos* reflects what intelligent, enlightened Spaniards were thinking. What is surprising is that Goya took the risk of printing and selling his satires. Possibly he remembered the effect of an anonymous cartoon illegally but widely circulated in Madrid. The price of bread, controlled by the government, had been raised. The print, says a contemporary source, "represented a man lying on a bench in the position of a person who wants to get up; below one read the caption: 'If they don't lower you, I will rise up.' " Spanish officials, nervous because of the recent French revolution, lowered the price.[7]

Goya took precautions. He veiled his true meanings or added a superficial ambiguity to the most dangerous of his images (for example, cat. nos. 78–80). He used titles subject to more than one interpretation. And in announcing the set in the *Diario de Madrid* for February 6, 1799, he took pains to say that in not a single composition "did the author have the intention to mock the particular faults of one or another individual . . . Painting (like poetry) selects from the universal that which it deems most fitting to its ends; unites in a single fantastic person, circumstances and characters which nature presents distributed among many; and from this ingenuously arranged composition springs that fortunate imitation

5. Earl of Ilchester (ed.), *The Spanish Journal of Elizabeth Lady Holland* (London, 1910), pp. 77, 86–7.

6. For an excellent discussion of the history of these years, see Rafael Altamira, Muna Lee (Transl.), *A History of Spain* (Princeton, 1949).

7. "Cependant la cherté du pain commençait à faire fermenter les esprits: à ce sujet l'on fit une gravure qui fut répandue avec profusion; elle représentoit un homme couché sur un banc, et qui étoit dans l'attitude de vouloir se lever; un pain étoit suspendu au-dessus de sa tête, et il sembloit faire d'inutiles efforts pour l'atteindre; on lisoit au bas ces mots: Si l'on ne te descend, je me souleverai. Cette caricature hardie sembloit être le présage de ce qu'il auroit pu arriver; pourtant elle inquiéta la cour, qui ne voulut pas risquer l'événement: le gouvernement prit un parti, et s'empressa d'arrêter l'effervescence du peuple, en faisant diminuer le pain." Chantreau, *Vie politique de Marie-Louise de Parme*, 1793, pp. 117–118.

through which a good craftsman wins the title of inventor rather than slavish copyist."[8] As Edith Helman observed, both the style and the sentiments of this well-known announcement are literary, and it seems likely that it was written for Goya rather than by him.[9]

It is interesting that the prints were not offered for sale at the customary bookseller but in a perfume and liqueur shop below the quarters in which Goya was living.[10] From the beginning purchasers of the plates wanted to know what they meant. Some of them drew their own conclusions. One occasionally finds names rather casually written on some of the figures: of prostitutes known to the print's owner, of the queen (thinly disguised) on an impression of a print showing an old lady primping.[11] Lefort in 1877 published a manuscript written in French in 1808 whose author was close enough to Goya to have seen the drawings of the Duquesa de Alba; but the identities he ascribes to persons in the prints seem based on contemporary gossip rather than on anything Goya may have told him. However, he recognized attacks on fanaticism, ignorance, superstition, and the clergy.[12] A different kind of early interpretation of the meanings of the *Caprichos* are the extremely rare sets that were hand colored during Goya's lifetime. The copy in the exhibition was colored by 1809.[13] It is a fascinating document because the owner colored the plates as he understood them. He had no difficulty in recognizing noblemen, administrators of law, or military men (see cat. no. 82). And he was well aware that the plates did not depict goblins and spirits but the abbés of Spain, a priest, and a number of monks.

One manuscript owned by the Boston Museum was written by Juan Antonio Llorente, who had been Secretario General of the Madrid Holy office when Goya published the *Caprichos*. He is an interesting figure who made an unsuccessful attempt to reform the Inquisition from within. In 1812 when the Inquisition had been abolished by the French during their occupation of Spain he wrote, with help from some of Goya's friends, a bitter, antagonistic account of its history in Spain.[14] After the war he went into exile in France, taking with him a great part of the archives, and there published a much longer and equally bitter book. He was asked what the *Caprichos* were about and responded that what impressed him most were the satires on prostitution, on illicit love, and on the unhallowed behavior of people who had entered the church. He notes, for example, "What a tailor can achieve" (*Lo que puede un sastre*) is "against monks who fake miracles" (*contre les moines qui feignent des miracles*) (cat. nos. 78–80).

The value of the foregoing type of evidence lies in what it reveals to us about contemporary insight into the *Caprichos* and to what extent an intelligent amateur was able to understand Goya's imagery even when it was partially veiled.

There are two additional categories of explanations that can be more directly related to Goya, the Prado manuscript and its copies and the López de Ayala manuscript and its variations. A number of each are to be

8. *Diario de Madrid*, pp. 149–50.

9. Helman, *Trasmundo*, pp. 46 ff.

10. Calle del Desengaño 1; see Pierre Gassier and Juliet Wilson, *The Life and Complete Work of Francisco Goya* (New York, 1971), p. 385.

11. *Caprichos* 55. There are five such prints in the Boston Museum.

12. Paul Lefort, *Francisco Goya* (Paris, 1877), p. 38, n. 1, first appeared in *Gazette des Beaux Arts*, 22, 24, 25, Paris, 1867–1868. Carlos IV and his wife María Luisa are referred to as though they were still reigning. They ceded the Spanish crown to Napoleon in 1808. The manuscript tentatively and probably slanderously identifies the bumbling military figure in *Capricho* 76 as Don Tomás de Morla (1752–1820) "lieutenant général d'artillerie, et actuellement gouverneur des Andalousies." He replaced Solano as governor of Cádiz after the murder of the latter by mobs in 1808. Called to Madrid, he took part in the surrender of the city to the French. On Morla see Adolfo de Castro, *Historia de Càdiz* (Càdiz, 1858), p. 541; the Earl of Ilchester, ed., *The Spanish Journal of Elizabeth Lady Holland* (London, 1910), p. 124, n. 1, p.159, n. 2.

13. The set, printed in 1799, was hand colored before it was bound in two parts, probably by the owner himself. Later he borrowed the Prado manuscript from Goya and added the relevant half to each volume, noting that *"los antedichos estan copiados de un Borrador original del celebre pintor Goya en 1809."*

14. See Juan Antonio Llorente, *Anales de la Inquisicion de España* (Madrid, 1812), p. ix. In 1797 he had written an "órden de procesar del Sant Oficio," which "me produxo grande persecucion en 1801." Three friends of Goya, Estanislao de Lugo, Bernardo de Iriarte, Leandro Fernández de Moratín, are among those he thanks for helping with the book.

found in public and private collections. They are written in early nineteenth century handwriting on papers that appear to have been manufactured by Spanish firms during Goya's lifetime. The copies of the Prado manuscript tend to be exact, although one often finds added in parentheses names of individuals or of institutions, such as the nobility and the Inquisition. The famous original, preserved in the Prado, is given authority by the fact that the great collector of Goya's graphic work, Eduardo Carderera, to whom the manuscript once belonged, wrote at the top: "Explanation of Goya's Caprichos written in his hand" (*Explicacⁿ de los Caprichos de Goya escrita de propia mano*). There is no doubt that Goya owned it for there are two brief notes in his handwriting on the last sheet. One of them, crossed out, is dated August 29, 1810. There are, however, aspects of the manuscript that tend to discredit its reliability. Harris raises the question as to whether the handwriting is Goya's own or that of his amanuensis.[15] In 1949 Sánchez Cantón had already observed first, that the sheets were obviously copied from another text, and second, that the literary style of these explanations was not at all like that of Goya.[16] And he is right. Goya's letters and the inscriptions on his prints and drawings are terse, direct, and often pithy.

Edith Helman noted that there is a great similarity in the use of words and feeling for irony between the Prado explanations concerning goblins, witches, and the Inquisition, and texts on the same subjects by Goya's friend, the playwright Leandro Fernández de Moratín; so much so that she suggests that either Moratín wrote the explanations or that Goya (or an unknown author) was imitating the playwright's style and using his material.[17]

It seems to me that one should scrutinize carefully what the Prado manuscript has to say about some of the prints. There are passages that betray a superficial or erroneous understanding of the imagery. One entry reveals an ignorance of eighteenth century iconography,

that common language used by artists to embody abstract concepts. In *Subir y bajar* (Ups and downs), a satyr raises up one man while two others tumble down (cat. nos. 81–82). "Fortune deals harshly with those who court her," the Prado manuscript tells us. "She rewards with smoke the effort of climbing and punishes him who has risen by casting him down." Fortune, sometimes blind, sometimes standing on wheel or globe, sometimes bearing a cornucopia of benefits for bestowal, was universally depicted as female. A satyr, on the other hand, commonly suggested something quite different: Lust.[18]

Since it is difficult to believe that Goya was the author of the Prado manuscript, one cannot expect to understand the true meaning of many of the *Caprichos* by relying on this document. We do not know when it was written—in February 1799, when Goya found it prudent to withdraw the prints from sale, or in 1803, when to avoid serious trouble with the Inquisition he presented the copper plates to the Real Calcografía.

The second group of manuscripts consists of embroideries and elaborations of an earlier, brief and pungent text that belonged to Adelardo López de Ayala and that was first published in 1887.[19] Its present location is not known. The López de Ayala explanations are closely related to those of the Prado manuscript; in satires where Goya was attacking personal follies and vices the phrasing is often virtually identical. It is in the area of political and religious abuses that the two explanations diverge sharply. The López de Ayala manuscript is dangerously explicit. To cite but two examples, in that same print, *Ups and downs*, the López de Ayala

15. Harris, vol. 1, p. 98.

16. Sánchez Cantón, *Caprichos*, pp. 18–19.

17. Edith F. Helman, "The younger Moratín and Goya," *Hispanic Review*, 27, no. 1, 1959, pp. 109–111.

18. On the ways to represent Fortune and Lust in the eighteenth century, see Gravelot and Cochin, *Iconologie par figures* (Paris, n.d.) [reprinted from *Almanach iconologique*, 1765–1781] vol. 2, p. 57, vol. 1, p. 58; Karl Wilhelm Ramler, *Allegorische Personen zum Gebrauche der Bildenden Künstler* (Berlin, 1788); *Dictionnaire Iconologique* (1756 ed.) vol. 1, p. 123, vol. 2, pp. 172–3. The Real Academia Española, *Diccionario de la lengua castellana*, 3rd ed. (Madrid, 1791), describes *Fortuna* as: "La diosa del bien y del mal. Se representaba en pie sobre una rueda para dar á entender la instabilidad de los sucesos humanos." The dictionary does not describe how Lust should be represented.

19. Cipriano Muñoz y Manzano, Conde de la Viñaza, *Goya su tiempo, su vida, sus obras* (Madrid, 1887), pp. 327–359.

manuscript identifies the figure of Godoy, prime minister and the queen's lover: "Prince of Peace. Lust raises him by his legs; his head is being filled with smoke and wind, and he discharges flashes of lightning against his rivals."[20] In *What a tailor can achieve* (which Llorente read as a satire against false miracles) the López de Ayala manuscript tells us that "superstition makes the ignorant mob worship a clothed tree trunk."[21] Here, as frequently occurs, an idea expressed in the López de Ayala manuscript is related in concept to a preliminary study by Goya that few people can have seen. In the drawing for this *Capricho* it is obvious that people are kneeling in awe before a broken tree draped in a monk's habit. In the etched plate the imagery was prudently blurred (cat. nos. 78–80). The López de Ayala may already, like other manuscripts in this group, have received additions and expansions, yet it still seems very close to what Goya may have written and shown to trusted friends. When the comments of this manuscript are compared with those of the Prado, the latter often read like the witty obfuscations of a literary man. (In this catalogue the relevant texts from the López de Ayala and Prado manuscripts are given after the individual entries.)

Goya's *Caprichos* made those of his contemporaries who saw and understood them aware of his importance as a moralist. Don Bartolomé José Gallardo, writing a note on the set in 1817 for the *Mercure de France* speaks of him as "this painter philosopher" and asserts that he is equal to the great fabulists of all time.[22] Certainly his prints are far more profound than the work of such English contemporaries as Rowlandson or Gillray. For them, the sinner retained an element of ridiculousness. But to Goya, sin was evil not simply because it was so designated, but rather because it had the power to transform any man who indulged in it repeatedly into something he need never have been. That is why, for example, in *Caprichos* 20 one sees the habitués of a house of prostitution in the form of spent, plucked birds with human heads being swept out by young whores (cat no. 57); or unspecified evils in the form of witches, flying over the land, *Caprichos* 64 (cat. no. 85).

The artist's life had changed dramatically since 1778, when he had set about reproducing the paintings of Velázquez. In February 1785 he was appointed assistant director of painting at the Real Academia de San Fernando, which seems to have been in the eighteenth century the most liberal and independent academy of fine arts in Europe. In August 1787 he was made a court painter (*Pintor del Rey*) by Carlos III.

In January 1793 Goya had been critically ill. By the end of March he had still not recovered; and through the unpublished minutes of the monthly Academia meetings we learn that for the next three years recurrent bouts of illness kept him from working for considerable periods of time.[23] In September 1795 he applied for and obtained the position of director of painting of the Academia, a post made vacant by the death of his brother-in-law, Francisco Bayeu.[24] In the spring or summer of 1796, Goya had gone to Cádiz and thence to Sanlúcar for his famous stay with the Duquesa de Alba.[25] By April 2, 1797, he was back in Madrid and had reported to the Academia that he must resign his position since "the deplorable state of his health, and especially the lack of hearing did not permit him to discharge the functions of Director" (*el deplorable estado de su salud, y especialmente la falta de oído no lo permitan desempeñar las funciones de Director*).[26]

In Sanlúcar, for the first time so far as we know, he began to make drawings that were independent works of

20. "Príncipe de la Paz. La lujuria le eleva por los piés, se le llena la cabeza de humo y viento, y despide rayos contra sus émulos."

21. "La superstición hace adorar un tronco vestido al público ignorante."

22. Antonio Rodriguez-Moñino, *Goya y Gallardo, noticias sobre su amistad* (Madrid, 1954); on page 11 he quotes the dispatch written for the issue of February 1817, "ce peintre philosophe est digne, par l'esprit de ses compositions, de figurer à côté des meilleurs fabulistes anciens et modernes."

23. Manuscript minutes of the Juntas Ordinarias of the Real Academia de Bellas Artes, *Discursos* (Madrid, 1928), p. 16. "An Old Man Writing," *Boston Museum Bulletin,* 56 (1958), p. 128 n. 4.

24. See F. J. Sánchez Cantón, "Goya en la Academia," Real Academia de Bellas Artes, *Discursos* (Madrid, 1928), p. 16.

25. See Eleanor Sayre, "Eight Books of Drawings by Goya," *Burlington Magazine,* 106, no. 730 (1964), pp. 20–21.

26. Manuscript minutes of the Juntas Ordinarias of the Real Academia . . . ; Sayre, *Boston Museum Bulletin,* p. 129, n. 5.

art in themselves. In a small sketchbook he filled both sides of the sheets of good Netherlandish paper with brush and gray wash drawings. These unnumbered pages constitute a paean to woman—the visual expression of Goya's delight in her. We see the elegant, enchanting femininity of a lady of fashion; the vital, unselfconscious grace of a girl dancing to the guitar; the soft contours of a female body sensed through a thin dress (cat. no. 50) or wholly revealed when it is naked. He delights in the endless variety of woman, so that by turns she is joyful, bawdy, pensive, tender, weeping. One face in particular recurs. It is almond shaped, framed with thick, dark hair, and has the small mouth, large eyes, delicate narrow nose, and the strong expressive, arching brows that were characteristic of the extraordinarily fascinating Ex. S. D. María Teresa Cayetana de Silva, Duquesa de Alba.[27]

A second volume of drawings was begun in Sanlúcar and finished in Madrid. Though larger, the pages are made of similar tough, resilient, off-white Netherlandish paper. Again both sides of the sheets were used. The drawings are in brush and gray wash and are sometimes heightened with touches of brown as well as black. Goya also numbered the pages. In the earlier part of the book, the world we are shown is still on the whole an agreeable one and the drawings preserve something of the delicacy of the smaller album. Then by page 55 the character of the drawings changes. Titles, many of them ironical, are now added to every page. At intervals special categories of drawings appear: playful combinations of a word and its opposite, such as Generosity versus Greed; masks; and caricatures.[28]

The censure of human stupidity and sin, which in the earlier part of the book was only hinted at in the nar-

rowed, predatory eyes of a prostitute, has now become the principal component of most of the drawings. It may be gentle in the case of a frivolous lady who gives way to a tantrum merely because her abbé says she looks pale, but it can be savage toward a lustful priest caught pulling on his clothes (cat. no. 53).

As the subject matter changes, so does the style of the drawings. The figures tend to be broadly delineated with modeling reduced to a minimum. Men and women are caricatured or transformed into animals and witches while evocative suggestions of landscape give way to geometric shadows.

There is a further significant change in this book. Goya began developing an extremely original concept: a journal-album of drawings illustrating what he thought, as opposed to what he saw, which was the visual equivalent of the literary journals that Spaniards were lending to their friends in manuscript form, because they could not be published. Many of the drawings from these two albums are the earliest sources for plates of the *Caprichos*.

In 1797 Goya had drawn a very different title page from the present one, which shows his portrait in profile (cat. nos. 34–36). The etching made from this drawing was finally used as *Caprichos* 43 (cat. nos. 74–75). In a preliminary study for this title page Goya is seen dreaming in his chair. In the darkness at the right are the creatures of folly and darkness; at the left, lit by rays of light emanating from the artist's head, his own face appears, sardonic, saddened, mocking (cat. no. 72).

In the final drawing the creatures of darkness are pushed back by the thrusting clarity of Enlightenment. Inscribed in the upper margin of the drawing is *Sueño I°* (First Dream); on the pedestal, "Universal language. Drawn and etched by Francisco de Goya in the year 1797"; and in the bottom margin, "The author dreaming. His one intention is to banish harmful beliefs commonly held, and with this work of caprichos to perpetuate the solid testimony of truth" (cat. no. 73). Goya had originally conceived of the set as *Sueños* (Dreams), that ancient device through which an author could indict with impunity various evils that had found indulgence or official protection in his society, since the author's criticisms could be regarded as "only a dream."

The sheet of paper on which *Sueño I°* appears is

27. For reproductions of the scattered surviving pages of the Sanlúcar album, Journal-Album A, see Pierre Gassier and Juliet Wilson, *The Life and Complete Work of Francisco Goya* (New York, 1971), nos. 356–371. They accept as genuine an additional sheet in Rotterdam; see also Pierre Gassier, *Francisco Goya, Drawings, The Complete Albums* (New York, 1973), A.a–A.p, reprod. pp. 21–36.

28. For reproductions of the surviving pages, now scattered, see Gassier and Wilson, *Complete Work*, nos. 377–450. The pages cited here are nos. 434, 419, and 423 respectively; see also Gassier, *Goya Drawings, the Complete Albums*, B. 76, B. 59, B. 63, reprod. pp. 106, 91, 95.

Netherlandish, with the watermark of the firm H. C. Wend Zoonen. In transferring the design Goya carefully wrapped the dampened sheet around the grounded copper plate and rolled it through a press. The resultant folds and oblique creases in the upper part of the drawing are still visible in the paper. There are twenty-five additional drawings in the Prado on identical paper. All the drawings were executed in pen and brown ink, occasionally with the addition of gray or, in one instance, sanguine wash. Unlike Goya's Journal-Album drawings these sheets vary in size and all but three show the same signs of having gone through a press. All were given titles, usually in chalk and often corrected in pen and brown ink. Most of the drawings are numbered, the highest being 28. Therefore, it is possible to reconstruct to a considerable extent the form of Goya's first concept, the dreams of a man capable of seeing the truth. The subject matter of the *Sueño* drawings has much in common with the Sanlúcar-Madrid Journal-Album, and indeed a number of the compositions are derived from this book as well as from the smaller Sanlúcar album. But in the *Sueños* they are sometimes given a savage new meaning.

The *Sueños* drawings served as sources for the *Caprichos:* sometimes it was a composition that was borrowed; in other instances it was only an underlying idea (see, for example, cat. nos. 90-91). As the *Sueños* were transformed into *Caprichos* many additional drawings were made in sanguine chalk or wash or a combination of the two. With a few exceptions on H. C. Wend Zoonen paper, they are on thinner papers, with various characteristic watermarks: a crown, a shield with a bird, the firm name of Joseph Gisbert Alcoy. These drawings, too, are sometimes based on Journal-Album compositions. *Caprichos* 10, *El amor y la muerte* (Love and death) began as page 35 of the Madrid Album in which a lady holds up her dying lover while casting her eyes romantically toward heaven (cat. no. 42).

Although Goya offered the work for sale under the title, *Los Caprichos,* he did not alter the concept set forth in the *Sueños.* In the eighteenth century, the *Diccionario* of the Royal Spanish Academy gave this definition for *capricho:* "In works of poetry, music and painting it is that which is done by the power of invention rather than by adherence to rules of art. It is also called fantasy."[29]

Neither this explanation nor the modern translation, "caprice," suggests the nature of the series.

The graphic style of the prints is very different from the etchings after Velázquez. Gone is the airy rococo sparkle and complex elegance. The *Caprichos* have an extraordinary stylistic variety when one considers that the time during which they were executed probably did not exceed a year and a half, that is, from the spring of 1797 to the final months of 1798. The prints range from broadly executed designs with sharp tonal contrasts to delicate etched designs enlivened and illuminated by pale tones of aquatint. Light throughout the series is used not only for its dramatic effects but also to signal the coming of enlightenment.

Still preserved by the Carderera family is the copy of a draft for an advertisement for the series, which was originally to have consisted of seventy-two prints. Copies were to be delivered in two months' time to those who subscribed, for "the work is finished and there remains only the printing of the plates."[30]

By January 17, 1799, some copies had been printed and delivered to one of Goya's great patrons, the Duquesa de Osuna, who was charged 1,500 *reales* "for the four books of *Caprichos* graved in etching by my hand" (*por los quatro libros de Caprichos grabados a lo aguafuerte p.r mi mano*).[31] Quite possibly these were brilliant preedition sets printed before mistakes were corrected in the captions.

On February 6 Goya's famous announcement appeared in the *Diario de Madrid*. He no longer sought subscribers, and he had added eight subjects. A second

29. "Capricho . . . En las obras de poesía, música y pintura es lo que se executa por la fuerza del ingenio mas que por la observancia de las reglas del arte. Llámase tambien fantasía."

30. "Se admitirán subscripciones á esta obra en la libreria de ——— pagando p.r cada coleccion de a 72 estampas, 288 r.s vn.

"El termino será de dos meses contados desde el dia de la publicacion, y cumplido este tiempo se entregarán inmediatamente á los suscriptores los primeros exemplares: antes de vender ninguno á los que no hubieran suscripto.

"Se advierte que la obra està concluida y falta solo el tirado de las estampas."

31. Archivo histórico nacional. Osuna archives, Legajo 515.

brief notice appeared in the *Gazeta de Madrid* on Wednesday, February 19.[32]

It must be noted that a good part of the paper used for the editions was probably unwittingly paid for by Carlos IV. In 1798 Goya had been commissioned to decorate the little hermitage of San Antonio de la Florida. The frescoes he painted there have great originality and a delightful, spiritual gaiety. On December 20 the king was billed for an astonishing quantity of materials purchased by Goya in the preceding six months, allegedly for the frescoes. He charged a *Media resma de papel imperial de marca mayor* (half a ream of the largest imperial size paper) at 250 *reales;* then another half ream and finally a third, this time described as from Genoa, always at the same price.[33] When Goya was painting the frescoes he freely improvised and was never constrained by the rough outlines he incised in the damp plaster at the beginning of each day. (The marks are still visible alongside or underneath the painted figures.) Therefore, preliminary drawings to scale would have been useless to him; furthermore, by then, Goya preferred to prepare for a painting with an oil sketch rather than with drawings. That is why it seems likely that 750 sheets of the largest size paper imported from Genoa were used to print satires, of which His Majesty, had he understood them, could hardly have approved.[34]

Goya shortly withdrew the set from sale, most probably because, as he wrote years later, he was reported to the Inquisition.[35] In 1803 he presented the plates to the Real Calcografía. In a letter written to the minister, Miguel Cayetano Soler, dated October 9, he says that he is also presenting them with 240 sets of the *Caprichos*.[36]

32. Harris, I, p. 103.

33. Valentín de Sambricio, *Tapices de Goya* (Madrid, 1946), Documento 191.

34. An 18th century Spanish ream had 500 sheets; see La Real Academia Española, *Diccionario de la lengua castellana,* 3rd ed. (Madrid, 1791): "*Resma . . .* El mazo de veinte manos de papel; *Mano . . .* 17. Una de las partes en que se divide la resma de papel que contiene veinte y cinco pliegos."

35. Ferrer had suggested that Goya reprint the *Caprichos*. He explains that they belong to the King, "y con todo eso me acusaron a la Santa" (i.e. Inquisition), Letter to Joaquín Ferrer, December 20, 1825, which has been published many times.

36. "240 exemplares de à 80 estampas cada exemplar." This letter in the Prado has also been published many times. It is reproduced in facsimile by Harris, vol. 1, p. 104. Not all of the copies seem to have arrived, for, almost hidden by scribbling at the end of the Prado manuscript of explanations, one can read a note written in pen by Goya that a book seller, "Ranz took thirty-seven copies. The day August 29, the year 1810" (*37 exemplares a llebó Ranz. Dia 29 de Agosto A 1810*). I am indebted to Antonio Rodriquez-Moñino for the information that Ranz was a bookseller, established in Madrid by 1789.

34–37

Caprichos 1 (Frontispiece)
Fran.co Goya y Lucientes, Pintor
D. 38, H. 36, B. 21, Hof. 1
215 × 150 mm.

34
Preparatory drawing
Red chalk
178 × 127 mm. (sight)
Verso: Two self-portrait sketches in red chalk
Coll.: Valentín Carderera y Solano, Madrid; General
Don Romualdo Nogués, Madrid; Don Manuel Nogués,
Madrid
Lent by the Estate of Walter C. Baker

35
Working proof, Harris I, 1
Etching, drypoint, and burin, touched with pencil;
pen and brown ink inscription and borderline
Mounted down
Coll.: Javier Goya; Pasqual de Gayangos; Stirling-
Maxwell, Pollok House, Glasgow
Anonymous loan

36
Working proof, Harris I, 2
Etching, aquatint, drypoint, and burin
Watermark: indecipherable fragment
Coll.: Carderera
Biblioteca Nacional, Madrid. 45631

37
Completed state, pre-publication impression, Harris II, 1
Etching, aquatint, drypoint, and burin
No watermark
Coll.: M. Mirault
The Art Institute of Chicago. The Clarence Buckingham
Collection. 48.110/1

34

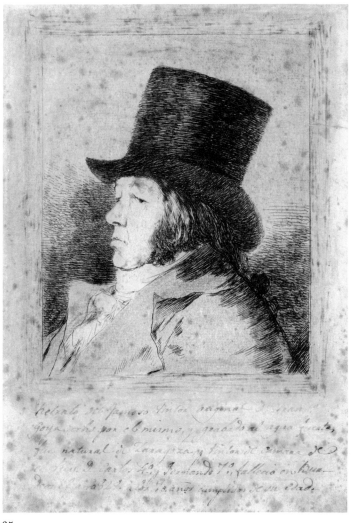

35

classical tradition, in imitation of the portrait busts on antique coins and medals. The profile portrait generally emphasizes the sitter's bone structure and carriage or bearing and does not allow for much exploration of physiognomy or psychology. It can, however, render dignity and strength. Goya's medium, red chalk, is the same he used for a good many of the preparatory drawings for the *Caprichos*. The drawing shows more of Goya's body than does the print, and he framed off the area to be included.

The unique working proof was printed after the plate was etched and worked up with burin and drypoint, but before any aquatint was applied. The aquatint, however, is anticipated here by Goya's pencil shading. The principal compositional elements of the drawing were preserved in the print, but there are important changes. All of the lines in the print, because they are bitten or incised into the plate, have a sharper and more regular character than the softer, broader, and more personal chalk lines. Less of Goya's body is shown, and its outline is altered so that it fills the bottom edge of the plate. These changes and the dark etched shadows behind Goya's figure give the portrait greater breadth and monumentality. There are other, more subtle changes from drawing to print: the sardonic upward tilt of the left eye, the accentuation of the downward turning of the mouth, the darkening of hair and fashionable beaver hat. The total effect of these changes is to add a sense of vitality and an imperious bearing to the portrait.

This proof is not characteristic of Goya's usual working method in the *Caprichos*. There seems to be only one other surviving example in which Goya printed an impression before the aquatint grain had been applied (see cat. no. 40). Aquatint now plays a co-equal part with etching, and backgrounds shaded with aquatint serve as a unifying element for the series.

The manuscript notations in brown ink in the lower margin identify Goya and give biographical details. They were probably made by an earlier Spanish owner, Pasqual de Gayangos. The wide borderline, consisting of short parallel strokes in iron gall ink over pencil shading serves as a trial frame. It is similar to the pen and ink borders used on many of the *sueño* drawings.

The second working proof was printed after a grain

Goya's self-portrait served as frontispiece in the first edition of the *Caprichos* printed in 1799. Two years earlier he had intended to use the design that finally appeared as *Caprichos 43, El sueño de la razon produce monstruos* (The sleep of reason produces monsters, cat. nos. 70–76) for the title page to the series. The cynical, rational Goya of the frontispiece provides a strong and ironic contrast to the insane behavior of the humanity we find depicted in the rest of the series.

The red chalk study has on its verso two studies in which Goya is seen almost full face with a cynical expression. This he rejected in favor of a profile. The profile view was frequently chosen by artists working in the

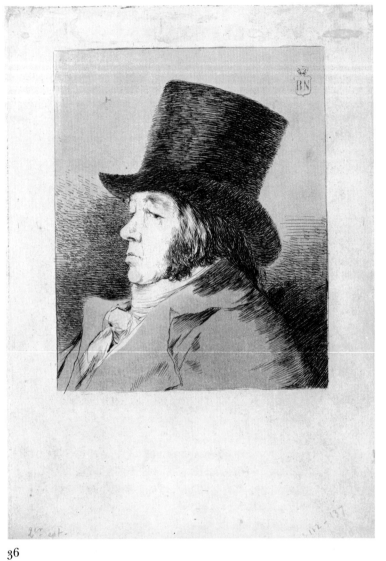

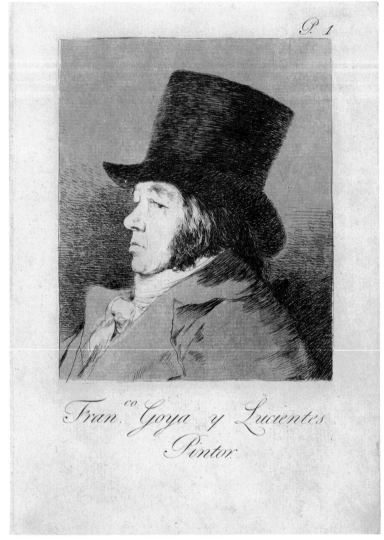

36

37

of aquatint had been added to the plate following the pencil shading in the previous impression. The even, medium gray tone of aquatint on the background and clothing gives new prominence to Goya's face. Strong, slanting burin lines in the lower right corner fuse the outline of Goya's shoulder with the surrounding shadow. A few burin strokes on the cravat around his neck, multiply the folds in the cloth and create a shadow under the chin, thrusting it forward and giving the jaw more strength.

Goya had a small number of sets of the *Caprichos* bound for himself in mottled brown leather, stamped with gold. These sets, with fresh, brilliant impressions, have errors in punctuation and spelling that were corrected in the published sets. The impression of the finished plate exhibited, from one of these prepublication sets in the Art Institute of Chicago, is before a comma was added after "Lucientes" and a flourish applied to the "r" of "Pintor."

A second, fine grain of aquatint is visible in the finished plate; it fills in the white edge of the left lapel and sets off the cravat. It is also visible on Goya's chin and hair. The second layer of aquatint applied over the first produces an intermediate tone that unifies the composition. This second biting weakened the surface of the plate; most posthumous impressions reveal very little background tone.

López de Ayala: *Verdadero retrato suyo, de gesto satírico.* (True portrait of the artist with satirical expression.)

Prado: No explanation given.

38
Caprichos 4
El de la rollona. (Nanny's Boy)
D. 41, H. 39, B. 24, Hof. 4
205 × 150 mm.

Working proof, Harris I, 2
Etching and burnished aquatint, with Goya's manuscript title in black chalk
No watermark
Coll.: Los Rios, Philip Hofer
Museum of Fine Arts, Boston. Gift of Ruth P. Cunningham. 1973.708

This impression with the title in Goya's hand was printed just after he had completed work on the plate. There are no surviving impressions showing the plate at an earlier stage in its development.

In this print, which typifies Goya's manner of working on the *Caprichos,* the lines were first etched into the plate, determining the arrangement of the figures. Then a fine grain of aquatint was applied to the entire plate except for a few areas that were to remain white and were therefore stopped-out. After the grain of aquatint was bitten to achieve a medium tone, the figures were stopped-out and a second, finer grained tone of aquatint was added to create the dark background. To model the figures and create an effect of light playing on the surfaces, Goya then burnished to achieve half-tones; for example, on the "child's" dress.

The print attacks the idiotic incompetence of the nobles, who would fall if not supported by their servants, and their self-indulgence. A bearded man, finger in his mouth, is dressed as a small child with a padded head protector. He pulls stubbornly against lead strings held by a lackey. To his belt are tied a book and the various charms of a high-born child. To the left is an enormous pot of food with which to stuff himself, and beyond a toilet seat with padded cushion on which he can afterward sit and relieve himself.[1]

1. For a similar pot used to feed nobles, see *Caprichos* 50, "*Los Chinchillas.*" The toilet seat cannot be a baby walker (as it is often described), since the latter had sloping sides to give it stability.

el de la Rollona

38

López de Ayala: *Los hijos de los grandes se ativorran de comida, se chupan el dedo y son siempre niñotes, aun con barbas, y así necesitan que los lacayos los lleven andaderas* (sic).[1]
(The children of nobles are stuffed with food, suck their fingers, and are always big babies, even after their beards grow, and thus they need their lackeys to pull them around with lead strings.)

Prado: *La negligencia, la tolerancia y el mimo hacen à los niños antojadizos obstinados soberbios golosos perezosos e insufribles. Llegan à grandes y son niños todavia. Tal es el de la rollona.*
(Negligence, indulgence, and fondling make children capricious, stubborn, haughty, sweet-toothed, lazy, and insufferable; they grow up and are still children. That's the way the nurse's child is.)

1. Viñaza seems to have transcribed this word incorrectly. "Baby-walker" makes no sense. In a close variant of the manuscript in the Berlin Kupferstichkabinett it is given as *andadores*.

39–41

Caprichos 5

Tal para qual. (Birds of a Feather)
D. 42, H. 40, B. 25, Hof. 5
200 × 150 mm.

39

Andalusian watching as a gallant bows to a maja
Page 40 from the Madrid Journal-Album ("B")
Brush and gray wash, touched with brown and black over pencil.
216 × 130 mm. (sight)
Verso: Page 39 from the Madrid Journal-Album
Watermark: fragment of coat-of-arms with bend and fleur-de-lis
Coll.: Paul Meurice
Anonymous loan

40

Working proof, Harris I, 1
Etching, touched with black chalk, rubbed or stumped
No watermark
Coll.: Sessler, 1930
National Gallery of Art, Washington, D.C. Rosenwald Collection. B–7363.

41

Completed state, pre-publication impression, Harris II
Etching, aquatint, and drypoint
No watermark
Coll.: M. Mirault
The Art Institute of Chicago. The Clarence Buckingham Collection. 48.110/5

Goya's second book of drawings, the Madrid Journal-Album,[1] was completed by the end of 1797. It contained two types of sketches. The earliest pages, quite light-hearted in spirit, may have been begun during his stay at Sanlúcar in Andalusia with the Duchess of Alba. The later sketches in the album are more satirical in attitude and anticipate his *Caprichos*. On many occasions, Goya used figures from both parts of the album to people his *Caprichos*.

1. This second journal album is also designated as "B" and the 'Large Sanlúcar.'

The brush and gray wash drawings of an *Andalusian watching as a gallant bows to a maja* was page 40 of the Madrid Journal-Album. The scene of flirtation in this drawing may be one source of inspiration for the print.[2]

The unique working proof with considerable additions in chalk was printed when the plate had been etched, but before further work in drypoint and aquatint. As we shall see in the finished plate, the drawn shading on the proof was used to set the pattern for extensive new areas of drypoint hatching. A pen and wash drawing in the Prado (No. 27), *Sueños* 19, bears a platemark and printing folds showing that it had been transferred to the copper plate. This drawing indicates, in a general way, the scheme used for the distribution of aquatint in the finished print.

Whereas the Madrid Album page presents a light-hearted scene of flirtation, the print portrays a sordid incident. The faces of the two old women who witness the encounter convey this, as does the arch pose of the openly inviting woman and interested male. The *sueño* drawing for the print has the following caption in Goya's hand, *"Las Viejas se salan de risa p[r] q[e] el no llevea un quarto"* (The old women are bursting their sides laughing because they know he hasn't got a cent). This young woman is not a victim; she will use him as much as he will use her. A number of contemporary manuscripts identify the couple as the Prince of Peace, Godoy, and his mistress, the Queen Maria Luisa, whose wanton behavior shocked many of her contemporaries. She is said to have been mocked during one clandestine outing by some fifty washerwomen, who were later arrested.[3] But ones does not need to know this to derive meaning from the print.

The setting of both the Prado drawing and the working proof is an outdoor one with leafy vegetation and a large stone on which the laughing old women sit. In the finished print, the addition of drypoint and aquatint has transformed the setting. Two coarse-grained tones of aquatint suggest a night sky, and drypoint strokes

2. A closer source of inspiration for the maja figure can be seen in another Madrid Journal-Album drawing preserved in the Biblioteca Nacional, Madrid (B. 1262).

3. Chantreau, *Vie politique de Marie-Louise de Parme*, 1793, pp. 115–116.

now obscure the foliage and stone on which the old women sit. The stopped-out white areas, in sharp contrast to the areas that received aquatint, become points of focus for the viewer.

López de Ayala: *María Luisa y Godoy.*
(The Queen María Luisa and her lover, Manuel Godoy.)

Prado: *Muchas veces se ha disputado si los hombres son peores que las mugeres ō lo contrario, Los vicios de unos y otros vienen de la mala educacion donde quiera que los hombres sean perversos las mugeres lo seran tanbien. Tan buena cabeza tiene la señorita que se representa en esta estampa como el pisaverde que la esta dando conversacion y en quanto a las dos viejas tan infame es la una como la otra.*
(It has often been argued whether men are worse than women or the opposite. The vices of both are the result of bad upbringing; wherever men are perverse, women will be too. The young lady in the picture has as good a head as the fop who is talking with her, and as for the old women, each is as vile as the other.)

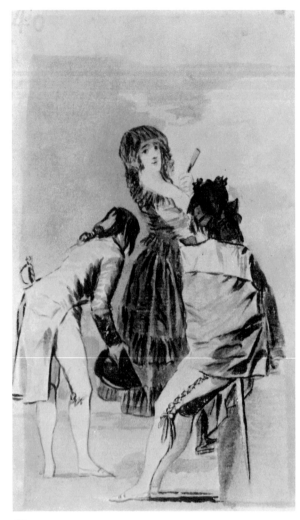

39

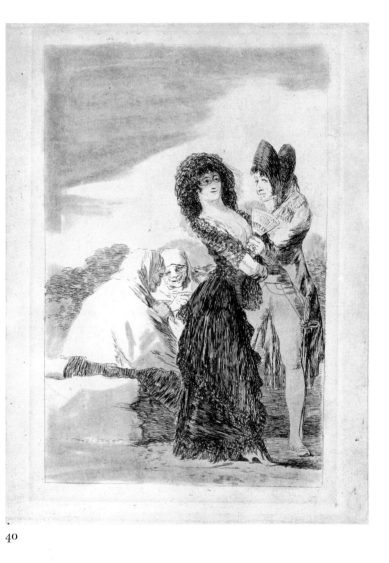

40

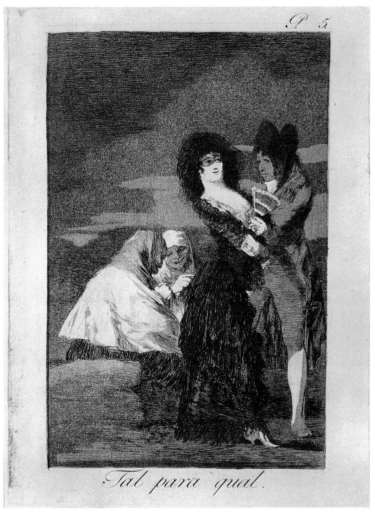

Tal para qual.

41

42–45

Caprichos 10

El amor y la muerte (Love and death)
D. 47, H. 45, B. 30, Hof. 10
215 × 150 mm.

42

Woman holding up her dying lover
Page 35 from the Madrid Journal-Album ("B")
Brush and gray wash
236 × 146 mm.
Verso: Page 36 from the Madrid Journal-Album
Watermark: fragment of coat-of-arms with bend
and fleur-de-lis
Coll.: Paul LeBas, Paris, de Buernonville; Philippe;
Philip Hofer
Museum of Fine Arts, Boston. Gift of the Frederick J.
Kennedy Memorial Foundation. 1973.700a.

43

Preliminary drawing for the print
Sanguine wash
207 × 145 mm.
No watermark
Museo del Prado, Madrid. 93.

44

Preparatory drawing for the print
Red chalk
197 × 141 mm.
Mounted down on thin paper
Museo del Prado, Madrid. 50

45

Completed state, pre-publication impression, Harris II
Etching, burnished aquatint, and burin
No watermark
Coll.: M. Mirault
The Art Institute of Chicago. The Clarence Buckingham
Collection. 48.110/10.

Page 35 from Goya's Madrid Journal-Album ("B")
also provided a source for one of the *Caprichos*. This
time, Goya borrowed the entire motif, not just a single
figure, as he had in *Caprichos* 5 (cat. nos. 39–41). The
emotional effect of the sketch page and of the finished
print is, however, profoundly different. The drawing
presents a graceful young woman with her arms about
her lover after he has fought a duel for her sake. That
he is dead is suggested only by his limp body and her
wistful gaze toward heaven. The mood is one of light
romance, almost unreal.

A second drawing is a direct study for the *Capricho*.
Also in brush and wash, it is very free in execution. The
facial expressions are radically altered so it is clear that
the man is in mortal pain, and that the woman realizes it
and suffers with him. The wall is lower now, less im-
portant as a support, and the woman bears much of the
weight of her lover. The uniform dark color of her dress
outlines his sagging body.

A final drawing, in red chalk, is very close to the
finished print, although it shows no signs of having been
transferred to the plate. The arrangement of the figures
is shifted. He is doubled forward in pain, his face
pressed against hers, and she must use the strength of
her entire body to prevent him from sinking to the
ground. His body now hides hers almost completely,
and our attention is focused on their tormented faces,
which mirror each other's anguish.

While the wall is now lower and less important as a
support, its new triangular shape reinforces the figural
group. To the left, behind the woman, a figure with out-
stretched arms is faintly visible. It has been said that this
is a personification of death, but it is more probably an
offset of a drawing for *Caprichos* 75 (cat. no. 89).

Goya's use of aquatint usually increases the expres-
siveness of a subject, giving the composition unity and
every element its proper emphasis. In the impression
from the finished plate from Chicago's pre-publication
set, the darker portion of the sky closing in on the figures
combines with the darkened wall to rivet one's attention
on the faces of the lovers. In contrast to the man's tor-
tured face, hers is darkened and blotched with grief.
There is no longer anything romantic in death by dueling.

López de Ayala: *No conviene sacar la espada muchas veces; los amores exponen á pendencias y desafíos.*
(It is not a good idea to draw one's sword too often. Passions lead to quarrels and duels.)

Prado: *Ve aqui un amante de Calderon que por no saberse reir de su competidor muere en brazos de su querida y la pierde por su temeridad. No conviene sacar la espada muy a menudo.*
(See here a lover of Calderón, who because he has not been able to laugh at his rival, dies in the arms of his mistress and loses her through his imprudence. It is not a good idea to draw one's sword too often.)

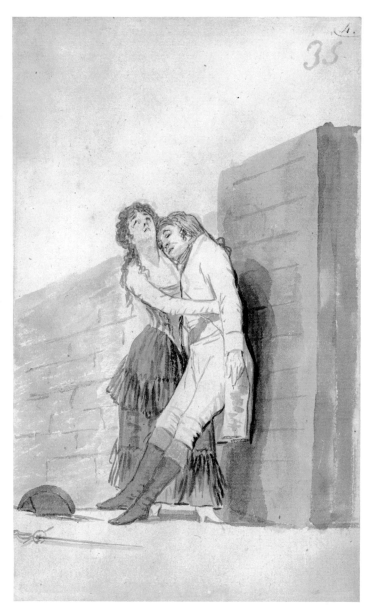

42

43 (full size)

44 (full size)

El amor y la muerte.

45 (full size)

46–47

Caprichos 12

A caza de dientes. (Hunting for teeth)
D. 49, H. 47, B. 32, Hof. 12
215 × 150 mm.

46

Working proof, Harris I, 2
Etching, burnished aquatint, and burin
No watermark
Coll.: M. Ballester; Prouté; Philip Hofer
Museum of Fine Arts, Boston. Gift of Paul Singer and
Henry Lusardi, and the Maria Antoinette Evans Fund,
by exchange. 1973.709.

47

Completed state, pre-publication impression, Harris II
Etching, burnished aquatint, and burin
No watermark
Coll.: M. Mirault
The Art Institute of Chicago. The Clarence Buckingham
Collection. 48.110/12

46

Goya often satirized the ability of love to drive a
person to idiotic lengths. Here, a well-dressed young
gentlewoman is stealing teeth from the mouth of a
hanged man by night. As Sánchez-Cánton has pointed
out, such teeth were considered useful ingredients for
love potions as far back as the fifteenth century.[1]

In the working proof, after etching the lines, Goya
added a coarse grain of aquatint to the plate, biting it
twice to produce two tones. He has begun to burnish
some of the aquatint on the woman's arms, over her left
eye, on her skirt, and on the man's hands.

The pre-publication impression from the finished
plate shows considerably more burnishing. It models the
hanged man's body and the woman's skirt, and makes her
frightened face more visible. The burnishing also adds a
sense of flickering moonlight playing on the figures
and the wall.

1. F. J. Sanchez-Canton, *"Los Caprichos" de Goya y sus dibujos
preparatorios* (Barcelona, 1949), pp. 40–41 and note. He traces this
practice back to the novel, *Tragicomedia de Calisto y Melibea,* act
vii, which is believed to have been published for the first time
in 1499.

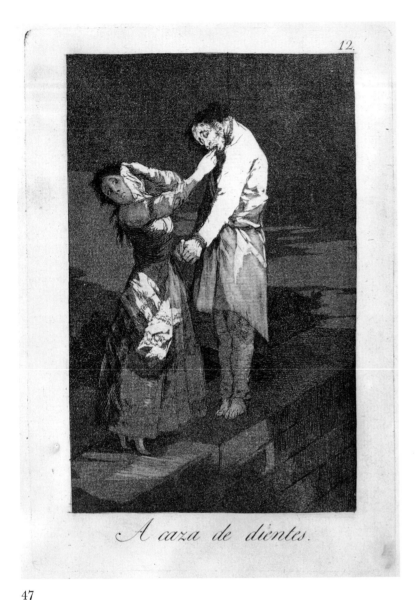

47

López de Ayala: *Los dientes del ahorcado son eficacisimos para hechizos. ¡ De qué no es capaz una mujer enamorada!*
(Hanged men's teeth are extremely powerful for sorcery. What won't a woman in love do!)

Prado: *Los dientes de ahorcado son eficacisimos para los ēchizos sin este ingrediente no se hace cosa de probecho. Lastima es que el vulgo crea tales desatinos.*
(A hanged man's teeth are extremely powerful for sorcery; without this ingredient, nothing can be accomplished. It's a pity that simple people believe such folly.)

48–49
Caprichos 13
Estan calientes. (They are hot; They are in heat)
D. 50, H. 48, B. 33, Hof. 13
215 × 150 mm.

48
Working proof, Harris I, 2
Etching and aquatint
No watermark
Coll.: P. Burty; H. F. Sewall
Museum of Fine Arts, Boston. Harvey D. Parker
Collection. P.19364

49
Completed state, pre-publication impression, Harris II
Etching and burnished aquatint
No watermark
Coll.: M. Mirault
The Art Institute of Chicago. The Clarence Buckingham
Collection. 48.110/13

There are three drawings related to this print. In the earliest, page 63 of the Madrid Journal-Album, *"Caricatura alegre"* (Merry Caricature, Prado No. 443, not in exhibition), where the foremost monk's long and all too sexual-looking nose is supported by a little crutch, an analogy is drawn between gluttony and sexual indulgence. In the second (Prado No. 20, not in exhibition), *Sueño. De unos hombres qᵉ se nos comían* (Dream. Of some men who devour us), the monks are served a human head on a platter. Goya here comments on the excessive wealth and lands owned by the monastic orders. This pen drawing shows signs of transfer to a copper plate, but a third drawing in red wash (Prado No. 94, not in exhibition) is closer to the finished print; and it is significant that the human head was omitted in it and in the print.

The working proof is one of several printed before any burnishing of the aquatint. In the finished print, burnishing further models the habit of the foremost monk and adds highlights to the two behind the table. The three monks are now linked by the same light source in a conspiratorial unity.

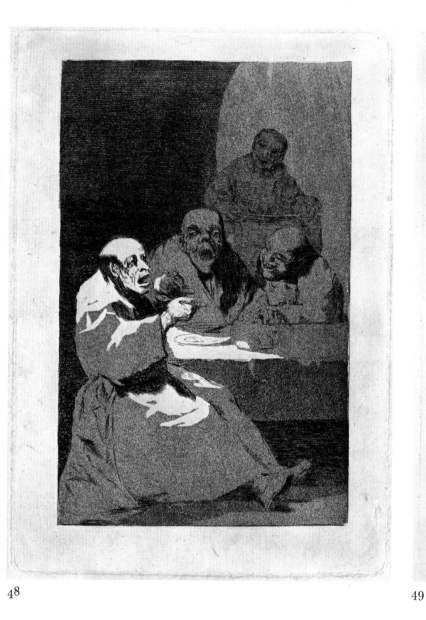

48

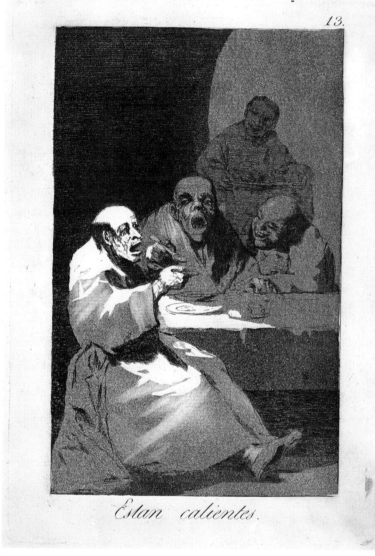

Estan calientes.

49

The ironic engraved inscription, with its double meaning (they are hot or they are "in heat") goes back in spirit to the first drawing.

López de Ayala: *Los frailes estúpidos se atracan, allá á sus horas, en los refectorios, riéndose del mundo; ¡qué han de hacer sino estar calientes!*
(Stupid monks stuff themselves at meals in their refectories and laugh at the world; how could they be anything but hot [in heat]!)

Prado: *Tal prisa tienen de engullir que se las tragan hirbiendo. Hasta en el uso de los placeres son necesarias la templanza y la moderacion.*
(They're in such a hurry to stuff themselves that they swallow things boiling hot. Even in the practice of pleasures, temperance and moderation are necessary.)

50–52
Caprichos 17
Bien tirada está. (It's pulled tight)
D. 54, H. 52, B. 37, Hof. 17
250 × 150 mm.

50
Young woman pulling up her stocking
Page j from the Sanlúcar Journal-Album ("A")
Brush and gray wash
On the reverse: Page i of the Sanlúcar Journal-Album
(Prado 427)
172 × 100 mm.
No watermark
Coll.: Javier Goya; Mariano Goya; Román Garreta;
Museo de la Trinidad
Museo del Prado, Madrid. 467.

51
Working proof, Harris I, 2
Etching, aquatint, and burin
Inscribed in lower margin in brown ink: *Bien tirada está*
No watermark
Coll.: Philip Hofer
Museum of Fine Arts, Boston. Gift of Mr. and Mrs.
Guy W. Walker, Jr., and Miss Ellen Bullard, by
exchange. 1973.710.

52
Completed state, pre-publication impression, Harris II, 2
Etching, burnished aquatint, and burin
No watermark
Coll.: M. Mirault
The Art Institute of Chicago. The Clarence Buckingham
Collection. 48.110/17

A Young woman pulling up her stocking is from the
earliest of Goya's Journal-Albums, the Sanlúcar ("A").
The young woman is seen giving a vigorous yank to her
stocking as she dresses. Deft, silvery gray brush strokes
delineate her figure, the bed, and basin. The drawing
gives the impression of a casual moment remembered
and recorded with pleasure.
 For his *Capricho,* Goya borrowed the figure from

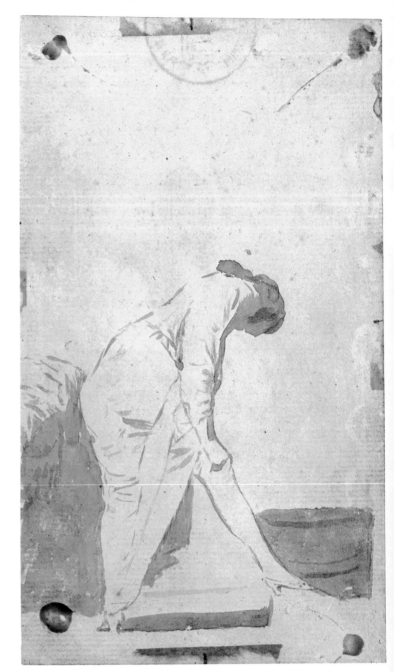

50

51

52

his Sanlúcar sketchbook, turning the innocent moment into a scene of vice. The bed remains, but the basin has been exchanged for a brazier, on which the young woman rests her foot. There is now a witness; a procuress oversees the proper fit of the stocking. In her deformed face is reflected the moral ugliness of her profession and the future of her young protégée, a prostitute. The plate is the third in a brief sequence on the life of prostitutes.

The working proof was printed before Goya burnished the aquatint. An impression from Chicago's pre-publication set shows the print after the aquatint was burnished to produce half-tones that model the forms and soften the effect of the highlights. With the addition of folds, the young woman's uplifted skirt is given greater emphasis and the shape of her buttocks revealed.

López de Ayala: *No puede haber cosa más tirada por los suelos que una ramera. Bien sabe la tía Curra lo que conviene estirar las medias.*
(There can be nothing lower than a prostitute. Aunt Curra knows full well the profitable advantages of well-stretched stockings.)

Prado: *Oh! la tia curra no es tonta Bien sabe ella lo que conviene que las mediàs vayan estiraditas.*
(Oh! Aunt Curra is no fool. She knows well enough the profitable advantages in keeping the stockings pulled tight.)

53–54

Caprichos 18

Ysele quema la Casa. (And he's burning the house down.)
D. 55, H. 53, B. 38, Hof. 18
215 × 150 mm.

53

Buen sacerdote ¿donde se ha celebrado?
(Good priest, where was it celebrated?)
Page 86 from the Madrid Journal-Album ("B")
Brush and gray wash touched with black
236 × 145 mm.
Title in pen and brown ink below image
Verso: Page 85 from the Madrid Journal-Album
Watermark: fragment of fleur-de-lis
Coll.: Javier Goya; Mariano Goya; V. Carderera; F. de
Madrazo; Clementi-Vannutelli, Rome.
Museum of Fine Arts, Boston. Ernest Wadsworth
Longfellow Fund. 63.984.

54

Completed state, pre-publication impression, Harris II
Etching and burnished aquatint
No watermark
Coll.: M. Mirault
The Art Institute of Chicago. The Clarence Buckingham
Collection. 48.110/18

Page 86 from the Madrid Journal-Album is titled in
Goya's hand: *Buen sacerdote ¿donde se ha celebrado?*
(Good priest, where was it celebrated?). A man, in a
stupor, fumblingly pulls on his breeches, possibly after
a guilty sexual encounter. The arched shadow may indi-
cate architecture, but more importantly, it serves to
accentuate the figure. A number of the Madrid Album
drawings have dark wash backgrounds that function in
the manner of the aquatint backgrounds of the *Caprichos*.
The captions in the latter part of the album often contain
double meanings, as does the word "celebrate" when
applied to a priest who has satisfied his lust.

There is an intervening *sueño* drawing (Prado No.
21) in which the "good priest" has been transformed
according to Goya's title on it into a "Drunken hemp
worker who can't get his clothes off and sets his house on

fire while giving good advice to his oil lamp" (*espartero
borracho qᵉ no acierta a desnudarse, y dando buenos
consejos a un candil yncéndia la casa*). Edith Helman
noted a great number of contemporary newspaper refer-
ences to fires attributed to drunkenness in the quarter
where hemp workers lived.[1]

The López de Ayala manuscript gives an explanation
of the *Capricho* that reflects the Journal-Album drawing:
"An old man, burning with lust, can't manage to get his
breeches on or off." This interpretation is interesting in
the light of the *Caprichos* that precede and follow the
print. In turning from the prostitute straightening her
stocking, *Bien tirada está*, to this drunkard fumbling with
his clothes, there is both a visual similarity and a contrast
between the two figures. Both have exposed a leg; the one
seductively, the other grotesquely. The prints which
follow deal with the demoralizing effects of prostitution
and suggest that *Ysele quema la Casa* may show lust as
well as drunkenness. In the finished print, which is close
to the *sueño* drawing, the man's legs have an unsteady
balance and his sodden face is slack.

1. Edith Helman, *Trasmundo de Goya* (Madrid, 1963), p. 54.

López de Ayala: *No acierta á ponerse y quitarse los calzones un
viejo que se arde todo de lascivia.*
(An old man burning with lust can't manage to get his breeches
on or off.)

Prado: *Ni acertara á quitarse los calzones ni dejar de hablar con
el candil, hasta que las bombas de la villa le refresquen. Tanto
puede el vino!*
(And he won't be able to get his breeches off or stop talking to his
oil-lamp until the town pumps cool him off. So great is the power
of wine!)

86

Buen Sacerdote ¿donde se ha celebrado?

53

18.

Ysele quema la Casa.

54

55–56
Caprichos 19
Todos caerán. (All will fall)
D. 56, H. 54, B. 39, Hof. 19
215 × 145 mm.

55
Completed state, pre-publication impression, Harris II, 2
Etching and burnished aquatint
No watermark
Coll.: M. Mirault
The Art Institute of Chicago. The Clarence Buckingham
Collection. 48.110/19

THOMAS ROWLANDSON. England, 1756–1827
56
Frigates Towing a Hulk, 1812
Watercolor over pen and ink
285 × 220 mm.
Pen and ink lower left: *Rowlandson 1812*
Pen and ink lower center: title
Watermark: RUSSELL & Cº/1797
Museum of Fine Arts, Boston. Gift of Mr. and Mrs.
John D. MacDonald. 50.3987.

55

López de Ayala: *Toda especie de avechuchos, militares, paisanos
y frailes, revolotean alrededor de una dama medio gallina; caen y
las mozas los sujetan por los alones, los hacen vomitar y los
sacan las tripas.*
(All kinds of ugly birds, soldiers, civilians, monks, flutter about a
lady, half-hen; they fall and the women pin them down by their
wings, make them vomit, and pull out their guts.)

Prado: ¡ *Y que no escarmienten los que van à caer con el exemplo
de los que han caído! pero no hay remedio* todos caeran.
(And to think that the ones who are going to fall don't learn from
the example of those who have fallen. But, there's no help for it,
all will fall.)

In the upper regions of the print, man-birds, including an officer, a monk, and a gallant, circle around a woman-bird on a perch, who acts as a decoy. Below are a procuress and two young prostitutes. The latter pluck the feathers from a victim who has fallen into their grasp. As the men are victims of the prostitutes' greed, so are they victims of their own behavior. The engraved title points to the inevitability of their downfall.

Thomas Rowlandson's watercolor of 1812, *Frigates Towing a Hulk,* represents the kind of satire on morals prevalent in England not long after Goya's *Caprichos* were published. The watercolor and *Todos caerán* deal with the same subject — a man falling victim to prostitutes because of his own weakness. There the similarities stop. One cannot help but laugh at Rowlandson's characterization of the lascivious, gluttonous old man preyed upon and teased by sly, coquettish women, more interested in his money than in his charm. Rowlandson's graceful drawing style and the pastel colors contribute to the light-hearted effect. The watercolor was published the same year by T. Tegg with the title *Catching an Elephant.* Such prints were sold "one-penny plain, two-penny colored."

Goya's print, on the other hand, conceived in terms of a subtle balance of gray and white, is a serious and profoundly disturbing allegory.

56

57

Caprichos 20
Ya van desplumados (They've already been plucked
[fleeced])
D. 57, H. 55, B. 40, Hof. 20
215 × 150 mm.

Completed state, pre-publication impression, Harris II
Etching, burnished aquatint, and drypoint
No watermark
Coll.: M. Mirault
The Art Institute of Chicago. The Clarence Buckingham
Collection. 48.110/20

The next plate after *Todos caerán* shows what hap-
pens to a prostitute's clients after they have been fleeced
for all they are worth in money and self-respect. Naked,
cowering, no longer able to fly, they are vigorously swept
out to make room for the next customers. Behind the
prostitutes with their brooms, two hooded figures look
on with approval. Above the group a pair of feathered
birds are coupling. It must not be forgotten that Goya's
contemporary, Gallardo, writing about the *Caprichos*
called Goya one of the world's great moralists. In unfor-
gettable imagery Goya shows how the repeated commis-
sion of sin can change the very being of man. The plates
that follow deal with the preying, self-righteous hypocrisy
of men who prosecute such women.

57

López de Ayala: *Después de desplumados los avechuchos son
arrojados á escobazos: una baja cojo y vizmado, y dos padres
reverendísimos, con sus rosarios al cinto, les guardan las espaldas,
y celebran las burlas.*
(Once they've been plucked the ugly birds are driven out with
blows of the broom; one comes down lame and with a poultice
on, and two very reverend fathers, with their rosaries hanging
from their belts, hold up the rear and enjoy the abuse.)

Prado: *Si se desplumaron ya, vayan fuera! que van à venir otros.*
(If they've been plucked already, let them get out, so that others
can come.)

58–59

Caprichos 23

Aquellos polbos. (That dust . . .)
D. 60, H. 58, B. 43, Hof. 23
215 × 150 mm.

58

Working proof for a rejected plate, Harris 116, I
Burnished aquatint and drypoint
215 × 149 mm.
Watermark: N. GISBERT (?)
Coll.: M. Ballester
Bibliothèque Nationale, Paris. A 11036

59

Completed state, pre-publication impression, Harris II
Etching, burnished aquatint, drypoint, and burin
No watermark
Coll.: M. Mirault
The Art Institute of Chicago. The Clarence Buckingham
Collection. 48.110/23.

Aquellos polbos is the first of two plates in the
Caprichos that deal with the Inquisition. The title refers
to a Spanish proverb: *De aquellos polvos vienen estos
lodos* (From that dust comes this mud).[1] In this context,
the word *polvos* could also have a more specific mean-
ing : powders that could be used in magic potions. A
number of manuscripts, including the López de Ayala,
identify the prisoner as Perico, the cripple. This beggar
and two women were arrested for selling magic love
powders. They were tried by the Inquisition rather than
the civil courts because it was feared that their testimony
would reveal the names of the many noble ladies who
had purchased their powders.[2]

The sole surviving impression from a plate on which
Goya etched an earlier version of *Aquellos polbos* is close
to the red chalk and wash drawing for the subject (Prado

No. 105). The plate, executed almost entirely in aquatint,
was bitten repeatedly to produce five tones. One possible
result of biting a plate so many times with acid would be
the breaking down and weakening of the surface of the
plate, making it unsatisfactory for printing an edition.
The plate seems more experimental than successful.
Three heads in the foreground are over-elaborated in
relation to the principal figures; the sharp blacks of the
prisoner's gown and tall pointed *coroza* have no counter-
balance in the grays; and some of the spatial relationships
are ambiguous and unconvincing.

In the published version Goya returned to a
combination of etched line and aquatint tone. This per-
mitted a greater range of facial expression in the audi-
ence: sanctimoniousness, avid interest, disdain. In this
version, the background is a single, uniform tone, remov-
ing the suggestion of an architectural setting provided by
the arch in the earlier version. The burnished podium
front and book call attention to the Inquisitor glancing
toward the prisoner as he reads the charges. Every change
Goya made increased the focus on the defendant. By
elimination of the foreground edge of the platform his
figure was made to loom larger and was brought closer
to the viewer. His state of being is summed up in his
dejected, humiliated pose.

1. *Diccionario De La Lengua Castellana* (Madrid, 1791), 3rd. ed.
See under *Lodo*.

2. For a description of the trial see Joseph Townsend, *A Journey
through Spain in the Years 1786 and 1787* (London, 1791), vol. 2,
pp. 321–325, and vol. 3, p. 335.

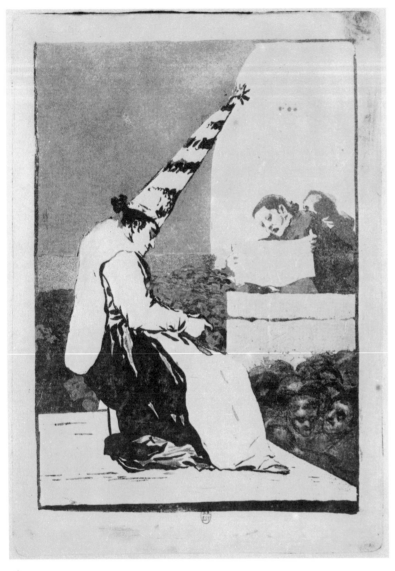

58

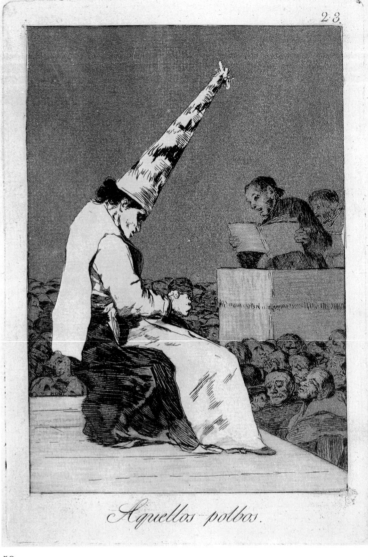

59

López de Ayala: *Auto de Fée. Un vulgo de curas y frailes nécios hacen su comidilla de semejantes funciones. Perico (?) el cojo que daba polvos á los enamorados.*
(An auto-da-fé. A mob of stupid priests and monks feast on such performances. Perico the cripple who gave powders [magic] to lovers.)

Prado: *Mal hecho! A una muger de õnor, que por una friolera servia à todo el mundo tan delijente, tan util, tratarla asi! mal hecho!*
(It's not right! To treat a decent woman like this, who would serve everyone for a trifle, so diligently, so usefully! It's not right!)

60–61
Caprichos 25
Si quebró el Cantaro. (If he broke the pitcher)
D. 62, H. 60, B. 45, Hof. 25
215 × 150 mm.

60
Working proof, Harris I, 2
Etching and aquatint
No watermark
Coll.: M. Ballester; Philip Hofer
Museum of Fine Arts, Boston. Gift of Mr. and Mrs.
James O. Welch, and the Hezekiah E. Bolles Fund,
by exchange. 1973.711.

61
Completed state, pre-publication impression, Harris II
Etching, aquatint, and drypoint
No watermark
Coll.: M. Mirault
The Art Institute of Chicago. The Clarence Buckingham
Collection. 48.110/25

This plate follows immediately after Goya's second
print dealing with the Inquisition and its meting out of
punishment that exceeds the crime. In *Si quebró el
Cantaro*, Goya shows the same practice being followed in
domestic matters. A mother who has been hanging out
the washing beats her son with a shoe because he
broke a pitcher.

The working proof is one of four known impres-
sions printed after the plate was etched and had received
a fine grain of aquatint bitten twice to create a pale and
a medium tone. In this impression, the focal point of
the composition is the unmodulated white area of the
boy's bottom.

A comparison between the working proof and an
impression from the pre-publication set shows what a
difference a very few drypoint lines could make. The
drypoint strokes on the boy's buttocks give them round-
ness and tone down the stark whiteness seen in the
working proof. This establishes a new expressive balance
between the instrument of punishment wielded by the
enraged mother and the target to which she applies it.
The print that follows this one in the *Caprichos* iron-
ically suggests another use for one's bottom.

López de Ayala: *Las madres coléricas rompen el culo á azotes á
sus hijos, que estiman menos que un mal cacharro.*
(Hot-tempered mothers beat up their children whom they value
less than a poor jug.)

Prado: *El hijo es travieso y la madre colerica. Qual es peor.*
(The child is mischievous and the mother hot-tempered. Which
is worse?)

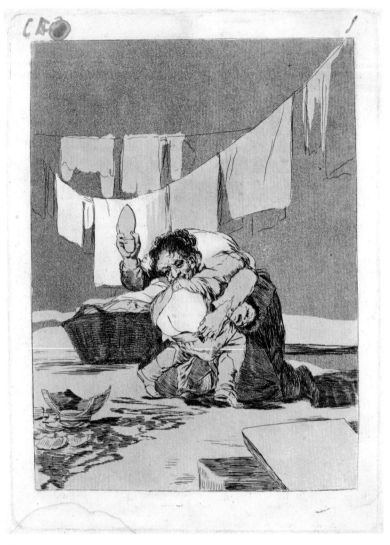

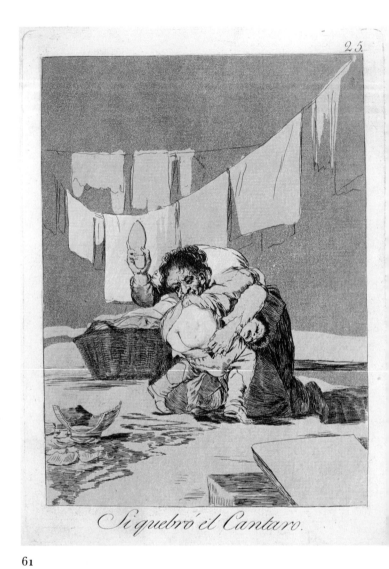

Si quebró el Cantaro.

60

61

62–63
Caprichos 26
Ya tienen asiento (Now they have a seat [good judgment])
D. 63, H. 61, B. 46, Hof. 26
215 × 150 mm.

62

Working proof, Harris I, 2
Etching and aquatint
No watermark
Coll.: Los Rios; Philip Hofer
Museum of Fine Arts, Boston. Gift of Dows Dunham, and the M. and M. Karolik Fund. 1973.712

63

Completed state, pre-publication impression, Harris II
Etching and burnished aquatint
No watermark
Coll.: M. Mirault
The Art Institute of Chicago. The Clarence Buckingham Collection. 48.110/26

Two pleasantly plump young ladies wear their petticoats around their faces and have upside-down chairs on their heads. Their bare legs are exposed, and the ruffled skirts are transparent, revealing their rounded forms. It is not difficult to grasp Goya's satirical meaning. These girls have brains where they sit, and they are completely insensitive to the jeers aimed at them. The title, as published, reinforces this interpretation because the word *asiento* has two meanings: a seat and good judgment. Only with a chair to hold them down, will these young women behave with prudence.

The working proof printed before a second, fine grain of aquatint was applied and the aquatint burnished, emphasizes the youthful curvaceousness of the young ladies.

In the finished print, another tone of aquatint, fine-grained, has been added. Goya stopped out only the faces of the girls and the upper part of their bodies, shifting the emphasis of the print to their faces and expressions. One is more aware of the coyness of the one and the cow-like admiration of the other. Their faces are too vacuous to identify them with Goya's prostitutes. Burnishing is used to lighten and enrich various details of the print such as the arm of the mocker at the right. The "seat" of their energies is less in their bodies, which are now in shadow, than in their empty-headed craving for any kind of attention.

López de Ayala: *Las niñas casquivanas tendrán asiento cuando se lo pongan sobre la cabeza.*
(Giddy-headed girls will settle down when a seat is landed on their heads.)

Prado: *Para que las niñas casquibanas tengan asiento nos no hay mejor cosa que ponerselo en la cabeza.*
(The only way giddy-headed girls will settle down is to land a chair on their heads.)

26.

Ya tienen asiento.

62

63

64–65
Caprichos 31
Ruega por ella (She prays for her)
D. 68, H. 66, B. 51, Hof. 31
205 × 150 mm.

64
Working proof, Harris I, 2
Etching, burnished aquatint, drypoint, and burin
No watermark
Coll.: Los Rios; Philip Hofer
Museum of Fine Arts, Boston. Gift of the Ian Woodner
Family Foundation, and the 1951 Purchase Fund,
by exchange. 1973.713.

65
Completed state, pre-publication impression, Harris II
Etching, burnished aquatint, drypoint, and burin
No watermark
Coll.: M. Mirault
The Art Institute of Chicago. The Clarence Buckingham
Collection. 48.110/31

The López de Ayala manuscript explains that before
sending the young prostitute out for the work for which
we see her being groomed, her mother prays to God for
fortune and protection against doctors and the police.

Goya's working proof, when compared with the final
version, shows a quite different conception of the lighting
and its dramatic effects. A single tone of aquatint prints
quite darkly. Burnishing, evident on the garments, faces
of the assistant and old woman, the prostitute's arm, the
basin, and the pitcher, seems carefully thought out and
executed. It is possible that when Goya arrived at this
stage and pulled his proofs, he considered the plate
finished. The expressions of the prostitute and the young
woman combing her hair are not, however, clearly
indicative of their profession.

The development from proof to finished plate
required very extensive alterations. Goya scraped away
completely the dark aquatint shading on the prostitute's
skirt, bodice, sleeve, and arm, and burnished most of it
on the old woman, the prostitute's hair, the basin,
pitcher, floor, and embroidered stool. Then he applied

a second, light tone of aquatint and proceeded to burnish
it. This second tone is apparent on the assistant's face
and left hand; traces of it after burnishing are visible
as shading on the prostitute's face and neck. Finally, to
strengthen some of the etched lines, accent the contours,
and refine the modeling, he used burin and drypoint.
This new work has produced a knowing smile on the
assistant's face and a sly expression on the prostitute's,
as well as a far more sensuous appearance. The lighting,
more logical and less artificially dramatic than in the
proof, is still used selectively to spotlight important
elements and relationships; the prostitute and her pray-
ing mother are united by the illumination, and one is
more conscious of the assistant's role.

López de Ayala: *Una madre, que llega á ser alcagüeta de su hija,
ruega á Dios la dé fortuna y la libre de todo mal de cirujanos y
alguaciles.*
(A mother, who becomes procuress of her own daughter, prays to
God that He may give her good fortune and spare her harm
from surgeons and constables.)

Prado: *Y hace muy bien para que Dios la de fortuna y la libre de
mal y de cirujanos y alguaciles y llegue á ser tan diestra tan
despejada y tan para todos como su madre que en gloria este.*
(And she is quite right to do it, so that God may give her good
fortune and spare her from the mischief of surgeons and constables,
and that she may become as sharp and able on all accounts as her
mother was, God rest her soul.)

64 (full size)

Ruega por ella.

65 (full size)

66–67

Caprichos 32

Por que fue sensible (Because she was susceptible)
D. 69, H. 67, B. 52, Hof. 32
215 × 150 mm.

66

Woman in Prison
Working proof for a rejected plate, Harris 117, I
Burnished aquatint, touched with black chalk
184 × 128 mm. (cut within platemark)
No watermark
Coll.: Carderera
Biblioteca Nacional, Madrid. 45621

67

Working proof for Plate 32, Harris I
Aquatint
No watermark
Coll.: P. Burty
British Museum, London. 1876–11–11–334

The published title, *Por que fue sensible,* refers
ironically to the girl's gullibility, which has led her to
prison. The López de Ayala manuscript suggests that she
is there because she has become pregnant. In eighteenth
century Spain there was a law that persecuted women
who gave birth to illegitimate children, thus encouraging
the practice of abortion.[1] This imprisoned woman may
be a victim of that law. Her forlorn pose and counte-
nance suggest misery, loneliness, and penitence.

Goya made and rejected another version of this
subject. It is known only by a unique proof executed
entirely in four tones of aquatint. Black chalk shading
on the woman's shoulders, back, and upper arm may be
notations for yet another biting of the plate. In this
undoubtedly early impression, one can see that the tones
lack clarity and evenness. It seems likely that either some
of the aquatint broke down in the acid bath or Goya felt
that the plate did not convey the subject with sufficient
clarity. The chained figure of the prisoner seems less

1. See "Discúrso sobre legislacion," *Correo de Madrid (o de los
ciegos),* Oct. 27, 1787, no. 106, p. 498.

important than the delineation of the stone vaulting of
the prison. For whatever reason, Goya began again on
a new piece of copper.

The second version, published as *Caprichos* 32,
is represented here by a proof printed after the work on
the image was complete but before the plate was given its
title and number. It, too, is executed entirely in aquatint,
in two tones. The whites were created by means of
stopping-out.

The young woman sits in prison; her bowed head,
hunched shoulders, clasped hands, and awkwardly thrust
forward legs convey a sense of tension and anxiety. Her
only company is a rat. Even in this version, with its
smaller number of bitings, the plate did not print
uniformly well.

López de Ayala: *La mujer de Castillo. Las muchachas incautas
vienen á parar y parir á una prison por demasiada sensibilidad.*
(Castillo's woman. Reckless girls end up in and give birth in
prison because they were too willing.)

Prado: *Como ha de ser este mundo tiene sus altos y bajos. La vida
que ella trahia no podia parar en otra cosa.*
(How else could it be. This life has its ups and downs. The life she
led couldn't get her anywhere else.)

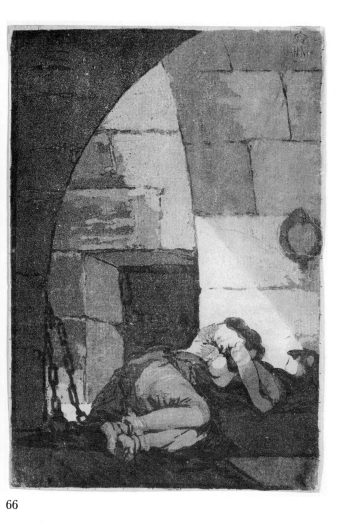

66

67

68–69
Caprichos 38
Brabisimo! (Bravissimo!)
D. 75, H. 73, B. 58, Hof. 38
215 × 150 mm.

68
"De todo" (Everything)
Red chalk. 210 × 149 mm.
Recto: (with title) Prado 480. Verso: ("Goya" not
autograph) Prado 481
Watermark: D^N J^PH GISBERT / ALCOY
Coll:. Lefort; D. Pedro Fernández-Durán
Museo del Prado, Madrid

69
Working proof, Harris I, 2
Etching, burnished aquatint, and drypoint
Inscribed in lower margin with various trial titles: in red
chalk (*Brabo*), black chalk, and brown ink, all crossed out
and finally in black chalk: *Protege las artes y se ve que lo
entiende* (He protects the arts and one can see he under-
stands them)
No watermark
Coll.: Philip Hofer
Museum of Fine Arts, Boston. Gift of Barbara D.
Danielson. 1973.715

The double-sided red chalk drawing with its inscription
De todo (Everything) is a study for a *capricho* never
executed. However, the subject matter, the ignorant
patron who pretends to have a knowledge of the arts, is
directly related to the present plate. In what seems to be
the earlier version (verso) the patron, wings of genius
sprouting from his head, the lower portion of his body
asinine, sits at a table. Under it we see a palette and
brushes, a lyre, and a manuscript. He clumsily holds a
compass with which he measures the architectural plan
to which he is pointing. He discourses to his audience,
who regard him with awe. On the recto, which bears
Goya's title, the patron's face has taken on a donkey-like
aspect, and he has a second pair of donkey legs.

Brabisimo! is one of a series of six *Caprichos* in
which humans are represented as donkeys. As Edith
Helman pointed out, this was a common device in
eighteenth century Spanish literature; an example is the
Memorias de la academia asnal (Records of the Asinine
Academy), a book of verses illustrated with charming
woodcuts.[1] In *Brabisimo!* a monkey strums the back of a
guitar for a donkey, who listens appreciatively. Behind
the donkey are two men who, aware of the farce, clap
and jeer in derision. In the margin, Goya has experi-
mented with various titles: "Bravo" and "He protects
the arts and they say he understands them," which was
then amended to "one can see he understands them."
For the published title Goya chose the succinct
"Bravissimo!"

Some of the explanatory manuscripts tell us that
this print represents Manuel Godoy, although they iden-
tify him with the monkey and the donkey with the king.
Godoy, the Prince of Peace, was a collector, who in his
role of secretary of state was also Protector of the academy
of fine arts, the Real academia de San Fernando. It is
altogether possible that the donkey figure in the two
versions of the drawing and in the print refers to Godoy.

1. Edith Helman, *Trasmundo de Goya* (Madrid, 1963), p. 63 ff.,
see particularly ills. pp. 30 and 33.

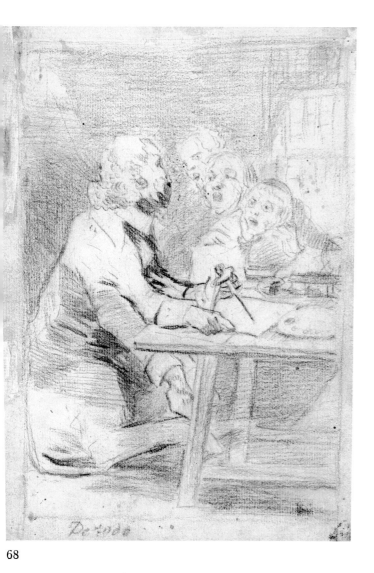

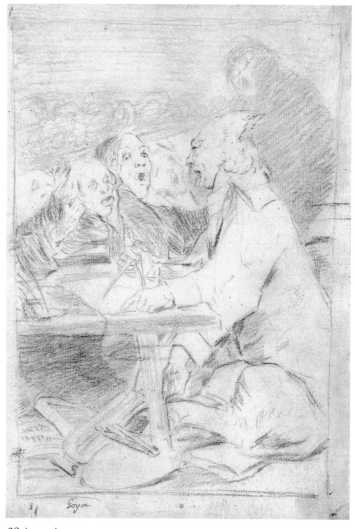

68

68 (verso)

69

López de Ayala: *Si para entenderlo bastan las orejas, ninguno más á propósito.*
(If ears were enough to understand it, no one is better endowed.)

Prado: *Si para entenderlo bastan las orejas nadie habra mas inteligente; pero es de temer que aplauda lo que no suena.*
(If ears were enough to understand it, no one could be wiser. But it must be feared that he applauds what cannot be heard.)

70–76
Caprichos 43
El sueño de la razon produce monstruos (The sleep of reason produces monsters)
D. 80, H. 78, B. 63, Hof. 43
215 × 150 mm.

70–71
Two frontispieces from *Oeuvres Complètes de J.-J. Rousseau,* Nouvelle Edition, Paris, 1793, Tomes XXIX and XXX
Engravings by I. S. Helman and A. C. Giraud, and J. B. D. Dupréel, respectively, after Charles Monnet
Images: 130 × 90 mm. and 138 × 91 mm.
Anonymous loan

72
Preliminary drawing for *Caprichos 43*
Pen and sepia ink wash over chalk
On the reverse chalk drawing for *Caprichos* 6 (Prado 47
230 × 155 mm.
Watermark: H C WEND / ZOONEN
Museo del Prado, Madrid. 470

73
Preparatory Drawing for *Caprichos 43*
Sueño 1º (First dream)
Ydioma univer / sal. Dibujado / y Grabado p.ͬ / F.ᶜᵒ de Goya / año 1797 (Universal language, drawn and etched by Francisco Goya in the year 1797)
El Autor soñando. / Su yntento solo es desterrar bulgaridades / perjudiciales, y perpetuar con esta obra de / caprichos, el testimento solido de la verdad. (The author dreaming. His one intention is to banish harmful beliefs commonly held, and with this work of *caprichos* to perpetuate the solid testimony of truth.)
Pen and sepia ink over chalk.
245 × 169 mm.
Watermark: shield of H C Wend/Zoonen
Museo del Prado, Madrid. 34

70

71

74
Working proof, Harris I, 2
Etching and aquatint
No watermark
Coll.: Los Rios; Philip Hofer
Museum of Fine Arts, Boston. Gift of Mr. and Mrs.
Burton S. Stern, Mr. and Mrs. Bernard Shapiro, and the
M. and M. Karolik Fund. 1973.716

75
First edition impression, Harris III, 1
Etching and aquatint
No watermark
Anonymous loan

76
An Allegory: Truth, Time, and History
Oil sketch on canvas related to the painting, *The Rescue of Spain by Time,* in the Nationalmuseum, Stockholm.
Unsigned
420 × 325 mm.
Coll.: Juan Carnicero (said to have been presented by Goya); Alejandro de Coupigny; bought in Madrid, 1918 by Ralph W. Curtis for Horatio G. Curtis
Museum of Fine Arts, Boston. Gift of Mrs. Horatio G. Curtis in memory of Horatio G. Curtis, 1927. 27.1330.

The two pages from Rousseau's *Philosophie,* published in 1793, are characteristic eighteenth century frontispieces. They provide an interesting comparison with the drawings for a print with which Goya originally intended to open his series of satires. In the first, Rousseau is threatened by personifications of folly, wrath, and envy. He looks up, bathed in the light of happiness of an ideal world. In the second, he is in the throes of composition. At his feet various other works of the author are represented. Again he is bathed in light, the rays issuing from the eye of God. He offers up to an image of the Virgin and Child a manuscript dedicated "to every Frenchman who is still a lover of Justice and Truth."

In the earlier of Goya's two drawings, the seated artist rests his head and folded hands on a piece of furniture that is either a very massive table or part of a printing press. Against his chair is propped the copper plate

for the etching of Margarita de Austria after Velázquez (cat. nos. 20–21). Above the artist, in the midst of grimacing, grotesque faces, can be seen Goya's own face reflecting various emotions. At the top of the sheet is a donkey, symbol of folly. At the right flutter various creatures of darkness. Unlike Rousseau's title pages, in this drawing the rays of light emanate from the head of the artist.

Goya seems to have made no attempt to etch the composition in this form. The design is chaotic and not easily legible, and in this respect is like a sketch sheet.

The second drawing is inscribed at the top "First Dream." On the pedestal on which the artist now rests his head is written "Universal language, drawn and etched by Francisco de Goya in the year 1797." In the lower margin is written "The author dreaming. His one intention is to banish harmful beliefs commonly held and with this work of *caprichos* to perpetuate the solid testimony of truth," a sentiment that echoes that of Rousseau's second frontispiece.

Above the artist the light of Reason or Enlightenment forms a strongly defined arc against which the creatures of darkness and disorder, bats, owls, and lurking cat, cannot prevail. A single broad beam of light issues from the artist's head, linking him with the circle of light.

The composition is more legible and forceful than that of the foregoing drawing. As platemark and printing folds indicate, this drawing was transferred to the copper plate on which *Caprichos* 43 was executed.

The working proof of this print is fairly close in composition to the foregoing drawing. The proportions of the design, however, have been broadened. The figure of the artist is made more prominent by shifting the position of the enormous bat of the drawing and reducing the creature's size. Other creatures have been added: a black cat and a group of owls who cluster round the artist's figure. On the pedestal are seen drawing tools and sheets of paper. One of the owls has had the audacity to seize a crayon holder and looks malevolently at Goya as he brandishes it. In eighteenth century Spain the owl was not a symbol of wisdom but rather of folly, stupidity, and acts committed under cover of darkness. The most dramatic change is the disappearance of the arc of light that had thrust against the creatures of darkness.

On the front of the pedestal appears the title: "The sleep of reason produces monsters." This was first lightly sketched in with drypoint and then executed with stop-out so that the letters appear white against the lighter of the two tones of aquatint Goya used for this plate. The plate was not cleanly wiped before printing, and there is a film of ink visible on highlighted areas. The grayish ink is typical of that used for the working proofs of this series.

In the impression from the first edition a great many etched lines have been added. It is one of the few plates in the *Caprichos* in which additional work was added in etching to complete the design. (See also *Caprichos* 52, cat. no. 80). Goya's usual method in the *Caprichos* was to add lines in drypoint or engraving. The flock of bats and owls has been multiplied so that they are now a swarm. Goya has elaborated some of the creatures, particularly the three immediately behind his figure, adding new details and giving them more emphasis by darkening them. The owls and cat now constitute a more threatening trio, and the darkening of their forms gives the figure of the artist yet more emphasis, as does the deepening of the shadow under his chair.

This early impression from the first edition is printed in a brownish ink. The sheet is untrimmed on all sides and has not been bound. The prints were sold individually or as a set in this condition. Binding was left to the purchaser. The title could serve as a title for most of Goya's graphic work: again and again Goya depicts the monsters produced by unreason. The print, in its present position, serves as a title page to the second part of the series, in which folly and evil are often represented by witches or demons.

The oil sketch, "Truth Rescued by Time," is related in conception to *Caprichos* 43. Naked Truth is being led by winged Time, who holds an hourglass, out of the regions of error, a darkness inhabited by bats and owls. History, seated in the foreground, holds a book in which to record what has happened. There are two drawings on recto and verso of the same sheet (Prado 423 and 463, not in exhibition) that are related to this oil sketch. They are on the Wend Zoonen paper Goya used for the *sueños*.

López de Ayala: *La fantasiá abandonada de la razón produce monstruos, y unida con ella es madre de las artes.*
(Fantasy deserted by reason produces monsters, and united with it, is mother of the arts.)

Prado: *La fantasia abandonada de la razon, produce monstruos inposibles: unida con ella, es madre de las artes y origen de sus marabillas.*
(Fantasy deserted by reason produces impossible monsters: united with it, fantasy is mother of the arts and source of all its marvels.)

72 (full size)

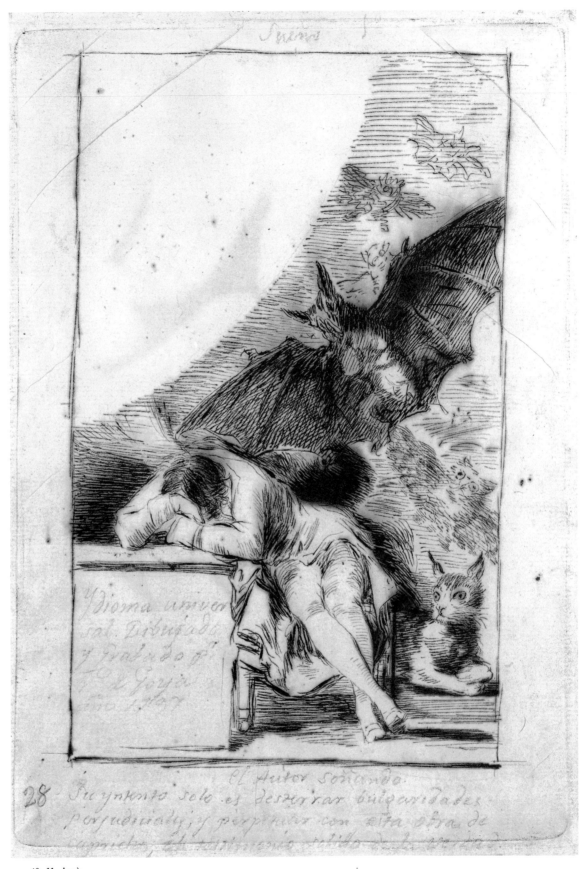

73 (full size)

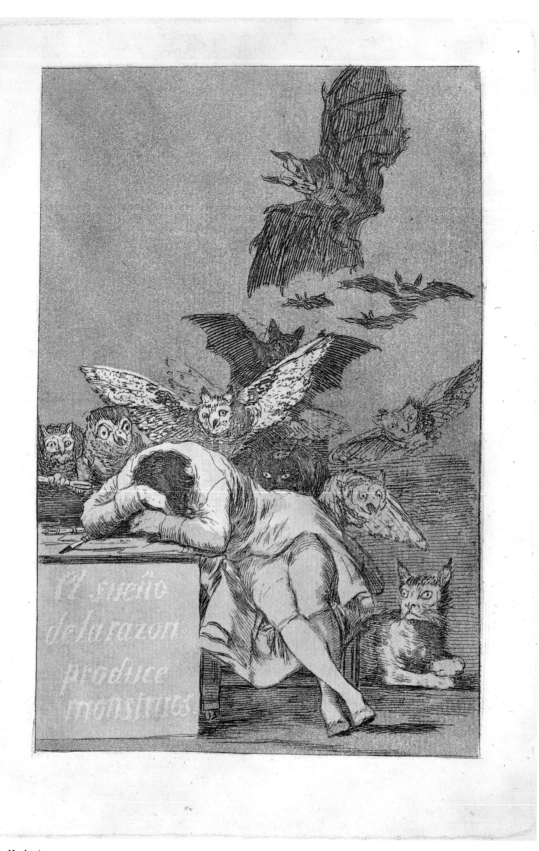

El sueño de la razon produce monstruos

74 (full size)

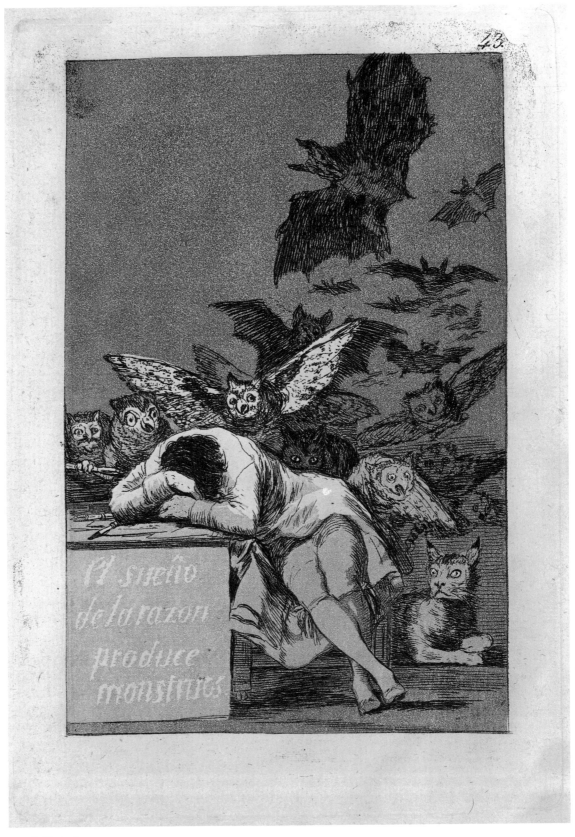

El sueño de la razon produce monstruos

75 (full size)

76

77

Caprichos 51
Se repulen (They spruce themselves up)
D. 88, H. 86, B. 71, Hof. 51
210 × 150 mm.

Completed state, pre-publication impression, Harris II
Etching, burnished aquatint, and burin
No watermark
Coll.: M. Mirault
The Art Institute of Chicago. The Clarence Buckingham
Collection. 48.110/51

A warlock at the left, armed with a huge pair of shears, cuts the claw-like nails of a companion. His own have already been trimmed. Behind them, a third witch, casting his eyes toward heaven, protectively spreads his clawed, bat-like wings like a cape to screen their activity. Their large forms huddle together, filling the lower half of the print.

To understand this print, one must be aware of the implicit visual and verbal puns. For example, the eighteenth century Spanish expression *"Ser capa de maldades de ladrones, pícaros,* etc." meant literally "to act as a cape for the evil deeds of thieves, knaves, etc."; that is, to cover up for or to protect them. Another expression *"meter la uña"* (to apply the claw) meant to take advantage of, to defraud.[1] The witches in the foreground "spruce themselves up" to hypocritically disguise their nature, protected by a third witch who conceals their transformation. This sense of hypocrisy is wonderfully expressed by the pious grimace of the witch at the right.

1. *Diccionario de la lengua castellana* (Madrid, 1791), under *Capa* and *Uña.*

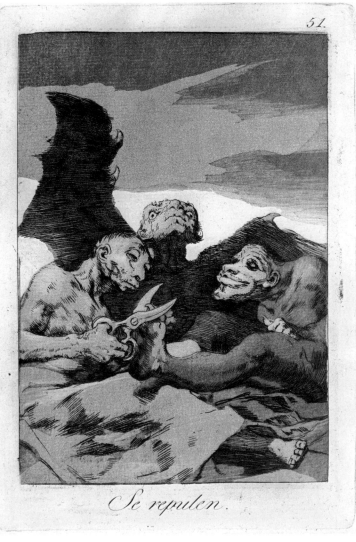

Se repulen.

López de Ayala: *Los empleados ladrones se disculpan y tapan unos á otros.*

(Crooks excuse and cover up for each other.)

Prado: *Esto de tener las uñas largas es tan perjudicial que aun en la Bruxeria esta prohivido.*

(This business of having long nails is so pernicious that even in witchcraft, they are prohibited.)

78–80

Caprichos 52

Lo que puede un sastre! (What a tailor can achieve!)

D. 89, H. 87, B. 72, Hof. 52

215 × 150 mm.

78

Preparatory Drawing

Sanguine wash

239 × 165 mm.

Watermark: Shield of H C Wend Zoonen

Museo del Prado, Madrid. 101

79

Working proof, Harris I, 2

Etching, burnished aquatint, drypoint, and burin, touched with chalk

No watermark

Coll.: Philip Hofer

Museum of Fine Arts, Boston. Gift of William A. Coolidge. 1973.717

80

Completed state, pre-publication impression, Harris II, 2

Etching, burnished aquatint, drypoint, and burin

No watermark

Coll.: M. Mirault

The Art Institute of Chicago. The Clarence Buckingham Collection. 48.110/52

Goya's drawing in sanguine wash for *Caprichos* 52 bears a platemark, indicating that it was transferred to the plate. The composition and lighting pattern were followed closely in Goya's first etching and aquatinting of the plate.

A young woman kneels and prays with adoring reverence before a tree draped as a hooded monk. The child directly behind her is terrified, but the other spectators display piety and awe. In the eighteenth century there was much criticism of priests and monks who created false miracles in order to dupe the pious and to profit from them. Only the innocent child sees this object of faith for what it is, a scarecrow.

In the working proof Goya made the expressions of

the young woman, child, and crowd of worshippers more explicit. He added in chalk a topknot to the monk's hood and lightly sketched in witches hovering in the sky.

In *Lo que puede un sastre!*, as in *Caprichos* 43 (cat. nos. 70–76) lines were etched in two stages. In *Caprichos* 43 the changes were made to give added force to the composition; here, they were made to give a prudent ambiguity to the true meaning of the plate. The Inquisition was still active in Spain, and the design as first conceived could not have been published. The topknot and the witches sailing through the air combine with the title "What a tailor can achieve!" to permit interpretation of the print as a scene of witchcraft.

López de Ayala: *La superstición hace adorar un tronco vestido al público ignorante.*
(Superstition makes the ignorant mob worship a clothed tree trunk.)

Prado: *Quantas vezes un bicho ridiculo se transforma de repente en un fantasmon que no es nada y aparenta mucha. tanto puede la habilidad de un sastre y la boberia de quien Juzga las cosas por lo que parecen.*
(How often a ridiculous creature is transformed into a ghost that is nothing and looks like a lot. That's what a tailor can accomplish and the stupidity of those who judge things by their appearance.)

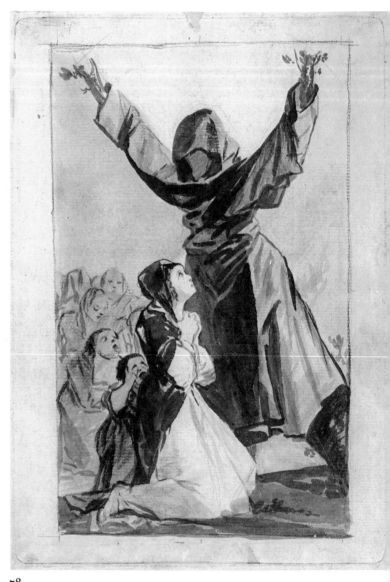

78

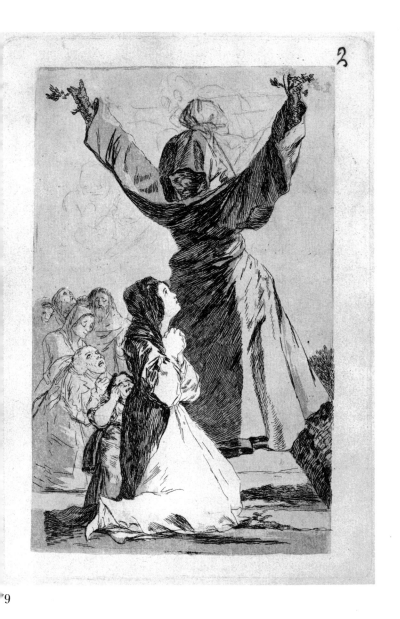

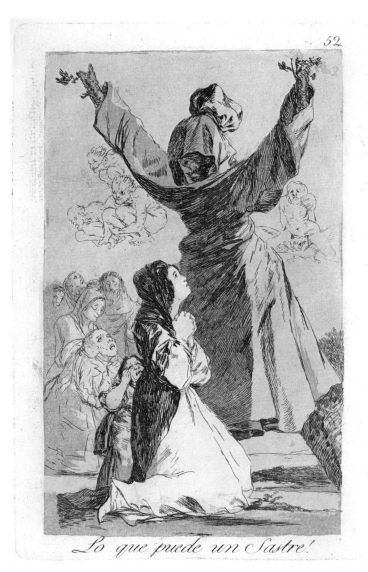

Lo que puede un Sastre!

81–82

Caprichos 56

Subir y bajar (Ups and downs)

D. 93, H. 91, B. 76, Hof. 56

215 × 150 mm.

81

Completed state, pre-publication impression, Harris II

Etching and burnished aquatint

No watermark

Coll.: M. Mirault

The Art Institute of Chicago. The Clarence Buckingham
Collection. 48.110/56

82

First edition impression, Harris III, 1

Etching and burnished aquatint, with contemporary
hand coloring

No watermark

Anonymous loan

A satyr, symbol of lust, perches on the edge of a globe
and grasps by the ankles a man whom he hoists aloft. In
foreground and background two other men, their faces
hidden, plummet downward. The brightly lit figure that
the satyr supports wears a military officer's jacket; smoke
billows from his head, and in his hands are fiery
thunderbolts.

Many manuscripts of explanation identify the
officer as Manuel Godoy, whose rise to power was due to
his being for many years the queen's lover. One English
visitor was horrified to find that one of the royal children
bore an indecent likeness to Godoy, rather than to the
king.[1] By 1798 Godoy had become a general, then
Prime Minister, and finally, had been given the title,
Prince of Peace. In his hands was the real government of
Spain. On March 28, 1798, he lost his offices and was
replaced by two ministers, one of them Goya's friend,
Jovellanos. They, in turn, were dismissed the following
August, and Godoy's power was felt again. Enlightened
intellectuals were galled that the quality of Spanish
government should seem dependent on the queen's
amorous involvements.

The smoke that issues from Godoy's head may be
understood in the light of the connotations of the word
"smoke" in Spanish. In the eighteenth century, it could
allude to vanity, arrogance, and presumption.[2] As the
López de Ayala manuscript says: "His head is being
filled with smoke and wind."

The second impression is in a bound copy of the first
edition of the *Caprichos*. The tonal qualities of Goya's
prints are so effective that one wonders what possessed
someone to color this set by hand. Internal evidence
suggests that this was done by 1809. The coloring is a
useful tool, since it indicates what an early owner of
Goya's prints thought they were about. In *Subir y bajar*,
the coloring makes us instantly aware that Godoy wears
no trousers, thus emphasizing the connection between
lust and his rise to power. It is interesting to note that
in Goya's red chalk drawing for the print (Prado No. 73,
not in exhibition), the Prince of Peace is virtually naked.

1. Earl of Ilchester, ed., *The Spanish Journal of Elizabeth Lady
Holland,* London, 1910, p. 75.

2. *Diccionario de la lengua castellana* (Madrid, 1791), under *Humo*

81

82

López de Ayala: *Príncipe de la Paz. La lujuria le eleva por los piés; se le llena la cabeza de humo y viento, y despide rayos contra sus émulos.*

(Prince of Peace. Lust raises him by his legs; his head is being filled with smoke and wind, and he discharges flashes of lightning against his rivals.)

Prado: *La fortuna trata muy mal à quien la osequia. Paga con humo la fatiga de subir y al que ha subido le castiga con precipitarle.*

(Fortune deals harshly with those who court her. She rewards with smoke the effort of climbing and punishes him who has risen by casting him down.)

83–84

Caprichos 59

Y aun no se van! (And still they don't leave!)

D. 96, H. 94, B. 79, Hof. 59

215 × 150 mm.

83

Working proof, Harris I, 2

Etching, burnished aquatint, and burin

Inscribed by Goya in lower margin in red chalk and crossed out in pen and brown ink: *La Trampa* (The trap)

In pen and brown ink, not by Goya: *Salga lo qᵉ sa-/-liere* (Let come out what will)

Upper right corner in pen and brown ink, not by Goya: *6*

No watermark

Coll.: Los Rios; Philip Hofer

The Museum of Fine Arts, Boston. Gift of Mr. and Mrs. Paul Bernat, and the M. and M. Karolik Fund. 1973.718

84

Completed state, pre-publication impression, Harris II, 2

Etching, burnished aquatint, and burin

No watermark

Coll.: M. Mirault

The Art Institute of Chicago. The Clarence Buckingham Collection. 48.110/59

The single surviving working proof is before additional aquatint and burnishing. In the lower margin are two hand-written titles. The earlier, in red chalk in Goya's hand, translates as "The trap." This has been crossed out and another title, "Let come out what will," added in brown ink in a different hand. It is possible that when Goya was working on the captions for his prints he sometimes shared the labor with friends, who suggested alternate titles.

A group of witches, some apprehensive, others lethargic, are about to be crushed by a great slab of stone. A single scrawny warlock attempts to restrain the great weight and prevent them from being crushed. They are entrapped by their own evil and make little attempt to escape or prevent their own annihilation.

At this stage the lines have been etched and three tones of aquatint bitten. The delicate aquatint tone in the sky is barely perceptible. Small areas of the aquatint have been burnished, including the upper edge of the stone. Burin was used to redefine this edge, perhaps because burnishing had blurred its definition.

In the impression from the pre-publication set, a diagonal swath of dark shadow has been added to the sky in a coarser grain of aquatint, following the pattern of the previous delicate tone. Additional aquatint seems to have been added to the face of the slab to darken it and give it more weight. The dark tone of aquatint in the sky has been burnished along its lower edge to produce a more gradual transition from dark to light, suggestive of twilight or dawn. The strong diagonal of the sky seems to further entrap the figures. It also visually reinforces the downward path of the great slab of stone. Additional burnishing on the figures models them further and produces highlights.

López de Ayala: *Encenagados los mortales en los vicios, están viendo caer la losa de la muerte y ni aún se enmiendan.*
(Mortals mired in the slime of their vices, see that the stone [trap] of death is about to fall on them and still they do not mend their ways.)

Prado: *El que no reflexiona sobre la instabilidad de la fortuna duerme tranquilo rodeado de peligros: ni sabe evitar el daño que hamenaza, ni hay desgracia que no le sorprenda.*
(He who does not reflect on the fickleness of fortune sleeps peacefully, surrounded by dangers; he does not even know how to avoid the harm that threatens them and there is no misfortune that does not take him by surprise.)

6

Salga lo q.º Sa-
liere.

83

84

59.

Y aun no se van!

85
Caprichos 64
Buen viage (Bon voyage)
D. 101, H. 99, B. 84, Hof. 64
215 × 150 mm.

Completed state, pre-publication impression, Harris II
Etching, burnished aquatint, and burin
No watermark
Coll.: M. Mirault
The Art Institute of Chicago. The Clarence Buckingham
Collection. 48.110/64

Goya did not believe in witches as such but used
them as symbols of the evils that plagued his nation.[1] In
the *Caprichos* witches use various means to fly: they wrap
their arms around their legs and sail through the air; they
ride a broomstick or an owl; and, in this print, a winged
witch bears others on his back.

As in "They spruce themselves up" (cat. no. 77)
wings protect the witches; here, they serve as a cradle,
shielding them from the world below and preventing
them from viewing its realities. Further protection is
offered by the darkness of the night. They seem trans-
ported by their sensations and passions, in awe of the
skies but oblivious to dangers.

The impression exhibited is from Chicago's pre-
publication set, with the work on the plate completed.
To create the effect of darkness, Goya bit the whole plate
with a coarse grain of aquatint. The landscape below is
indicated partly by etching and partly by the addition of
a second tone of aquatint. Highlights produced entirely
by burnishing suggest the light of the moon and direct
our attention to the distorted mouths and hollowed eyes
of the witches, so that one can almost hear their howls
and screeches.

1. See for example the drawing *Sueño* 27 (Prado No. 26), where the
inscription makes it clear that witches are disguised as doctors.

85

López de Ayala: *Vuelan los vicios con alas extendidas por la
región de la ignorancia, sosteniéndose unos á otros.*
(Vices fly with their wings spread over the region of ignorance,
each holding the other up.)

Prado: *A donde irà esta caterba ynfernal dando aullidos por el
aire, entre las tinieblas de la noche, Aun si fuera de dia ya era otra
cosa y a furza de escopetazos caeria al suelo toda la gorullada, pero
como es de noche nadie las-ve.*
(Where can this infernal swarm be going, shrieking through the
air in the dark of night? If it were day, it would be another matter,
for the whole mass would be brought to the ground with gunshots,
but since it is night no one sees them.)

86–87

Caprichos 68

Linda maestra! (A fine teacher!)

D. 105, H. 103, B. 88, Hof. 68

Signed in plate lower right: "Goya"

210 × 150 mm.

CLAUDE GILLOT. France, 1673–1722

86

Witches' Sabbath

Etching, with engraving added by Jean Audran, 1722

251 × 335 mm.

Museum of Fine Arts, Boston. Ellen Page Hall Fund.

34.842

87

Working proof, Harris I, 2

Etching, burnished aquatint, and drypoint

Lower margin in brown ink, not by Goya: title as engraved

Upper margin in brown ink, not by Goya: various numerals

Coll.: Prouté (?); Philip Hofer

The Norton Simon Foundation

In the eighteenth century an interest in witchcraft became very much the fashion. Goya, for example, was commissioned to paint six scenes of sorcery for the country house of the Duque and Duquesa de Osuna, completing them by the end of June 1798.[1]

Gillot's print of 1722 is a scene of witchcraft etched by a Frenchman who, as the verses in the lower margin indicate, was skeptical about the existence of such creatures. The verses, translated, begin: "Is it an enchantment, is it an illusion! Should I believe my fear, my eyes, or my reason?" and end: "The earth trembles and opens . . . and what emerges? Monsters I say; and others chimeras." Gillot executed a small group of such subjects and, although the compositions are rococo in taste, many of the individual figures of witches old and young, warlocks and demons, are surprisingly close in conception to Goya's.

In A Fine Teacher! a shapely young woman is being initiated into one of the means by which witches travel. A broomstick thrust suggestively between her naked thighs, they soar over a moonlit landscape under the watchful eyes of an owl.

This print has an etched signature, "Goya," in the lower left corner. It belongs to a group of prints etched with fine, delicate lines, of which nine are signed. They are based on sueño drawings which often show signs of transfer to the plate. Like the drawings, they are conceived primarily in terms of line. Modeling of forms and rendering of atmosphere is accomplished with etched parallel hatching, rather than broad aquatint tones. Here, aquatint was used, but in a limited way, for the middle tone of the background. Drypoint contributes to the modeling; and stopping-out and light burnishing produce highlights on the figures of the old hag and her pupil, and on the broom they ride.

1. Condesa de Yebes, La Condesa-Duquesa de Benavente (Madrid, 1955), p. 42.

López de Ayala: La escoba suele servir á algunas de mula de paso: enseñan á las mozas á volar por el mundo.
(For some the broom serves as a she-mule, too: they teach young girls to fly off over the world.)

Prado: La escoba es uno de los utensilios mas necesarios a las brujas: porque ademas de ser ellas grandes barrenderas como consta por las istorias tal bez conbierten la escoba en mula de pasa y van con ella que el Diablo no las alcanzara.
(The broom is one of the most necessary utensils for witches because, being great sweepers, as is recorded in the stories, they can convert the broom into a mule as well and go at such a pace that not even the Devil can catch up with them.)

86

87

88

Caprichos 71

Si amanece, nos Vamos (When day breaks, we go)
D. 108, H. 106, B. 91, Hof. 71
200 × 105 mm.

Completed state, pre-publication impression, Harris II
Etching, burnished aquatint, and burin
No watermark
Coll.: M. Mirault
The Art Institute of Chicago. The Clarence Buckingham
Collection. 48.110/71

When day breaks, we go concludes a sequence of prints
on witchcraft. Only when the light of day, that is, the
light of reason and truth, appears to expose them will
the evil creatures of darkness be dispersed.

A group of witches with deformed features huddle
together, protected by the outspread wings of a shadowy
demon. They are prepared to flee, their belongings
wrapped in a lewd looking sack on which the leader sits.
Around the leader's waist is a cord to which several
children are tied. This is one of several *Caprichos* in
which witches are shown ready to use babies or young
children for obscene purposes.

The dark, velvety sky in which stars brilliantly
flicker is evidence of the approach of a clear dawn. The
great brilliance of the stars can be seen only in the finest
early impressions. The lights of the foreground, created
by means of stopping-out and burnishing, suggest that
dawn is breaking from the viewer's direction. With one
hand their leader attempts to hold back the light and,
with the other, points in the direction of the darkness
into which they must go. The witches in Goya's *Caprichos*
have a power of malevolence that is unforgettable.

88

López de Ayala: *Conferencian de noche las alcahuetas sobre el
modo de echarse criaturas al cinto.*
(The procuresses are discussing at night how they can get more
babies on their string.)

Prado: *Y aunque no hubierais venido no hicierais falta.*
(And if you hadn't come, you wouldn't have been missed.)

89

Caprichos 75

¿No hay quien nos desate? (Is there no one to untie [annul] us?)

D. 112, H. 110, B. 95, Hof. 75

215 × 150 mm.

Completed state, pre-publication impression, Harris II, 2

Etching and burnished aquatint

No watermark

Coll.: M. Mirault

The Art Institute of Chicago. The Clarence Buckingham Collection. 48.110/75

A man and woman, bound to one another and to a barren tree, struggle in vain to free themselves. A tremendous owl, wearing antiquated spectacles, stands over them, one foot on the dead trunk and the other pressing down on the anguished woman's head. The couple is bound together in a marital relationship that cannot be dissolved. The owl who presides over their union is not a symbol of wisdom, since in eighteenth century Spain the owl generally signified folly, stupidity, or other evils. In this instance, the bird's old-fashioned spectacles suggest that he stands for outmoded custom, the weight of convention, or religious dogma that would not permit divorce.

Only one grain of aquatint was used on the plate. Some of the tonal variation in the sky may have been produced by tilting the plate so that the right side would be bitten longer.

Burnishing describes the owl's feathers and models the young woman's figure.

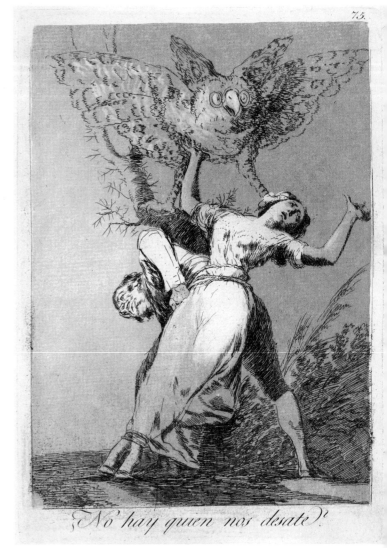

89

López de Ayala: *Dos casados por fuerza ó dos amancebados.*
(Two married in forced union; or maintaining a common law marriage.)

Prado: *Un hombre y una muger atados con sogas forcejeando por soltarse y gritando que los desaten a toda prisa? O yo me equiboco o son dos casados por fuerza.*
(A man and a woman tied together with ropes, struggling to get free and crying out to be untied as fast as possible? Either I am mistaken or they are married in forced union.)

90–91

Caprichos 77
Unos à otros (Turn about)
D. 114, H. 112, B. 97, Hof. 77
215 × 150 mm.

90

Completed state, pre-publication impression, Harris II
Etching, burnished aquatint, drypoint, and burin
No watermark
Coll.: M. Mirault
The Art Institute of Chicago. The Clarence Buckingham
Collection. 48.110/77

91

Sueño (16) / Crecer despues de morir
(Dream. (16) To grow after one is dead.)
Pen and brown ink over chalk; with platemark, though
not engraved
239 × 167 mm.
Inscribed in chalk above center: 16, and below it: title;
to left of this in pencil, though not autograph: 59.
Watermark: H C WEND / ZOONEN
Museo del Prado, Madrid. No. 18

In *Turn about* a monk and nobleman ride piggy-back
on an abbé and a footman. Wielding pics, they take turns
in attacking the crouching figure of a peasant, whose head
and shoulders are hidden under a basketry form repre-
senting a bull. The noble wears a suit long since out of
fashion, and his cadaverous features give him the appear-
ance of already being half dead. The monk, equally
cadaverous, looks up to the nobleman while the abbé
bearing him shuts his eyes and yawns.

The *sueño* drawing "To grow after one is dead"
provides further insight into this *Capricho*. Though it
shows signs of transfer to a copper plate, it is not known
to have been etched. A noble, again wearing antiquated
dress and equally cadaverous in appearance, has grown
to giant proportions. The weight of his toppling figure
is borne by a sturdy working man with his sleeves
rolled up while, at the left, two figures, one certainly a
cleric, tug at the noble so that he will stand upright
and not fall.

Spanish intellectuals complained with justice about
the disproportionate wealth and great land holdings of
the church and the nobility, who were not required to
pay taxes. The burden of these inequities was borne by
the peasant and the working man.

López de Ayala: *Aun siendo los hombres unos carcamales se
torean los unos á los otros.*
(Even when men are on their last legs, they still play at bullfighting
and use others as bulls.)

Prado: *Asi va el mundo unos a otros se burlan y se torean el que
ayer hacia de toro hoy hace de caballero en plaza. La fortuna dirige
la fiesta y distribuye los papeles segun la inconstancia de sus
caprichos.*
(That's the way the world goes; some make fun of the others and
use them as bulls to fight; the one that played the bull yesterday,
today is the horseman fighting the bull in the square. Fortune
directs the game and distributes the roles in accordance with the
inconstancy of her whims.)

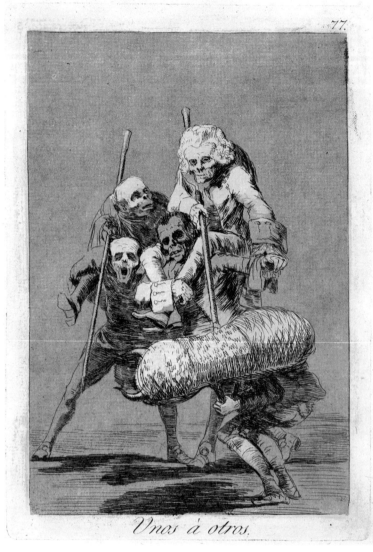

90

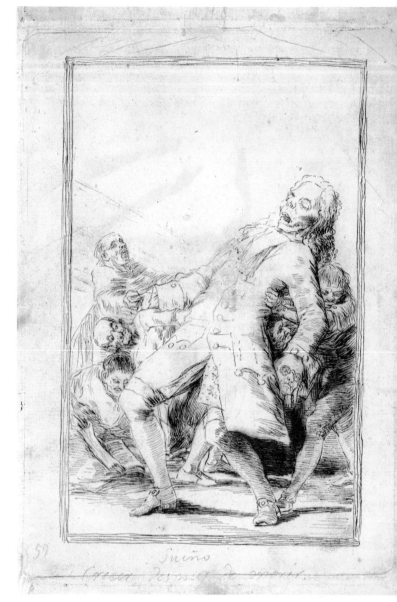

91

92

Unpublished **Capricho**
ueño. De la mentira y la ynconstancia (Dream. Of lying
nd inconstancy)
D. 118, H. 119, B. 101, Hof. 81
oo × 132 mm. (cut within platemark)

Working proof, Harris I, 2
tching and burnished aquatint
erso: Harris 120, I, 2
o visible watermark
oll.: Carderera
iblioteca Nacional, Madrid. 45637

his unique impression of an unpublished *Capricho*
as a second unique unpublished *Capricho* printed on
s verso (Harris 120). The plate is slightly larger than
hose used for the published series.

The somewhat enigmatic allegory is generally pre-
umed to refer to Goya's relationship with the Duquesa
e Alba. The weight of evidence seems to indicate that
he was, for a brief period, the painter's mistress.

The drawing for the print, a *sueño* numbered "14"
Prado No. 17, not in exhibition) was inscribed by Goya:
ueño. *De la mentira, y la ynconstancia.* It bears the
narks of transfer to the plate.

In the print the foreground is occupied by an in-
ricately related group of figures; in the distance, beyond
what may be a body of water, is a fortified castle. The
entral figure is a woman with two faces and one breast
ared, who half reclines upon a bed. Attached to her
ead are butterfly wings, an eighteenth century symbol
f inconstancy or fickleness. If she were not restrained by
he figures who surround her she would float off into the
ir, like the butterfly woman in *Capricho* 61 (not in
xhibition), who also resembles the Duquesa de Alba.
Her right arm is amorously embraced by a man who
ooks like Goya. In response, the fingers of her right
and curl around his arm. Her left hand is clasped by
wo other persons: a man who touches his nose with a
nocking gesture and a second two-faced woman who sits
n the ground. This second figure of two-facedness or
uplicity wears fashionable shoes and also has her right
reast bared. The features of the two faces are a coarsened

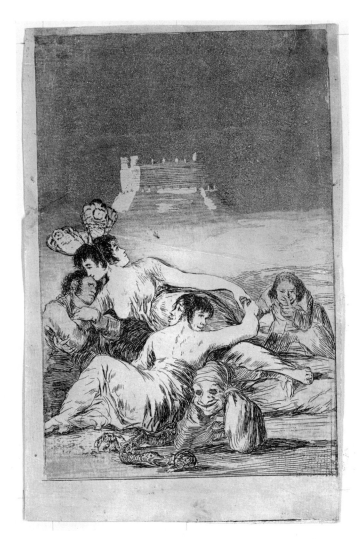

92

version of those of the figure representing the Duquesa.
In the immediate foreground we see a pair of animate
bags wearing a grinning mask, and a snake that has
hypnotized, and is about to swallow, a frog. The print is
a many-layered image of love thwarted by fickleness and
duplicity. The distant castle, dream-like and inaccessible,
will not capitulate to the lover's siege.

The relationship between Goya and the Duquesa as
represented here is too explicit to have been included
in the eighty *Caprichos* published in 1799.

The Landscapes

93

Landscape with Great Rock, Buildings, and Trees
By about 1810
D. 22, H. 23, B. 253, Hof. 243
165 × 285 mm.

Working proof. Harris I, 2
Etching and burnished aquatint
Art Institute of Chicago. The Clarence Buckingham
Collection. 1957.13

94

Landscape with Great Rock and a Waterfall
By about 1810
D. 23, H. 24, B. 254, Hof. 244
165 × 285 mm.

Working proof. Harris I, 2
Etching and burnished aquatint
Art Institute of Chicago. 1974.16

GABRIEL PERELLE. France, ca. 1603–1677
95
Landscape
Etching. 190 × 315 mm.
Museum of Fine Arts, Boston. Anonymous gift, 1891.
M7503

Between the publication of the *Caprichos* in 1799 and 1810, the only date to appear in Goya's set of war prints, the *Desastres,* he is not known to have made any etchings, with the probable exception of these two landscapes. They must have been executed by about 1810, for these two very beautiful plates were each cut in half and the versos used by Goya for four subjects from the *Desastres:* 13 (not in exhibition), 14, 15, and 30 (cat. nos. 112, 114, 137). These four prints relate in style and technique to those dated 1810. As Harris pointed out, this is but one indication that copper suitable for etching became difficult for Goya to find in Madrid during the war.[1]

Goya had great skill in suggesting aerial perspective or conveying the qualities of weather and of light in an oil painting or a print. Yet he was not at heart a landscapist; humanity was the substance of his work. There are no known painted landscapes by him, and only five landscape drawings that are certainly from his hand, two of which are preliminary studies for these prints.[2] It is for the above reasons that the very existence of these aquatints with their monumentality, great brooding rocks, and sober quiet is in itself surprising.

Goya's manner of cleanly stopping out the aquatint, producing strong passages of white in the prints, is reminiscent of the *Caprichos.* So too, is the use of burnishing on the waterfall and on the right background in one print, and on the cliff, building, clouds, and mountains in its companion. In *Caprichos* 19 (cat. no. 55) the manner of delineating a tree and the treatment of aquatint are similar. On these grounds the landscapes may be closer in date to 1799 than to 1810. Two or three working proofs of each have survived.[3]

Only two landscapes are known to have belonged to Goya. They are listed in an inventory of his household goods taken in 1812[4] and were prints by one of the Perel family who lived in France during the seventeenth century and etched or designed a great number of landscape prints. They made a similar use of atmospheric movement suggested by windblown clouds and trees. In the present example, as in Goya's prints, an isolated rock rises up from the earth.

1. Harris, vol. 1, p. 139.

2. Red chalk, Prado, nos. 190, 191.

3. The two halves of each plate were printed together by the Calcografía about 1920. These impressions are of very little artistic interest.

4. Under prints, *Dos países de Perelle.* F. J. Sánchez Cantón, "Como vivía Goya," *Archivo Español de Arte,* vol. 19, 1946, p. 106.

93

94

6 Perelle inu. et fecit De l'impression de Pierre Mariette Auec priuilege du Roy

95

The Desastres de la guerra

Goya's *Disasters of War* need to be seen against the background both of the war with France from the spring of 1808 to December of 1813, and of the postwar years until March 1820. For Spain, the war years were crowded with dramatic events that aroused passionate responses in her citizens. It was an international war, involving England and Portugal. There were also elements of internal civil strife, of ideological struggles, and of revolution.

In January and February of 1808 French troops began to occupy towns and citadels in northern Spain. In March Carlos IV abdicated in favor of his son, Fernando, and shortly afterward French cavalry and infantry were welcomed into the capital, Madrid. In April, king and ex-king were lured to Bayonne by Napoleon.

The emperor proposed his new constitution to an assembly of Spaniards convoked there on May 15, 1808, after the Spanish crown had been bartered to the Bonapartes by the Bourbons, and when French troops already dominated part of Spain. A few of its provisions were measures that enlightened Spaniards had long been urging. Some of Goya's close friends, including the playwright Moratín, became *afrancesados* and would remain on the side of the French. Yet the articles of the constitution adopted at Bayonne were cynical in intent, as was the emperor's manifest disinclination that the document should ever be much more than a piece of paper. Freedom of the press was to be granted at a future date, the state still reserving the right to censor any work deemed to be against its interest. The Inquisition was not suppressed nor were monastic foundations reduced in number. These measures appeared as decrees suddenly improvised by the emperor for public effect and signed December 4 as he waited to enter Madrid upon the city's capitulation.[1]

The constitution had been signed July 7, 1808. By that date the citizens of Spain, with no king, no central government of their own, no army at their command, had embarked with spontaneous and collective determination on a six-year struggle for their independence from France. The war was triggered by two events which Goya would later paint, the insurrection and executions at Madrid on May 2 and 3, 1808.[2] One municipality after another then denounced the invaders. The first summons to revolt was given by a village near Madrid. The province of Oviedo declared war on Napoleon and petitioned England for help. The provinces of Valencia, Andalucía, Extremadura, and Aragón rose up.

Heads of households in Madrid were required to swear allegiance to the 1808 constitution, and to a new French king on Friday, December 23, 1808, after a high mass. The terms of the constitution were not made generally available to citizens, however, until three months later.[3] The common people in general hated the French government to whom their Spanish sovereigns had surrendered the nation. They even imagined their loathing to be shared by animals. Thus we are told how starving wolves in the countryside near Madrid had left a French corpse untouched.[4]

No documentary evidence seems to have survived that would tell us what Goya felt about these events. Three factors must be kept in mind: the strength of Goya's Aragonese pride; his sympathy (manifest in the *Caprichos*) for many of the ideas of the French Enlightenment; and the essential cynicism of the Bayonne Constitution.

Zaragoza, capital of Aragón, under the leadership of Brigadier General José de Palafox, issued a defiant proclamation to the French on May 31. The city was defenseless from a military point of view; the troops consisted of 220 men, sixteen guns, and a small number of muskets; and there was virtually no money in the treasury.[5] Nevertheless, the city became one of the first rallying points in the war for independence. On June 15 the French attacked. The city was manned mostly by civilians: her own citizens, refugees coming in from the countryside, and the volunteers who had come to fight for king and country. By July 21, the armed forces had been supplemented with companies and guardsmen from

1. See Pierre Conard, *"La Constitution de Bayonne (1808),"* *Bibliothèque d'histoire moderne* (Paris, 1910), vol. 2, fasc. 4.

2. These two famous paintings, *El 2 de Mayo de 1808* and *El 3 de Mayo de 1808,* are both in the Prado (nos. 748, 749; Gassier and Wilson nos. 982, 984). They were painted in 1814 after the war.

3. *Diario de Madrid,* Dec. 23, 1808, p. 690. Conard, *Constitution,* p. 66; the constitution was published in the *Gazeta de Madrid* March 29–April 2, 1809.

4. *Gazeta de los pueblos inmédiatos á Madrid,* Madrid, 1808, news from Boadilla del Monte, Sept. 8.

5. Robert Southey, *History of the Peninsular War* (London, 1823), vol. 1, p. 398.

other parts of Spain and mounted dragoons as well as a small number of smugglers with horses at their command.[6] Zaragoza held against heavy, repeated attacks of the Napoleonic army, against relentless bombardment, and in one section of the city house-to-house fighting. On August 14 the citizens saw with surprise that the French columns were retreating across the plain.[7]

On July 20 Joseph Bonaparte entered Madrid as king. At the same moment improvised Spanish forces won a stunning victory against the French at Bailén. Ten days later Joseph was forced to flee and would not reenter the city until the following January. In the meantime Spain began to organize its own government. Victorious Spanish troops from Andalucía, Valencia, Aragón, and Castilla la Vieja, ragged, often half naked, began to enter the capital. Patriotic citizens gave generously to clothe and supply them. On October 11 among the "Donations of shirts and other goods for the army of Aragón" (*Donativos de camisas y otros efectos para el exército de Aragon*) [8] one finds "Francisco Goya 21 yards of linen" (*21 varas de lienzo*).

Goya, by then sixty-two, had already departed for Zaragoza, as we learn from a letter written on Sunday, October 2, 1808, to the Real Academia de San Fernando: "I have finished the painting of the King, our Lord, Ferdinando VII, which the Royal Academy had the good grace to commission me [to paint]. It is drying and will be hung at my request, by Don Josef Fol, as I am unable to do it because I have been called by His Excellency Don Josef Palafox to go this week to Zaragoza to see and examine the ruins of that city and to paint the glorious deeds of her citizens, from which I cannot excuse myself as I am so much interested in the glory of my native land."[9] It is to be hoped that his journey was less hazardous than that of two colleagues from the Real Academia de San Fernando, Juan Gálvez (1774–1847) and Fernando Brambila (d. 1832?), who also arrived despite difficulties and arrests on the way. Their intention was to execute a series of aquatints on the siege.[10]

In a book published two years after Goya's death we are told that he "arrived in Zaragoza during the last days of October 1808 and made, though hastily, two oil sketch of the principal ruins, depicting in one of them the boys' act of dragging French corpses along the ground throug the Calle del Coso during the attack of August 4th; since Napoleon's troops approached again in the last days of November, he could not continue the project and he left for his native village of Fuendetodos, district of Zaragoz where to avoid being compromised he covered them [the canvases] with a coat of paint he could not afterwards remove and left the work useless."[11]

6. José Valenzuela la Rosa (ed.), *Los sitios de Zaragoza, diario de Casamayor* (Zaragoza, 1908), p. 51.

7. Charles Richard Vaughan, *Narrative of the Siege of Zaragoza* (London, 1809), p. 29. The author stayed for some weeks with Palafox after the siege (pp. iii–iv). The pamphlet must have been popular, for it was in a sixth edition in 1809.

8. *Gazeta de Madrid,* Tuesday, October 11, 1808, pp. 1285–1286; Felipe Pérez y González, *(Obras completas) Un cuadro...de historia* (Madrid, 1910), p. 30. He also called attention to this gift citing the *Diario de Madrid,* in which the information appeared earlier on Oct. 4.

9. The painting had been commissioned on March 28 and the kin had granted Goya two brief sittings during the first week in April before he left for Bayonne. Letter to Don Josef Munarriz: "Tengo acabado el retrato del Rey ñtro Sọr D. Fernando 7° que la real academia de San Fernando ha tenido à bien de encargarme, el que estando seco pasará à colocar de mi orden D. Josef Fol, no pudiend hacerlo yo personalmente à causa de haberme llamado el Exmo Sọr D. Josef Palafox para que vaya esta semana à Zaragoza à ver y exáminar las ruinas de aquella ciudad con el fin de pintar las glori de aquellos naturales, à lo que no me puedo escusar por interesarm tanto en la gloria de mi patria...," Real Academia de San Fernando, archives.

10. Galvez and Brambila, "Pequeña memoria de las circunstancias que ocurrieron para egecutar la obra de las estampas del primer sit de Zaragoza": ... emprendiendo un viage sumamente arriesgado para aquella Ciudad, en donde sufrieron infinitos travajos y prisiones en su viage... Alli permanecimos hasta la salida del General... dias despues sucedio la batalla de Tudila... [Nov. 22] Academia de San Fernando, Archives, Prémios generales, 1832, 1–4

11. Agustín Alcaide Ibieca, *Historia de los dos Sitios que pusieron á Zaragoza en los años de 1808 y 1809 las tropas de Napoleón* (Madrid, 1830–31), vol. 3, p. 51.
"llegó a Zaragoza á ultimos de octubre de 1808, y formó, aunque precipitadamente, dos bocetos de las principales ruinas, figurando en uno de ellos el hecho de arrastrar los muchachos, en el choque del 4 de agosto, por la calle del Coso los cadáveres franceses; y como á últimos de noviembre se aproximaron de nuevo las tropas de Napoleon, no pudo continuar el proyecto, y partió al lugar de Fue de Todos, corregimiento de Zaragoza, pueblo de su naturaleza, en e que, para evitar un compromiso, los cubrió con un baño que despues no pudo quitar, y quedo inutilizado aquel trabajo."

Zaragoza fell on February 21 after being bombarded ceaselessly for forty-two days; once more her citizens had defended the city, house by house and even floor by floor; moreover, they had been wracked by an epidemic of typhus. When the French entered the city thousands of corpses, many of them naked, lay rotting in the streets.[12]

From Lady Holland, an English visitor to Spain, we learn more of Goya's activity in Zaragoza. In commenting on the cruel treatment of Palafox, who was very ill when captured, she writes: "In his room there were several drawings done by the celebrated Goya, who had gone from Madrid on purpose to see the ruins of Saragossa; these drawings and one of the famous heroine [Agustina Aragón] . . . , also by Goya, the French officers cut and destroyed with their sabres."[13] These may have been drawings, but it is equally probable that the word she actually heard was "sketches." It is more likely that the room contained oil studies, the medium Goya customarily used when preparing a painting. Canvases have all too often been destroyed with sabres, but there are easier and more effective ways to dispose of paper.

Goya was back in Madrid by May 5, 1809, as we learn from another letter to the Real Academia de San Fernando concerning the portrait of Fernando VII:

"During my absence from this Court, I received your letter dated November 8th, in which I was informed of the Academy's decision regarding myself, about the painting that I executed on your orders, a labor which I enjoyed very much.

"Now at my return I find to my surprise, I do not mind stating, that the Junta has not yet arrived at any decision regarding my painting.

"The pressing need I have compelled me to inquire from the warden the cause for such an incredible delay."[14] Save for one abortive attempt Goya is not known to have left Madrid until after the war ended in 1814.

When Napoleon himself entered Spain on November 4 he thought that the nation with its ill-trained troops would fall in two months. He left in January believing that his generals would soon win the war. But the Spanish people's love of freedom and country, and their belief in church and king, gave them a strength and determination that outweighed the professionalism of Napoleon's armies. Any Spaniard could fight, and people of all classes did so, each in his own way: women provided support, tended the wounded, and at times also fought; children carried supplies; priests and monks were also active participants. Cities fortified themselves and resisted. Bands of guerrillas—the modern usage of this word emerged during this war—descended from the hills to raid supply convoys, to blow up ammunitions, to snipe at stragglers. They formed the backbone of the popular resistance.

Not only were the French troops confounded by this unknown type of warfare, but their officers could not readily accept Joseph Bonaparte's leadership. There was no quick victory, and the war dragged on for nearly six years, ending in defeat for the French. In 1808 England entered the war to fight on Spain's side. Wellington, who fought in the decisive battle of Arapiles in 1812, was a major force in Spain's ultimate victory.

When most of Spain was dominated by French troops, the deputies to the Spanish *Cortes* (legislative assembly) withdrew to Cádiz, and on March 19, 1812, they defiantly promulgated their own constitution. It was as idealistic as Napoleon's had been cynical. Two divisive issues, the suppression of the Inquisition and a reduction in the number of monastic foundations, were enacted in the following year. There can be no doubt of Goya's passionate belief in what was accomplished at Cádiz. Yet though he dealt with the subject at length in a Journal-Album of drawings, it is rightly omitted from the *Desastres,* which treat the effects of war and its terrible aftermath.[15]

12. On the second siege see Gabriel H. Lovett, *Napoleon and the Birth of Modern Spain* (New York), 1965, vol. 1, pp. 263–281.

13. Lady Holland's informant was General Doyle. *The Spanish Journal of Elizabeth Lady Holland* (London, 1910), Earl of Ilchester (ed.), pp. 324–325.

14. Letter to Don Josef Munarriz: "Durante mi ausencia de esta corte recivi el oficio de VS. fecha 8 de Noviembre, por el qual se me

abisaba la determinacion de la Academia respecto à mi, por el quadro q.ᵉ de su orden havia executado y de la que quedé sumamte gustoso; pero no puedo menos de decirlo, quedé sorprendido de ver à mi llegada que aun no havia tenido efecto la determinacion de la Junta. La precision me ōbligō à preguntar al conserge la causa de tan notable demora . . . ," Real Academia de San Fernando, archives.

15. See the last third of his Journal-Album C, reprod. Pierre

During the occupation 1808–1814, some Spanish intellectuals welcomed the French as liberators and bringers of enlightenment, who would free Spain as they had freed themselves by means of the French Revolution. Throughout the war Joseph Bonaparte had support from them and from other sympathizers. These Spaniards were as suspect as any Frenchman, and many of them were accused of treason or collaboration and killed by their countrymen. Goya was commissioned to paint an allegorical portrait of Joseph Bonaparte[16] and was also decorated by him. The artist lived in material comfort while much of Madrid was hungry,[17] but in the *Desastres* his sympathies come out strongly on the side of the Spanish people. Some of these prints allude to the tragedy of a divided Spain.

Nowhere are the complicated dramatis personae, the fierce intensity, the cruel nature, and the bloody texture of the war's confrontations more vividly portrayed than in the series of aquatints to which Goya gave the title "Fatales consequencias de la sangrienta guerra en España con Buonaparte. Y otros caprichos enfaticos . . ." (Fatal consequences of Spain's bloody war with Buonaparte. And other striking caprichos . . .). As Lafuente noted, the individual titles constitute a laconic and violent monologue. They are always short; they have a deeply impressive bitterness, are cynical, pathetic, sometimes enigmatic, but always to the point.[18] The set was published posthumously under the title by which it has become commonly known: *Los Desastres de la Guerra* (The Disasters of War).

We can only speculate as to when he began making drawings for the series—during the slow journey back to Madrid in the winter of 1808–09 or after he reached the city in the spring. The only date that appears on a print is 1810. Many of the drawings for the prints portray the terrible year of the famine in Madrid, 1811–12, when 20,000 Spaniards perished in the city. News of atrocities committed elsewhere traveled by word of mouth. On the verso of an impression of a print representing one of these atrocities Goya documented the locale, Chinchón, a town some twenty miles south of Madrid (cat. nos. 141–142), where his youngest brother, Camillo, was a priest.

But specific references are alien to the *Desastres* on the whole, for in the prints Goya generalized settings and costumes that were more localized in the drawings, thereby making the scenes pertinent to all Spain rather than to only Zaragoza, Chinchón, or Madrid. With very few exceptions the quotations we have selected to accompany the entries do not identify the site of an incident. They have been selected to exemplify the nature of the war and the events that took place in many parts of Spain. It was never the broad historical canvas that interested Goya, but the individual humans who were a part of it. We see their bravery, their resignation to death by hunger, their cruelty, and the slow dehumanization of men and women living through a war.

It was probably in the few months of optimism early in 1814 when Spain, with her own liberal constitution, was once again free, and before Fernando VII's absolutist intentions were known, that Goya believed it would be safe to publish the *Desastres* and numbered the plates that then existed. These fifty-six plates are numbered in the lower left corner. In 1808–09 in Madrid, Galvez and Brambila continued working on their aquatints on the siege of Zaragoza, but they reported that, when the French learned what they were doing, they were forced to flee.[19] On May 11, 1814, Fernando declared that the war was to be forgotten, the constitution of 1812 nullified, and it was as if the years 1808 to 1814 had never existed. All evidence of the words Constitution and

Gassier, *Francisco Goya, Drawings, the Complete Albums* (New York, 1973).

16. Inserted into the painting *Alegoría de la Villa de Madrid* (Gassier and Wilson 874), the portrait was painted over several times depending on whether the Spanish or the French held Madrid.

17. The 1812 inventory of Goya's house showed him to be well off in worldly goods; F. J. Sánchez Cantón, *"Como vivía Goya,"* *Archivo Español de Arte,* vol. 19, 1946, pp. 73–109.

18. E. Lafuente Ferrari, *Los desastres de la guerra de Goya y sus dibujos preparatorios* (Barcelona, 1952), pp. 76–80.

19. Gálvez and Brambila, *Pequeña memoria:* "á pesar de haber dominado Napoleon a la Capital seguimos nuestros travajos, . . . Luego que supo el govierno Frances nuestro proyecto trataron de perseguímos obligandanos á ocultarnos hasta tener ocasion de poder salir al punto de Sevilla."

National were removed from public view.[20] The *Desastres* could not possibly be published.

The fifty-six subjects that were included in the earlier arrangement of the set are all scenes of war and famine. Since the numbering of these plates ranges from two to sixty-four, eight prints may have been rejected. All three of the prints dated 1810 appeared in this first grouping of the series.

In dating the preliminary drawings, all in the Prado, for the eighty-two plates of the *Desastres*, one must not rely unduly on their watermarks. Yet, because the drawings appear to have been made over a period of time, it is not surprising to find that there is an observable sequence to the kinds of paper Goya had on hand and used. This sequence is related to obvious changes in the style of the prints.

Spanish artists liked imported Netherlandish paper. Goya used it for drawings for two prints dated 1810 (*Desastres* 20, 27) as well as for drawings for a group of prints related to these in technique (*Desastres* 15, 18, 19, 24, 25, 30, 41, 44, and the unique proof). The characteristic firm names for these papers are D. & C. Blauw and Kool. But by 1810 it may have been too difficult or prohibitively expensive to buy Netherlandish paper. The preliminary study for the third print dated 1810 is on Spanish paper with the firm name Joseph de Roda. Other watermarks with firm names which appear on drawings executed around 1810 are the sword of A. F. Capellades, the Capellades Maltese cross, and the Alva chalice.

Only one slight sketch for an atrocity subject is preserved, the drawing for *Desastres* 38 (see cat. no. 143). The watermark is "Joseph de Roda." It is, however, on the verso of a drawing for *Desastres* 43 (cat. no. 147).

The Madrid famine occurred from 1811 to 1812. The plates depicting this period have a much freer application of aquatint which is often quite heavy and dark (*Desastres* 48–61 and 63–64). Harris, who examined the original copper plates, noted that as the war progressed Goya was obliged to use defective plates and in some cases seems to have reused old plates after scraping and burnishing them. He suggests that this may account for

the manner of handling the aquatint.[21] For the drawings Goya used only one kind of paper, which frequently has part of the figure of a griffin as its watermark.

With one exception, the drawings for the *caprichos enfáticos* (striking caprichos) 65–82, are executed on two rather thin, soft Spanish papers, with either the watermark Olva or a coronet.[22] The same watermarks appear on the sheets used for the preparatory drawings for *Desastres* 1, 8, 29, 40, 45, and 62. The etching style of these plates is closely related to the *caprichos enfáticos* of 1820–23. Furthermore, not one of these plates was numbered by Goya according to the earlier system. Some of the subjects are allegorical (1, 40, 62), or satirical (42), while others treat wartime subjects, but in a style closer to the etchings of 1820–23 (8, 28, 29, and 45).

After March 1820, when Fernando swore a second time to the constitution of Cádiz, and a more liberal atmosphere appeared conducive to publication, Goya executed the *caprichos enfáticos*, commenting on the restrictive years since 1814 under Fernando. It was probably then that he rearranged and renumbered the entire series of eighty-two prints. At this time he inserted some new prints among the earlier wartime and famine subjects, namely 1, 8, 28, 29, 40, 42, 45, and 62. During the three years of constitutional monarchy Goya apparently never had the courage to publish the set.

After the artist's death, the copper plates were stored in Madrid by his son, Javier, who died in 1854. Not until 1863 were they published by the Real Academia de nobles artes de San Fernando, which had purchased all but the final two plates the previous year.[23]

The *Desastres* are known in contemporary impressions only in working proof states, those pulled by or for Goya as he worked on the plates. There are more states than for any other series, perhaps because the media (etching, drypoint, engraving, aquatint, and lavis) are used with such precision and subtlety. There are 493 known work-

20. Gabriel H. Lovett, *Napoleon and the Birth of Modern Spain* (New York, 1965), vol. 2, pp. 829–832.

21. Harris, vol. 1, p. 139.

22. 69, *Nada's* unusual, heavy wash drawing, which is unlike any other for the series, is on a Netherlandish paper. The print may have been executed in 1814, when Goya realized the futility of publishing the series.

23. Harris, vol. 1, p. 141.

ing proofs, mostly of the wartime subjects. Only two complete sets of these proofs exist. One is the mock-up set that Goya submitted to his friend Juan Agustín Ceán Bermúdez, so that, as Carderera noted at the bottom of the carefully lettered title page, his friend might "correct the titles" (*corriguese los epigrafes*). This was done by writing over those of Goya in pencil.[24] The other set is privately owned in England. The majority of the remaining working proofs are now to be found in seven collections, Boston's being the richest.[25] In this exhibition a very large number of the working proofs are included because one can neither fully appreciate the beauty of these prints nor understand their full meaning unless they are seen in proof form.

Boston is also fortunate in owning one of the six known sets of posthumous proofs made for the Real Academia de San Fernando in 1862–63 to ascertain the condition of the plates. These proofs show the plates as Goya left them; they have Goya's consecutive numbers, but they are still untitled. Before printing the edition it was found necessary to burnish some of the plates in order to clean off scratches or marks of corrosion and to add additional aquatint to mask defects. When aquatint extended to the plate edges, it was sometimes necessary to burnish it from the lower margin in order to make room for the engraved titles, and this was usually done for the other three sides as well, reducing the field of the original design. Borderlines, and occasionally new work to the image, were added (for examples of these posthumous changes see cat nos. 101, 134, 144, and 157).

When the Academia published the first edition of Goya's *Desastres* in 1863, all of the plates were printed with a great deal of ink left on the surface, so that nowhere does the white paper show. This certainly was not Goya's intention, for not only were his working proofs clean wiped, but many of the plates had an extremely pale etched tone of lavis that required the white of the paper in order to be effective. The museum's copy of the first edition appears to be one of twelve special sets printed on heavy, fine quality wove paper that was intended for presentation to the royal family and ministers.[26] It was printed before various mistakes in the titles were corrected.

24. There were to have been, we learn from this title page, "85 estampas," eighty-five prints, but the additional plates were not available to the Real Academia de San Fernando when they published their edition in 1863. Two clearly belong to the *caprichos enfáticos, Fiero monstruo* (Bloodthirsty monster) no. 81 (not in exhibition), in which a bloated animal spews corpses from its mouth, and no. 82, *This is the true way*. The three remaining prints pasted onto the end papers of the volume are very small prints attacking torture of prisoners (see cat. nos. 160, 161).

25. On other collections see Harris, vol. 1, pp. 147–149.

26. Harris, vol. 2, p. 174.

96
Desastres 3 (48)*
Lo Mismo (The Same)
D. 122, H. 123, B. 105, Hof. 147
160 × 220 mm.

Working proof, Harris I, 3
Etching, lavis, drypoint, burin, and burnishing
No watermark
Coll.: Infante Don Sebastian; Provôt; Hofer
Museum of Fine Arts, Boston. Gift of Russell B. Stearns.
1973.720

* The number in parentheses is the earlier number that appears
in the lower left of the plate.

As is so often the case in this series, the title is related to
a preceding print, *Con razon ó sin ella* (With or without
cause). This print expresses the patriotic intensity of the
Spanish cities and provinces who, with neither Spanish
army nor national government, rose up one by one against
the French invaders in the summer of 1808. "The indig-
nation and hatred of the Spaniards, which had so long
been repressed, now broke forth. As fast as the alarm
spread, every man of the lower ranks who could arm
himself with any kind of weapon, ran to attack the
French."[1] "Fowling-pieces were put in requisition, pikes
were forged . . . The Zaragozans were ready to endure
any suffering and make any sacrifice in the discharge of
their duty . . . One cry was heard from the people . . .
that, if powder failed, they were ready to attack the enemy
with their knives, formidable weapons in the hands
of desperate men."[2]
 Although the subject matter is appropriate to the
beginning of Goya's series, this may not have been one of
the very first plates to have been etched. The style is some-
what broader and the figures larger than in the prints
dated 1810 (cat. nos. 126, 127, 130). Lavis, a pale tone
created by direct application of acid to the copper plate,
can be seen in the background and foreground. The
figures remain white, for the lavis follows their outlines

1. Robert Southey, *History of the Peninsular War* (London, 1823),
vol. 1, p. 246.

2. Ibid., pp. 398, 418.

precisely; see for example the upraised hand of the
central French soldier. The face and throat of the peasant
with the upraised axe were darkened by a different
means—a film of ink left on the plate surface when this
particular impression was printed. This crude wiping
and hasty printing underscores the brutality of the action.

97
Desastres 5 (28)
Y son fieras (And they are like wild beasts)
D. 124, H. 125, B. 107, Hof. 149
155 × 210 mm.

Working proof, Harris I, 2
Etching, aquatint, drypoint, and burnishing
No watermark
Coll.: Carderera; Stirling-Maxwell
Museum of Fine Arts, Boston. 1951 Purchase Fund.
51.1625

This print is one of several depicting brave Spanish
women, and the title is related to that of the print that
precedes it in the series, *Las mugeres dan valor* (The
women give courage). Whether fighting beside them or
in supportive roles, Spanish women encouraged the men
in their fight for independence. In Zaragoza, "The
women were eminently conspicuous in their exertions,
regardless of the shot and shells which fell about them,
and braving the flames of the building . . . When circum-
stances, forcing them out of the sphere of their ordinary
nature, compel them to exercise manly virtues, they
display them in the highest degree, and when they are
once awakened to a sense of patriotism, they carry the
principle to its most heroic pitch. The loss of women
and boys, during this siege, was very great, fully propor-
tionate to that of men; they were always the most forward,
and the difficulty was to teach them a prudent and proper
sense of their danger."[1] "During the [second] siege six
hundred women and children perished, not by the
bombardment and the mines, but in action, by the sword,
or bayonet or bullet."[2] Here the women fight with rock,

1. Southey, vol. 1, pp. 411–412.

2. Ibid., vol. 2, p. 150.

96

97

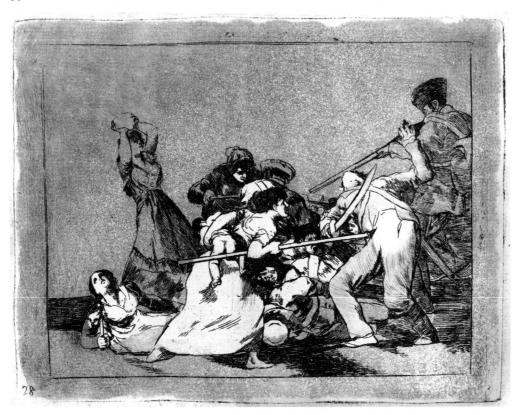

knife, and sword, while one, baby under her arm, effectively wields a pike.

The print differs from *Desastres* 3 in its use of tone. Here a moderately dark aquatint was freely applied to suggest shadows. Its gradation from a fine grain at the upper left to a coarse one at the lower right may have been achieved by controlling the application of the powdered resin so that the heavier grains settled on one corner of the plate. Drypoint was used to shade the trousers of the wounded soldier, and the aquatint on his jacket as well as that on the skirt of the recumbent woman at the left has been partially burnished. In this working proof there is a strong sense of violent action, achieved by the dramatic spotlighting of the foremost figures. In the finished state the aquatint on the figures would be burnished further, making the contrasts of dark and light less pronounced, but giving greater cohesion to the scene.

98–101

Desastres 7 (41)
Que valor! (What courage!)
D. 126, H. 127, B. 109, Hof. 151
155 × 210 mm.

JUAN GALVEZ (1774–1847) and
FERNANDO BRAMBILA (died 1832?)

98

Bateria del Portillo
Aquatint from *Ruinas de Zaragoza,* published in Cádiz, 1812
Rijksmuseum, Amsterdam

99

Working proof, Harris I, 2
Etching, drypoint, and burnishing
Watermark: SERRA
Coll.: Carderera; Stirling-Maxwell
Museum of Fine Arts, Boston. 1951 Purchase Fund.
51.1627

100

Posthumous proof, for the Academia, 1862–63.
Harris II
Etching, drypoint, burnishing, and burin
Coll.: Stirling-Maxwell; Hofer
Museum of Fine Arts, Boston. Gift of Mrs. Russell Baker and Bequest of William P. Babcock, by exchange.
1973.732 (7)

101

First (posthumous) edition, Madrid, Academia de San Fernando, 1863
Harris III, 1, a, special set
No watermark
Etching, drypoint, burnishing, burin, and aquatint
Museum of Fine Arts, Boston. Harvey D. Parker Collection (1911 Purchase). M21914 7/80

This is the only print in the *Desastres* that depicts a person who can be positively identified. She is Agustina Aragón, the heroine of the first siege of Zaragoza, which lasted from mid-June 1808, when the French attacked, until August 14, when they retreated.

"The sand-bag battery before the gate of the Portillo, was gallantly defended by the Aragonese . . . It was here, [in the first days of July] that an act of heroism was performed by a female, to which history scarcely affords a parallel. Augustina Zaragoza, about 22 years of age, a handsome woman, of the lower class of the people, whilst performing her duty of carrying refreshments to the gates, arrived at the battery of the Portillo, at the very moment when the French fire had absolutely destroyed every person that was stationed in it. The citizens, and soldiers, for the moment hesitated to re-man the guns; Augustina rushed forward over the wounded, and slain, snatched a match from the hand of a dead artilleryman, and fired off a 26-pounder, then jumping upon the gun, made a solemn vow never to quit it alive during the siege, and having stimulated her fellow-citizens by this daring intrepidity to fresh exertions, they instantly rushed into the battery, and again opened a tremendous fire upon the enemy. When the writer of these pages saw this heroine at Zaragoza, she had a small shield of honour embroidered

Ruinas de Zaragoza.

BATERIA DEL PORTILLO.

Donde, al ver á sus defensores caer muertos ó heridos sin quedar quien sirviese la artilleria, la intrepida
Agustina Aragon saltando por encima de los cádaveres arrebató la mecha de manos de un artillero que acababa
de espirar; y haciendo fuego con gallarda bizarria atajó el impetu furioso de los enemigos en el ataque del 4. de Julio.

98

upon the sleeve of her gown, with 'Zaragoza,' inscribed upon it, and was receiving a pension from the government and the daily pay of an artilleryman."[1]

Goya himself met her in Zaragoza. He had been invited there by General Palafox in October 1808 to paint the heroic events. The design of Goya's print of Agustina is derived from another aquatint by two artists who were in Zaragoza at the same time. Both were from Madrid and were teaching at the Academia de San Fernando, Juan Gálvez, painting, and Fernando Brambila, perspective. They risked their lives to get to Zaragoza and make drawings of the ruins and the heroes of the siege. They were not able to print their aquatints until 1812 in Cádiz, at that moment the only part of Spain not dominated by the French.[2] *Ruinas de Zaragoza* consists of twenty-three views of the ravaged city and twelve portraits of citizens who distinguished themselves.[3] The set is admirably executed in etched outlines and a variety of aquatint tones and in technique resembles Goya's *Caprichos*. Gálvez, who was an expert aquatinter by 1798, was probably responsible for this part of the project. The subjects of the heroic portraits are for the most part posed with a weapon held triumphantly. The views of Zaragoza are

equally monumental and convey the terrible events no better than commemorative tableaux. In contrast, Goya's anonymous but vital men and women, glimpsed in the midst of war, have the capacity to provoke a passionate response.

Goya's preparatory drawing for the print (Prado 455, not in exhibition) has a close relationship to Gálvez and Brambila's aquatint and even more to its preparatory drawing (now in Zaragoza). He changed the position of Agustina's head and her upraised arm.

In the working proof, Goya eliminated all but the

1. Charles Richard Vaughan, *Narrative of the Siege of Zaragoza* (London, 1809), pp. 15–16. The author was in Zaragoza in the summer of 1808; his preface is dated January 25, 1809.

2. "En aquel punto [Sevilla] nada pudimos hacer porque en aquella ocasion no había prensas para poder estampar nuestros gravados. Luego que el govierno se trasladó a la Ciudad de Cadiz, bolvimos á emprender nuestras Tareas, hasta su conclusion." Gálvez and Brambila, "Pequeña memoría de las circunstancias que ocurrieron para egecutar la obra de las estampas del primer sitio de Zaragoza," Academia de San Fernando, Archives, Prémios generales, 1832, 1–42.

3. Don Agustín Alcaide Ibieca, *Historia de los dos Sitios que pusieron á Zaragoza* (Madrid, 1830), vol. 3, p. 53.

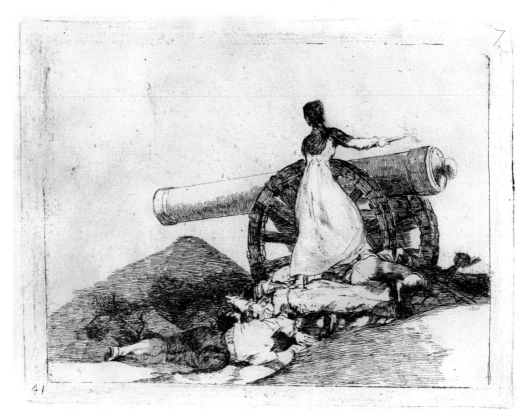

99

necessary elements of the event, retaining, however, the
tent's triangular shape as a compositional element. He
further dramatized Agustina's extraordinary act by
increasing the number of fallen bodies upon which she
stands. He attempted to remove the foul biting on her
skirt by burnishing and added a few drypoint strokes.

In the posthumous proof printed for the Academia de
San Fernando in 1862–63 it can be seen that Goya had
added drypoint to Agustina's dress as well as burin
strokes that enlarged her head and shoulders to correct
their proportions, and had completed the right wheel of
the cannon to make it more massive. The pitting in the
background caused by the passage of time and lack of
care is now also visible.

The first edition of the *Desastres* appeared in 1863
with the titles engraved on the plates. Applying the
aesthetic standards of the time, the Academia found it
necessary to make other changes they believed would en-
hance the appearance of the prints and make them look
more professional. Agustina's skirt therefore received
further burnishing, and more drypoint strokes were
added to it. Furthermore, the Academia added aquatint
to this plate, probably to mask the pitting. In so doing
they altered the tonal balance of Goya's original design.

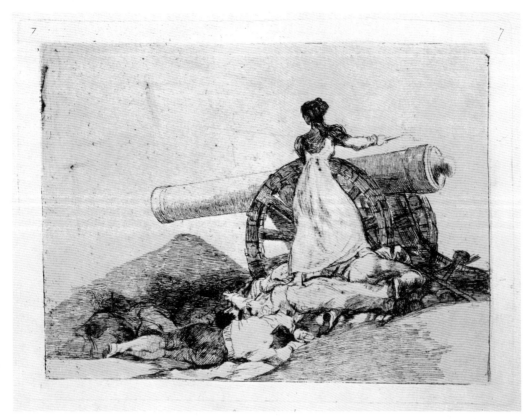

100

101

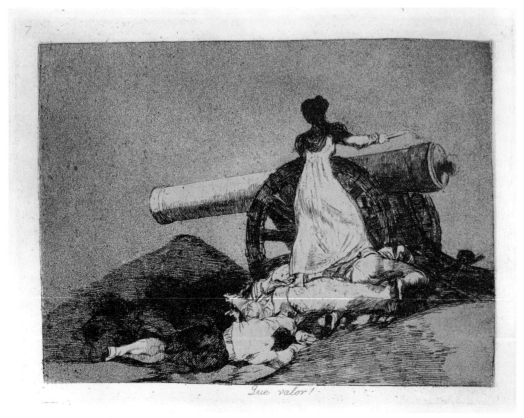

Que valor!

102–103

Desastres 8
Siempre sucede (It always happens)
D. 127, H. 128, B. 110, Hof. 152
175 × 220 mm.

102
Working proof, Harris I, 1
Etching and drypoint
No watermark
Coll.: Carderera; Stirling-Maxwell
Museum of Fine Arts, Boston. 1951 Purchase Fund.
51.1628

JACQUES GAMELIN. France, 1738–1803
103
Nouveau recueil d' ostéologie et de myologie . . .
(Toulouse, 1779)
Scene of horses in battle. Etching.
Anonymous loan

In this print it is difficult to be certain whether the cavalry is wearing French or Spanish uniforms. At the battle of Medellín in March 1809, "the whole of the Spanish cavalry on the left took panic, and without facing the foe, without attempting to make the slightest stand, fled in the greatest disorder from the field . . . Instances of such scandalous panic were but too frequent in the Spanish armies during the war."[1] Indeed, the Spanish dragoons made a poor showing on June 15, 1808, during the first siege of Zaragoza.[2]

In at least two prints, this and *The Giant* (cat. no. 230) there seems to be a possible dependence on an earlier French volume illustrated by Gamelin.[3] The book is an anatomical study of the skeleton and muscles of both men and animals. Like Gamelin's print, Goya's preparatory drawing for his etching (Prado 118, not in exhibition) shows distant figures at the right. Besides the similarity of composition, the two prints share a sense of the confusion and dust of battle, and a fluidity of design.

Goya's working proof was rather heavily inked and not clean wiped, therefore the etched lines appear broader and darker than in the posthumous Academia proofs, where the delicacy of the etching is closer to Gamelin's. The proof is essentially complete; only a few drypoint strokes were to be added in the background.

The etching style is comparable to that of the last group of prints executed for the *Desastres*, the *caprichos enfáticos* (see for example 78, cat. no. 239). No print in that group was given an earlier number, nor was this one. Moreover, its preparatory drawing is on paper with the watermark Olva, which is to be seen on many of the sheets of studies for these late subjects. This print may have been executed as late as 1820 but, because of its subject matter, inserted among the earlier group of prints on the war.

1. Southey, vol. 2, p. 228.

2. *Los sitios de Zaragoza, diario de Casamayor*, ed. José Valenzuela la Rosa (Zaragoza, 1908), p. 41.

3. Paul Lafond was the first to call attention to this work of Gamelin in connection with Goya's prints (*Goya*, Paris, 1902, p. 87). Gamelin himself later became an eyewitness to war when he joined the French army of the East Pyrenees in 1793. From this experience came a series of painted battle scenes considered among his best work. Thieme-Becker, *Allgemeines Lexikon der Bildenden Künstler*, vol. 31 (Leipzig, 1920), pp. 144–145, article by H. Vollmer.

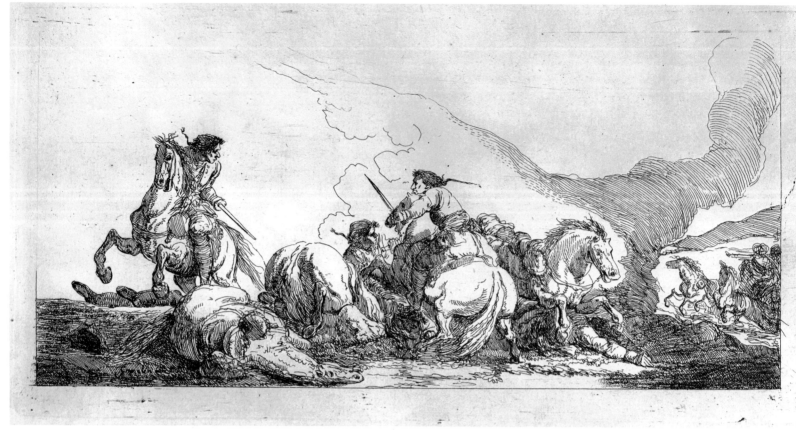

103

102

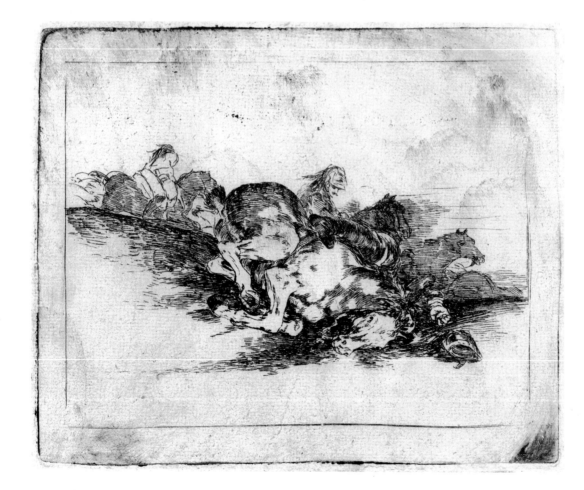

104–105

Desastres 9 (29)

No quieren (They don't want to)

D. 128, H. 129, B. 111, Hof. 153

155 × 210 mm.

104

Working proof, Harris I, 2

Etching and aquatint, touched with black chalk

Bibliothèque Nationale, Paris

105

Working proof, Harris I, 3

Etching, aquatint, burnishing, and burin

Watermark: SERRA

Coll.: Carderera; Stirling-Maxwell

Museum of Fine Arts, Boston. 1951 Purchase Fund.

51.1629

In early 1809 Spanish troops were quartered in Tarancon and neighboring villages south of the Tagus River. In one of these villages, Uclés, in January 1809, the following events took place.

"Never indeed did any men heap upon themselves more guilt and infamy than those by whom this easy conquest was obtained [i.e., the French]. The inhabitants of Uclés had taken no part in the action . . . Plunder was the first object of the French, and in order to make the townspeople discover where their valuables were secreted, they tortured them . . . They then in mere wantonness murdered above threescore persons . . . Several women were among these sufferers, and they might be regarded as happy in being thus delivered from the worse horrors that ensued: for the French laid hands on the surviving women of the place, amounting to some three hundred . . . they tore the nun from the altar, the wife from her husband's corpse, the virgin from her mother's arms, and they abused these victims of the foulest brutality, till many of them expired on the spot . . . These unutterable things were committed in open day, and the officers made not the slightest attempt at restraining the wretches under their command; they were employed in securing the best part of the plunder for themselves. The Spanish government published the details of this wickedness, in order that if the criminals escaped earthly punishment, they might not escape perpetual infamy."[1]

The large-scale figures in this brutal scene, drawing style, and use of aquatint, all of which have much in common with the other scenes of French atrocities (cat. nos. 138, 140, 143), suggest that it was probably executed later than the group made around 1810.

The early Paris working proof is touched with black chalk to shade the medallion of the soldier's hat, his fingers, the space between his head and that of the young woman, and the right side of her skirt. These changes were effected in a final working proof (not in exhibition). The result is to separate more clearly the woman from her attacker.

The Boston proof represents a stage in these alterations. It shows the addition of some burin lines across the medallion. Moreover, the aquatint has been burnished away from the plate margins, which diminishes the field and concentrates attention on the action portrayed.

1. Southey, vol. 2, pp. 66 f., and reference to reporting in the *Gazeta del Gobierno,* April 24, 1809.

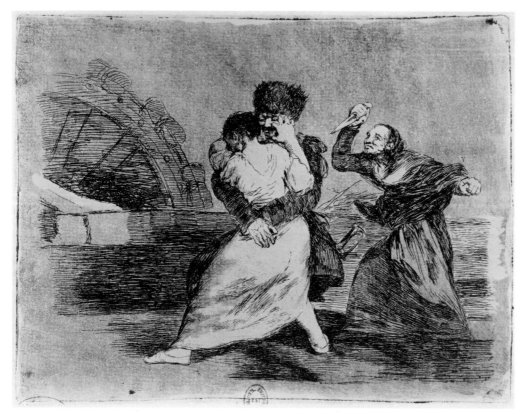

104

105

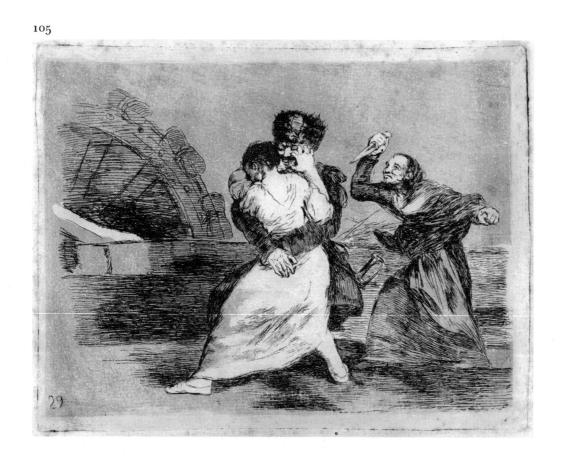

106–107
Desastres 10 (19)
Tampoco (Nor these)
D. 129, H. 130, B. 112, Hof. 154
150 × 215 mm.
Lower right in the plate, in reverse: *Goya*

106
Related drawing
Red chalk, pen and sepia, brush and brown wash
160 × 224 mm.
Museo del Prado, Madrid. 168

107
Working proof, Harris I, 2
Etching and burin
No watermark
Colls.: Carderera; Stirling-Maxwell
Museum of Fine Arts, Boston. 1951 Purchase Fund.
51.1630

The title, *Nor these,* refers back to the preceding plate, *They don't want to.*

 This is one of five *Desastres* drawings executed primarily in pen, brush, and brown ink. Etchings close to three of these drawings, although in reverse, are numbers 11, 15, and 30 (cat. nos. 108, 114, 137). The composition of this drawing, like a fifth (Prado 166, not in exhibition) does not appear in printed form. While Harris rightly relates the general design to *Desastres* 21 (not in exhibition), the violent content is more closely akin to *Desastres* 10. No other drawings for either plate are known. Possibly this drawing was a preliminary source for both prints. Two men, apparently a Spaniard and a French soldier, struggle at the left, while the body of a woman lies at the right. In the foreground is a fallen Spaniard with striped sash.

 In the etching, women are attacked by three French soldiers, while the body of a Spaniard lies at the left. The plate was overbitten, and many areas, such as the heads, intended to be dark, print gray. Some burin lines have been added to correct these faults.

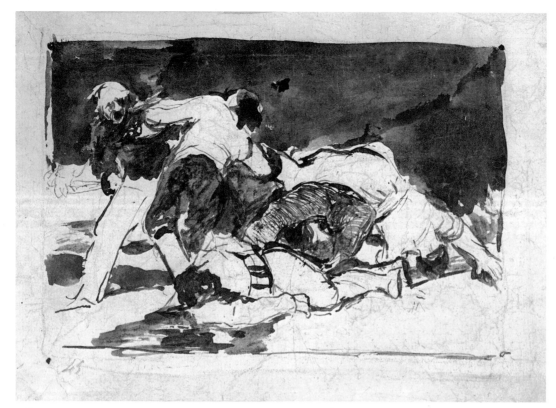

106

107

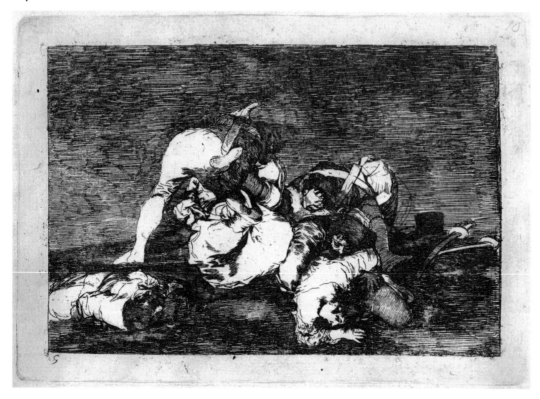

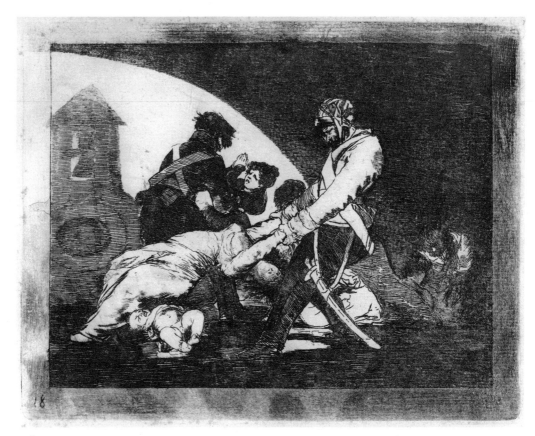

108

108

Desastres 11 (18)
Ni por esas (Neither do these)
D. 130, H. 131, B. 113, Hof. 155
160 × 210 mm.
Lower left in the plate: *Goya*
Working proof, Harris I, 3
Etching, drypoint, burin, and lavis
No watermark
Coll.: Carderera; Stirling-Maxwell
Museum of Fine Arts, Boston. 1951 Purchase Fund.
51.1631

This title also refers back to *Desastres* 9, *They don't want to.*

The copper plate was pitted from the beginning, and the reason for its use by Goya was probably a wartime shortage of copper. It was first etched, and then a few drypoint or burin touches were added to the white skirt of the woman at the left and to the seat of the trousers of the soldier behind her.

In this third working proof the lavis that was added in the second state is clearly visible. It was applied to the background arch, the foreground, and the tower, and it extends to the plate edges. Relatively uneven in tone and darker at the edges, it was applied freely, probably with a brush or feather, in comparison to the carefully controlled areas of lavis in *Desastres* 16 (cat. no. 116). The figures are left white. As in *Desastres* 10 (cat. no. 107) the etched lines were laid too closely together, and much of the background was overbitten. To some extent the lavis corrects this faulty biting. Yet these technical defects are insignificant compared to the emotional power of Goya's image.

109–110

Desastres 12 (24)

Para eso habeis nacido (This is what you were born for)

D. 131, H. 132, B. 114, Hof. 156

160 × 235 mm.

At left, in the plate: *Goya*

109

Working proof, Harris I, 2

Etching, drypoint, and burin

Metropolitan Museum of Art, New York. Harris
Brisbane Dick Fund, 1932.

110

Working proof, Harris I, 3

Etching, drypoint, burin, and lavis

No watermark

Coll.: Carderera; Stirling-Maxwell

Museum of Fine Arts, Boston. 1951 Purchase Fund.
51.1633

During January 1809 typhus fever struck many of the people crowded into the besieged town of Zaragoza and grew to epidemic proportions. "The season proved . . . mild enough to increase the progress of the disease . . . The average of daily deaths from this cause was at this time not less than three hundred and fifty . . . neither medicines nor necessary food were to be procured, nor needful attendance, for the ministers of charity themselves became victims of the disease . . . There was now no respite neither by day nor night for this devoted city; even the natural order of light and darkness was destroyed in Zaragoza: by day it was involved in a red sulphureous atmosphere of smoke and dust, which hid the face of heaven; by night the fire of cannon and mortars, and the flames of burning houses, kept it in a state of horrible illumination."[1]

This plate seems to be among the earliest executed for the *Desastres*. A few of them are dated 1810, and they can be characterized by a delicacy of etching and lavis (see cat. no. 116). In the first working proof (not in exhibition) several successive bitings were discernible and a few drypoint lines were added to shade the inside of the hat at right.

In this second working proof, the plate was further etched, shading the left and right foreground, and the burin was used for additional touches on the man vomiting. The signature was also engraved.

In the third working proof lavis was added to the sky and foreground. It was carefully controlled and stops precisely at the contours of the figures. The effect of this tone is to create a hazy atmosphere and to define more clearly the volume and placement of the figures. Their reality is thus increased, and our emotional response to the scene is heightened. For all its horror, the subject is rendered with great sensitivity to draughtsmanship, modeling, and light.

1. Southey, vol. 2, pp. 130–132.

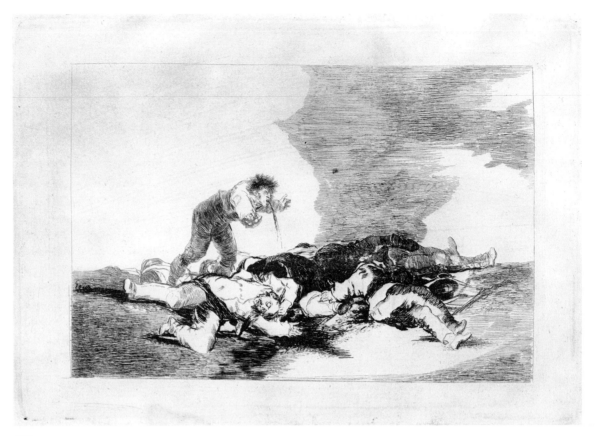

109

110

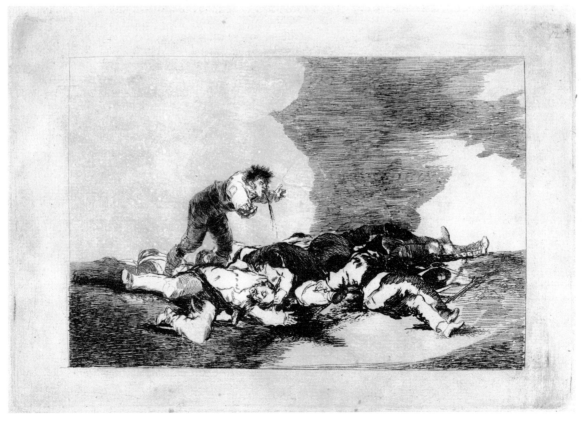

111–112
Desastres 14 (23)
Duro es el paso! (It's a hard step!)
D. 133, H. 134, B. 116, Hof. 158
155 × 165 mm.

111
Preparatory drawing for the print
Red chalk; rubbed with chalk on verso, incised
for transfer.
151 × 208 mm.
Watermark: ALVA Custodio (sword in circle)
Museo del Prado, Madrid. 121

112
Working proof, Harris I, 2
Etching, drypoint, burin, and lavis; in reverse from
the drawing.
No watermark
Coll.: Carderera; Stirling-Maxwell
Museum of Fine Arts, Boston. 1951 Purchase Fund.
51.1636

Spanish civilians are hanging other civilians who may be Spaniards accused of collaborating with the enemy: many of them were killed or executed by their enraged fellow citizens. The victims might also be Frenchmen. The Spaniards took care to see that their victims were confessed, as they did during the slaughter of over three hundred French residents of Valencia in June 1808.[1]

This drawing is one of two red chalk preparatory drawings for the *Desastres* which is reversed in the finished print. The verso was rubbed with chalk and a stylus used to trace the main outlines in order to transfer them to the grounded plate. In the etching some elements of the drawing were eliminated or simplified.

In this second working proof one sees numerous drypoint and burin additions that had been made in the previous state (not in exhibition). Drypoint shades the central figures, the hanging men, and the distant hill. There are strong burin lines on the back of the man about to be hanged. In this state very pale lavis was applied to the sky, the ground, the background figures at the right, and the breeches of the man in the foreground. The stark whiteness of the central group projects strongly.

This plate was probably made during a wartime shortage of copper, for it utilized the back of half of the plate for *The Landscape with Waterfall* (cat. no. 94). It shows evidence of foul biting due to the earlier use of the plate.

1. Southey, vol. 1, pp. 285–286.

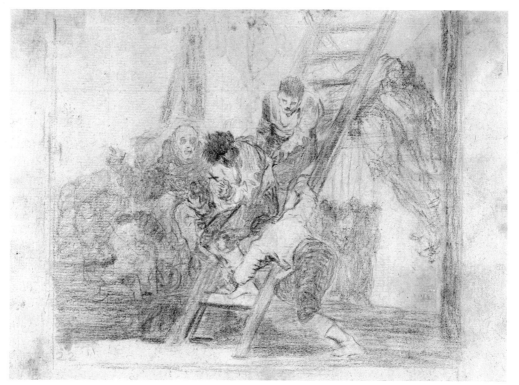

111

112

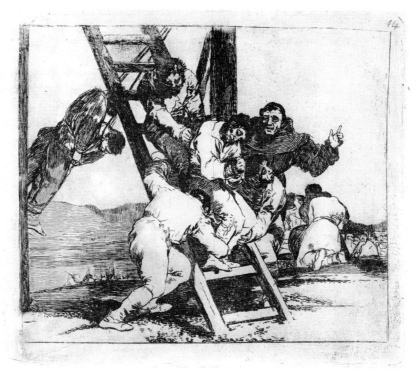

113–114
Desastres 15 (22)
Y no hai remedio (And there is no help)
D. 134, H. 135, B. 117, Hof. 159
145 × 165 mm.

113
Preparatory drawing for the print
Pen, brown ink, and wash over black chalk; in reverse.
184 × 218 mm.
On the verso appears the drawing for *Desastres* 30
A platemark appears on the sheet (see cat. 136)
Museo del Prado, Madrid. 460

114
Working proof, Harris I, 1b
Etching, drypoint, burin, and lavis
No watermark
Coll.: Carderera; Stirling-Maxwell
Museum of Fine Arts, Boston. 1951 Purchase Fund.
51.1637

Countless executions of Spaniards took place under the French occupation. The drawing is one of three pen and brown wash preparatory studies used for the *Desastres* that are in reverse of the finished print. There is a plate-mark on the sheet, but because the direction of drawing and print are reversed from one another, the drawing was not transferred to this copper plate. Nor was the drawing on the verso transferred, because it also is in reverse (cat. no. 136).

The etching was executed on the back of half of the plate used for *The Landscape with Buildings and Trees* (cat. no. 93). The dark shape at the left of the drawing, the kneeling figure of a priest holding up a crucifix, was eliminated in the print and a French firing squad sub-stituted. After the plate was etched, the figures were modeled and shaded with drypoint to give them more volume. Harris cites only one working proof state known in the unusually large number of twelve impressions. Actually there appear to be two states, one before and one after lavis. Here lavis may be seen on the sky and the firing squad.[1]

This and *Desastres* 26 contain the startling and original motif of gun barrels thrust into the picture area, deadly weapons that lack all human context.

1. Harris saw the background tone as foul biting alone; however, in the posthumous Academia proof, the same white dots appear in the sky as in other prints where lavis was incontrovertibly used.

113

114

115–116
Desastres 16 (4)
Se aprovechan (They avail themselves)
D. 135, H. 136, B. 118, Hof. 160
160 × 235 mm.
Lower left in the plate: *Goya*

115
Working proof, Harris I, 1
Etching and drypoint
Metropolitan Museum of Art, New York. Harris
Brisbane Dick Fund. 1932

116
Working proof, Harris I, 2
Etching, drypoint, lavis, burnishing, and burin
No watermark
Coll.: Carderera; Stirling-Maxwell
Museum of Fine Arts, Boston. 1951 Purchase Fund.
51.1638

Neither the Spanish civilians nor their soldiers were well equipped to fight. Descriptions abound regarding lack of supplies. Here Spanish soldiers are depicted stripping their dead of usable clothing. Despite the grim subject matter, this is one of the most beautifully designed and delicately executed plates of the *Desastres*.

The figures are small. The draughtsmanship of the first working proof is precise and descriptive; textures of flesh, fabric, or foliage are clearly differentiated. The lines are fine and cleanly etched in several stages of biting. A few drypoint strokes detail the folds of the shirt on the clothed body and add hair to the soldier's head at the far left. Stylistically and technically this print belongs with the earliest group in the set, of which three are dated 1810, *Desastres* 20, 22, and 27 (cat. nos. 126, 127, and 132–134).

In the second working proof the effects of space and atmosphere have been increased by reducing the earlier proof's strong black and white contrasts. The dark ground around the corpses has been lightened by extensive burnishing. The softened contours and more gradual tonal transitions increase feeling of volume in the figures and contribute to a more painterly effect. Hazy atmosphere surrounds the figures, suggested by an extremely pale lavis on the sky and ground. It was applied with great precision so that the living and the dead retain the bright whiteness of the paper.

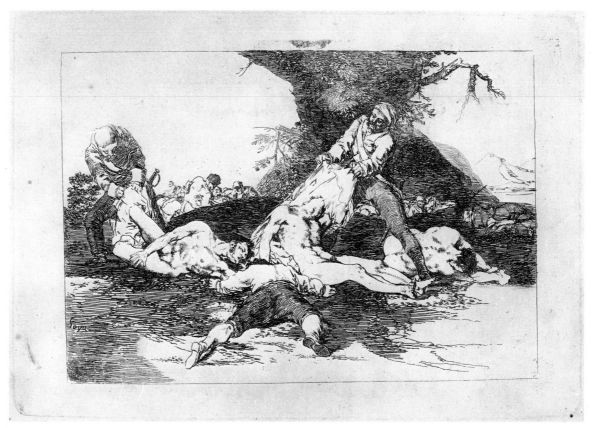

115

116

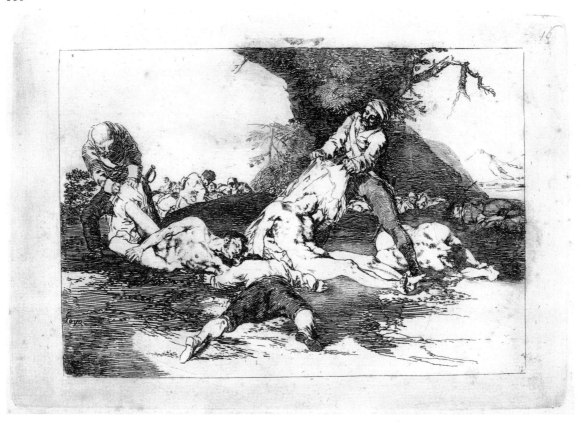

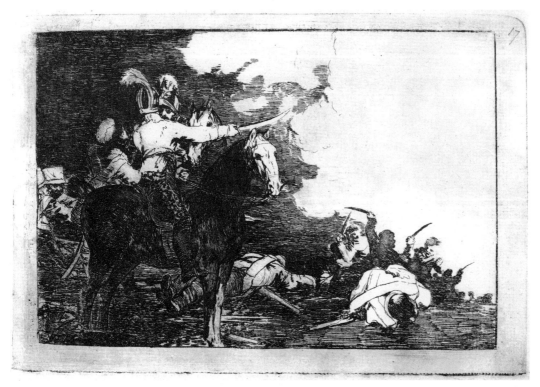

117

117

Desastres 17 (17)
No se convienen (They do not agree)
D. 136, H. 137, B. 119, Hof. 161
145 × 215 mm.
Lower right center in the plate: *Goya*

Working proof, Harris I, 2b
Etching, drypoint, burin, and lavis
No watermark
Coll.: Carderera; Stirling-Maxwell
Museum of Fine Arts, Boston. 1951 Purchase Fund.
51. 1639

Again, as in *Siempre sucede* (cat. nos. 102–103), it is difficult to be certain whether the cavalry wears French or Spanish uniforms. The plate was quite deeply bitten except for a few fine lines. The textured tonal effect that underlies almost all of the left side of the plate is not aquatint, but may be due to foul biting. Goya used the burin to draw a few definitive lines between the horse's rump and tail where the etching overbit and to sign his name. In this working proof a pale lavis covers all but the highlights of the figures, the raised sword, and a white area in the sky at the lower right.[1] This explosive flash consumes and dematerializes the soldiers caught in its light.

1. Harris did not recognize the presence of lavis on this plate. He does, however, comment on the difficulties of seeing very pale lavis on clean-wiped working proofs (vol. 1, p. 150).

118–120

Desastres 18 (16)

Enterrar y callar (Bury them and be quiet)
D. 137, H. 138, B. 120, Hof. 162
160 × 235 mm.
Lower left in the plate: *Goya*

118

Preparatory drawing for the print
Red chalk over pencil. 186 × 238 mm.
Watermark: monogram of D. & C. Blauw
The sheet shows a platemark
Museo del Prado, Madrid. 123

119

Working proof, Harris I, 3
Etching, drypoint, burin, and lavis
No watermark
Coll.: Carderera; Stirling-Maxwell
Museum of Fine Arts, Boston. 1951 Purchase Fund.
51.1640

120

Working proof, Harris I, 3
Etching, drypoint, burin, lavis, and burnishing
No watermark
Coll.: Carderera; Stirling-Maxwell
Museum of Fine Arts, Boston. 1951 Purchase Fund.
51.1641

The disposal of bodies after both sieges of Zaragoza
was a major problem. After the first siege of 1808, "Here,
in Spain, and in the month of August . . . the pestilence
was dreaded from the enormous accumulation of putrify-
ing [sic] bodies."[1] Or, in February 1809, after the second
siege, during which there was a typhus epidemic, an
eyewitness reported: "On the square itself there were
countless corpses, many completely naked . . . lying
around in heaps."[2] This print could equally well refer to
a mass execution such as that which took place in
December 1808 in Chinchón (see cat. nos. 141–142).

The preparatory drawing is characteristic of the
majority for the *Desastres,* some fifty-seven out of sixty-
two, in red chalk and in the same direction as the

finished print. Most of these were transferred by running
grounded plate and dampened drawing together through
the press. The tiny particles of red chalk transferred to
the waxy ground and provided guidelines for the etch-
ing needle. As the platemark on the sheet reveals, Goya
shifted the horizontal axis when he transferred the draw-
ing. In the print, the ground tilts up slightly more to the
left. By this time it was not uncommon for Goya to
make such compositional adjustments in the process
of transferring a design.

The third and final working proof state shows that
Goya abandoned the dense background shading of the
drawing so that the living man and woman stand in
lonely isolation against the sky. Numerous fine drypoint
and burin lines model the figures. The two impressions
are printed differently. In one, a fairly heavy tone of ink
was left on the plate and the edges of the lavis are clearly
distinguishable. The lavis forms a darker area of upper
sky while defining a cloud-like, white form below; it
covers the ground and most of the figures except for one
brightly lit foot. The tone of ink left on the plate,
perhaps through careless wiping, suggests a gathering
storm and lends additional drama to the scene.

In the other working proof the plate was wiped clean
of any residual ink. The lavis tone is subtler but no less
effective. The hazy atmosphere strongly suggests the
sun's heat, its deteriorating effects on the corpses, and the
resulting nausea of the two searching among the dead.[3]

1. Southey, vol. 1, p. 419.

2. Gabriel H. Lovett, *Napoleon and the Birth of Modern Spain*
(New York, 1965), vol. 1, p. 282.

3. There appear to be burnished highlights on the corpses not
visible in the other impression. If so, this would constitute a
further state progression.

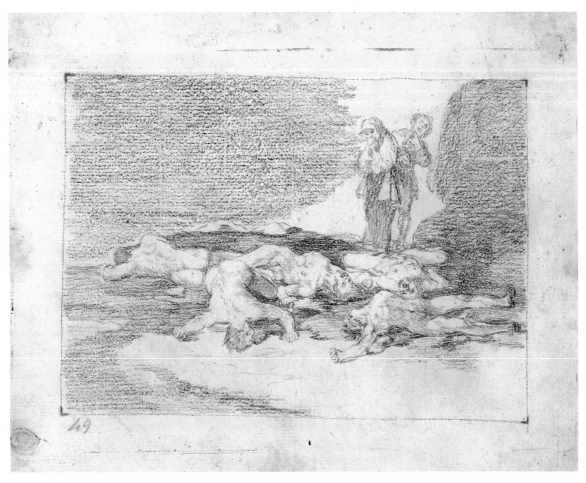

118

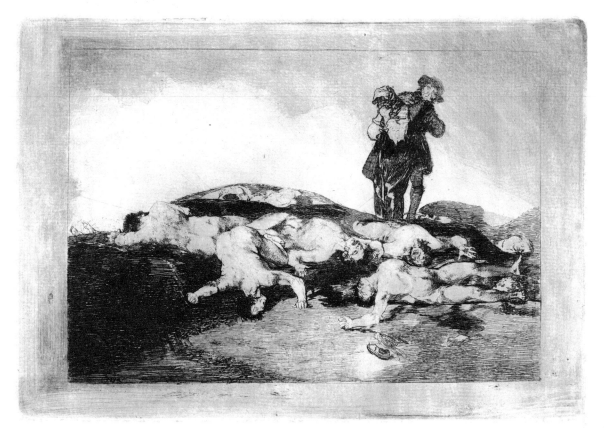

119

120

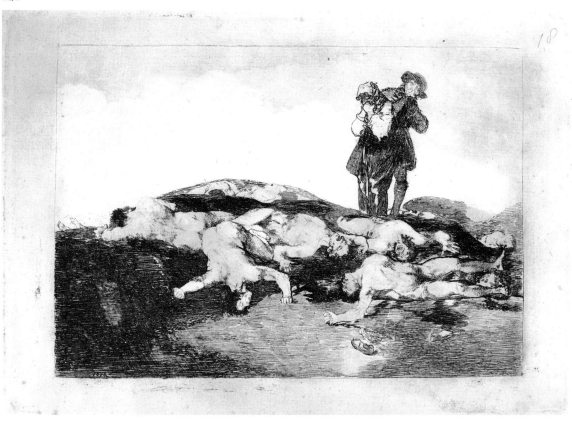

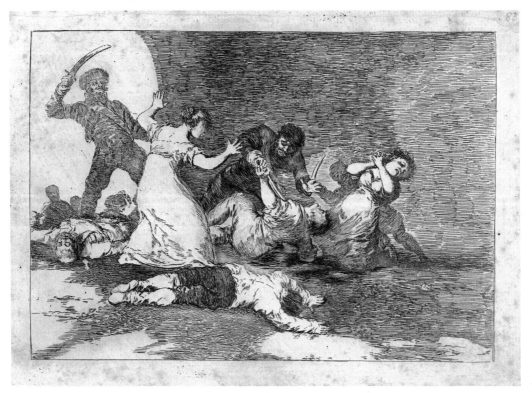

121

121
Desastres (Unpublished, unnumbered, untitled)
[Vile advantage]
H. 203
160 × 220 mm. (unique impression; cut to platemark at top and sides)

Working proof, unique, Harris I, 1
Etching, burin, drypoint, and burnishing
No watermark
Coll.: Carderera; Stirling-Maxwell
Museum of Fine Arts, Boston. 1951 Purchase Fund.
51.1697

"General Hugo, father of France's great poet Victor Hugo, who for a while occupied the post of governor of the provinces of Avila, Segovia, and Soria, complained bitterly in a report drawn up in April, 1810, about excesses . . . 'Some detachments of the 11th regiment of dragoons . . . treat the inhabitants like enemies, rob them and rape the women even in front of their husbands . . . If the troops do not abandon this system of laying everything waste, of spreading terror everywhere, they should give up the conquest of Spain.' "[1]

This composition, known only through a unique impression, is essentially the same subject as *Ya no hay tiempo, Desastres* 19 (cat. nos. 122–123). It would appear that the plate was rejected for technical reasons. The etched lines are very lightly bitten and do not print well. There is considerable burin work on the figures that strengthens darks and redraws contours, and also some drypoint shading. The ground above and below the man prostrate in the foreground has been burnished. Nevertheless, judging from the red chalk preparatory study (Prado 184), the full potential of the design was not realized. The drawing (not in exhibition) is on good quality Netherlandish paper and was obviously transferred to the plate. Style, figure scale, and type of paper place the drawing among those early ones executed for prints of about 1810 (see, for example, cat. nos. 118, 125).

The distinctive body in the foreground turns up in almost exactly the same pose in *Desastres* 22, both in the preparatory drawing (Prado 127) and in the etching dated 1810 (cat. no. 127). A slight variant appears in *Que Valor* (cat. no. 99). Goya must have found this pose effective, for he rarely repeated himself.

1. Lovett, *Napoleon,* vol. 2, p. 728.

2–123

esastres 19 (19)

a no hay tiempo (There isn't time now)

. 138, H. 139, B. 121, Hof. 163

5 × 235 mm.

ower left, in the plate: *Goya*

2

orking proof, Harris I, 1

tching and drypoint

atermark: Romani

oll.: Carderera; Stirling-Maxwell

useum of Fine Arts, Boston. 1951 Purchase Fund.

.1642

23

orking proof, Harris I, 3

tching, drypoint, burin, and lavis

o watermark

oll.: Carderera; Stirling-Maxwell

useum of Fine Arts, Boston. 1951 Purchase Fund.

.1643

The overlapping arms and hands, and the swords play a significant part in this intricate design, much as the arrangement of bodies does in *Desastres* 16 (cat. nos. 115–116). The careful delineation of the figures is also typical of the plates in the series of about 1810.

The first working proof is executed in both very fine and broader etched lines with delicate drypoint strokes that shade and add volume to the faces of the three central women.

The third working proof shows the further etching added in the previous state, which resulted in a more cohesive grouping of dark figures punctuated by light accents. The application of lavis indicates the care Goya took with this plate. Two different tonalities are employed. A darker tone shades the upper sky, its ragged edge defining a paler, cloud-like form. This same pale tone is found on the breeches of the victim at the right and on the stone and ground beside him. His shirt and the face and sleeve of the horror-stricken woman facing the soldier remain white, linking these two Spaniards by means of identical tonalities.

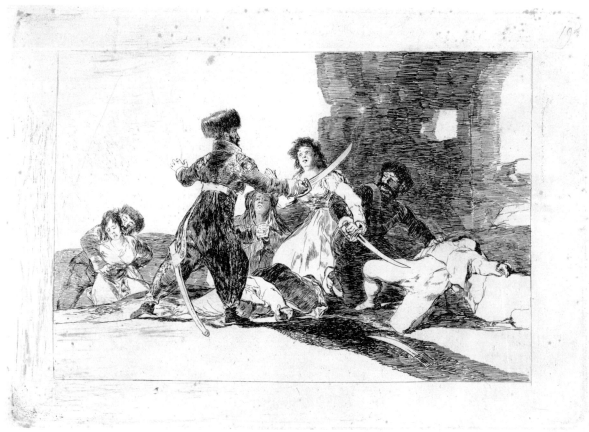

122

123

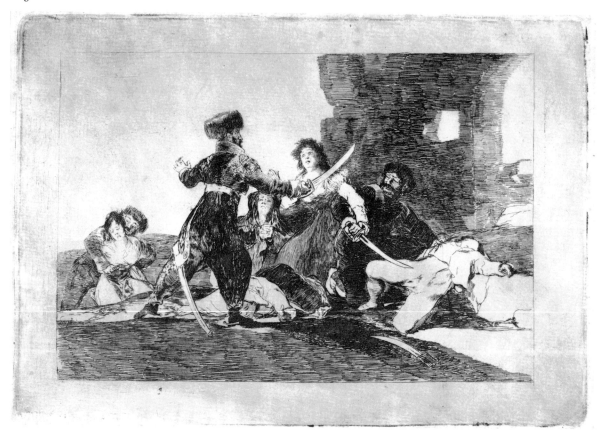

124–126

Desastres 20 (8)

Curarlos, y á otra (Take care of them, and on to the next)

D. 139, H. 140, B. 122, Hof. 164

160 × 235 mm.

Lower left in the plate: *Goya 1810*

124

Preliminary drawing

Pencil and red chalk. 196 × 249 mm.

Watermark: [K]OOL

Museo del Prado, Madrid. 125

125

Preparatory drawing for the print

Red chalk. 182 × 231 mm.

Watermark: D & C BLAUW

Sheet shows platemark

Museo del Prado, Madrid. 126

126

Working proof, Harris I, 2

Etching, burin, drypoint, and lavis

No watermark

Coll.: Carderera; Stirling-Maxwell

Museum of Fine Arts, Boston. 1951 Purchase Fund.

51.1645

Spanish wounded, including an officer with his arm blown off, are awaiting medical attention.

In the earlier, preliminary study, the group on the left, two men supporting a wounded soldier, is well defined, whereas the group of four figures at the right is more summarily sketched. The man standing directly behind the soldier wears a distinctive Aragonese hat, such as may be seen in Gálvez and Brambila's prints of the *Ruinas de Zaragoza* (see cat. no. 98).

The second drawing was transferred directly to the plate. Here the two groups of figures have been better related to each other by a change in the position of the head of the seated soldier and by improvement in the delineation of the soldier on the ground. The setting is now clearly in the countryside; trees with broken branches echo the soldier's missing limb. While the Aragonese hat has been eliminated, the faces have acquired individual characteristics. This is but one instance suggesting that although many of the drawings for the *Desastres* are early and originally referred to Zaragoza, some were revised and the prints put into a context that makes them refer to Spain as a whole.

The etching follows the drawing quite closely, although there is some simplification of the right background. The plate was bitten in several stages and touched with burin and drypoint to model the leg of the seated soldier and to shade the foreground and the bodies at the right.

The second working proof has additional etching that darkens the left background and right foreground, as in the drawing. A pale lavis was applied to the sky and the left foreground, on the drapery under the seated soldier, and on the attendant soldier at the right. The two wounded soldiers remain white. These changes concentrate attention on the group of pale figures that stands out against the diagonal swath of darkness.

63

124

125

126

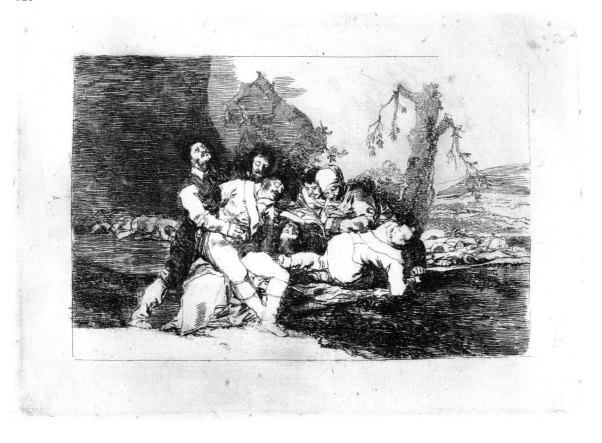

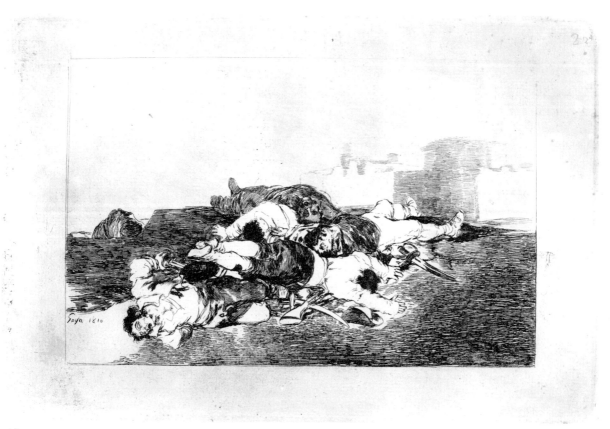

127

127

Desastres 22 (7)

Tanto y mas (Even worse)

D. 141, H. 142, B. 124, Hof. 166

160 × 250 mm.

Lower left in the plate: *Goya 1810*

Working proof, Harris I, 3

Etching, burin, and lavis

No watermark

Coll.: Carderera; Stirling-Maxwell

Museum of Fine Arts, Boston. 1951 Purchase Fund.

51.1648

Again, the title refers to a preceding print where men pile up the bodies of the dead. The scene of dead Spaniards, weapons lying beside them, may originally have been inspired by the accounts Goya was given of those killed in the hand-to-hand fighting that took place during the first siege of Zaragoza in August 1808. "One side of the street Cozo . . . was now occupied by the French . . . The Aragonese maintained their positions on the opposite side, throwing up batteries at the openings of the streets, within a few paces of similar batteries of the French. The intervening space was soon heaped up with dead either thrown from the windows of the houses in which they had been slain, or killed in the conflicts below."[1] However, mass executions took place in almost every part of Spain.

The motif of the rigid body with outstretched hands seen from the back is almost identical to that in *Vile advantage* (cat. no. 121), a plate never used in the series.

The plate was first etched in several stages; in the second working proof state, additional etching was added to darken the right foreground. Here, in the third working proof, very pale lavis was applied to the sky and the ground, increasing the sense of heat and barren earth and giving greater impact to the mass of bodies.

1. Vaughan, *Narrative,* p. 23.

128–129
Desastres 26 (27)
No se puede mirar (One can't look)
D. 145, H. 146, B. 128, Hof. 170
145 × 210 mm.
Lower left in the plate: *Goya*

128
Working proof, Harris I, 1
Etching, drypoint, and burin
Sheet mounted down
Coll.: Boix
Staatliche Museen, Preussischer Kulturbesitz,
Kupferstichkabinett, Berlin. 763–1906

129
Working proof, Harris I, 3
Etching, drypoint, burin, and lavis
No watermark
Coll.: Carderera; Stirling-Maxwell
Museum of Fine Arts, Boston. 1951 Purchase Fund.
51.1651

These Spanish civilians, women and children among
them, kneeling in a cave, are about to be shot, probably
in retaliation for resistance in the locality.

Some parts of the first working proof have a peculiar
texture, possibly due to foul biting. It appears to have
been burnished off some of the figures, but traces remain,
for example, as shading on the dress of the prostrate
woman at the far left.

In the third working proof fairly dark lavis has been
added over all the plate except on the women's clothing
and the faces, which are left white. The lavis blends with
the foul biting to produce a deeper tone on the ground.
Because the right background is shaded, one's attention
is inescapably drawn to the terrified fugitives brilliantly
illuminated in their plight.

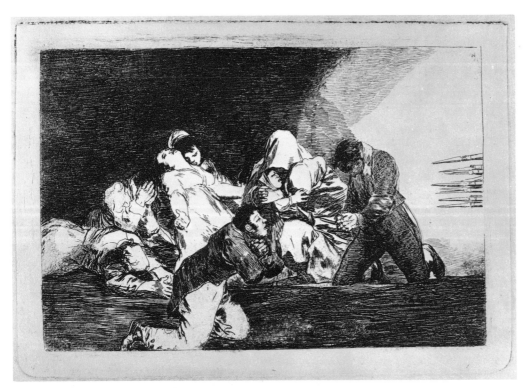

128

129

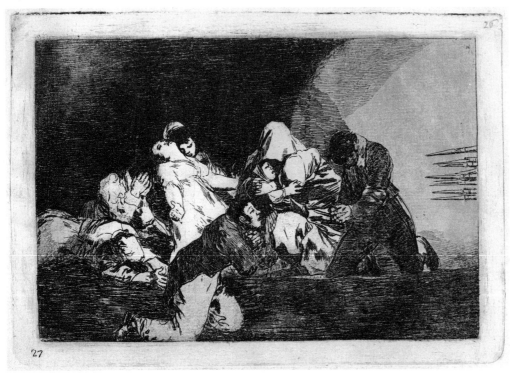

130–134
Desastres 27 (11)
Caridad (Charity)
D. 146, H. 147, B. 129, Hof. 171
160 × 235 mm.
Lower left in the plate: *Goya 1810*

130
Working proof, Harris I, 1
Etching and drypoint
No watermark
Coll.: Carderera; Stirling-Maxwell
Museum of Fine Arts, Boston. 1951 Purchase Fund.
51.1652

131
Working proof, Harris I, 2
Etching, drypoint, and burin
Watermark: Romani
Coll.: Infante Don Sebastian; Provôt; Hofer
Museum of Fine Arts, Boston. Gift of Mr. and Mrs.
Charles C. Cunningham, Jr., and the 1894 Purchase
Fund, by exchange. 1973.734

132
Working proof, Harris I, 3
Etching, drypoint, and burin
Metropolitan Museum of Art, New York. Harris
Brisbane Dick Fund. 1932

133
Working proof, Harris I, 4
Etching, drypoint, burin, and lavis
No watermark
Coll.: Carderera; Stirling-Maxwell
Museum of Fine Arts, Boston. 1951 Purchase Fund.
51.1653

134
Posthumous edition, Madrid, Academia, 1863
Harris III, 1, a, special set
No watermark
Etching, drypoint, burin, lavis, and burnishing
Museum of Fine Arts, Boston. Harvey D. Parker
Collection (1911 Purchase). M21914 27/80

In February 1809, during the second siege of
Zaragoza, many died from typhus and from wounds.
"The cemeteries could no longer afford room for the
dead; huge pits were dug to receive them in the streets
and in the courts of the public buildings . . . When the
French entered the city six thousand bodies were lying
in the streets and trenches, or piled up in heaps before
the churches."[1] "The thousands of corpses rotting in
the streets, which presented an immediate sanitary prob-
lem, were disposed of with quicklime in deep pits dug
for that purpose."[2]

All four working proof states are included here in
order to show the numerous changes made to this plate,
all in the interest of a more powerful and more profound
image. The progressive proofs move toward greater
spatial clarity and the more vivid occupation of space by
more substantial figures. Only in the last proof does
Goya's moral commentary on the scene become visible.

The first working proof was delicately etched with
incredibly minute dots describing the corpses. In several
instances there are no contour lines, only a row or area
of dots being used to define a leg or an arm.

In the second working proof the plate was etched
further, darkening the clothing of the living to differ-
entiate the two groups and adding deep shadows to the
pit. Goya has also begun to shade and model the corpses
with some drypoint and burin work.

In the third working proof, signed and dated 1810,
the composition has been completed. Goya etched shad-
ing on the ground at the left that levels it. There is
much new burin work that outlines and models the
corpses. It covers the dotted texture, but increases the
volume and the sense of dead weight of the bodies.

The fourth working proof has a lightly bitten tone
of lavis over the ground and upper sky. Save for one
small area, it is not applied to the figures. The treatment
of the heads of the men engaged in burial is subtle but
effective. The face of the man in the cocked hat is set
apart from the white sky by a tone of lavis. The expres-
sionless face of the observer standing with folded arms,
drawn with dots like the corpses, and the face of the

1. Southey, vol. 2, pp. 131, 148.
2. Lovett, *Napoleon*, vol. 1, p. 283.

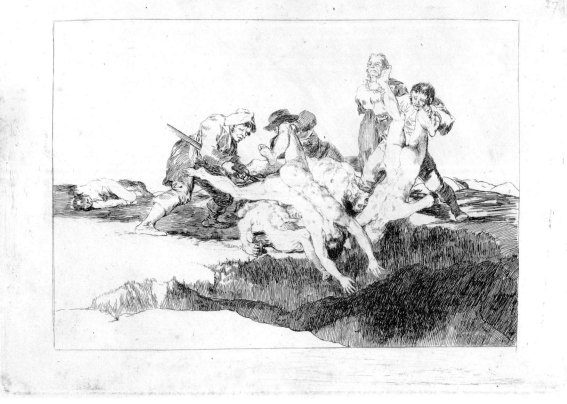

130

131

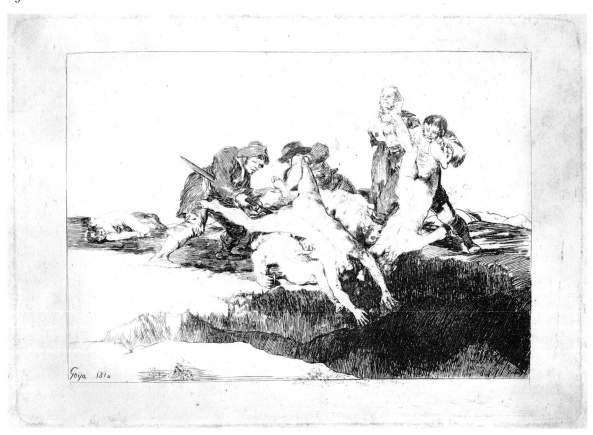

Goya 1810.

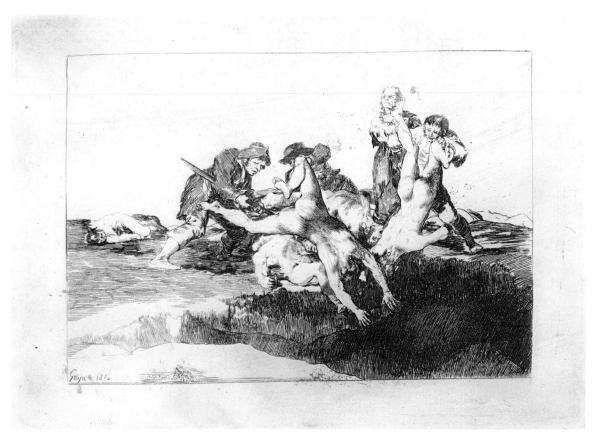

132

133

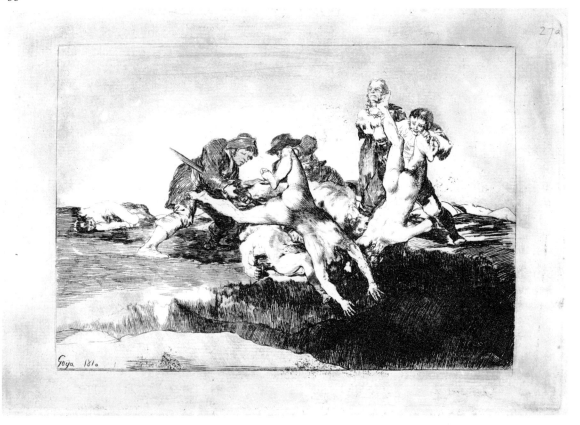

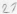

Caridad.

134

man next to him are white against the toned background. By this means Goya focusses attention on their expressions so that one is instantly aware that they no longer remember that the dead were once their friends and neighbors. They push them into a common grave with neither feeling nor compassion. In the *Caprichos* the repetition of sin was depicted as having the power to alter the nature of man. So also in the *Desastres* does war exercise its inexorable power. This is reinforced by Goya's ironic title "Charity."

In 1863 the Academia de San Fernando published the first but posthumous edition of the *Desastres*. This impression, like all the rest of the set, is printed with a great deal of plate tone. It obscures Goya's subtle use of light and shade and distorts his painterly balance of tones. The meaning of the print has been blunted, for the callous faces recede into the background while the bodies achieve a prominence they were not intended to have. In Goya's final proof the significant havoc of war had not been death but the terrible changes wrought upon the living.

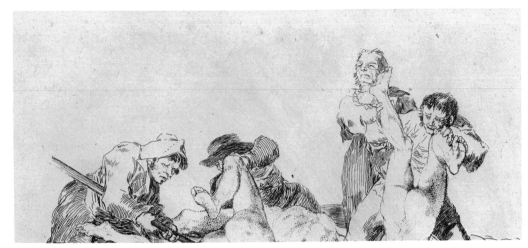

130 (full size detail)

133 (full size detail)

134 (full size detail)

135

Desastres 29

Lo merecia (He deserved it)

D. 148, H. 149, B. 131, Hof. 173

175 × 215 mm.

Working proof, Harris I, 3
Etching, drypoint, and burin
No watermark
Coll.: Infante Don Sebastian; Provôt; Hofer
Museum of Fine Arts, Boston. Gift of Mr. and Mrs. Harry
Remis and Lincoln and Therese Filene Foundation, Inc.
1973.726

Both this print and its companion, Plate 28, *Populacho* (Rabble; not in exhibition) depict a mob of Spanish civilians torturing a single victim, as happened in a number of cities in May and June 1808, when the people rose up against their own leaders. "Men were sacrificed to the suspicions and fury of the multitude, as accomplices and agents of the French, whose innocence . . . was established when too late. Such crimes were committed at Valladolid, Cartagena, Granada, Jaen, San Lucar, Carolina, Ciudad Rodrigo, and many other places."[1] One prominent citizen of Sevilla was dragged from his carriage, killed, and his body exposed on a city gate; another was hauled to the gallows but set upon and stabbed to death on the way. The governor of Valencia was seized and beheaded by a mob.[2]

The spare treatment and freedom of etching are similar to the allegorical prints at the end of the series. This dating is supported by the watermark on the preliminary drawing (Prado 134, not in exhibition). The composition was executed almost entirely in etching, only a few burin lines being added to the jacket of the man at the left with upraised stick.

Goya had first exaggerated the size of the victim's shoes, but had shaded in a smaller area of the soles. The larger outlines were burnished somewhat, but traces of them remain in the posthumous editions. By reducing the size of the shoes, less attention is drawn to the victim and more to the men who are about to kill him. The one on the right, jaw set, an abstracted look on his face, plods unthinkingly on. The other, wearing an indeterminate garment, his feet wrapped in rags, looks back. His expression indicates his awareness of the victim and even a touch of remorse for his actions. In contrast to the brutal enemy soldiers of *Desastres* 33, 36, and 37 (cat. nos. 138, 140, 141), this particular Spaniard evinces some sympathy.

1. Southey, vol. 1, p. 270.

2. Ibid., vol. 1, pp. 270–283. For a partial list of prominent victims, see E. Lafuente Ferrari, *Los Desastres de la Guerra de Goya y sus dibujos preparatorios* (Barcelona, 1952), p. 156.

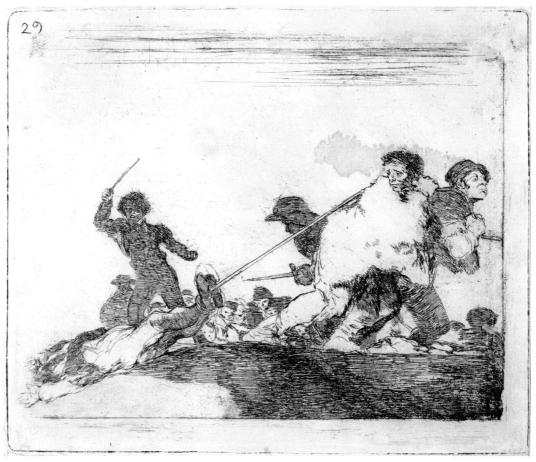

135

136–137
Desastres 30 (21)
Estragos de la guerra (Ravages of war)
D. 149, H. 150, B. 132, Hof. 174
140 × 170 mm.
Lower left, in the plate: *Goya*

136
Preparatory drawing for the print
Pen, brush, brown ink, touched with graphite
184 × 218 mm.
In reverse
No visible watermark
On the verso appears the drawing for *Desastres* 15,
cat. no. 113
A platemark, 143 × 172 mm., appears on the sheet.
Museo del Prado, Madrid. 436

137
Working proof, Harris I, 1
Etching, drypoint, and burin
Touched in pen and gray ink (not by Goya)
Coll.: Infante Don Sebastian; Provôt; Hofer
Museum of Fine Arts, Boston. Gift of Jeptha H. Wade
and the M. and M. Karolik Fund. 1973.727

"About the last day of June [1808], a powder-magazine, a very strong building in the heart of the city of Zaragoza, blew up, and in a moment nearly a whole street was reduced to a heap of ruins; the inhabitants of Zaragoza had scarcely recovered from their consternation at this fatal, and irreparable loss, and from the labour of extricating their fellow-citizens from the ruins of their houses, when the French . . . opened a destructive fire upon the city."[1]

Unlike most of the preparatory drawings for the *Desastres,* which are in red chalk and in the same direction, this drawing is in pen and brown wash and in the opposite direction from the print, as is its verso (cat. no. 113). Although a platemark close to the size of this plate appears on the sheet, the drawing could not have been transferred directly by means of a press because the direction of the print would then be the same instead of reversed.

The etching was made on half the verso of the plate for the *Landscape with a Waterfall* (cat. no. 94), an action necessitated by a wartime shortage of copper (see also cat. no. 112).

This first working proof shows some burin touches in the overbitten shadows. There are also extensive drypoint additions that model the figures, increasing their weight and volume, and giving startling reality to the woman who is falling. Photography has accustomed us to the immediacy and explosive confusion of such a moment, but in the early nineteenth century it required an extraordinary graphic intuition on Goya's part.

On this impression lines in pen and gray ink have been added to drape the exposed breast and thighs of the woman in the foreground. This was done not by Goya but by a prudish and as yet unidentified collector, possibly the Infante Don Sebastian, who also owned *Escapan entre las llamas* (cat. no. 146), which is touched in a similar fashion.

1. Vaughan, *Narrative,* p. 14.

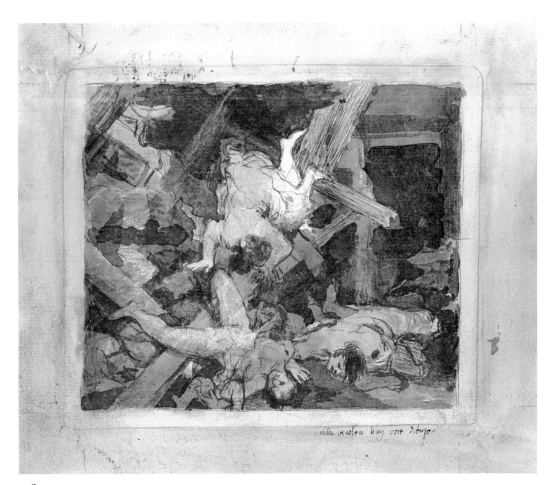

136

137

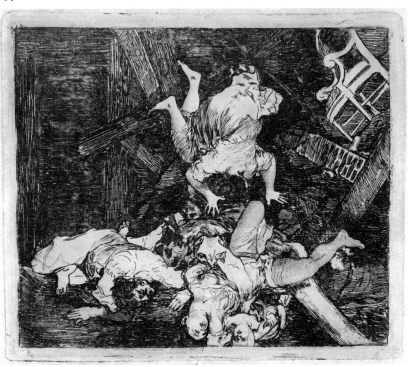

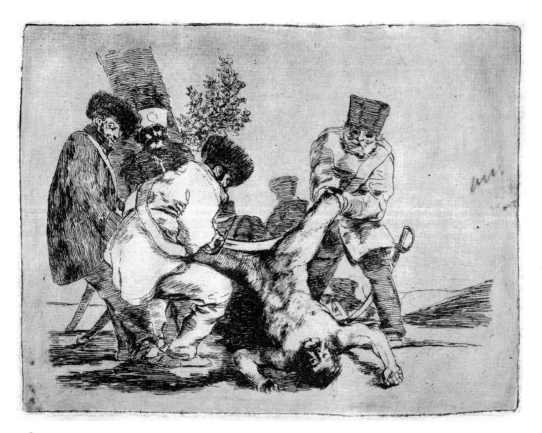

138

138

Desastres 33 (42)

Qué hai que hacer mas? (What more can be done?)

D. 152, H. 153, B. 135, Hof. 177

155 × 205 mm.

Working proof, Harris I, 2
Etching and lavis; touched with brush and gray wash
No watermark
Coll.: Infante Don Sebastian; Provôt; Hofer.
Museum of Fine Arts, Boston. Gift of Landon T. Clay.
1973.728

"The atrocities of the War of Spanish Independence cannot, of course, compare in scope to the bestialities committed in our twentieth century, but to those who witnessed it it seemed that all the worse instincts of man had chosen the Iberian Peninsula to manifest themselves with a massive violence which dwarfed the conflicts waged in Europe in the previous century."[1]

The style and execution of this print, as well as *Desastres* 31–33 and 36–39, are different from those of the group executed around 1810. The scale of the figures is larger, the drawing is broader, and the etching was accomplished with a minimum of biting, most lines being of uniform width. The tone, whether lavis or aquatint, is not contained within the etched outlines, and tends to be heavier. With the exception of *Desastres* 38 (cat. no. 143) no drawings are known to have survived for any of the group of atrocities.

In this earliest working proof, a rather spotty lavis was applied over the background of the plate. Because the plate had not been sufficiently polished, the figures pick up a film of ink and the contrasts are therefore diminished. On this impression Goya added shading in brush and gray wash on the victim's pubic area. In the following state this and other portions of his body would be shaded in drypoint.

The amplitude of the composition requires the full width of the copper plate; in the posthumous edition, the design would be reduced and confined within border lines.

1. Lovett, *Napoleon*, vol. 2, p. 722.

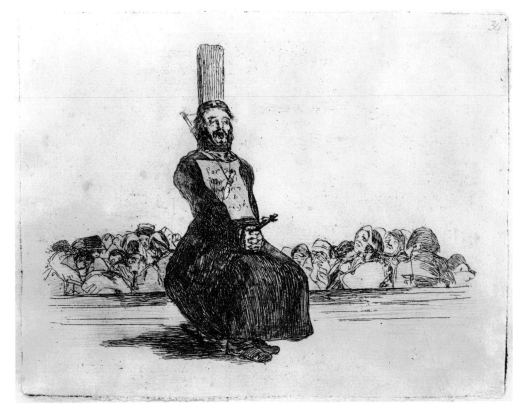

139

39

Desastres 34 (?)
Por una navaja (On account of a knife)
D. 153, H. 154, B. 136, Hof. 178
155 × 205 mm.

Working proof, Harris I, 1
Etching and drypoint
No watermark
Coll.: Carderera; Stirling-Maxwell
Museum of Fine Arts, Boston. 1951 Purchase Fund.
51.1657

Hanging from a cord around his neck, the victim wears a small knife which he has been arrested for carrying as a weapon against the French. Decrees prohibiting Spaniards from bearing arms were made in Madrid by the French general Murat in May 1808[1] and again by Joseph Bonaparte in January 1809.[2] In September 1809 Joseph decreed "strangulation the mode of death for all criminals of whatever rank."[3] Lord Blayney, who was himself taken prisoner by the French in 1810, wrote: "This is an old Spanish punishment and seems to be one of the easiest kinds of death. Scarce a day passes without several

similar executions, the sufferers being mostly those whom the French stigmatize with the names of rebels and brigands, but to whom the page of history will accord those of loyalists and patriots."[4]

Goya did not add aquatint to this plate. Instead, he used fine, parallel drypoint lines to give a middle range of tone to the crowd and to shade the planking so that its perspective is convincing. The crowd looks on with expressions ranging from cursory interest to avidity.

In the finished state (not in exhibition), Goya will extend the skirt of the victim's robe to the floor, making his form pyramidal and more monumental. New, heavy shading on the observers will veil their individual responses to the execution, further isolating the garroted figure, who now dominates the scene.

1. Lovett, *Napoleon,* vol. 1, pp. 147 f.

2. Southey, vol. 2, p. 23.

3. Southey, vol. 2, p. 479.

4. Major-General Lord Blayney, *Narrative of a Forced Journey through Spain and France as a Prisoner of War in the Years 1810 to 1814* (London, 1814), vol. 1, pp. 73 f. Several patriotic victims of garroting are depicted in *Desastres* 35, most of them displaying a weapon. See also *The Garroted Man* (cat. nos. 7–10).

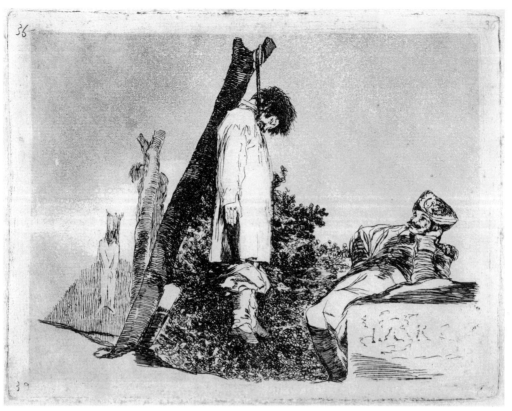

140

140
Desastres 36 (39)
Tampoco (Nor this time)
D. 155, H. 156, B. 138, Hof. 180
155 × 205 mm.

Working proof, Harris I, 2–3
Etching, aquatint, burnishing, drypoint, and burin
Watermark: SERRA
Coll.: Carderera; Stirling-Maxwell
Museum of Fine Arts, Boston. 1951 Purchase Fund.
51.1659

The memoirs of the French general Lejeune include an evocative passage in which he comes across a corpse hanging from a branch and agitated like a rag in the wind.[1] Another French general, Carrié, "who was in command in the Old Castilian town of Palencia in early 1809, was one of these officers who thought that terror was a legitimate weapon. In a letter to Marshal Bessières dated February 3, 1809, he wrote that he had given orders to hang at Carrión half the Spanish prisoners taken in the north and to 'keep the chiefs' for Palencia. 'It would be indispensable,' added the general, 'to send immediately a hangman from Valladolid if the surplus should be executed here!...'" At about the same time he announced to the town of Palencia that thirty-two guerrillas, includ-

ing a captain, had been captured and all had been hanged.[2]

The title refers back to the preceding print, in which eight guerrillas are seen executed, *No se puede saber por qué* (One doesn't know why). The manner in which the motionless soldier is portrayed contrasts chillingly with the frenzied activity of *Desastres 33, Que hai que hacer mas* (cat. no. 138).

This intermediate working state shows the first transparent application of aquatint, which has been burnished away from the plate margins in order to concentrate attention on the figures. There were slight drypoint additions to the hanged man, most importantly on the front of his smock. The drypoint burr and subsequent burnishing soften the division between shirt and bush. The resulting blurriness produces an uncanny sense of swaying motion in the hanged man.

The lesson of this early nineteenth century print is an extraordinary one in that for Goya the worse crime does not seem to be that his fellow countrymen have been hanged, but that a human being, Polish mercenary[3] though he is, can gloat over the death of other men.

1. Cited by Lafuente Ferrari, *Los Desastres,* p. 160.

2. Lovett, *Napoleon,* vol. 2, pp. 725–726, and note 13.

3. Identified as such by Lafuente, ibid.

141–142
Desastres 37 (32)
Esto es peor (This is worse)
D. 156, H. 157, B. 139, Hof. 181
155 × 205 mm.

141
Working proof, Harris I, 1
Etching and lavis [?]; touched with charcoal
Watermark: SERRA
Coll.: Carderera; Stirling-Maxwell
Inscribed on verso in charcoal, in Goya's hand:
el de Chinchon.
Museum of Fine Arts, Boston. 1951 Purchase Fund.
51.1660

142
Working proof, Harris I, 2
Etching and lavis
Touched with black chalk
Sheet mounted down
Coll.: Boix
Staatliche Museen, Preussischer Kulturbesitz,
Kupferstichkabinett, Berlin. 769–1906

The first working proof bears a charcoal inscription on the verso in Goya's hand, *el de Chinchon* (the one at Chinchón). The French massacred every man they could lay hands on, over one hundred, in that town twenty-three miles south of Madrid in December 1808. A contemporary report states that it was a reprisal for the death of two or three French soldiers killed by the townspeople.[1] Goya's youngest brother, Camillo (1753–1828), who became a parish priest in Chinchón in 1783, may well have been the source for the information.[2]

This impression was printed imperfectly, so that some parts lack clarity, such as areas of the impaled corpse, or the soldier's upraised arm with sword. The plate was not clean wiped, and some tone is on the print, which has also been extensively touched with charcoal and rubbed to indicate where lavis was to be added. Although it is difficult to be certain because of the printing quality and the charcoal, there may be a very light tone of lavis over all but the corpse which is more easily seen on the background figures in the following second state.

In the second working proof a rather spotty, darker lavis has been applied to most of the sky and ground to correspond with those areas shaded in charcoal in the first proof. This impression is again touched with black chalk around the victim's hair. The final working proofs (not in exhibition) show that Goya lengthened the hair in drypoint, as though it were blown by the wind.

1. Lovett, *Napoleon*, vol. 2, pp. 724–725; Narciso del Nero, *Chinchón desde el siglo XV* (Madrid, 1958), pp. 65–66, note 4.

2. The date is given in an unpublished letter from Goya to Zapater (Casa Torres coll.). On Camillo's birth and death dates see E. Lafuente Ferrari, *Antecedentes, coincidencias e influencias del arte de Goya* (Madrid, 1947), p. 294. Goya made a painting for the church at Chinchón (Gassier and Wilson, 1567, which they date about 1812).

141

142

143 (full size detail)

A faint and incomplete drawing for this print appears on the verso of that for *Desastres* 43 (cat. no. 146). It is, moreover, the only drawing for *Desastres* 31–39, all of which deal with French executions and atrocities. In this instance a Spanish civilian, bound to a tree stump, is being shot in the back by soldiers, probably in retaliation for guerrilla activities.

The first working proof contains a single aquatint tone that has been burnished extensively in the sky and on the soldier's coat. The lighter area in the right background is entirely created by burnishing. Goya began working from dark to light in the prints after Velázquez, experimented further in the *Caprichos,* but in the prints of the *Desastres* executed around 1812–14 uses burnishing with expressive freedom (see cat. no. 158).

In a further working proof (not in exhibition), using burnishing and burin work, Goya changed the near soldier's jacket into a greatcoat and thus stabilized the composition with a strong pyramidal form.

The impression published by the Academia in 1863 shows changes not visible in their trial proofs. There is further burnishing and burin lines on the coat. Moreover, the publishers reduced the breadth of the composition with its large-scale figures into a smaller one tidily bounded by careful border lines.

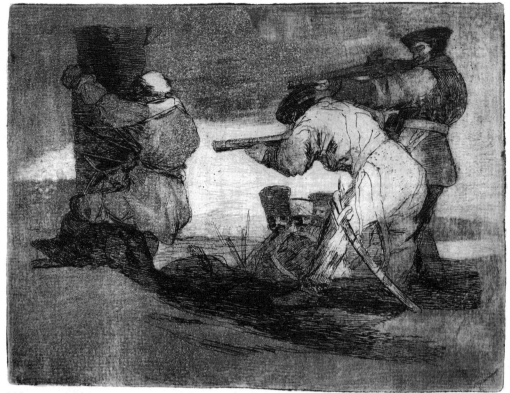

143

144

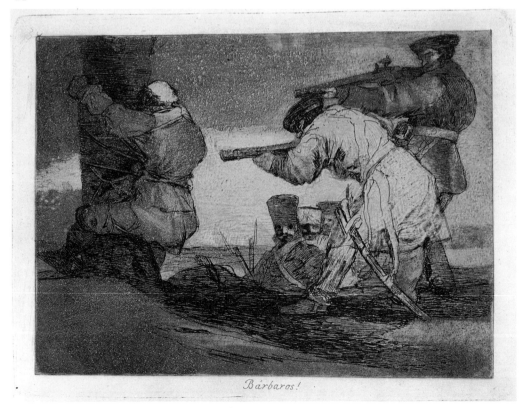

Bárbaros!

145–146
Desastres 41 (10)
Escapan entre las llamas (They escape through the flames)
D. 160, H. 161, B. 143, Hof. 185
160 × 235 mm.
Lower left in the plate: *Goya*

145
Working proof, Harris I, 1
Etching and burin
Watermark: ROMANI
Coll.: Carderera; Stirling-Maxwell
Museum of Fine Arts, Boston. 1951 Purchase Fund.
51.1665

146
Working proof, Harris I, 2
Etching, burin
Coll.: Infante Don Sebastian; Provôt
Touched in pen and gray ink (not by Goya)
Anonymous loan

Occurrences such as are shown here took place all over Spain, but a graphic description of one was published by Vaughan in 1809. "On the night of the 2d of August [1808], and on the following day the French bombarded Zaragoza . . . A foundling-hospital, which contained the sick and wounded, who from time to time had been conveyed there during the siege, unfortunately caught fire, and was rapidly consumed . . . Everybody was seen hastening to the relief of the sick, and helpless children who occupied this building; but in this act of humanity none were more conspicuous than the women, who persisted in their humane exertions, equally undaunted by the shot, and shells of the enemy, and the flames of the building before them."[1]

The first working proof shows that this plate was executed with the same delicately drawn and finely etched lines as other prints of about 1810. Drypoint was used to complete the flames and model the figures.

The second working proof indicates that the plate underwent a second etching that darkened the perimeters of the plate and emphasized the smoke and confusion. One is far more aware of the burst of flames and those who are illuminated by its glare, notably the women in their light-colored dresses.

The same prudish collector who retouched *Desastres* 30 (cat. no. 137), possibly the Infante Don Sebastian, added drapery to the naked breasts of the woman carried by two men.

1. Vaughan, *Narrative,* pp. 20–21.

145

146

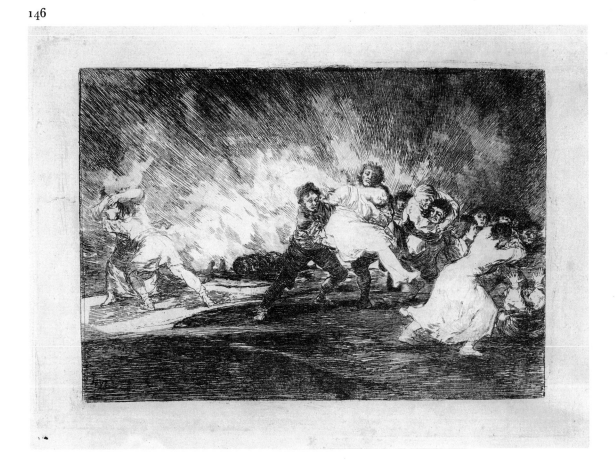

147–148

Desastres 43 (40)

Tambien esto (This too)

D. 162, H. 163, B. 145, Hof. 187

155 × 205 mm.

147

Preparatory drawing for the print

Red chalk. 158 × 211 mm.

Watermark: Dⁿ JPH / DE / RODA

On verso study for *Desastres* 38

Printing creases

Museo del Prado, Madrid. 431

148

Working proof, Harris I, 2

Etching and burnished aquatint

No watermark

Coll.: Carderera; Stirling-Maxwell

Museum of Fine Arts, Boston. 1951 Purchase Fund.

51.1667

The title refers back to the preceding print in the series, *Todo va revuelto* (Everything's in turmoil; not in exhibition), where the monks are more broadly caricatured and their activities are satirized. Various orders of monks are shown in hasty flight. One does not know the cause. Over and over again one reads of the French robbing church treasure, of priests killed with sacred relics in their hands. If we understand this print as a representation of the kind of event Goya witnessed or heard about, then it is probable that this group left their monasteries at the advance of the French. Yet, since there is no sign that they are carrying holy objects to safety, one should consider that the print may refer to another kind of event. Both the French in 1808 and the Spanish liberals who formed the Constitution of Cádiz in 1812 moved toward the dissolution of monastic foundations with small populations.

Goya's drawing expresses the confusion of these cloistered individuals who find themselves suddenly in the world. There is a touch of satire in his drawing, which was transferred directly to the plate. Here two monks have hoisted the skirts of their habits, revealing that they wear laymen's breeches.

In the etching Goya was slightly more discrete, for he extended the skirt of the monk in the foreground, although breeches can still be seen on the monk behind him. The print was executed swiftly and surely. A pale, coarse-grained aquatint shades the sky, foreground, and hill. Subsequently some burnishing would lighten the lines of this hill, the only change Goya made to the plate.

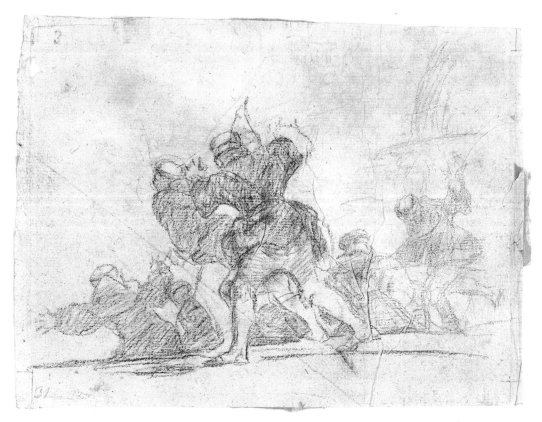

147

148

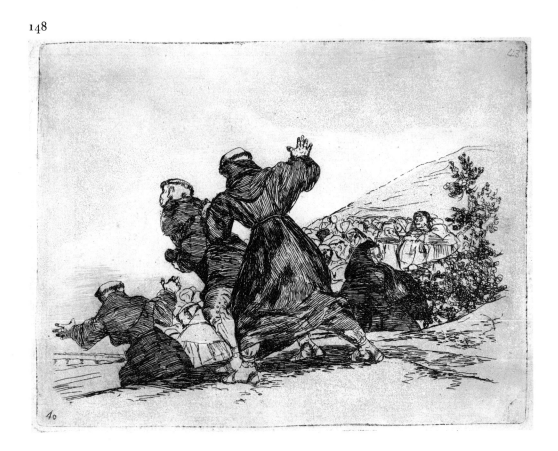

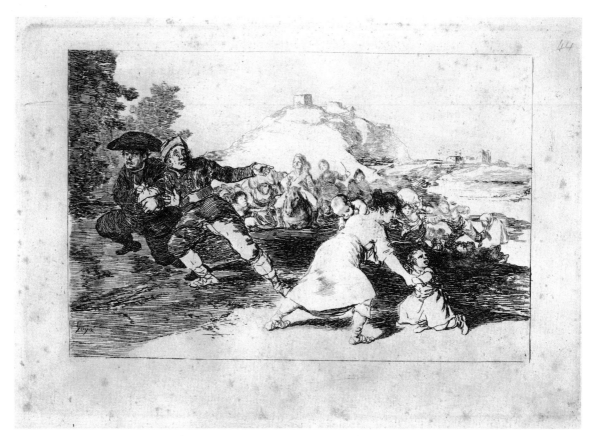

149

149
Desastres 44 (15)
Yo lo vi (I saw it)
D. 163, H. 164, B. 146, Hof. 188
160 × 235 mm.
Lower left in the plate: *Goya*

Working proof, Harris I, 1
Etching, drypoint, burin, and lavis
No watermark
Coll.: Carderera; Stirling-Maxwell
Museum of Fine Arts, Boston. 1951 Purchase Fund.
51.1668

In late 1808 peasants from the countryside fled their
homes. Many of them entered Zaragoza, which was
fortifying itself against another French attack that would
be launched in December. "As many as 15,000 peasants
entered the city to share in the dangers and merit of its
defence."[1] Goya left Zaragoza before the French returned,
went to Fuendetodos, and was back in Madrid by May
5 ,1809. He must have seen many such scenes on his
journey.

Some insight into the dating of the *Desastres* drawings
and prints may be revealed by comparing *I saw it* with
And this too (cat. nos. 150–151). *I saw it* was etched in a
painstakingly specific manner and the lines vary in width.
A light tone of lavis in the sky gives subtle emphasis to
the advancing figures. The print is comparable to those
dated 1810 and is signed with the burin like others of
this early group. Its red chalk preparatory drawing (Prado
138, not in exhibition) is also detailed and is on a sheet
with the watermark "Kool." Similar good quality Nether-
landish paper is used for stylistically similar studies for
early *Desastres* 18 and 20 (cat. nos. 118, 124, and 125).

1. Southey, vol. 2, p. 108.

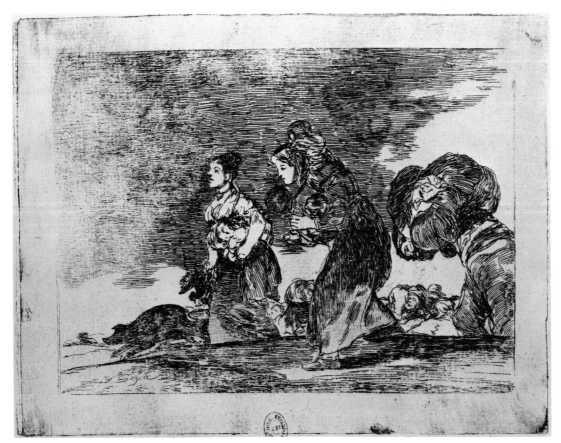

150

151

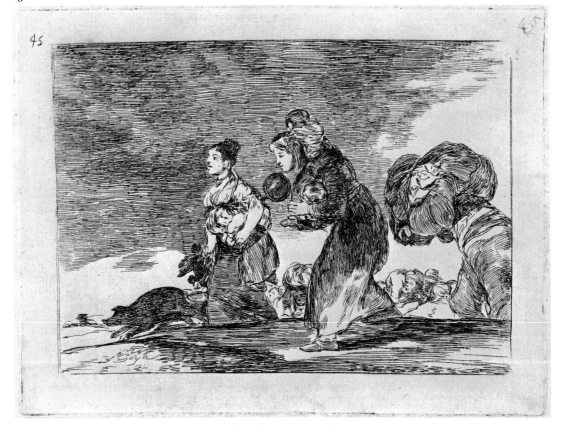

150–151
Desastres 45
Y esto tambien (And this too)
D. 164, H. 165, B. 147, Hof. 189
165 × 220 mm.
Lower left in the plate: *Goya*

150
Working proof, Harris I, 1
Etching. Touched with black chalk
Bibliothèque Nationale, Paris

151
Working proof, Harris I, 2
Etching, burin, and drypoint
Watermark: trace of SERRA (?)
Coll.: Carderera; Stirling-Maxwell
Museum of Fine Arts, Boston. 1951 Purchase Fund. 51.1669

The title refers back to the preceding print, *I saw it*.

And this too was etched in a more generalized manner; the lines are essentially of the same width, and the cursive signature has been etched. The first proof is shaded in chalk on the bottom of the left-hand woman's skirt, her fan, the central woman's sleeve and skirt, and the bundle above the man's head. The plate was not etched further, but the areas shaded with chalk were filled in with drypoint and burin in the second working state. In the third state (not in exhibition), lavis would be very freely applied. The etching style has moved toward the later group of the *Desastres*, the *caprichos enfáticos*, and like them, the plate has one number rather than two.[1] Its preparatory drawing (Prado 139, not in exhibition) is generalized, suggestive, and is on a thin Spanish paper suitable for writing, with the watermark "Olva." A number of drawings for the *caprichos enfáticos* have the same watermark, which is not to be found in the sheets of studies for etchings earlier in style.

When Goya arranged and prepared the *Desastres* for publication, between 1820 and 1823, he placed these two related subjects together, executed about a decade apart.

1. This print can also be compared with *Disparate feminino* (not in exhibition) for the treatment of women, application of aquatint, and cursive signature.

152
Desastres 47 (33)
Así sucedió (This is how it happened)
D. 166, H. 167, B. 149, Hof. 191
155 × 205 mm.

Working proof, Harris I, 3
Etching, burnished lavis, drypoint, and burin
No watermark
Coll.: Carderera; Stirling-Maxwell
Museum of Fine Arts, Boston. 1951 Purchase Fund.
51.1671

French troops looted homes and churches continuously during their occupation of Spain, often killing in order to pillage. When the French army retreated to Pamplona they were seen "exposing their booty to sale, and courting purchasers for church plate, watches, jewels, linen, and apparel, the plunder which they had collected in Navarre and Aragon; and which, in their eagerness to convert into money, they were offering at a small part of their value."[1] Lafuente quotes the memoirs of the French general Lejeune relating to an attack on Zaragoza where the corpse of a young monk was discovered, still holding in his hand the ciborium with the consecrated host, which he had bravely carried to those dying in the midst of the slaughter.[2]

The breadth of technique and use of aquatint in this print relate it to the group depicting French atrocities, such as *Desastres* 33, 36, and 38 (cat. nos. 138, 140, and 143). Fine drypoint shading was added to the booty-laden French soldiers. Lavis or an almost grainless aquatint darkens the background. Its irregular edges suggest that Goya brushed on the acid rather than stopped out the white areas. He then burnished some of these dark, jagged edges, as on the skirt of the monk, but left them sharp and clear around the booty. With abrupt transitions and swift technique Goya achieved a sense of violence and urgency in this scene of pillage.

1. Southey, vol. 1, p. 422.
2. Lafuente Ferrari, *Los Desastres,* p. 168.

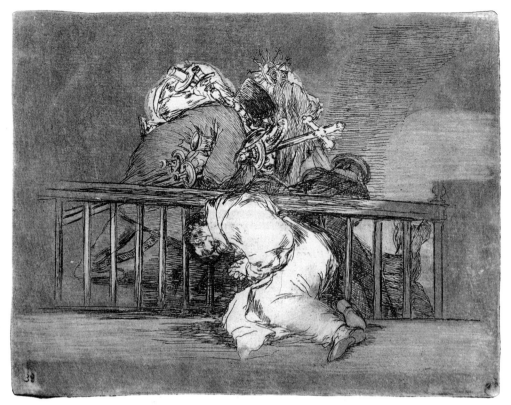

152

153

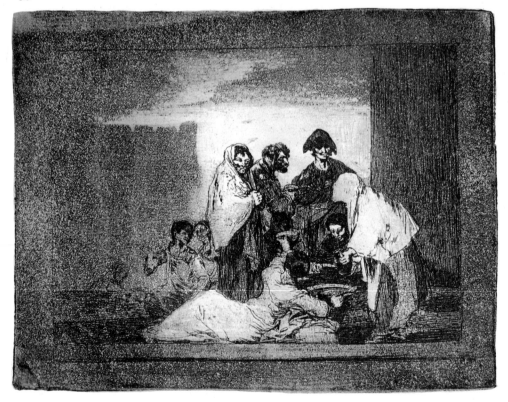

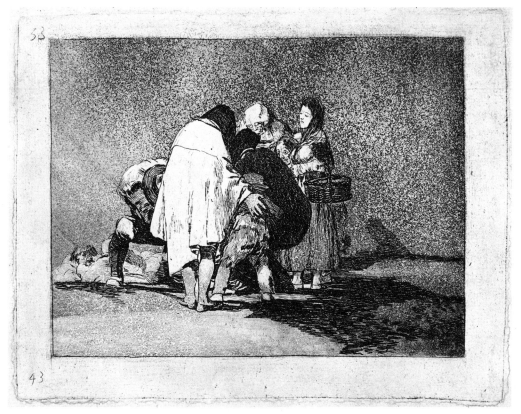

154

153

Desastres 51 (46)
Gracias á la almorta (Thanks to the millet)
D. 170, H. 171, B. 153, Hof. 195
155 × 205 mm.

Working proof, Harris I, 2
Etching and burnished aquatint
Coll.: Infante Don Sebastian; Provôt
Anonymous loan

By 1811 famine had spread through many areas of Spain. In Madrid it began to affect the poor by September. The eleven months that followed until the city was relieved briefly by Wellington in August 1812 came to be known there as *el año del hambre,* the year of the famine. Some 20,000 people died. As a seventy-year-old man, Ramón de Mesonero Romanos recalled what he had seen as a child: "This spectacle of despair and of anguish," he wrote in his memoirs, "the sight of an infinite number of human beings expiring in the middle of the streets and in the middle of the day; the lamentations of women and children at the side of the corpses of their fathers and brothers stretched out on the sidewalk, who were picked up twice a day by carts; that prolonged . . . and pitiful moan of agony coming from so many unfortunates, instilled in the few passers-by, equally starving, an unconquerable terror."[1]

Millet porridge was a staple during the Madrid famine.[2] The treatment of this print is characteristic of a number of the scenes of famine. The figures are smaller in scale than those of the scenes of atrocities. A dark tone of aquatint provides an abstract city background. These great rectangles seem to press against the huddled, starving group who survive from meal to meal.

1. Lovett, *Napoleon,* vol. 2, p. 734, quoting Ramón de Mesonero Romanos, *Memorias de un sententón* (Madrid, 1881), p. 86.

2. Lafuente Ferrari, *Los Desastres,* p. 171.

154
Desastres 53 (43)
Espiró sin remedio (He died without help)
D. 172, H. 173, B. 155, Hof. 197
155 × 205 mm.

Working proof, Harris I, 2
Etching, burnished aquatint, lavis, and burin
No watermark
Coll.: Hofer
Museum of Fine Arts, Boston. Gift of Mr. and Mrs. Harry
Remis. 1973.729

Goya depicted the war that ravaged most of Spain in
terms of individual human beings. Famine is treated in
similar terms. A priest and a layman lift a corpse that is
hidden from sight. The poignancy of this person's death
is apprehended through the expressive faces of three
women and through the compassion with which a man
spreads his hand across the tense shoulders of a little boy.

Both lavis and aquatint were used in this print. On the
sky a pale, even tone of lavis underlies the dark, coarse-
grained aquatint that, except for parts of the figures,
covers the rest of the image. The white cloak was burn-
ished to soften the etched folds.

155–157
Desastres 55 (37)
Lo peor es pedir (The worst is to beg)
D. 174, H. 175, B. 157, Hof. 199
155 × 205 mm.
Lower left in the plate: *Goya*

155
Preparatory drawing for the print
Red chalk over pencil. 172 × 219 mm.
Watermark: Griffin
Museo del Prado, Madrid. 147

156
Working proof, Harris I, 2
Etching and lavis
No watermark
Coll.: Carderera; Stirling-Maxwell
Museum of Fine Arts, Boston. 1951 Purchase Fund.
51.1676

157
First (posthumous) edition, Madrid, Academia, 1863
Harris III, 1, a, special set
Etching and lavis
No watermark
Museum of Fine Arts, Boston. Harvey D. Parker
Collection. (1911 Purchase). M21914 55/80

The French occupation of Madrid during almost the
entire period of 1808–1814 forced coexistence. Inevitably
there was collaboration in great and small matters, will-
ingly and unwillingly. "It was not uncommon for a girl
to marry a French officer or a French employee of the
French administration."[1] In the drawing such a young
woman openly takes the arm of a French soldier, while
in the print a different soldier waits for her in the
background.

In the working proof her isolation and her bowed
head suggest her vulnerability. Goya handled the lavis
with mastery. It emphasizes the fresh, white dress and
charming bonnet so that her cleanliness and plumpness
seem indecent when set against the starving misery of
her fellow citizens.

In the 1863 edition the ink left on the plate diminishes
the tonal contrasts. The girl's dress is now gray, and the
full meaning of the print is impossible to grasp.

1. Lovett, *Napoleon,* vol. 2, p. 743.

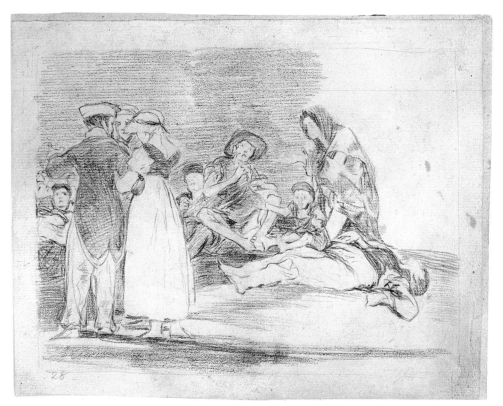

155

156

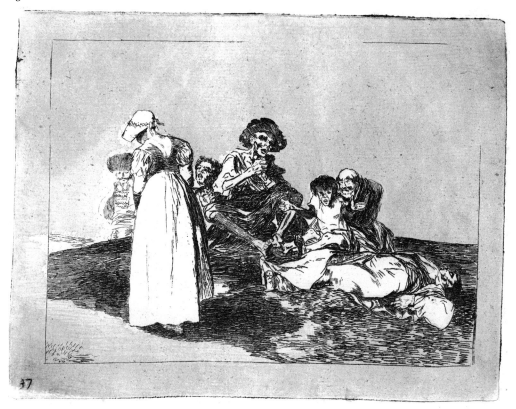

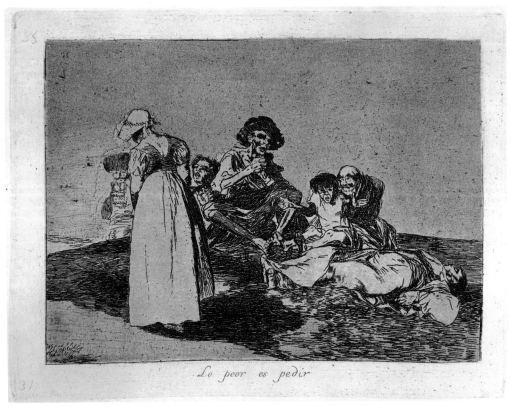

Lo peor es pedir

157

158

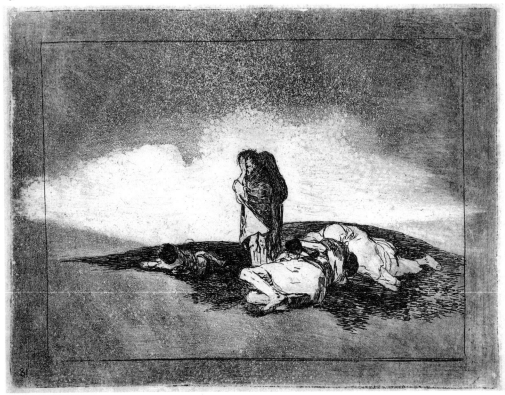

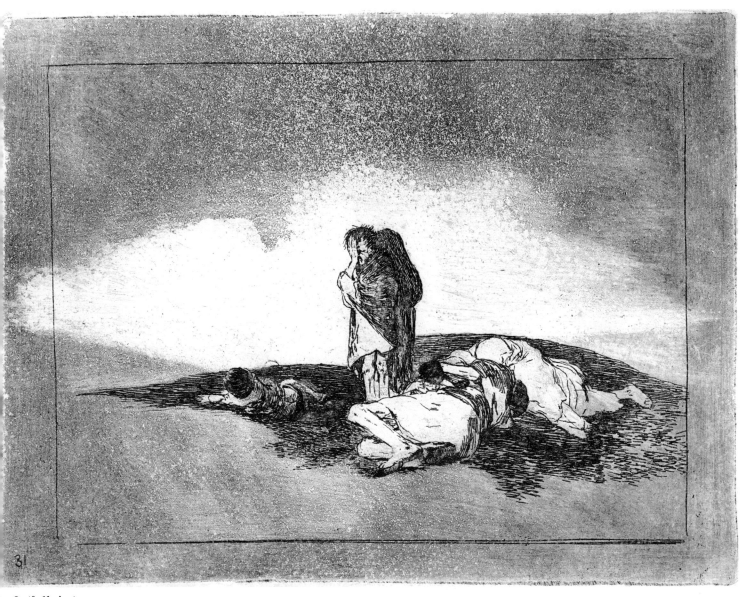

158 (full size)

158

Desastres 60 (31)

No hay quien los socorra (There is no one to help them)

D. 179, H. 180, B. 162, Hof. 204

150 × 205 mm.

Working proof, Harris I, 2
Etching and burnished aquatint
No watermark
Coll.: Carderera; Stirling-Maxwell
Museum of Fine Arts, Boston. 1951 Purchase Fund.
51.1681

The design of this print is extremely simple, and yet it shows Goya's ability to make us keenly aware of the thoughts and emotions of his subjects. Here they vividly express their total isolation and hopeless misery.

The aquatint appears to have been applied completely over the entire plate and the pale figures drawn out of it by scraping and burnishing. The light area of sky was in part stopped out and in part burnished. The roughness with which this was done underscores the starkness of the content.

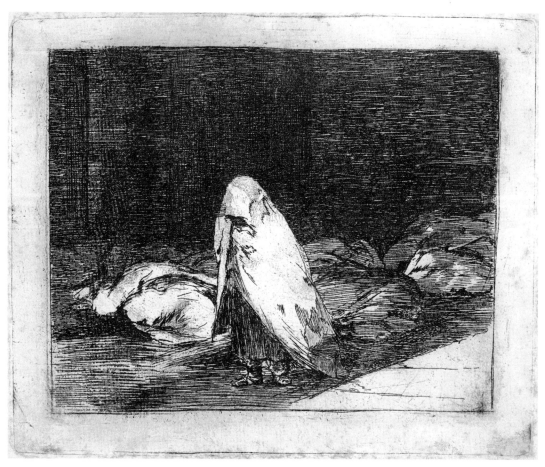

159

159

Desastres 62

Las camas de la muerte (The beds of death)
D. 181, H. 182, B. 164, Hof. 206
175 × 220 mm.
Working proof, Harris I, 1
Etching; touched with graphite (?)
No watermark
Coll.: Carderera; Stirling-Maxwell
Museum of Fine Arts, Boston. 1951 Purchase Fund.
51.1683

The style of the drawing (Prado 154, not in exhibition), the paper used for it, and the technique of the print are characteristic of the *caprichos enfáticos*.[1] Because the bodies are only implied and we cannot see the woman's face, the print is an almost abstract commentary on death.

This impression of the first working proof has been extensively shaded with graphite on the shrouded corpses and on the old woman covering her face. In the finished state (not in exhibition), Goya carried out these changes with further etching and with lavis which darkened all but the cloak of the old woman. Her figure, compressed into a smaller volume, gains in its feeling of abandonment

1. The drawing is on paper with the watermark "Olva," which is associated with the drawings for the *caprichos enfáticos*.

The Prisoner

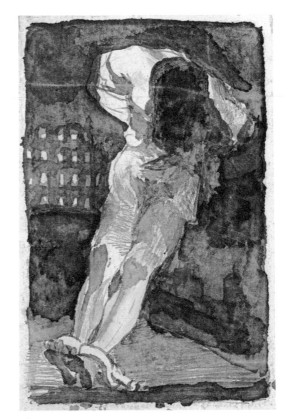

160

160–161

La seguridad de un reo no exige tormento (The custody of a criminal does not call for torture) about 1810
D. 32, H. 27, B. 263, Hof. 240
115 × 85 mm.

160

Preparatory drawing. Pen, brush, and brown ink over red chalk
Verso rubbed with red chalk
106 × 71 mm.
No watermark
Coll.: W. G. Russell Allen
Museum of Fine Arts, Boston. Bequest of W. G. Russell Allen. 1974.223

161

Posthumous impression, ca. 1859. Harris III
Etching and burin
No watermark
Coll.: Gottfried Eissler; W. G. Russell Allen
Museum of Fine Arts, Boston. Bequest of W. G. Russell Allen. 1974.246

161

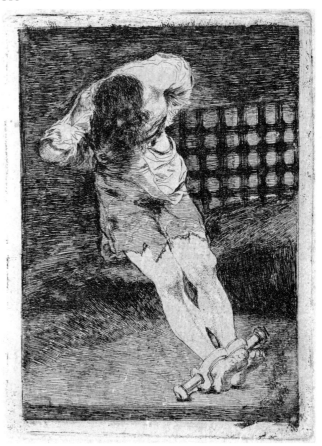

In the mock-up set of the *Desastres* that Goya gave to his friend Juan Agustín Ceán Bermúdez so that the titles might be corrected, the lettered title page states that there are eighty-five prints. Three of these, small prints of prisoners, were not bound like the other working proofs into the volume, but were pasted in at the end. Titles were inscribed in chalk in the lower margins. One is a unique contemporary impression of the present print. The other two were inscribed "The custody is as barbarous as the crime" (*tan barbara la seguridad como el delito*) and "If he is guilty, let him die quickly (*Si es delinguente, qᵉ muera presto*).

Three drawings of prisoners, in pen, brush, and brown ink over a slight red chalk sketch, are on small pieces of Netherlandish paper.[1] Two of them, the present drawing and that for "If he is guilty, let him die quickly"

1. The other two are in the Prado, nos. 388 and 389 respectively. In my opinion two additional Prado drawings, nos. 386 and 387, are not by Goya.

were transferred to the plate by the orthodox method of rubbing the verso with red chalk and incising the outlines with a pointed implement. The resultant image in the print is therefore reversed.

The delicate modeling of the figures and the closely laid lines of etching in the background are related in style to three *Desastres* etched about 1810 whose drawings are also in pen, brush, and brown ink, and in reverse (cat. nos. 108, 113–114, and 136–137). The plates for the *Prisoners* are slightly irregular in shape and of uneven size.

Goya's titles on the three small prints suggest that they were not in the beginning conceived as war prints. Carlos III had been against the use of torture either to exact a confession from the accused or during his prison term. By 1810 the public was increasingly critical of its continued use by judges and jailors.[2] Both the 1808 Constitution imposed by Napoleon and the 1812 Constitution of Cádiz contain articles expressly forbidding torture.[3] A year earlier the Spanish constitutional convention discussed the abolition of torture in language strikingly close to that of Goya's titles.[4]

2. Enrique Tierno Galván (ed.), *Actas de las Cortes de Cádiz* (Madrid, 1964), vol. 1, pp. 52–57.

3. Pierre Conard, "La Constitution de Bayonne (1808)," *Bibliothèque d'histoire moderne*, vol. 2, fasc. 4 (Paris, 1910), article 133. *Constitucion politica de la monarquia española promulgada en Cádiz a 19 de Marzo de 1812* (Cádiz, 1812), article 303.

4. Tierno Galván, ibid.

The Tauromaquia

Goya was seventy years old when in 1816 he offered to the public a set of prints: *Treinta y tres estampas que representan diferentes suertes y actitudes del arte de lidiar los Toros, inventadas y grabadas al agua fuerte en Madrid por Don Francisco de Goya y Lucientes* (Thirty-three prints which represent different maneuvers and positions in the art of contesting with bulls, invented and etched in Madrid by Don Francisco de Goya y Lucientes).[1] The title *Tauromaquia* (The bullfight), which is customarily used for Goya's series on bullfighting, came into general use later in the nineteenth century. The prints could be bought at a print shop facing the Conde de Oñate's house on the Calle Mayor, for 300 reales the set, or 10 reales singly—no more than the average price paid for any uncolored etching of comparable size then sold in Madrid.

Goya's was not the first set of Spanish prints on bullfighting; its important predecessor was a series of twelve hand-colored etchings, designed, executed, and published by Antonio Carnicero in 1790, together with the title: *Coleccion de las principales suertes de una corrida de toros* (Set of the principal maneuvers in a bullfight). Carnicero showed the pent-up bull suddenly freed and charging into the ring with full force (No. I); the mounted picador (pike man) against whose *pic* (pole with a very short steel point) a brave bull is willing to hurl himself repeatedly, straining with the powerful muscles of his neck to lift and toss both horse and rider—and often succeeding (Nos. II–V)—the occasional bull who proves an unworthy adversary killed by dogs (No. VI); the *torero* (fighter on foot), running to the bull and placing pairs of *banderillas* (harpoon pointed darts ornamented with banderols) in the crest of his neck from which the bull tries to free himself, thus further tiring his neck muscles (Nos. VII–VIII); and then the matador (full-fledged fighter who will kill the bull), or to use the eighteenth century term, the *primera espada* (first sword). Carnicero showed him inducing the bull to bend his head

down low; then reaching with his sword across the murderous horns to pierce through the spinal column into the aorta with one thrust so that the bull will die instantly (Nos. IX–XI). The set ends with the animal's body dragged from the ring by mules (No. XII).[2]

Simple, graphic, and enormously popular, these prints were many times copied and recopied. For foreigners they served as a simple introduction to the art of bullfighting, and as early as 1797 were pirated in France, by 1803 in Italy, and by 1808 in England. Printmakers elaborated or expanded the set, while artisans adapted the compositions to porcelain, to the decoration of furniture, and to fans.

It is interesting to compare the two artists' work. In Carnicero's hand-colored etchings both figures and animals have the wooden simplicity of gaily painted toys, while the compositions are unstructured and episodic (fig. 6). Goya, in his series, using only the sober tones of etching and aquatint, manages to suggest not only the confused color of an actual bullfight but also that every protagonist is filled with individual vitality and tense emotion. His compositions are controlled; complex patterns of strong dark and light masses are precariously balanced against each other (see cat. no. 191).

Where Carnicero portrayed nothing more than what routinely took place in the ring during a fiesta, Goya's project was far more ambitious. In the *Diario de Madrid* for October 28, 1816, he advertised his etchings as: "Collection of prints, invented and etched by Don Francisco Goya, Court Painter to His Majesty, wherein are represented diverse maneuvers with bulls . . . an idea being given in the series of prints of the origin, the growth, and the present state of the said fiestas in Spain, which will be self evident without an explanation solely by looking at the plates . . ."[3]

Goya's set differs from Carnicero's even in the section concerned with the "present state of the said fiestas." For one thing, Goya does not withhold the tragedies that may

1. Goya concluded an advertisement for the set in the *Diario de Madrid*, Oct. 28, 1816: "Véndese en el almacén de estampas Calle Mayor, frente a la casa del Exmo. Sr. Conde de Oñate, a 10 rs. vn. cada una suelta y a 300 íd. cada juego completo, que se compone de 33," quoted by P. Beroqui, "La fecha de 'La Tauromaquia' de Goya," *Archivo Español de Arte y Arqueología,* vol. 5, 1929, p. 287.

2. The thirteen plates are reproduced by José María de Cossío, *Los Toros* (Madrid, 1960–), vol. 2, pp. 852–858. Enrique Lafuente Ferrari was responsible for the section of this compendium concerning bullfighting in art.

3. *Diario,* p. 287: "Colección de estampas inventadas y grabadas al agua fuerte por D. Francisco Goya, pintor de Cámara de S. M.

occur: the spectator who dies when a bull leaps into the bleachers (No. 21, cat. no. 184), or the matador, "Pepe Hillo," who in Goya's print lies caught under the horns of the bull, Barbudo, who a moment later will lift him up and kill him (No. 33, cat. no. 199).[4] But there is a second, far more striking difference between the two sets. Where Carnicero's bullfighters were in every case typical, Goya's are not. What he depicts is a series of various extraordinary individuals who performed their brilliant feats, adding their own bravura to an art.

In the October advertisement Goya had claimed that his plates were self-explanatory and needed no titles, that indeed the public would recognize "Martincho," who intentionally does not take advantage of a fundamental aspect of bullfighting, the acquisition of a pragmatic knowledge of how a particular bull will behave. He sits instead on a chair, hat in one hand, sword in the other, legs fixed in irons and waits to kill a fresh bull, as it charges into the ring, or himself to die (No. 18, cat. no. 179);[5] or the matador, Pedro Romero, who learned to kill bulls classically and so perfectly that not one of the six thousand he faced in his long career ever managed to mark his body with a single scar (No. 30, cat. no. 191).[6]

However, Goya's selection of contemporary fighters was a very individual one. He omits such prototypical figures as Francisco Romero and Joaquín Rodríguez, "Costillares," who gave to bullfighting the particular form it was to have during the painter's life.[7] Conversely a picador, Manuel Rendón, whose fame rests almost exclusively on Goya's aquatint, is included (No. 28, not in exhibition).[8]

Goya must have sensed almost immediately that

en que se representan diversas suertes de toros . . . dándose en la serie de las estampas una idea de los principios, progreso y estado actual de dichas fiestas en España, que sin explicación se manifiesta por la sola vista de ellas . . ." A second advertisement appeared in the *Gazeta de Madrid* on December 31; see Beroqui, *La fecha*, p. 287. The second text is quoted in full by Harris, vol. 2, p. 449.

4. Cossío, *Los Torros*, vol. 2, pp. 816–820.

5. Ibid., pp. 793–796.

6. Ibid., pp. 810–814.

7. Ibid., vol. 3, pp. 819–820 and 793–800, respectively.

8. Ibid., vol. 2, p. 808, vol. 3, p. 770.

titles could not be dispensed with, because a sheet with a brief description of each subject was printed and sold with the set. Here it must be admitted that we are confronted by the problem of how much we should rely on the printed titles; for as we shall see, these titles were not written by Goya, and in some instances do not conform with what he had intended to represent.

Goya's own titles, pithy, straightforward, personal, are preserved as pencil captions in his handwriting on the lower margins of a set of thirty-three plates owned by the Boston Public Library (cat. no. 184). Only on the prints numbered 30 and 31 are the titles identical with the printed ones he was to authorize. In No. 28 (not in exhibition) where the printed version reads *El esforzado Rendon picando un toro, de cuya suerte murió en la plaza de Madrid* (The valiant Rendón using the pic on a bull, from which *suerte* [maneuver] he died in the Madrid ring), Goya's pencil title is simply *Cornada en el pecho* (Horn wound in the chest), an occurrence that was frequent enough that no identity needed to be assigned to the picador whose horse was thus gored.

On the first print (not in exhibition) Goya gives his title for the series, *Origen de delas* [sic] *fiestas de Toros. Grabadas a la agua fuerte pᵣ Dⁿ Francᶜᵒ Goya, Pintor de Camᵃ del Rey* (The origin of fiestas of bulls. Etched by Don Francisco Goya, Court Painter to the King). On *Tauromaquia* 3 (not in exhibition), which was to appear with the didactic printed title, *Los moros establecidos en España, prescindiendo de las supersticiones de su Alcorán, adoptaron esta caza y arte, y lancean un toro en el campo* (The Moors, settled in Spain, disregarding the superstitions of their Koran, took over this hunt and skill and spear a bull in the countryside), Goya, himself, wrote, *De los moros* (Of the moors).

The printed title for No. 15 (not in exhibition) is *El famoso Martincho poniendo banderillas al quiebro* (The celebrated "Martincho" feinting to place banderillas), but in the pencil version Goya writes with characteristic pride in his native province, *El famoso Aragones Martincho* (The famous Aragonese, "Martincho,"[9] fig. 7). No. 21 (cat. no. 184) the *Desgracias acaecidas en el tendido de la plaza de Madrid, y muerte*

9. Ibid., vol. 2, pp. 789–791.

Fig. 6. Carnicero, *Coleccion de las principales suertes de una corrida de toros,* Plate 10. Boston Athenaeum.

Fig. 8. "Pepe Hillo." Engraved frontispiece to *La Tauromaquia* (Cádiz, 1796). The matador is holding a watch, since on one notable occasion he substituted it for a cape. Private collection.

Fig. 7. *El famoso Aragones Martincho,* Goya's title to *Tauromaquia* 15. Boston Public Library.

del alcalde de Torrejon (Unhappy accident in the bleachers of the Madrid ring and death of the mayor of Torrejón) is inscribed, *Salto el toro al tendido y mato à dos. Yo lo vi* (The bull jumped into the bleachers and killed two. I saw it).

Fewer individuals are identified in the handwritten titles than in the printed ones—probably because Goya still clung to the idea that anyone who knew bullfighting would recognize the man from the exploit: Mariano Ceballos, for example, on horseback, killing a bull with a dagger (No. 23, cat. no. 187).[10] In No. 16 (cat. no. 176) however, where a bull is forced to make a circular turn by a fighter, the printed title names him as that same "Martincho" mentioned above, whereas the pencil inscription describes him as *El famoso Mamon* (The famous "Mamón"), who would often divert the public with various clownish acts as he fought.

The Boston Public Library set raises various questions. How did it happen, to take No. 16 as an example, that "Mamón," with his love of buffoonery, was transformed at the last moment into the more serious fighter "Martincho"? And who rewrote Goya's succinct titles, turning them into the wordy but instructive text that was sold with the set of prints?

The documentary evidence of what happened exists. Goya had taken a sheaf of the thirty-three plates, to which had been added a thirty-fourth, *Modo de volar* (Way of flying) to his friend, Juan Agustín Ceán Bermúdez and asked him to edit the title and inscriptions. This set, now privately owned in Madrid, was acquired by Valentín Carderera, the famous collector of Goya's graphic work. It contains the title carefully, almost professionally, written in pen: *Treinta y tres Estampas, que representan diferentes suertes y actitudes del arte de lidiar los Toros, y una el modo de poder volar los hombres con alas. Inventadas, diseñadas y grabadas al aquafuerte por el Pintor original D. Francisco de Goya Y Lucientes En Madrid* (Thirty-three prints which represent different *suertes* and positions in the art of contesting with bulls and one of the ways in which men can fly with wings. Invented, drawn, and etched by the original painter, Don Francisco de Goya y Lucientes. In Madrid).

10. Ibid., vol. 2, p. 805.

This is followed by another set of titles for the prints that lie between Goya's pencil inscriptions and the printed explanations of the subject matter. Carderera added his own note to the set, and it is he who tells us: *Este egemplar es el que Goya entregó a D. Agⁿ Cean Bermudez pⁿ redactar el titulo y epigrafes . . .* (This copy is the one which Goya gave to Don Agustín Ceán Bermúdez to edit the title and the inscriptions). Further on, he describes these intermediary titles as *la explicacⁿ escrita por el hijo de Cean Bermudez segun le dictaba su Padre* (the explanation written down by the son of Ceán Bermúdez as his father dictated it). (For the complete Spanish text of Goya's and Ceán Bermúdez's titles, see Appendix to this introduction).

One may well believe Carderera. The brevity and power of suggestion that is so characteristic of the titles Goya gave his drawings and prints is almost nonexistent. On the other hand, the literary style of the second text, alien to Goya, is what one might expect from the art historian, Ceán Bermúdez. For example, No. 10 (cat. no. 173), *Carlos quinto, en la Plaza de Valladolid* (Carlos the fifth in the Valladolid plaza) was expanded to *Carlos V mata un Toro de una lanzada en la plaza de Valladolid en las fiestas de Toros, que se celebraron allí por el nacimiento de su hijo Felipe II* (Carlos V kills a bull with one spear thrust in the plaza at Valladolid at the fiestas of bulls which were celebrated there at the birth of his son, Felipe II).[11] No. 16 (cat. no. 176), *El famoso Mamon,* remained "Mamón" for the time being, although Bermúdez made the title more descriptive, *El esforzado Mamon vuelca un Toro en la de Madrid* (The valiant "Mamón" makes a bull turn in the [ring] at Madrid).

In addition to rewriting all but two of Goya's titles, Nos. 30 and 31, Ceán Bermúdez, with his respect for history, did not confine his editing to the titles but in addition gave the plates a different order. Throughout the set the etched numbers were scraped from the paper and different ones pasted neatly onto the sheets. He seems to have had two objectives. The first was to give Goya's sequence of "the origin" and "growth" of bullfighting the accuracy it lacked. Thus it is scarcely surprising to find that Ceán Bermúdez put Goya's No. 11, *El Zid*

11. Ibid., vol. 2, pp. 779–783.

ampeador, Ruy Díaz de Vivar, the legendary "Champion Lord" who died in 1099,[12] well before Goya's No. 10 *Carlos quinto*, Emperor of the Holy Roman Empire who died in 1558. The second objective was to give the prints concerning "the present state of the said fiestas" a more logical order.

There is no indication that Goya raised any objection to Ceán Bermúdez's changes in the titles. The artist also dropped his thirty-fourth print *Modo de volar* (Way of flying) from the series, presumably at the urging of his friend and editor. But as to the original numbering Goya proved adamant. He would not change it, if for no other reason than that he was unwilling to go to the expense of having his numbers burnished from the copper plates and replaced with new ones. Prior to the printing of the explanations, further textual refinements and one change were made. The identity of "Mamón" in No. 16, which lies in the middle of a group of prints representing "Martincho," was altered for the sake of conformity to that of the later fighter. At least two persons seem to have preferred the plates in Ceán Bermúdez's more logical order. One such set, with a copy of his intermediary titles is in the Ashmolean Museum at Oxford. A second set is included in the exhibition (cat. no. 162).

During Goya's lifetime his 1816 set of prints was to attain none of the wide popularity of Carnicero's earlier, uncomplicated work. Probably it was not so much the startling compositions and the great sophistication of style in Goya's thirty-three prints that kept them from a similar public acclaim, but the difficulty of their content. For his work could not then, nor can it now, be understood without a considerable knowledge of the beginnings of bullfighting and of its development into an art.

One may assume that foreigners, with their lack of experience in watching ordinary bullfights, had difficulty in comprehending the unusual feats executed by fighters in Goya's day, but one might suspect that the earlier plates—those concerned with "the origin" and "growth" —were difficult for the majority of Spaniards as well. For Goya goes beyond the mere illustration of the history of the art. Implicit in his work are many of the contemporary speculations and controversies as to the true origins of bullfighting.

Von Loga noted that the published titles were related to passages in a brief history of bullfighting *Carta histórica sobre el origen y progresos de las fiestas de toros en España* (Historical paper on the origin and progress of the festival of bulls in Spain) published in Madrid, 1777, by the poet Don Nicolás Fernández de Moratín.[13] The author was the father of Goya's close friend, the playwright Don Leandro. Classicists liked to trace bullfighting back to the Romans, who sometimes pitted a man and a bull against one another. Don Nicolás rejected this proposition.[14] For him it began in Iberia. In the first centuries, he writes, Spaniards hunted bulls *à pie, y a caballo en batidas, y cacerías* (on foot, and on horse in drives and hunts), phrasing that in effect sums up the published titles of Goya's first two plates[15] (see Appendix). He also argued that, since in any region where both ferocious beasts and men of great natural courage abound, humans have baited and played the animals they hunted, therefore this must have occurred in Spain, where the ferocity of the wild bulls peculiar to this peninsula and the valor of her men had been fabled since the most remote antiquity.[16]

13. Valerian von Loga, *Francisco de Goya* (Leipzig, n.d.), *Meister der Graphik,* vol. 4, pp. 31 ff.

14. Moratín, *Carta,* pp. a2 verso–a3 recto: "Las Fiestas de Toros conforme las executan los Españoles, no trahen sus origen, como algunos piensan, de los Romanos; à no ser que sea un origen muy remoto, desfigurado, y con violencia; porque las Fiestas de Aquella Nacion en sus Circos, y Amphiteatros, aun quando entraban Toros en ellas, y estos eran lidiados por los hombres, eran con circunstancias tan diferentes, que si en su vista se quiere insistir en que ellas dieron origen à nuestras Fiestas de Toros, se podrá tambien afirmar, que todas las acciones humanas deben su origen precisamente à los antiguos."

15. Moratín, *Carta,* pp. a4 recto–verso.

16. Moratín, *Carta,* pp. a3 verso–a4 verso: "La ferocidad de los Toros que cria España en sus abundantes Dehesas, y salitrosos pastos, junto con el valor de los Españoles, son dos cosas tan notorias desde la mas remota antigüedad . . . haviendo en este terreno la prévia disposicion en hombres, y brutos para semejantes contiendas, es muy natural que desde tiempos antiquisimos se haya exercitado esta destreza, yá para evadir el peligro, yá para obstentar el valor, ò yá para buscar el sustento con la sabrosa carne de tan grandes reses, à las quales perseguirian en los primeros siglos à pie, y à caballo en batidas, y cacerías."

12. Ibid., vol. 2, p. 783.

Because so many of the printed titles bear a similar relationship to Don Nicolás' *Carta histórica,* it has been suggested that Goya's initial intention was to illustrate this work, an idea that has found acceptance among scholars. Yet when one reexamines the prints themselves, keeping in mind Goya's manuscript titles and the role played by Ceán Bermúdez, the suggestion seems less convincing. On No. 1 (not in exhibition), Goya wrote *Origen de delas* [sic] *fiestas de Toros* (Origin of the fiestas of bulls) and on No. 2 (cat. no. 166) *Lo mismo* (The same). What he represents are bulls overpowered by rough-looking hunters who have singled out their prey from roaming herds. They neither bait nor play the animals. In his imagery, Goya is closer to another book on bullfighting, *Tauromaquia, o arte de torear á caballo y á pie* (The bullfight, or the art of contesting bulls, mounted and on foot), Madrid, 1804. This was the second edition of a short manual originally published in Cádiz in 1796, as by the great matador, "Pepe Hillo," though it is believed to have been written for him by Don José de la Tixera[17] (fig. 8). After the matador's death the book was rewritten and expanded for the 1804 edition by the same extremely knowledgeable author. It was his opinion that the Spaniards simply hunted wild animals (including bulls) in the mountainous regions as Goya shows them doing.[18] For "Pepe Hillo" bullfighting did not begin until the Moors had conquered Spain, began to practice it in their principal courts, and made it a spectacle worth seeing.[19]

Goya devotes the next six plates to the Moors. Here he depends principally on Moratíns's text. They begin to play the bull on foot with *el Albornóz, y el Capellar* (the burnoose and the cloak)[20] (Nos. 6, not in exhibition and 4, cat. no. 167). In the latter following the "Pepe Hillo" text, Goya shows the Moors exercising their skill in an enclosed area where an audience can watch.[21] These two elements were prerequisites for the development of the spectacle. We learn from both texts that the men who played and killed the bulls belonged to the high nobility, and that it was in the most polished courts of Europe that they performed what Moratín calls their *gentilezas* (graces).[22] Goya had little interest in the historical accuracy of costume, and one cannot help but observe that the low turbans and clothing have a very strong resemblance to the dress worn by Napoleon's Moorish Mameluke troops in Goya's *El 2 de mayo, 1808,* painted in 1814.[23]

Both the authors tell us that by the twelfth or thirteenth century the Christians had adopted the pastime from the Muslims.[24] Gradually, as mounted nobles fought, it took on something of the character of a tournament. The finest bulls were brought from the Sierra de Ronda to be worthy opponents of the knights (a concept so basic to bullfighting that the art has been said to have begun at that moment). Each knight dedicated his prowess to a lady and wore her colors. There were servants on foot to hold his gear and assist him; but he, himself, fought mounted on the finest possible horse, choosing for weapons either a spear such as used in hunting, or a *rejón* (short spear).[25] Both Moratín and the "Pepe Hillo" writer list various well-born Christian practitioners of this form of bullfighting, among them Carlos V, who killed a bull with one blow at a fiesta held

17. Cossío, vol. 2, pp. 59–63. The author of the *Tauromaquia* is given as Josef Delgado, the real name of "Pepe Hillo."

18. "Pepe Hillo," *Tauromaquia,* 1804, p. 3: "siendo muy equívoca y violenta qualquiera otra que se pretenda fixar con antelacion á ella, pues aunque se refieren algunos hechos de los toros con mucha anticipacion, no fuéron otros que algunos pequeños encuentros que tuvieron los Españoles dedicados á las batidas y cacerías de reses en el monte, y ninguno de ellos merece el nombre y formalidad de expectáculo, que es precisamente de lo que se trata."

19. Ibid., p. 2: "no cabe la mas pequeña duda en que los primeros á quienes se vió luchar con los toros fuéron los Moros de Toledo, Córdova y Sevilla, . . . cuyas Cortes . . . eran en aquellos tiempos las mas cultas de Europa.

20. Moratín, *Carta,* p. c3 verso.

21. "Pepe Hillo," *Tauromaquia,* p. 5.

22. Moratín, *Carta,* p. a8 recto: "huvo diestrisimos Caballeros que executaron gentilezas con los Toros (que llevaban de la Sierra de Ronda) en la Plaza de Bibarrambla, y de estas hazañas están llenos los Romanceros, y sus Historietas.

23. Prado 748.

24. Moratín, *Carta,* pp. a4 verso–5 verso. "Pepe Hillo," *Tauromaquia,* p. 2.

25. Moratín, *Carta,* pp. a4 verso; a8 recto and verso; c3 verso. "Pepe Hillo," *Tauromaquia,* pp. 4–6.

Valladolid to honor the birth of his son and heir (cat. no. 173).[26]

Despite its courtliness, the bullfighting of this era lacked form. The number of blows a knight might give in killing his bull was no more limited than in a boar hunt. If he did not prove sufficiently expeditious, the *canalla* (rabble, Ceán Bermúdez' term) was allowed to come down from the stands with hamstringing spears, javelins, swords, or even sticks to finish off the animal.[27]

It is hardly surprising that neither writer considered the bullfighting of that period a true art. To them no such term was justified until the eighteenth century, when the nobility began to withdraw from their privileged pasttime and common men took it over as a profession.[28]

Herdsmen, with their long working goads were brought in from the ranges. No longer mounted on the highly trained, obedient horses used by the nobility, these new picadors lured the bull into hurling himself repeatedly against a pic, not to injure or to kill him, but to make him waste his strength, especially in the great muscles of his neck.

Toreros fought the bull on foot, and for the first time *cara a cara, y á pie firme* (face to face, and with steadfast foot), as both writers put it.[29] *Toreros* learned to place pairs of *banderillas* with great accuracy in a bull's withers so that as he tossed his head to shake them loose his neck became further fatigued; they learned to value skill and precision;[30] to fight together with picadors as a team; and they learned to gauge not only the temperament and character of each individual bull but also to sense the changes in his state of mind as the contest progressed so that the bullfighter knew when and at what point the various *suertes* and passes would be advisable. The bullfighter learned to impose his human will on a wild animal, so

that at the precise moment he chose, the bull would lower his head and the matador could reach across the horns, and with one sword-thrust pierce through to the vital aorta, the bull then dying instantly.

If skill and knowledge were essential to a bullfighter, no less so, the "Pepe Hillo" writer tells us, was his ability to preserve the serenity of his mind, will, and spirit when facing mortal danger.[31] These disciplined eighteenth century commoners transformed the spectacle into an art. It was as artists that bullfighters came to have passionate adherents. Paris might be divided by its two rival composers, Gluck and Piccinni, but Madrid at the end of the eighteenth century was split from top to bottom by the graceful, foolhardy brilliance of Pepe Hillo (No. 33, cat. no. 199) versus the informed intelligence of Pedro Romero (No. 30, cat. no. 191).

Goya's pictorial history of bullfighting is personal, cogent, ambitious, faulty, and beautiful. Yet it is also worth noting that if he could not, during Fernando VII's oppressive reign, publish etchings of the stunning achievement of ordinary men during the war for the liberation of Spain, Goya could and did publish the *Tauromaquia*. Here, plainly to be seen by anyone with sufficient knowledge, are commoners taking a pasttime from the nobility and transforming it into a great art.

It is interesting that in the mock-up copy of the *Tauromaquia*, given by Goya to his friend Ceán Bermúdez to edit, the thirty-fourth print is described on the title page as: *el modo de poder volar los hombres con alas* (the way men can fly with wings) and in the table of contents as *34. Modo de volar* (Way of flying). A working proof of the same print belonging to the Fundación Lázaro Galdiano is inscribed in Goya's hand with the same title (cat. no. 201). The print shows five winged men circling through the air. Cataloguers of Goya's work have always included it in his series of *Disparates* (Follies), although, unlike other plates in the set, no working proof is known with any such title.

In contrast to Goya's flying warlocks and witches who (when not borne aloft by other creatures) are literally self-propelling, these men use their legs to pump the great wings attached to their bodies. Their apparatus

26. Moratín, *Carta*, p. b1 recto. "Pepe Hillo," *Tauromaquia*, p. 8.

27. Moratín, *Carta*, pp. c2 recto–verso. "Pepe Hillo," *Tauromaquia*, p. 6.

28. Moratín, *Carta*, pp. c4 recto–c5 recto. "Pepe Hillo," *Tauromaquia*, pp. 11–13.

29. Moratín, *Carta*, p. c4 verso. "Pepe Hillo," *Tauromaquia*, p. 13.

30. Moratín, *Carta*, pp. c4 verso and c7 recto.

31. "Pepe Hillo," *Tauromaquia*, p. 12.

appears to have been suggested by the curious aerial device used by the Viennese clockmaker Jacob Degen from 1808 to 1812. His weight, to be sure, was partly carried by a small balloon, but Degen claimed that this was not really necessary and merely helped him maintain an upright position (see cat. no. 200). The likely explanation for this conjunction of themes is that in bullfighting common men learned to triumph through knowledge, skill, and inner serenity over a tremendously strong, wild member of the animal kingdom; here common men with the same abilities conquer an element of nature.

All the known preparatory drawings for the *Tauromaquia* were made with sanguine chalk, ranging in color from orange to purplish red. Goya sometimes added tone with a stump, and on four sheets he combined sanguine wash with the chalk.

When one sees a drawing that is extremely close to a print by Goya one must be instantly suspicious about its authenticity, for his preliminary studies were never exact models but served him in much the same way as does a writer's rough draft. All of the studies have individuality, immediacy, and freshness, but inevitably between the rougher images and the completed aquatints Goya made major painterly alterations. *Tauromaquia* drawings were, as was Goya's custom, transferred directly to the copper plate in the press.

Goya made use of four kinds of paper for this series of drawings: a rather soft, white paper with vertical laid lines and no watermark; a thin, wove paper, also without watermark, and which had probably been used for another purpose, since every sheet has a vertical fold across which Goya's chalk strokes can be seen to have skipped (see, for example, Prado 218, cat no. 170); a slightly more substantial wove paper with the watermark "Crimaned"; and a good, tough Netherlandish paper with horizontal laid lines and the beehive and firm name of Honig and Zoonen. For a reason which is not apparent, Goya himself pasted at least fifteen of these sheets onto pages cut from a discarded ledger with the watermark of the Spanish papermaker R. Romani. In one instance Goya's drawing includes a portion of the mount, and again and again his swiftly drawn border lines pass freely from drawing sheet to mount and back again.

To an art historian, this mounting is serendipitous, for it provides some evidence as to the date of the drawings, since the ledger had been used for entering the number of trousers and greatcoats issued to soldiers of the French army in Spain. Napoleon invaded the peninsula in 1808, and in the winter of 1813–1814 was obliged to withdraw his defeated forces. Possibly the volume fell into Goya's hands during the course of the Peninsular War, but it is far more likely that such a record was not abandoned by the French until their retreat from Spain.

If Goya was thinking of publishing the *Desastres de la Guerra* early in 1814, it is unlikely that he began a new work, the *Tauromaquia*, before May 4, when Fernando VII's denunciation of the constitution ended any hope of the publication of the war series. Three of the *Tauromaquia* plates are dated 1815, and the set was ready for sale during the final week of 1816. The span of time from their conception to their completion can have been at the most two and one half years. For this reason stylistic differences in the *Tauromaquia* are less dramatic and less decisive than they were in the *Desastres*.

It seems extremely risky to date any print or drawing by Goya purely on stylistic grounds. Nevertheless, as Harris noted, Goya worked on the set in two distinct styles. In one of them, most of the plate is covered with delicate etched hatching, much as he had done in the *Desastres* plates of about 1810, save that the shading is less dense and is composed of smaller, freer patches of shading. The aquatint and lavis, however, are applied in quite a different manner, often covering the whole plate. At times the tone has the almost aggressive darkness of some of the famine scenes in the *Desastres,* where Goya seems to have used aquatint to mask the deficiencies of the copper plates (see for example cat. nos. 153–158). The only dated prints in the series are in this style. That the combination of techniques was not always a happy one is evinced by Goya's abandonment of various plates (cat. nos. 188, 189, 196, and 198). Throughout the series we have seen Goya eliminating irrelevant detail as he worked on compositions and giving focus to disparate elements of a design. In a characteristic plate, the etched composition, loose and episodic, is first covered with heavy aquatint or lavis which is then burnished to the

point where the scene achieves a coherent unity
(cat. nos. 185–187).

The other style, which may well be later, depends far less on etching. Even without aquatint, the designs have force and simplicity and what can best be described as a painterly manner of shading, not unlike the brush-strokes on the canvasses Goya was painting. The aquatint, lighter in these prints, and delicately burnished, is extraordinarily subtle and evocative. Goya was profiting from the "tricks" he had taught himself in working on the *Desastres* plates. It is worth noting that all the prints that treat the art of bullfighting before the eighteenth century are in this style.

Appendix

Titles to the Tauromaquia

GOYA	CEÁN BERMÚDEZ	PUBLISHED
	Treinta y tres Estampas, que representan diferentes suertes y actitudes del arte de lidiar los Toros; y una el modo de poder volar los hombres con alas. Inventadas, diseñadas y grabadas al aguafuerte por el Pintor original D. Francisco de Goya y Lucientes. En Madrid.	Treinta y tres estampas que representan diferentes suertes y actitudes del arte de lidiar los Toros, inventadas y grabadas al agua fuerte en Madrid por Don Francisco de Goya y Lucientes
	Asuntos de las Estampas	
1. Origen de delas [sic] fiestas de Toros. Grabadas a la agua fuerte p.r D.n Fran.co Goya, Pintor de Cam.a del Rey	1. El modo con que los antiguos españoles cazaban los Toros á caballo en el campo	1. Modo con que los antiguos españoles cazaban los toros á caballo en el campo
2. Lo mismo	2. Otro modo de cazarlos á pie	2. Otro modo de cazar á pie
3. De los Moros	3. Los Moros establecidos en España, prescindiendo de las supersticiones de su Alcoran, adoptaron esta caza y arte	3. Los moros establecidos en España, prescindiendo de las supersticiones de su Alcorán, adoptaron esta caza y arte, y lancean un toro en el campo
4. Principio de torear los	4. Comienzan los Moros á capear los Toros en cercado con el albornoz	4. Capean otro encerrado
5. El famoso Moro Gazul	8. El valiente moro Gazul lanzeó con galanteria y destreza	5. El animoso moro Gazul es el primero que lanceó toros en regla
6. Suerte de capa p.r detras	5. Otro capeo de Toros, hecho por los Moros en plaza	6. Los moros hacen otro capeo en plaza con su albornoz
7. Clabar dardos, Origen de las banderillas	6. Los Moros torean con harpones ó banderillas	7. Origen de los arpones ó banderillas

GOYA	CEÁN BERMÚDEZ	PUBLISHED
8. Cogida de un Moro	7. Un Moro es cogido del Toro, lidiando con banderillas	8. Cogida de un moro estando en la plaza
9. Suerte de caballeros Españoles	10. Otro Caballero español, despues de haber perdido el Caballo, mata el Toro á pie con suma gallardia	9. Un caballero español mata un toro despues de haber perdido el caballo
10. Carlos quinto, en la Plaza de Valladolid	12. Carlos V mata un Toro de una lanzada en la plaza de Valladolid en las fiestas de Toros, que se celebraron allí por el nacimiento de su hijo Felipe II	10. Carlos V. lanceando un toro en la plaza de Valladolid
11. El Zid campeador	9. El Cid campeador, el primer Caballero español que alanceó los Toros con esfuerzo	11. El Cid Campeador lanceando otro toro
12. Desgarretar	14. Desjarrete de la Canalla con lanzas, medias-lunas, banderillas y otras armas	12. Desjarrete de la canalla con lanzas, medias-lunas, banderillas y otras armas
13. Quebrar rejones	13. Un Caballero en plaza quebrando rejoncillos	13. Un caballero español en plaza quebrando rejoncillos sin auxilio de los chulos
14. El famoso estudiante de Falzes	15. El diestrisimo y famoso Estudiante de Falces, embozado burlando al Toro con sus quiebros	14. El diestrísimo estudiante de Falces, embozado burla al toro con sus quiebros
15. El famoso Aragones Martincho	16. El insigne Martincho poniendo banderillas al quiebro	15. El famoso Martincho poniendo banderillas al quiebro
16. El famoso Mamon	19. El esforzado Mamon vuelca un Toro en la de Madrid	16. El mismo vuelca un toro en la plaza de Madrid
17. Palenque con Borricos	11. Palenque que hacia la Canalla con burros para defenderse de los Toros	17. Palenque de los moros hecho con burros para defenderse del toro embolado
18. Matar sentado, con grillos	17. Temeridad del mismo Martincho en la plaza de Madrid	18. Temeridad de Martincho en la plaza de Zaragoza
19. Saltar el toro con grillos	18. Otra locura del propio Martincho en la de Zaragoza	19. Otra locura suya en la misma plaza
20. Saltar el toro con palo	20. Ligereza y atrevimiento de Juanito Apiñani, alias el de Calahorra tambien en la de Madrid	20. Ligereza y atrevimiento de Juanito Apiñani en la de Madrid
21. Salto el toro al tendido, y mato à dos. Yo lo vi	21. Desgracias acaecidas en el tendido de esta plaza, y muerte del Alcalde de Torrejon	21. Desgracias acaecidas en el tendido de la plaza de Madrid, y muerte del alcalde de Torrejon
22. La pajuelera picando	22. Valor varonil de la celebre Pajuelera en la de Zaragoza	22. Valor varonil de la célebre Pajuelera en la de Zaragoza
23. Matar à caballo	23. Mariano Ceballos, alias el Indio mata el Toro desde su caballo	23. Mariano Ceballos, alias el Indio, mata el toro desde su caballo
24. Montar el toro	24. El mismo Ceballos quiebra rejones montado sobre otro Toro, en la de Madrid	24. El mismo Ceballos montado sobre otro toro quiebra rejones en la plaza de Madrid
25. Suerte de Perros	28. Perros	25. Echan perros al toro

GOYA	CEÁN BERMÚDEZ	PUBLISHED
26. Suerte de Picador	25. Caida de un Picador de su caballo debaxo del Toro	26. Caida de un picador de su caballo debajo del toro
27. Picador puesto en Suerte	26. El celebre Fernando del Toro barilarguero obligando á la fiera con su garrocha	27. El célebre Fernando del Toro, barilarguero, obligando á la fiera con su garrocha
28. Cornada en el pecho	27. El esforzado Rendon que murió en esta suerte en la plaza en Madrid	28. El esforzado Rendon picando un toro, de cuya suerte murió en la plaza de Madrid
29. Recortar el toro	32. Pepe-Illo haciendo al Toro el recorte	29. Pepe Illo haciendo el recorte al toro
30. Pedro Romero Matando à toro parado	31. Pedro Romero matando á Toro parado	30. Pedro Romero matando á toro parado
31. Vanderillas de Fuego	29. Vanderillas de fuego	31. Banderillas de fuego
32. Suerte de Picador	30. Dos grupos de Picadores arrollados en el suelo de seguida por un solo Toro	32. Dos grupos de picadores arrollados de seguida por un solo toro
33. La muerte de el famoso Pepillo	33. Su desgraciada muerte en la plaza de Madrid	33. La desgraciada muerte de Pepe Illo en la plaza de Madrid
———	34. Modo de volar	———

Asuntos de las Estampas.

1. El modo con que los antiguos españoles cazaban los Toros á caballo en el campo.
2. Otro modo de cazarlos á pie.
3. Los Moros establecidos en España, prescindiendo de las supersticiones de su Alcoran, adoptaron esta caza y arte.
4. Comienzan los Moros á capear los Toros en cercado con el albornoz.
5. Otro capeo de Toros, hecho por los Moros en plaza.
6. Los Moros torean con harpones ó banderillas.
7. Un Moro es cogido del Toro, lidiando con banderillas.
8. El valiente moro Gazul lanceó con galantería y destreza.
9. El Cid campeador, el primer Caballero español que alanceó los Toros con esfuerzo.
10. Otro Caballero español, despues de haber perdido el Caballo, mata el Toro á pie con suma gallardia.
11. Palenque que hacía la Canalla con burros para defenderse de los Toros.
12. Carlos V mata un Toro de una lanzada en la plaza de Valladolid en las fiestas de Toros, que se celebraron alli por el nacimiento de su hijo Felipe II.
13. Un Caballero en plaza quebrando rejoncillos.
14. Desjarrete de la Canalla con lanzas, medias-lunas banderillas y otras armas.
15. El diestrisimo y famoso Estudiante de Falces, embozado burlando al Toro con sus quiebros.
16. El insigne Martincho poniendo banderillas al quiebro.
17. Temeridad del mismo Martincho en la plaza de Madrid.
18. Otra locura del propio Martincho en la de Zaragoza.
19. El esforzado Mamon vuelca un Toro en la de Madrid.
20. Ligereza y atrevimiento de Juanito Apiñani, alias el de Calahorra tambien en la de Madrid.
21. Desgracias acaecidas en el tendido de esta plaza y muerte del Alcalde de Torrejon.
22. Valor varonil de la celebre Pajuelera en la de Zaragoza.
23. Mariano Ceballos, alias el Indio mata el Toro desde su caballo.
24. El mismo Ceballos quiebra rejones montado sobre otro Toro, en la de Madrid.
25. Caida de un Picador de su caballo debaxo del Toro.
26. El celebre Fernando del Toro barilarguero obligando á la fiera con su garrocha.
27. El esforzado Rendon que murió en esta suerte en la plaza de Madrid.
28. Perros.
29. Vanderillas de fuego.
30. Dos grupos de Picadores arrollados en el suelo de seguida por un solo Toro.
31. Pedro Romero matando á Toro parado.
32. Pepe-Illo, haciendo al Toro el recorte.
33. Su desgraciada muerte en la plaza de Madrid.

162

62

Bound, pre-publication set of the *Tauromaquia*, 1816
Manuscript title in pen and brown ink:
*Treinta y tres Estampas, / que representan diferentes
suertes y actitudes / del arte de lidiar los Toros. / Inven-
tadas, diseñadas y grabadas al aqua fuerte / por el Pintor
original / D Francisco de Goya y Lucientes. / En Madrid.*
Thirty-three prints which represent different maneu-
vers and positions in the art of contesting with bulls.
Invented, drawn, and etched by the original painter,
Don Francisco de Goya y Lucientes. In Madrid.)
Watermarks: title page: JN GUARROY M; title sheet:
tower with banner.
Sheet size: 282 × 403 mm.
Bound in green marbled boards
Anonymous loan

The titles are taken from Augustín Ceán Bermúdez'
first draft. When necessary, etched plate numbers have
been scraped away and corrected in pen to conform with
this revised order. The paper used for these fine early
impressions, like that in Goya's mock-up set (cat. no. 184),
has no watermark. The Ashmolean Museum, Oxford,
also owns a set with the same titles and numbering, but
on paper with the Serra watermark.

ANTONIO CARNICERO Spain, 1748–1814
163
View of the bull ring in Madrid, 1791
Etching, hand colored
435 × 555 mm.
The Boston Athenaeum

Until the middle of the eighteenth century bullfights
were held in the principal square, which was blocked off
for the purpose, as they continue to be to this day in
towns and villages that cannot afford a permanent ring.

The old Madrid plaza, inaugurated in 1754, is
believed to have been the first permanent ring built in
Spain.[1] At the center of the covered balcony, marked by
its own little spire, is the official box. Directly below
this can be seen, slightly ajar, the outer gate of the *toriles*
(bull pens), where the bull comes through the wooden
barrier and into the ring. The ledge near the bottom of
the boarding is to make it easier for the toreros to jump
over the barrier, as one sees them in Goya's *Tauromaquia*.
The circular *callejón* (alley way) is for the use of fighters.
In the ring, a picador is forcing the bull to tire the
powerful muscles of his neck. Along the side are two
toreros with *banderillas* (harpoon-pointed darts orna-
mented with banderols). The ropes strung between posts
are there to prevent a bull that has jumped over the
barrier from making a second leap into the wooden
bleachers (see cat. no. 184).

1. José Maria de Cossío, *Los Toros* (Madrid, 1960–), vol. 1,
pp. 512–514.

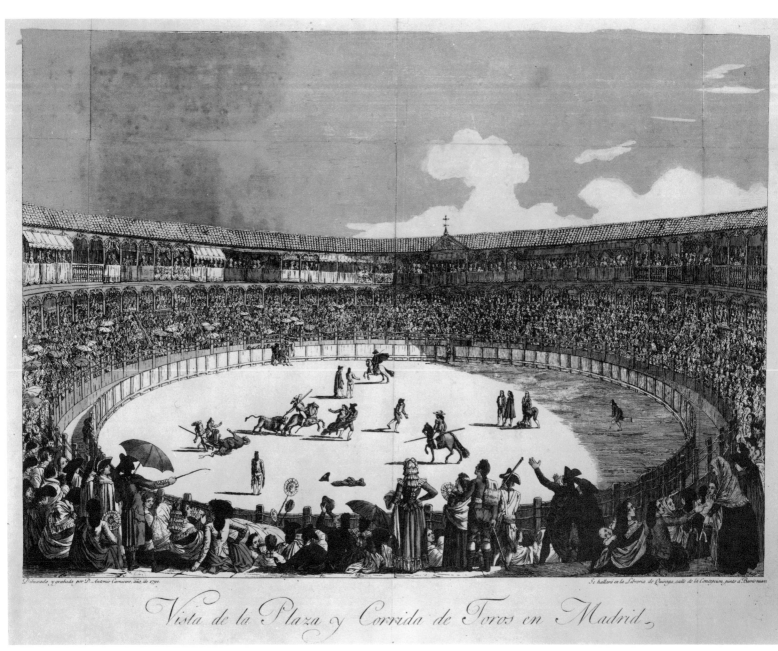

Vista de la Plaza y Corrida de Toros en Madrid.

163

164–166
Tauromaquia 2
Otro modo de cazar á pie (Another way of hunting on foot)
Goya's title: *Lo mismo* (The same)
D. 225, H. 205, B. 208, Hof. 84
245 × 350 mm.

164
Preparatory drawing for the print
Red chalk
181 × 292
No watermark
Coll.: Cabot, José Porter
Anonymous loan

165
Working proof, Harris I, 1
Etching, burin, and drypoint
Coll.: Provôt, Martí
Bibliothèque Nationale, Paris

166
First edition impression, Harris III, 1
Etching, burnished aquatint, drypoint, and burin
No watermark
Museum of Fine Arts, Boston
Bequest of W. G. Russell Allen. 1974.258

164

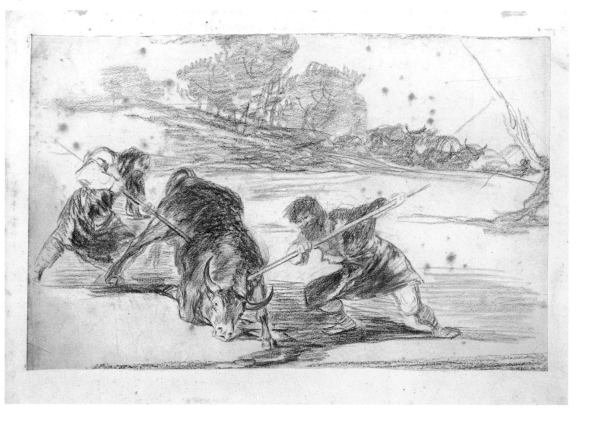

In the eighteenth century there was much agreeable speculation on the origin of Spanish bullfighting. Some traced it to ancient Rome, where men and bulls were sometimes pitted against one another in the arena.[1] Others, having learned that natives living along the Orinoco River played alligators very much as though they were bulls, argued that in any region inhabited by both ferocious animals and courageous men one might expect to discover humans proving their manhood by baiting the wild beasts that they hunted. Since Spain had always been famous for its valiant men and its ferocious bulls ranging the salty peninsular pasture lands, a primitive form of tauromachy must already have been developed before the Roman conquest.[2] Yet another view was that the ancient Spaniards did no more than hunt wild beasts, including bulls, in the mountainous regions and therefore true bullfighting, which is a spectacle, did not exist prior to the Moorish conquest in the eighth century.[3]

This last opinion is in fact what Goya represents: his ancient forebears—rough, brutish-looking hunters—who have separated a bull from a roving herd and transfix him between two spears. Goya's own title *Lo mismo* (The same) in the Boston Public Library set refers back to his title for the first print in the series *Origen de delas* [*sic*] *fiestas de Toros* (The origin of fiestas of bulls).

In the drawings for the *Tauromaquia* Goya used a sanguine chalk that ranges in color from orange to purplish-red. He used the chalk consistently for the *Tauromaquia* drawings, sometimes achieving tone with a stump or using a sanguine wash with the chalk. In this drawing the vigorous, well-defined forms of men and bull contrast with the cursory indication of trees, mountains, and herd of bulls.

Roughly half of the drawings have printing folds. Here they can be seen at the upper right running through the mountain and the sky. The folds and the fact that all of the drawings are in the same direction as the prints, plus the appearance of an occasional plate mark, all suggest that Goya was still transferring his drawings to the copper plate by running both through the press just as he had done in the *Caprichos* and the *Desastres*.

For the *Tauromaquia* as for the *Desastres*, many proofs survive showing the line work only: etching with additions in drypoint and burin. A careful comparison of the working proof with the drawing shows that the three central figures correspond to those in the drawing with respect to size, pose, and positions. In most of the *Tauromaquia* plates, Goya retained from the drawing the carefully elaborated principal figures as the core of his composition.

In the print the hunters are less shaggy and wild looking. The placement of the man at the left has been shifted so that he no longer attacks the bull from an awkward angle. By straightening the other hunter's left leg the entire weight of his body is placed behind the thrust of his spear. The background has changed considerably: the herd and mountain have disappeared. As with the *Caprichos* and the *Desastres*, Goya eliminated or simplified background detail in the transition from drawing to print.

The black printing ink is typical of that Goya customarily used for the working proofs of the *Tauromaquia* and is particularly effective in rendering the crisp, etched lines.

Tones produced by aquatint and occasionally by lavis were added to complete the plates for the first edition of the *Tauromaquia*. In the finished state of this print the aquatint was bitten twice to produce two tones. Delicate burnishing is apparent on the pale tone of the sky, on the medium tone of the foreground, and the middle ground behind the figures. These subtle burnished lights behind the bull and the hunters also serve to focus attention on the struggle, emphasizing the strength still remaining in the bull's body.

The closely etched shading lines on the bull broke down when the aquatint was bitten. The lines broadened and did not hold ink and thus printed unevenly. This happened many times throughout the series. Only the working proof impressions before aquatint show the

1. Nicolás Fernández de Moratín, *Carta historica* . . . (Madrid, 1777), pp. a2 verso–a3 recto.

2. Moratín, *Carta*, pp. a3 recto–a4 verso.

3. "Pepe Hillo," Josef Delgado, *Tauromaquia, o arte de torear* . . . (Madrid, 1804), p. 3.

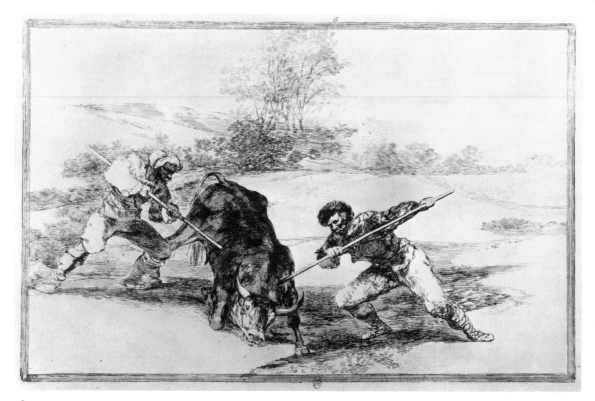

165

166

164 (full size detail) 166 (full size detail)

etched lines in their full crispness and clarity.

The plate is executed in what seems to be Goya's later style for the *Tauromaquia*. The figures are large in scale, grouped together at the center of the design, and few in number; the setting is simple and does not detract from the central action. The lighting pattern is broad, accomplished mainly by the burnishing of a medium tone of aquatint. A wide borderline composed of parallel etched lines frames the image.

First edition impressions are printed on two Spanish papers: the earlier ones with the watermark "Serra" and the later ones with the watermark "Morato." The former are to be found printed in a greenish-black ink and the latter in brownish-black.

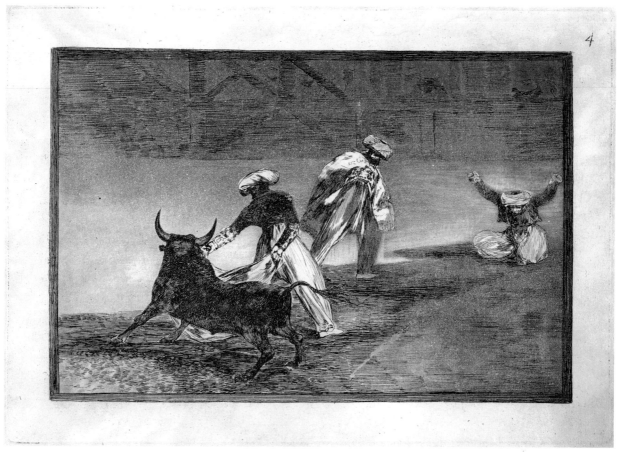

167

167
Tauromaquia 4
Capean otro encerrado (They bait another in an enclosure)
Goya's title: *Principio de torear los* (The beginnings of fighting them)
D. 227, H. 207 ,B. 210, Hof. 86
245 × 350 mm.
First edition impression, Harris III, 1
Etching, burnished aquatint, drypoint, and burin
No watermark
Museum of Fine Arts, Boston
Bequest of W. G. Russell Allen. 1974.260

Wild bulls had been tracked down primarily for food. Because there is little in hunting that attracts spectators, the "Pepe Hillo" book did not dignify it as bullfighting. It was not until after the Moorish conquest of Spain that their noblemen, belonging to the very elegant and sophisticated courts of Toledo, Cordova, and Sevilla played bulls before their well-born friends to demonstrate their courage and skill. It was then, we read, that true bullfighting began.[1]

Goya shows a Moor in the dress of the artist's own day, using what appears to be a shawl to execute a very specific pass, *suerte de espaldas* (maneuver from behind). Goya may never have read the main body of the "Hillo" text because it deals with the technique of fighting, which he understood very well. Certainly he was not aware that "Pepe Hillo" was credited with the invention of this pass.[2] Yet Goya succeeded brilliantly in suggesting what was important—the modest beginnings of what became an extraordinary art, awkwardly practiced at first, on a nervous, eager, little bull.

The aquatint is handled like that in *Otro modo de cazar á pie* (cat. no. 166). The area around the figures and the bull is burnished to create a patch of light that draws them together and frames them. The burnishing around the two Moors at the right is particularly effective in that it suggests the fluidity of their movements.

A long curving scratch occurred in the lower right corner of the plate which Goya only partially burnished away. Traces of it are still apparent under the aquatint.

1. "Pepe Hillo," *Tauromaquia,* pp. 2–3.
2. Ibid., p. 65. Cossío, *Los Toros,* vol. 2, pp. 772–775; Enrique Lafuente Ferrari was responsible for the section on art.

168–169

Tauromaquia 9

Un caballero español mata un toro despues de haber
perdido el caballo (A Spanish noble kills a bull after
he has lost his horse)

Goya's title: *Suerte de caballeros Españoles* (Maneuver
of Spanish nobles)

D. 232, H. 212, B. 215, Hof. 91

Signed in plate lower left: *Goya*

245 × 350 mm.

168

Working proof, Harris I, 1
Etching and burin, borderline partially cut
No watermark
Coll.: Lhardy, Provôt, Gobin, Philip Hofer
Museum of Fine Arts, Boston. Gift of Mrs. Marshall
Dwinnell, and the M. and M. Karolik Fund. 1973.704

169

First edition impression, Harris III, 1
Etching, burnished aquatint, and burin
Watermark: MORATO
Museum of Fine Arts, Boston. Bequest of W. G. Russell
Allen. 1974.265

Spanish Christians became as interested as the Moors
in the pastime of bullfighting. Toward the end of the
Moorish occupation bulls were being especially bred to
be worthy and equal opponents of knights. In the seven-
teenth century, when the Spanish king and his nobles
engaged in bullfighting, fiestas were still conducted with
all the gallantry and formality of a tournament. Each
knight who fought dedicated his combat to a lady. The
"Pepe Hillo" text says they "performed their engage-
ments on horseback, a knight not being permitted to
dismount unless the bull should wound one of the
unmounted assistants he had brought with him; or unless
he should lose his *rejón* (short spear), his lance, his glove,
or his hat. In any of these instances the gentleman was
obliged to dismount and not take horse again until he
should first have killed the bull and then recovered
what he had lost."[1]

1. "Pepe Hillo," *Tauromaquia*, p. 10.

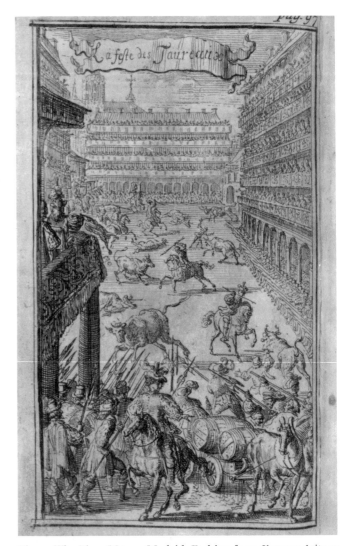

Fig. 9. The Plaza Mayor, Madrid. Etching from *Voyages faits en
divers temps en Espagne* (Amsterdam, 1699). Museum of Fine Arts,
Boston.

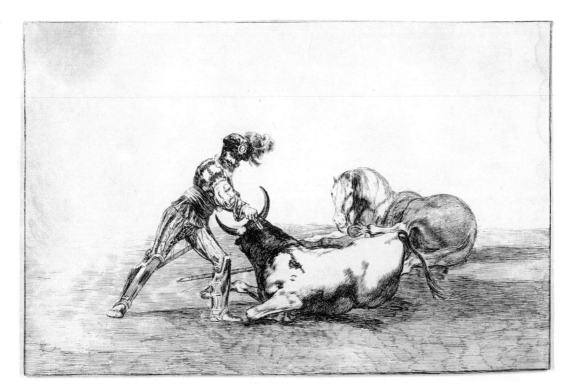

168

169

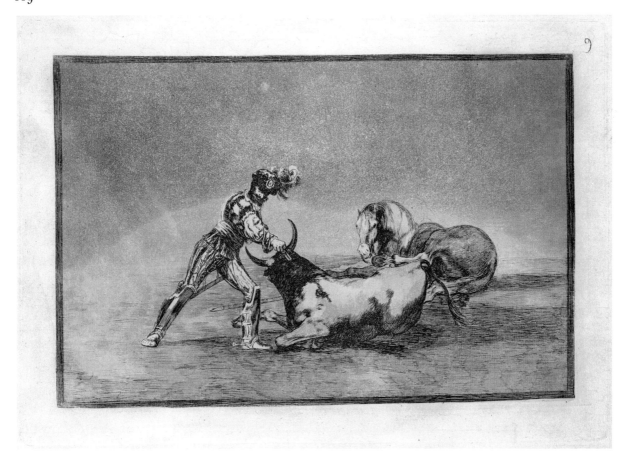

Alvarez de Colmenar wrote an account: "This festival is of the utmost magnificence, and it is the most beautiful spectacle one could hope to see. These five rows of balconies on every side of the arena, hung with magnificent tapestries, with velvets, with a diversity of colors, with gold embroidery, occupied by all those most beautiful, grandest and most important in Spain, and the grandstands too, filled with an infinity of people, present to the eye, from every direction, subjects for admiration ... The guards form a line, clinging tightly one to another, because there is neither barrier nor grandstand where they are, and when a bull comes toward them, they are not allowed to retreat a single step, so that the only resource they have is the point of their halberd ... [The knights] salute their majesties and the entire assembly, asking the king's permission to fight, and after receiving it, they separate and each one goes to salute the lady of his acquaintance; all this done to the sound of trumpets, whose fanfares resound from all sides. To have the honor of fighting the bull on horseback, one must be a gentleman and be known as such."[2] (See fig. 9).

The working proof reveals the etched and engraved lines in their full clarity and freshness, before the etching of the aquatint overbit the closely laid lines. The full narrative impact of Goya's subject is already conveyed, and the plate could almost have been published at this point.

The addition of aquatint, as in the foregoing plates, contributes to the drama of the event. An elliptical zone of light gives greater emphasis to the figures. Tone reduces the contrast between ground, figures, and background, producing a vagueness and murkiness that evokes for us a mysterious sense of the past recalled. The aquatint tone on the bodies of bull and horse models them and adds to the sense of their volume.

Stopping out emphasizes the shimmering texture of the knight's dress and preserves the feathery delicacy of the etched lines that describe the plume on his hat. A white strip of stop-out outlines his back, accentuating the forward thrust of his body.

2. Don Juan Alvarez de Colmenar, *Les Delices de l'Espagne et du Portugal*, 2nd ed. (Leyden, 1715), pp. 861–864. The first edition appeared in 1707.

170–173
Tauromaquia 10
Carlos V. lanceando un toro en la plaza de Valladolid
(Carlos V spearing a bull in the Valladolid plaza)
Goya's title: *Carlos quinto, en la Plaza de Valladolid*
(Carlos V in the Valladolid plaza)
D. 233, H. 213, B. 216, Hof. 92
Signed in plate at lower left: *Goya*
250 × 350 mm.

170
Preliminary drawing for *Tauromaquia* 10
Red chalk
283 × 194 mm.
No watermark, mounted on R. Romani ledger paper
Museo del Prado, Madrid. 218

171
Preparatory drawing for *Tauromaquia* 10
Red chalk
220 × 279 mm.
No watermark, mounted on R. Romani ledger paper
Museo del Prado, Madrid. 219

172
Working proof, Harris I, 1
Etching, drypoint and burin
Coll.: Duthuit
Musée du Petit Palais, Paris. 5413a

173
First edition impression, Harris III, 1
Etching, burnished aquatint, drypoint, and burin
Watermark: SERRA
Museum of Fine Arts, Boston. Bequest of W. G. Russell Allen. 1974.266

Carlos V, King of Spain and Emperor of the Holy Roman Empire, held a fiesta at Valladolid in July 1527 in honor of the birth of his son Felipe. Two centuries later the prowess of their Hapsburg king on that occasion was still viewed by Spaniards with a certain chauvinism. "He killed a bull with a single thrust of his lance, despite having been born and raised abroad," Moratín

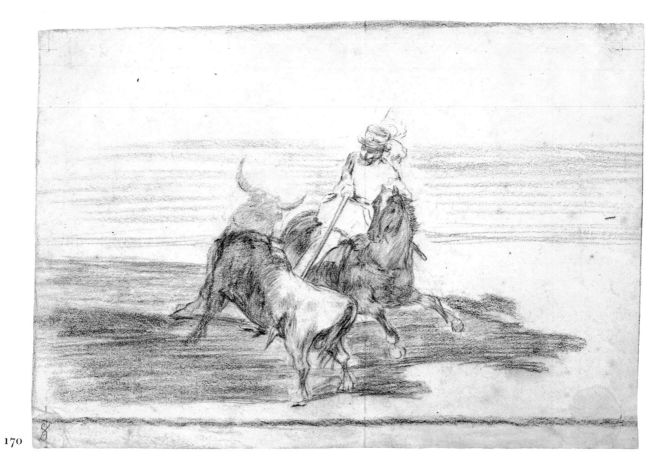

170

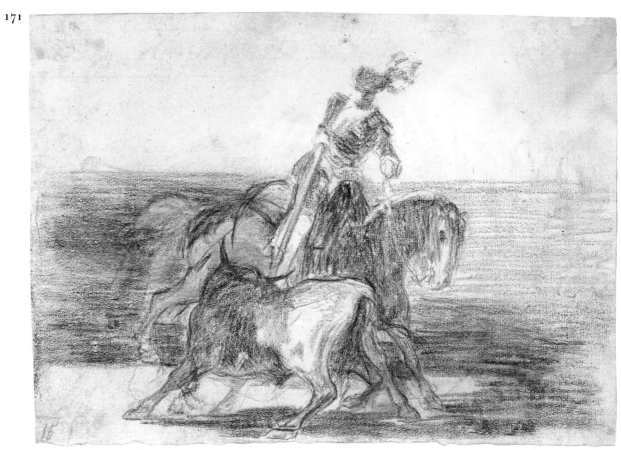

171

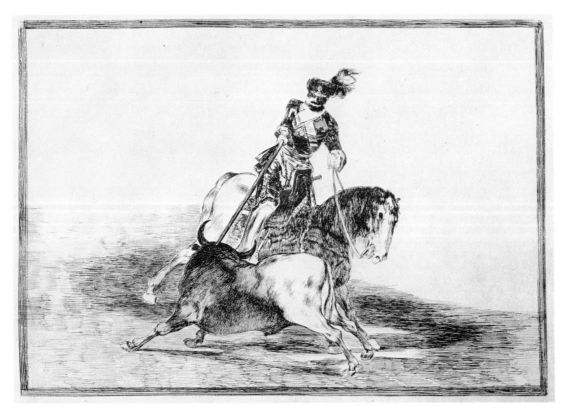

172

173

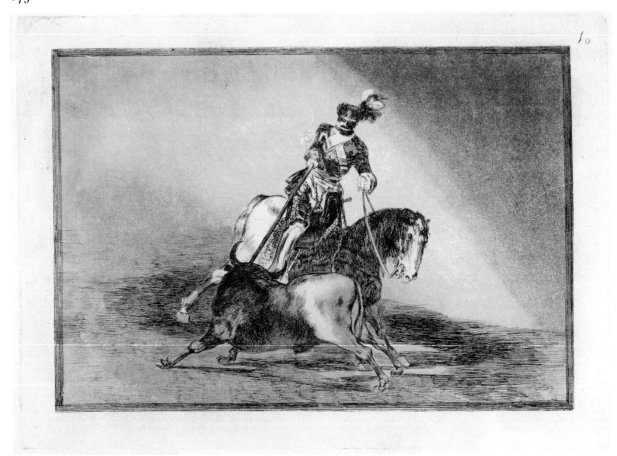

writes of the event, although he also remarks that Carlos V had a great love of hunting and was skillful in killing many kinds of dangerous game with this very weapon.[1]

These studies have been associated with this print, although scholars do not agree about the order of their execution. In the drawing that appears to be the earliest, the horse is seen almost head on and the spear pierces the bull near his hindquarters. Originally the bull's head had been lifted, but Goya rubbed it out and lowered it, redrawing it with a darker orange-red chalk. The drawing is mounted on a sheet from a ledger used to account for trousers and greatcoats issued to Napoleon's army in Spain (see introduction). The mounting was certainly done by Goya, since some of his drawn border line runs over into the mount.

In the drawing closest to the print (Prado 219) both horse and bull are seen almost in profile. The rider rises and pivots in his saddle, thrusting his lance into the bull's neck. Goya's chief concern in this drawing seems to have been to determine the relative position of bull and horse. Passages of rubbed chalk and of new drawing reveal a rethinking of the composition. The paper used is quite thin, and through it the ledger entries in French on the mount are visible.

The working proof before aquatint shows the core of Goya's final composition and reveals the nature of the changes between drawing and print. The King's posture is essentially the same as in the last drawing. The hindquarters of the horse have been shortened in accordance with a correction in the drawing. The bull, whose legs are now firmly planted, has greater bulk and seems a more formidable opponent. Boldly contrasting, overlapping patterns of light and dark lock the bull and horse together. Carlos V, beribboned and decorated, wears greaves to protect his shins.

The first edition impression makes the most theatrical use of aquatint of any print in the series. Light pours down on the protagonists, emphasizing the drama of the moment. The diagonal shadow counterbalances the strong diagonal created by the thrust of the lance. The gradual merging of the shadow with the light was probably created by tilting the plate during the biting of

1. Moratín, *Carta*, p. b1 recto and verso.

the aquatint. Stopping out creates bright accents on the figures. The closely etched work on the bull, which printed sharp and black in the proof, broke down during the biting of the aquatint, resulting in small grayish bald patches near the entry of the spear.

174–175
Tauromaquia 13
Un caballero español en plaza quebrando rejoncillos sin auxilio de los chulos (A Spanish nobleman, without the help of assistants, breaks short rejónes in the plaza)
Goya's title: *Quebrar rejónes* (To break *rejónes*)
D. 236, H. 216, B. 219, Hof. 95
250 × 350 mm.

174
Working proof, Harris I, 1
Etching and drypoint
Watermark: SERRA
Coll.: M. G. Marti, Provôt, Gobin, Philip Hofer
Museum of Fine Arts, Boston. Gift of Mrs. Christopher Tunnard in honor of Eleanor Sayre, and Bequest of W. G. Russell Allen, by exchange. 1973.705

175
First edition impression, Harris III, 1
Etching, burnished aquatint, drypoint, and burin
No watermark
Museum of Fine Arts, Boston. Bequest of W. G. Russell Allen. 1974.269

The horses ridden by the knights were superbly trained and rarely killed. Nobles considered it a distinction to be asked to lend a mount for a fiesta. We are told, "there is nothing extraordinary in . . . the knights' appearance, aside from a few white plumes in their hats; they are dressed in black cape and shoes."[1] The greaves to protect their shins are Goya's additions. The knights,

1. Monsieur M, *Voyages faits en divers temps en Espagne, en Portugal, en Allemagne* . . . (Amsterdam, 1699), p. 102. See also Cossío, *Los Toros*, vol. 2, pp. 786–789.

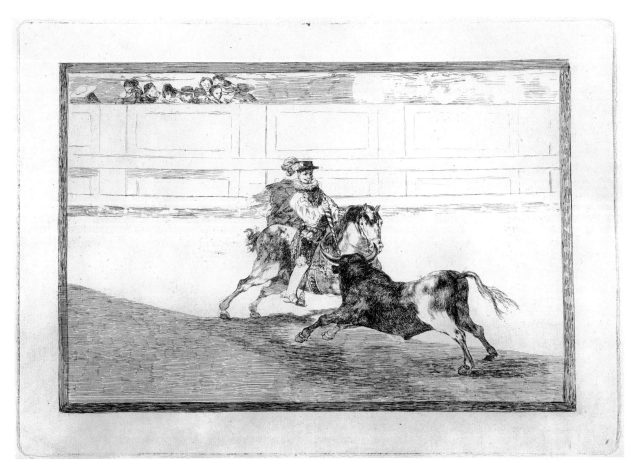

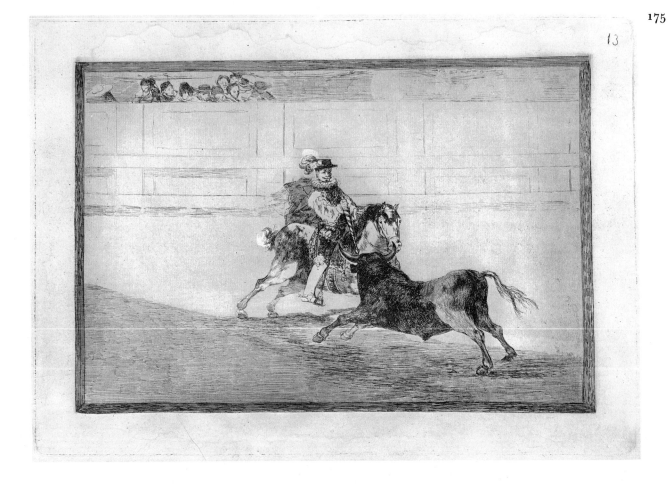

13

Moorish or Christian, fought with lances or, as here, *rejónes* (short spears).

The working proof, executed in etching and drypoint only, has an expressive clarity of its own. There is an effect of strong sunlight falling into the arena. At the upper right the presence of spectators is suggested not by line, as at the left, but by the device of painting on stop-out, which leaves blank areas. A few drypoint strokes on the bull's back, flank, and underbelly print with a burr that is brownish in tone.

In its completed state, a single pale tone of aquatint covers the plate except for a few stopped-out highlights on the knight and his horse. These highlights, in the context of the muted tone of the rest of the plate, give a new prominence to the horse and its noble rider. Stop-out adds to the plumes on the nobleman's hat, thereby increasing his height and suggesting motion. The horse's tail has been treated in a similar fashion. Drypoint as well as aquatint shades the bull's hindquarters, defining him as a solid, dark mass. A few burin strokes add to the curvature of his underbelly. The blank spaces at the upper right, which were reserved in the working proof, are now veiled by aquatint.

176
Tauromaquia 16
El mismo vuelca un toro en la plaza de Madrid (The same person [i.e., "Martincho"] makes a bull turn in the Madrid ring)
Goya's title: *El famoso Mamon* (The famous "Mamón")
D. 239, H. 219, B. 222, Hof. 98
245 × 350 mm.

First edition impression, Harris III, 1
Etching, burnished aquatint, drypoint, and burin
Watermark: MORATO
Museum of Fine Arts, Boston. Bequest of W. G. Russell Allen. 1974.272

Goya's handwritten title for this print gives a different identity to the matador. Pedro de la Cruz, who fought under the name of "el Mamón" (the suckling), was born in Murcia and by mid-century was famous for his droll actions which delighted the public. The picador Daza called him "the ugly and graceful Mamón," and in 1778[1] Moratín lists him among the great fighters of a bygone day. "A thousand times," he writes, "we saw Mamón sieze [bulls] by the tail and mount upon them."[2] Goya shows him smiling as he does so. The published title, probably used for the sake of consistency with the preceding print and Nos. 18 and 19, identifies him as "Martincho" (see cat. nos. 178–182).

Although the ground has been partially defined with etched lines and burnishing of the aquatint, the space, as so often in the *Tauromaquia* prints in the later style, remains essentially abstract.

1. Cossío, *Los Toros,* vol. 3, p. 210.

2. Moratín, *Carta,* p. c8 recto.

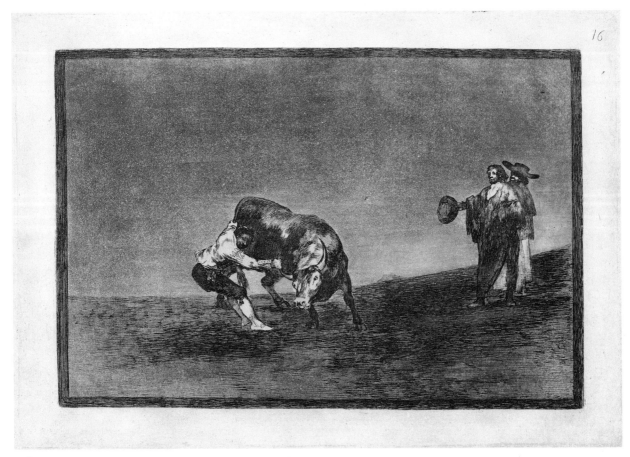

176

177

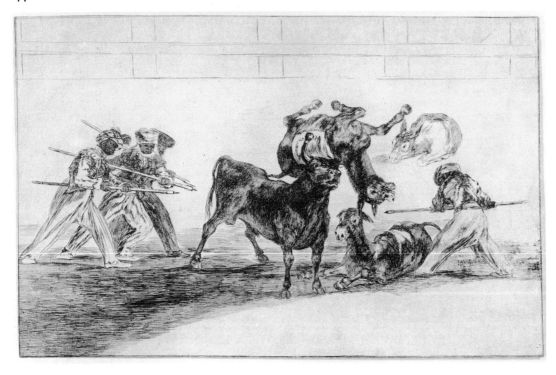

177
Tauromaquia 17
Palenque de los moros hecho con burros para defenderse del toro embolado (Barricades that the Moors made with donkeys to defend themselves from a bull with covered horns)
Goya's title: *Palenque con Borricos* (Barricade with little burros)
D. 240, H. 220, B. 223, Hof. 99
245 × 250 mm.

Working proof, Harris I, 1
Etching and drypoint
No watermark
Coll.: Lhardy, Provôt, Philip Hofer
Museum of Fine Arts, Boston. Gift of George C. Seybolt and the M. and M. Karolik Fund. 1973.706

In Madrid, corridas took place on Mondays—for the whole day—with sixteen or eighteen bulls. Two bulls, their horns tipped, were reserved for amateurs, who thronged out of the bleachers to try their hand. Goya represented them in his lithograph *Dibersion de España* (cat. no. 257). There might also be an extra bull for an interlude used for a comic turn or a pantomime. Here men dressed as Moors use pics against the bull. Donkeys are their steeds; one, with sorrowful eyes, lies with one leg stretched awkwardly on the ground.[1] This working proof before aquatint, its etching and drypoint sparkling and clear, has been trimmed so that most of the broad etched border line was cut off.

1. Cossío, *Los Toros*, vol. 2, p. 793.

178–179
Tauromaquia 18
Temeridad de Martincho en la plaza de Zaragoza ("Martincho"'s recklessness in the ring at Zaragoza)
Goya's title: *Matar sentado, con grillos* (To kill seated, with leg-irons)
D. 241, H. 221, B. 224, Hof. 100
245 × 345 mm.

178
Preparatory drawing
Red chalk
186 × 270 mm.
Watermark: CRIMA. .D (Crimaned)
Museo de Prado, Madrid. 226

179
First edition impression, Harris III, 1
Etching, burnished aquatint, and drypoint
No watermark
Museum of Fine Arts, Boston. Bequest of W. G. Russell Allen, 1974.274

This fighter was called "Martincho" because he had begun his career by fighting with an older relative, Martin. Antonio Ebassun was born in the north of Spain at Egea de los Caballeros, Aragón. His first fight took place at Pamplona. It was a brilliant performance, and he was granted an extra 130 *reales* to marks his extraordinary work. We are told that "he was called the inimitable because in truth he was, in the twists and circular turns with which he made bulls cut their charges."

He fought at Zaragoza in 1764 at two fiestas held to celebrate the inauguration of the new bull ring. But by then "Martincho" must have been past his prime. He was aging and had suffered the indignity of having to write the authorities at Pamplona to remind them of his merit. He wanted to fight there on horseback adding, stoutly: "there is no one to be found who can touch me in my crazy doings."[1]

1. Cossío, *Los Toros*, vol. 3, pp. 257–258; the source of the second quotation is Don José de la Tixera.

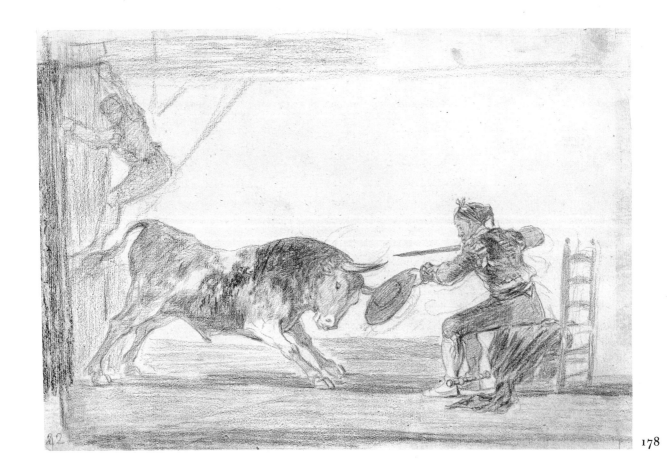

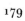

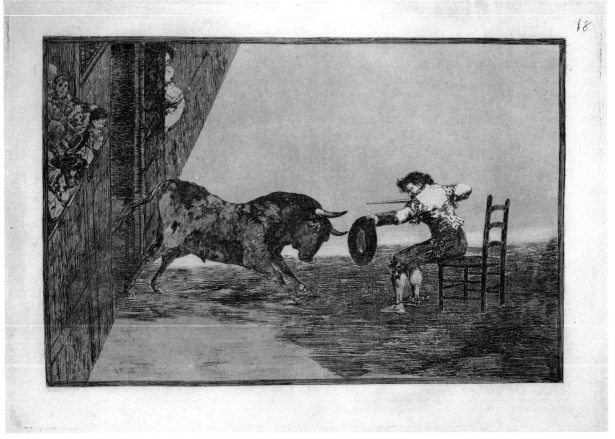

He often used a round shield to play the bull instead of a *muleta* (rectangle of cloth). In the drawing, "Martincho," with a hat, is staking his life on that same skill with a sword. He cannot dodge, seated in a chair. He cannot run should he fail, for his ankles are fettered with irons. He has had no chance to observe his adversary, noting its individual traits, for the bull, strong and fresh, is only now charging into the arena. If "Martincho" does not kill by piercing the bull's vital spot with his sword, he has virtually no chance of survival. The gatekeeper, who flung open the gate, has leapt to safety. Sketchy lines indicate an earlier positioning of the matador and bull.

While the relationship of the main elements is roughly the same in the drawing and print, there are numerous and expressive changes. Because the bull is darker he seems more massive and threatening. "Martincho," sitting on the edge of his chair, leans closer to the bull. He stretches out his arm, dangling his hat as a dark target for the bull. He bends his head, sighting the bull along the blade of his sword.

The gatekeeper is almost hidden by the gate, and an audience is seen witnessing the daring feat. The strongly defined diagonals of the receding barrier and the shading of the foreground dramatize the conflict of man and bull. Burnishing behind the two figures further emphasizes the opponents and defines the path of their confrontation.

180–182
Tauromaquia 19
Otra locura suya en la misma plaza (More of his ["Martincho"'s] madness in the same ring)
Goya's title: *Saltar el toro con grillos* (To jump over the bull in leg-irons)
D.242, H. 222, B. 225, Hof. 101
Lower right in the plate: *1815* and *Goya*
245 × 350 mm.

180
Working proof, Harris I, 1a
Etching and burnished aquatint
No watermark
Coll.: Philip Hofer
Museum of Fine Arts, Boston. Gift of Mr. and Mrs. Kenneth Germeshausen. 1973.707

181
Working proof, Harris I, 2
Etching and burnished aquatint, with chalk border
Watermark: SERRA
Coll.: Duthuit
Musée du Petit Palais, Paris. 5425

182
First edition impression, Harris III, 1
Etching, burnished aquatint, drypoint, and burin
No watermark
Museum of Fine Arts, Boston. Bequest of W. G. Russell Allen. 1974.275

The province of Navarra, close by the matador "Martincho"'s birthplace, had a style of fighting of its own, one of its specialties being leaps over the bull.[1] These served no functional purpose, but they could be fantastic and beautiful. Ebassun's assistants were from that province.[2]

Again locked into leg-irons, the matador stands atop a table draped with his cape. In the split second before the animal's charge knocks away his perch, he

1. Cossío, *Los Toros*, vol. 1, pp. 777–778.
2. Moratín, *Carta*, pp. c5 verso-c6 recto.

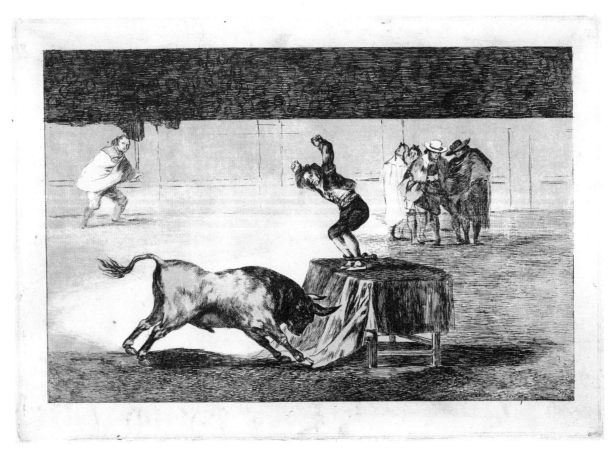

180

will begin the jump which must carry him the length of the bull's body. Goya may have witnessed this extraordinary feat in 1764, when Ebassun fought at Zaragoza again, or after 1775, when he moved to Madrid.[3]

In the first working proof, a single pale tone of aquatint has been stopped out and burnished to produce a zone of light that encompasses the central action. One might easily believe that the plate was complete in this stage, but Goya developed it further.

In the second working proof, a second, coarser grain of aquatint has been added to the plate. In combination with burnishing and stopping out, it serves to model the figures further and to define more clearly the space of the arena. The light area that silhouettes the combatants is reduced but is more dramatic in effect. Owing to brilliant highlights created with the aid of stopping out, the assistants in the background right and left are more prominent and draw our attention from "Martincho." On three sides Goya added in chalk a wide framing border. He evidently decided that the action was

already well enough framed, for he did not finally etch this border into the plate.

The impression from the finished plate is more muted in effect than the two foregoing states. The plate appears to have been printed with a film of ink left on it. The group of assistants in the right background have been again subordinated by means of further work: light burnishing of the two figures at the left of the group and burnishing, shading with drypoint, and engraved cross-hatching on the figure with the white hat.

This is one of three plates in the series dated 1815. It is close in style and medium to the *Tauromaquia* plates that Goya rejected and did not publish. His earlier style, as exemplified by this print, is more circumstantial in its treatment of the subject. An audience seated behind a barrier on raised stands occupies the background. The crowd is heavily etched and hatched with strong horizontal strokes. Goya takes care to delineate the other fighters in the ring who are ready to assist "Martincho." The two principal figures are smaller in scale than in the preceding prints. Except for the working proofs with borders added in chalk, none of the early prints have the wide border line that occurs in the later prints with their simpler compositions.

3. Cossío, *Los Toros*, vol. 3, pp. 257–258; on the print see vol. 2, p. 796.

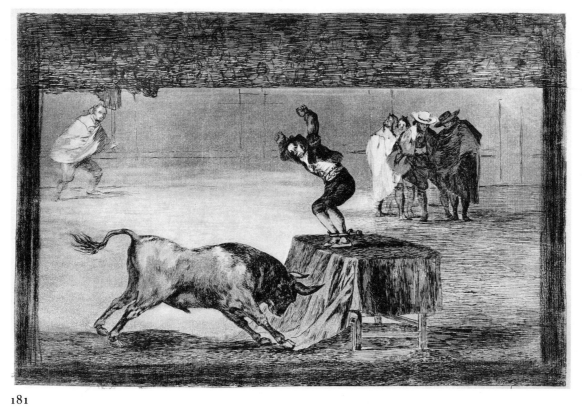

181

182

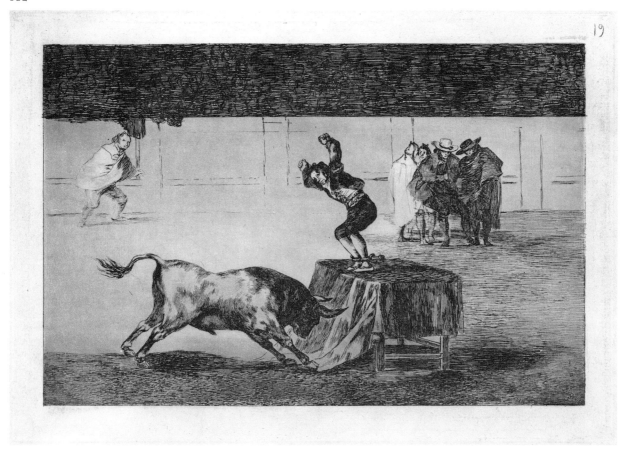

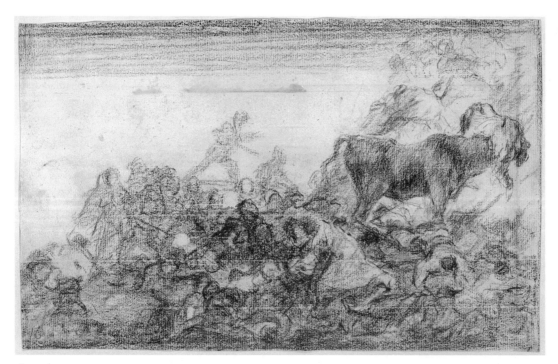

183

184

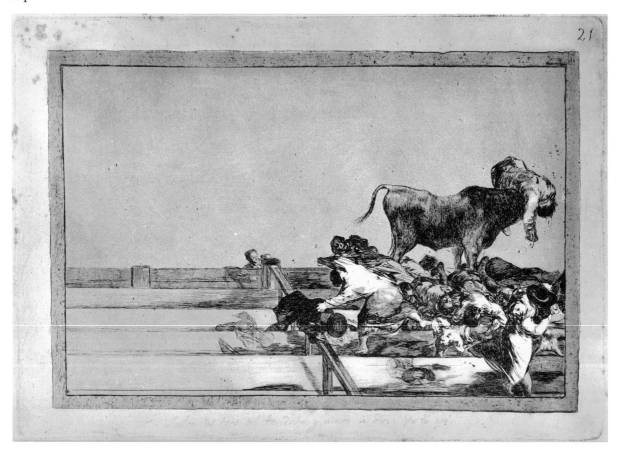

183–184

Tauromaquia 21

Desgracias acaecidas en el tendido de la plaza de Madrid, y muerte del alcalde de Torrejon (Unhappy accident in the bleachers of the Madrid ring and death of the mayor of Torrejón)

Goya's title: *Salto el toro al tendido y mato à dos. Yo lo vi* (The bull jumped into the bleachers and killed two. I saw it.)

D. 244, H. 224, B. 227, Hof. 103

245 × 355 mm.

183

Preparatory drawing
Red chalk, wetted
186 × 301 mm.
Watermark: J HONIG / & / ZOONEN
In pencil lower left corner, not autograph: *16*
Museo del Prado, Madrid. 230

184

Completed plate, from a pre-publication set (1816) with Goya's handwritten titles in pencil
Etching, burnished aquatint, lavis, drypoint, and burin
No watermark
Coll.: McDonald Smith; Albert Henry Wiggin
Boston Public Library. Wiggin Collection

Now and then a rare bull still jumps over the wooden barrier and into the circular passage that lies behind it, but this causes relatively little havoc. Until quite late in the eighteenth century there was nothing to prevent a second leap into the bleachers, where the mass of common people sat. A bull could and sometimes did traverse the bleachers and reach the covered balconies.

About 1778 the picador Don José Daza recommended that bull rings install a protective cable to prevent such bloody and panic-stricken scenes as Goya depicts.[1] In 1784 the Madrid plaza followed his advice, but twenty years later the government was bitterly criticized for not requiring such protection in every ring.[2]

Goya's drawing in a brick-red chalk presents a scene of chaos and utter pandemonium. The dense, surging crown seen from above is broadly suggested. The figure of the bull with a body impaled on his horns is almost lost in the turbulent throngs of the audience.

The impression from the finished plate is in a bound set with Goya's own manuscript titles. Here the viewpoint is lower and the asymmetrical composition is startlingly economical. The first thing one sees is the triumphant bull standing above a knot of fleeing and fallen spectators silhouetted against the field of aquatint. An abandoned hat and cloaks suggest that some spectators have already fled. The crowd is smaller but no less effective in conveying a sense of panic. At least two figures, a recumbent man and a woman with outflung arms, have been retained from the drawing, which was transferred directly to the plate. This is one of the most concise and powerful of all Goya's etched works. His inscription ends with the terse comment: "I saw it."

1. Cossío, *Los Toros,* vol. 1, p. 465; vol. 3, p. 220.

2. Cossío, *Los Toros,* vol. 2, pp. 799–802. Lafuente doubts Mayer's statement that the mayor was killed in 1789 at a fiesta held to celebrate the coronation of Carlos IV.

185–187
Tauromaquia 23
Mariano Ceballos, alias el Indio, mata el toro desde su caballo (Mariano Ceballos, called "el Indio," kills the bull from horseback)
Goya's title: *Matar à caballo* (To kill on horseback)
D. 246, H. 226, B. 229, Hof. 105
250 × 350 mm.

185
Working proof, Harris I, 2
Etching and burnished aquatint, with black chalk border
No watermark
Coll.: Burty, Bullard
Museum of Fine Arts, Boston. Gift of Miss Ellen Bullard. M30827

186
Working proof, Harris I, 2a
Etching and burnished aquatint
Watermark: SERRA
Coll.: Duthuit
Musée du Petit Palais, Paris. 5429b

187
First edition impression, Harris III, 1
Etching and burnished aquatint
No watermark
Museum of Fine Arts, Boston. Bequest of W. G. Russell Allen. 1974.279

Mariano Ceballos, "The Indian," is thought to have been born in Argentina because we first hear of him at Buenos Aires in 1772, when he was commended for his skill and paid an extra 100 pesetas. In 1775 he fought in Pamplona, Spain, where he was commended for his skill in fighting mounted on horseback or on another bull (cat. no. 258). But the municipal archives noted that on foot with a sword he did not cut much of a figure.[1] Swinburne, an English traveler who saw him that year, heard that as a very little boy Ceballos had gotten his start hunting wild cattle. Swinburne watched with alarm how the "very extraordinary feats of strength and dexterity" performed by the matador, "generally brought on him a dangerous spitting of blood."[2] In 1784 he was killed.[3]

In Goya's print he is not using a *rejón*, but kills the bull with a short sword or dagger, so that he is obliged to lean almost off the back of his horse, stretching across the thrusting horns of the bull to reach his mark.

This is one of the most successful *Tauromaquia* plates executed in the earlier style. Goya proceeded through at least four stages, pulling proofs for each, before he arrived at the final version. The principal figures, Ceballos, his horse, and the bull, were transferred to the copper plate from Goya's drawing, and the entire composition, including parallel shading, executed in etching. The working proof with etched line only (fig. 10, not in exhibition) reveals a composition of many disparate elements, which the horizontal shading strokes only partially succeed in unifying.

In the first working proof exhibited, a single layer of aquatint has been applied to the plate and burnished to produce highlights on the principal figures. In Goya's later *Tauromaquia* style attention is drawn to such figures not by stopping out or burnishing them but by lightening the area around them to silhouette them or make them appear to glow with light.

The aquatint grain is varied in its degree of coarse-

1. Cossío, *Los Toros,* vol. 3, pp. 186–187, information and quotation.

2. Henry Swinburne, *Travels through Spain in the Years 1775 and 1776* (Dublin, 1779), pp. 367–368.

3. Cossío, *Los Toros,* vol. 2, pp. 802–805.

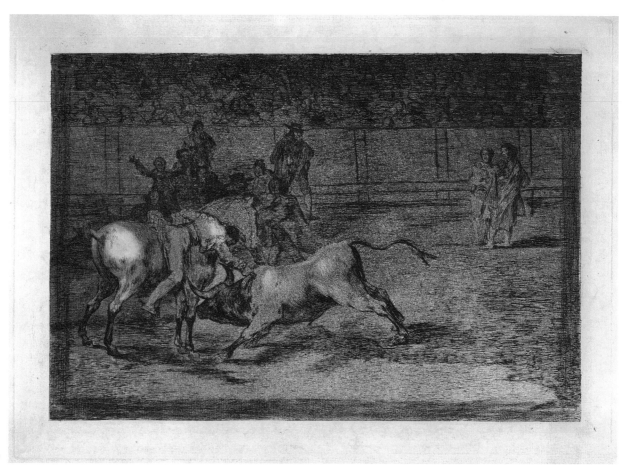

185

(full size detail) 185

233

ness or fineness. At the left of the plate, the tone is smoother and more continuous, while toward the center of the plate and in the lower right corner, it displays an open, reticulated pattern.

A chalk border, like that in the working proof for *Tauromaquia* 19, has been added, but was not etched.

The next working proof has additional burnishing on the figures. As a result the central figures stand out more legibly against the background.

The finished print has yet more burnishing. Ceballos' figure above the knee and the hindquarters of the horse have been completely burnished so that almost no aquatint remains. The horse's head is highlighted so that it is better related to the rest of its body. The bull has acquired an additional sense of volume and equal emphasis with horse and rider. The actions of Ceballos and his opponent are now the main elements, and they occur within a comprehensible space.

The film of ink left on the plate, as opposed to the clean wiping of the plate for the working proofs, is characteristic of many first edition impressions.

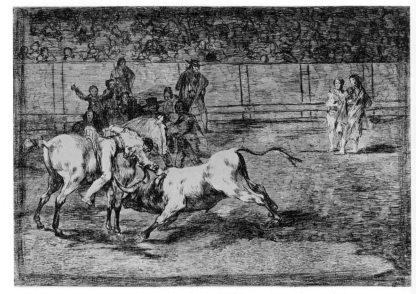

Fig. 10. *Tauromaquia* 23. Working proof, etching only. Musée du Petit Palais, Paris.

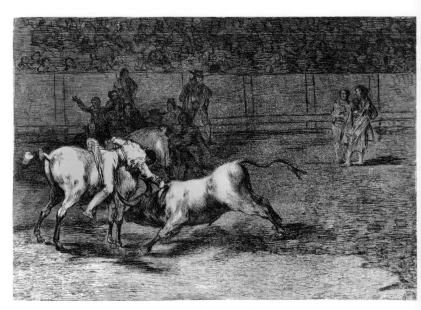

186

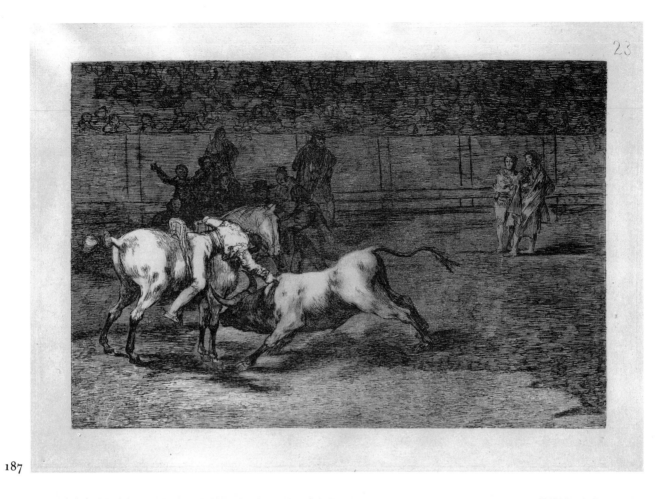

187

187 (full size detail)

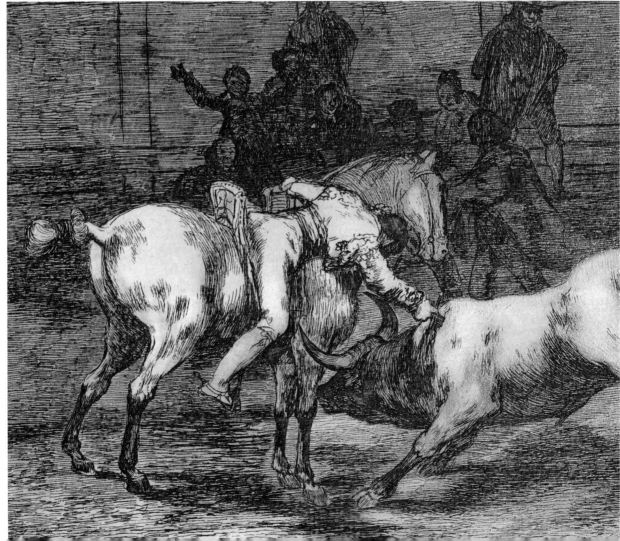

188–191
Tauromaquia 30
Pedro Romero matando á toro parado (Pedro Romero killing a bull that he has subdued)
Goya's title: *Pedro Romero Matando à toro parado* (Pedro Romero killing a bull that he has subdued)
D. 253, H. 233, B. 236, Hof. 112
245 × 355 mm.

188
Matador using a hat instead of a cape, preparing to kill a bull
Rejected plate (D. 265, H. 245)
Etching and lavis, with burnishing, with black chalk border
Working proof, Harris I, 2
250 × 350 mm.
Watermark: SERRA
Coll.: Carderera
Biblioteca Nacional, Madrid. 45682

189
Matador killing the bull as he holds its horn
Rejected plate (not in D. or H.)
Etching, aquatint, and lavis with burnishing, and burin
Unique-working proof
Coll.: Duthuit
Musée du Petit Palais, Paris. 5439

190
Preparatory drawing for *Tauromaquia* 30
Red chalk
200 × 289 mm.
Watermark: Beehive of J. Honig & Zoonen
Coll.: Paul Lefort; Mrs. Jay, Frankfurt; Colnaghi, Philip Hofer
Museum of Fine Arts, Boston. Gift of the Frederick J. Kennedy Memorial Foundation. 1973.696

191
First edition impression, Harris III, 1
Etching, aquatint, drypoint, and burin
Watermark: MORATO
Museum of Fine Arts, Boston. Bequest of W. G. Russell Allen. 1974.286

It was Pedro Romero, tall, with an aristocratic face, with intelligence, integrity, and gravity, who made bullfighting a greater art by his own example and through the eight homely precepts where he set down its principles, among which were:

> "In the bull ring, you can do more with a bushel of courage and a pint of intelligence than with a bushel of intelligence and a pint of courage.

> "Stand fast as if to let yourself be caught: that is the way to make the bull give in and lay himself wide open for the sword thrust.

> "The fighter should rely on his hands, not his feet; and in the face of the bull he should kill or be killed, rather than shrink away or degrade himself."[1]

This grandson of the great matador, Francisco Romero, was born in Ronda in 1754. When he was seventeen he fought as second swordsman for his father in a fiesta for aspirant matadors. He had what his contemporaries termed gigantic power, courage, and skill in all aspects of the art. He was almost uncanny in his effectiveness at rescuing other men in the ring when professional judgment saw the circumstances as hopeless.

In the eighteenth century bulls were less carefully bred than they are today. In that Homeric age they came into the ring, huge, older, wiser, and more cunning and vicious. The most notorious and the toughest were a Castillian breed. In 1778 at the royal fiestas held in Madrid in honor of the Infante Carlos two matadors, "Costillares" and "Pepe Hillo," stipulated that Castillian bulls should not be used. Romero when questioned said bluntly that "if they are bulls such as eat grass in fields," he had no objection.

Madrid was divided from top to bottom in its partisanship for this great classicist and for "Pepe Hillo." The Duquesa de Alba was Romero's admirer. Hale and hearty, he killed his last bull when he was about eighty. In 1839 he died, and when they laid him out they discovered that not one of the some five thousand bulls he had killed had left a mark on his body.[2]

Goya executed two rejected plates of a matador

1. Angus Macnab, *Fighting Bulls* (New York, 1959), p. 111.

2. Information and quotation from Cossío, *Los Toros*, vol. 3, pp. 825–834; see also vol. 2, pp. 810–814.

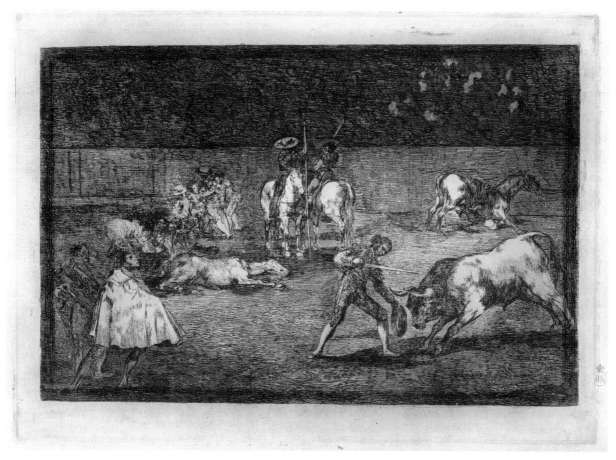

188

189

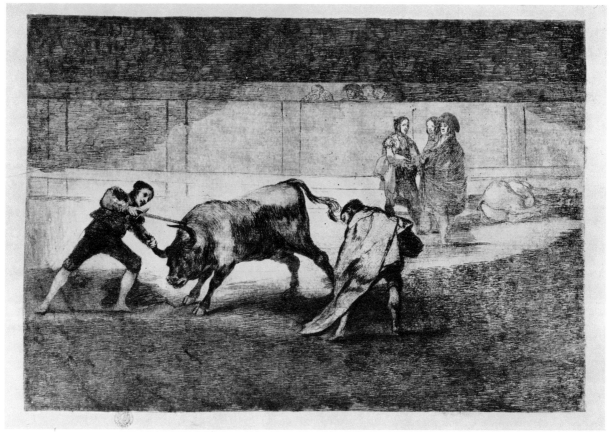

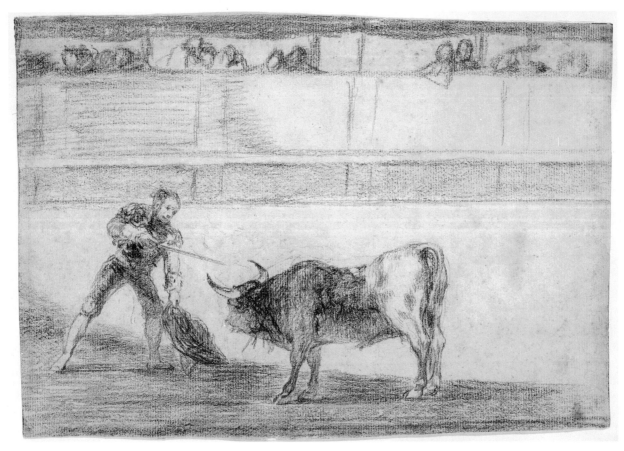

190

191

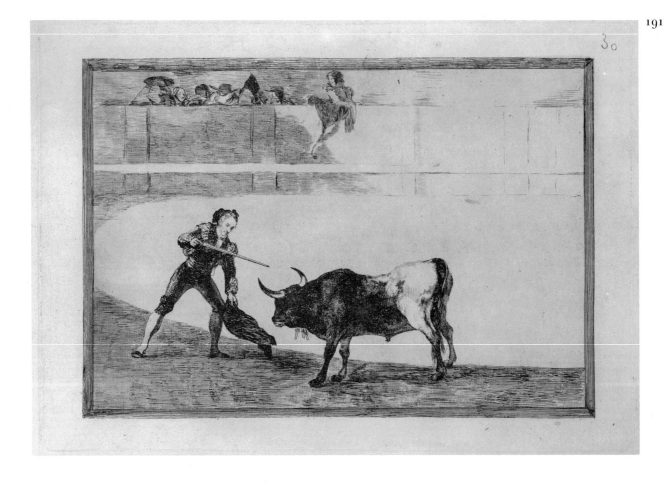

about to plunge his sword into the bull. The one that is probably the earliest is represented by one of two known impressions from the plate, which has not survived. The composition is typical of the earlier style, so that a number of toreros, picadors, and their horses are to be seen in the ring. The matador, using a hat, induces the bull to lower his head as he moves to kill him. The action is not shown at the center but in the right foreground, with other figures dispersed in a semicircle around this final act. Because these subordinates remain strongly highlighted, they tend to draw attention away from the action. The plate was not technically successful, and many of the etched areas do not print properly. Its splotchy, unclear appearance is partly due to the mottled effect of the lavis that Goya has used to model the figures. A broad border line was added in black chalk.

In the unique proof from the second rejected plate, bull and matador, much larger in scale, have been shifted to the left and closer to the center. The matador grasps one horn of the bull. A second torero, cape draped over his shoulder, stands ready to help should he be needed at this critical moment. The number of assistants in the ring is reduced. Other fighters look on from the alley way behind the barrier. The figures are modeled with parallel etched shading, and Goya has bitten the plate twice to achieve both fine and coarse lines. For further modeling he has used a combination of burnished aquatint and lavis tones, but the methods used were not totally successful. The simplified composition and lighting pattern suggest Goya's later *Tauromaquia* style.

The preparatory drawing in red chalk for the published print was perhaps already intended to portray Pedro Romero. He uses a dangerous *suerte*, the *volapie* as it was then performed. He uses his *muleta* to induce the bull to charge. Erased or rubbed out chalk lines reveal Goya's original placement of the figures on the page. The drawing has been trimmed at the edges to within its border line.

In transferring this drawing to the copper plate, Goya cut the design at the right. The treatment of the barrier and the toreros waiting behind it is strikingly asymmetrical. The diagonal of the shading on the planking echoes and reinforces the thrust of Romero's sword. The position of the barrier was moved back so that its lower edge no longer cuts through Romero's head but instead is part of the shadow that encircles and frames the opponents. Small but important changes were also made in the drawing of the matador and bull. Romero puts more weight on his left leg, his body arching toward the horns while the bull spreads his hind legs in a nervous stance. Everything has been subordinated to the tense battle of wills.

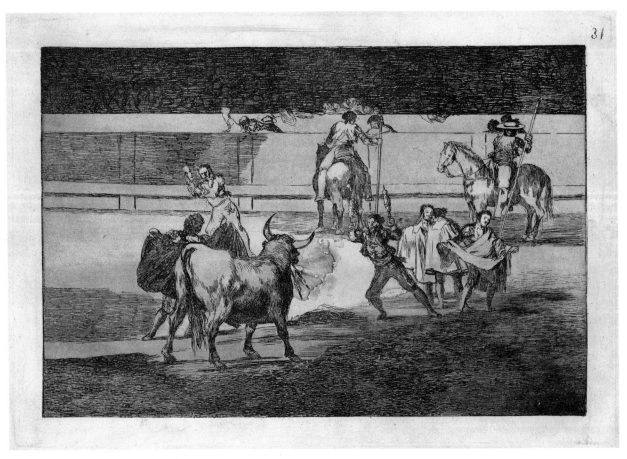

192

192

Tauromaquia 31
Banderillas de fuego (Banderillas with firecrackers)
Goya's title: *Banderillas de Fuego* (Banderillas with firecrackers)
Lower right in the plate: *1815/Goya*
D. 254, H. 234, B. 237, Hof. 113
245 × 350 mm.

First edition impression, Harris III, 1
Etching, drypoint, lavis
No watermark
Museum of Fine Arts, Boston. Bequest of W. G. Russell Allen. 1974.287

A torero is running in to place barbed *banderillas* behind the bull's horns. The bull's effort to shake them loose tires his great neck muscles a little more, and if he has become tired, incites him to continue charging. In this instance the *banderillas* are special ones with firecrackers attached. A contemporary writer describes their use: "Some of the darts are set with squibs and crackers. The match, a piece of tinder, made of a dried fungus, is so fitted to the barbed point, that, rising by the pressure which makes it penetrate the skin, it touches the train of the fireworks. The only object . . . is to confuse the bull's instinctive powers, and, by making him completely frantic, to diminish the danger of the *Matad*or, who is never so exposed as when the beast is collected enough to meditate the attack."[1] The *suerte* of placing *banderillas* has changed very little since then, although they are now longer and less rotund.

The print, dated 1815, is in the early *Tauromaquia* style. As in a number of the rejected plates (see cat. nos. 188, 189, and 198), Goya has achieved tone by means of lavis. A puddle of lavis was skillfully employed to represent the smoke from the exploding firecrackers.

1. Don Leucadio Doblado (Joseph Blanco White), *Letters from Spain*, 2nd ed. (London, 1825), p. 135.

193–195

Tauromaquia 32

Dos grupos de picadores arrollados de sequida por un solo toro (Two groups of picadors put to rout, one after the other, by a single bull)

Goya's title: *Suerte de Picador* (Maneuver of the picador)

D. 255, H. 235, B. 238, Hof. 114

245 × 350 mm.

193

Preparatory drawing

Sanguine wash and chalk

182 × 313 mm.

Coll.: F. B. Cosens, London (?);

Kunsthandlung B. Quaritsch, 1891.

Hamburger Kunsthalle, Graphische Sammlung. 38541

194

Working proof, Harris I, 2

Etching, burnished aquatint, drypoint, and burin

Watermark: SERRA

Coll.: Duthuit

Musée du Petit Palais, Paris. 5541a

195

Working proof, Harris I, 2a

Etching, burnished aquatint, drypoint, and burin

Watermark: SERRA

Coll.: Duthuit

Musée du Petit Palais, Paris. 5541b

As the mounted noblemen withdrew from bullfighting in the eighteenth century, their place was taken by picadors, horsemen whose task was no longer to kill the bull, but rather to slow him down by inducing him to push with his great neck muscles against their herdsmen's goads. In the eighteenth century their work, which required strength and skill, still retained something of its earlier prestige. Nobly born amateurs occasionally exercised their old privilege of riding into the ring. It is interesting to note that picadors were permitted to wear silver lace earlier than their colleagues on foot, who respectfully applied for the same privilege.

From the hips down, however, their primary need was for protection. A Spaniard described the picadors as "wearing scarlet jackets trimmed with silver lace. The shape of the horsemen's jackets resembles those in use among the English postboys. As a protection to the legs and thighs, they have strong leather overalls, stuffed to an enormous size with soft brown paper—a substance which is said to offer great resistance to the bull's horns."[1]

In the print, one extremely strong brave bull has managed to overturn two groups of picadors.[2] Four preparatory drawings on the characteristic papers for the *Tauromaquia* are executed in brush and sanguine wash as well as chalk. They all are for plates executed in the early style. Two show signs of having been transferred to the copper plate in the press. This drawing is typical in that the space devoted to the audience is relatively large. Goya drew the composition with brush and various tones of sanguine wash. The crowds were first suggested with swift, almost abstract lines. Heavy chalk strokes over the audience suggest that Goya had already thought of simplifying the background by changing the position of the barrier.

The earlier working proof reveals changes that have transformed the composition. The wooden barrier is clearly defined and the spectators, obscured by shadow, are barely visible. The diffuse lighting of the drawing is replaced by subdued shadows that unify the scene and burnished highlights that bring the principal figures into focus. The two men behind the fallen horse at right in the drawing were originally transferred to the plate, but were omitted from the finished print. Faint traces of etched lines that set their position on the copper plate are still visible. The running figure between the horse and bull, whose original contours are also still visible, now crouches forward and is darkened so that he is subordinate to the struggling animals. The group at left with the wounded or dead picador and his fallen horse is brought closer to the central group and given more prominence.

Goya has employed subtle devices to create effects that are sensed but are not immediately obvious. A series of drypoint strokes beside the rump of the picador's

1. Don Leucadio Doblado (Joseph Blanco White), *Letters from Spain*, 2nd ed. (London, 1825), p. 133.

2. See also Cossío, *Los Toros*, vol. 2, p. 816.

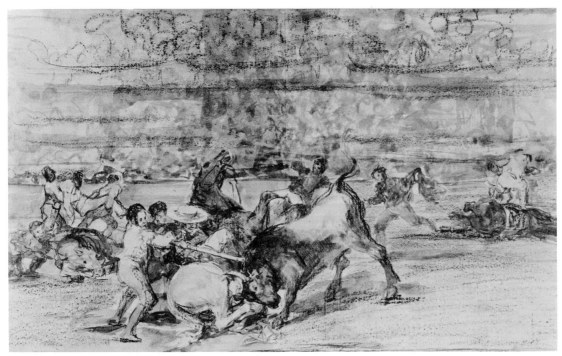

193

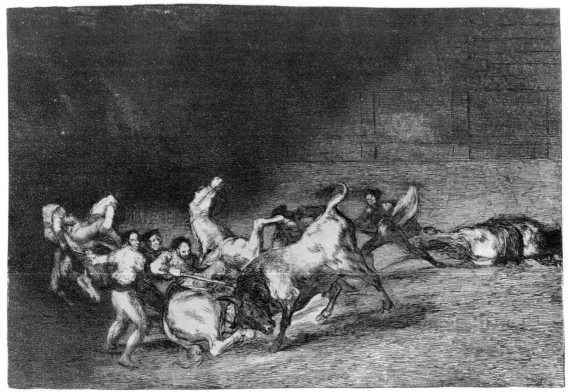

194

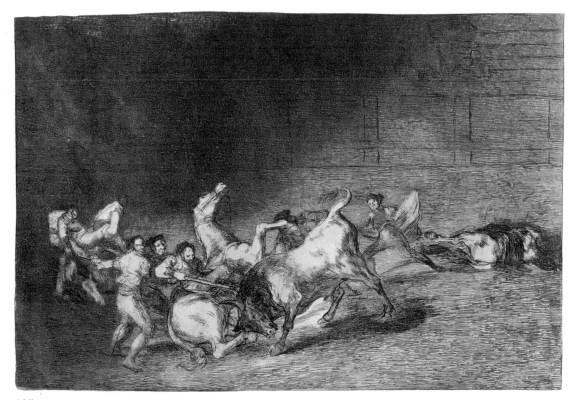

195

orse suggest the animal's agonized writhing. Drypoint
with burr around the body of the fallen horse at right
describes a pool of blood.

A subsequent working proof reveals further burnish-
ing. The burnishing is minor but demonstrates again
Goya's sensitivity to the importance of small nuances. In
the previous proof, the sash around the waist of the torero
to the left of the falling horse was darkened by aquatint.
The sash is now burnished and blends in with the rest of
his costume. Only by comparing the two impressions is
it possible to see how discordant the sash was in the earlier
example. Besides visually cutting the fighter's body in
two it gave him undue emphasis so that he tended to
upstage horse and bull.

196-199

Tauromaquia 33

La desgraciada muerte de Pepe Illo en la plaza de Madrid (The ill-fated death of "Pepe Hillo" in the Madrid ring)

Goya's title: *La muerte de el* [sic] *famoso Pepillo* (The death of the famous "Pepe Hillo")

D. 256, Harris 236, B. 239, Hof. 115

245 × 350 mm.

196

Death of Pepe Hillo (Loizelet's Plate F)

Working proof, Harris I, 2. Unique

Etching, burnished aquatint, and drypoint

Verso: an impression of the same print

245 × 350 mm.

No watermark

Coll.: Carderera

Biblioteca Nacional, Madrid. 45679

197

Preparatory drawing for the *Death of Pepe Hillo* (Loizelet's Plate E)

Sanguine wash and chalk

190 × 313 mm.

Coll.: F. B. Cosens, London; Kunsthandlung B. Quaritsch, 1891.

Hamburger Kunsthalle, Graphische Sammlung. 38533

198

Death of Pepe Hillo (Loizelet's Plate E)

Working proof, Harris I, 2

Etching, lavis over aquatint, with burnishing, drypoint, and burin, with black chalk border

245 × 350 mm.

Watermark: SERRA

Biblioteca Nacional, Madrid. 45678

199

First edition impression of *Tauromaquia* 33, Harris III, 1

Etching, burnished aquatint, drypoint, and burin

No watermark

Museum of Fine Arts, Boston. Bequest of W. G. Russell Allen. 1974.289

Josef Delgado Guerra, called "Pepe Hillo," was born in Sevilla in 1754, the same year as Pedro Romero. With his inventive brilliance he was the apogee of a different late eighteenth century style of fighting whose adherents were as passionate as those of Romero. Once, when badly hurt, Delgado was carried into the box of another of Goya's great patrons, the Duquesa de Osuna. As with Romero the adulation accorded him by public and professionals was so great that enough contemporary evidence has been preserved so that we can still see him as a three-dimensional, complex, living person. We can apprehend the extraordinary grace with which he moved even when he was a sixteen-year-old novice; the inconsequence in which he held his own life, so that of the twenty-five times he was gored, half were very nearly fatal. We can sense the pride that in Cádiz made him insist on being paid as much as a rival; and the impulsive generosity with which he refunded a part of the money the following day, stating that "I don't want to take more than you've always paid me."

When he was killed in 1801, men sang:

> "Tell it in Cádiz
> who has felt it deeply;
> Puerto recounts nothing
> and Jerez with great grief.
> Finally, I say, they
> have felt it in all,
> all the lands that knew him
> for his grace and his humility;
> surely the grief is so great,
> so great the pain
> contained therein that
> there is not one soul that does not sorrow."[1]

Goya executed two earlier etched versions of "Pepe Hillo"'s demise, both of which show these last moments —the matador impaled on the bull's horns. Both were rejected in favor of Plate 33 when the series was published. Goya had used the backs of these plates for *Tauromaquia* 11 and 17. In 1876, when E. Loizelet published the third edition in Paris, he also printed the rejected plates.

1. Cossío, *Los Toros*, vol. 3, pp. 221–231 for information and quotation.

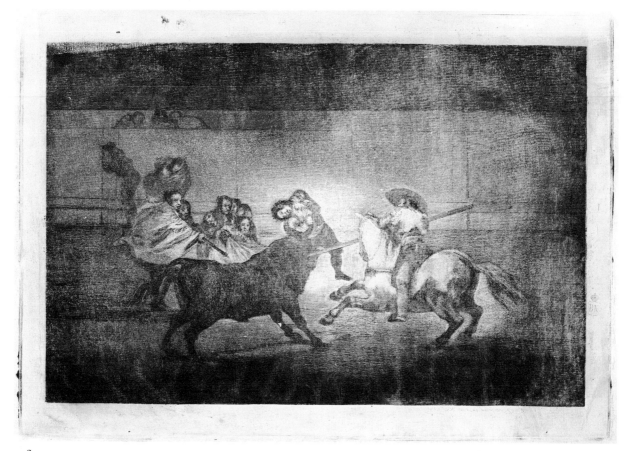

196

197

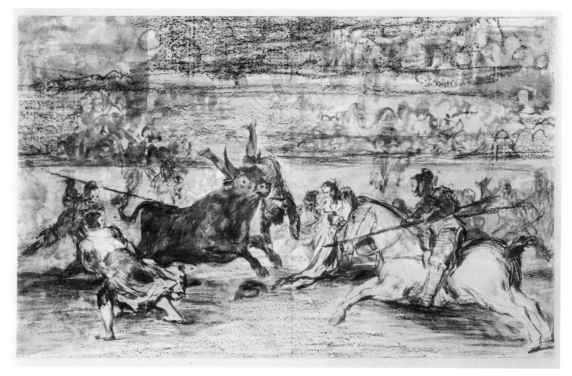

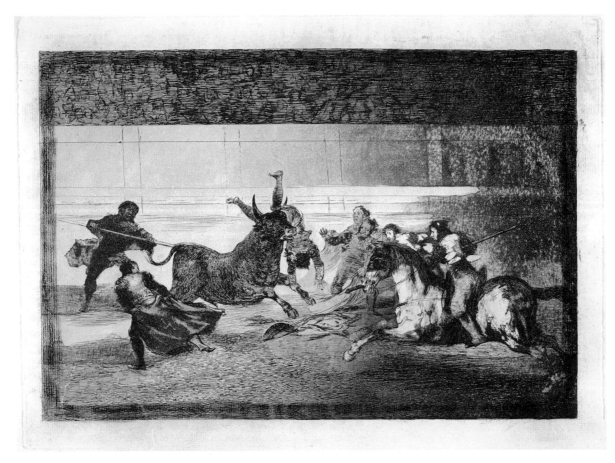

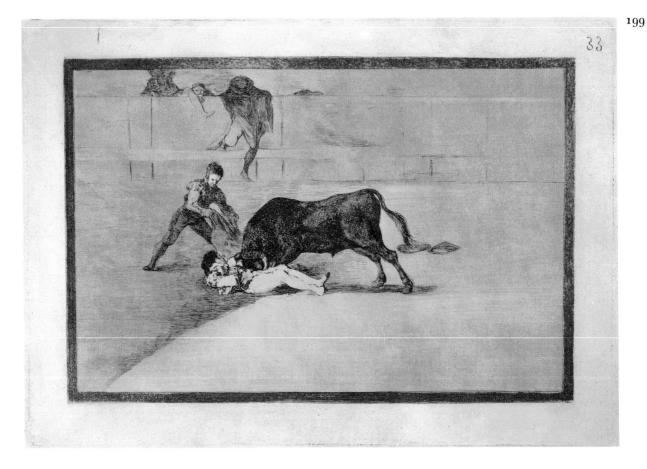

One version of the subject is represented by a unique working proof that has been unevenly printed on both sides of the sheet (cat. no. 196). On May 11, 1801, "Pepe Hillo" was fatally gored by the bull, Barbudo. A contemporary describes how the bull then lifted his body into the air with his horn.[2] A popular print shows how at first he struggled to free himself.[3] Goya's print shows him in this position, one hand clutching a horn. A mounted picador jabs at the bull's neck with his lance, while a second fighter, on foot, holds a pic in readiness. The four principals, and "Pepe Hillo," in particular, are spotlighted by a single central glow of light. Goya clearly encountered technical difficulties, perhaps in the biting of aquatint.

The drawing for the other rejected plate is one of the four *Tauromaquia* drawings in which Goya used sanguine wash as well as chalk. It is very similar in technique and manner of composition to the drawing for *Tauromaquia* 32 (cat. no. 193), except that the contours of the principal figures here have not been as extensively redrawn. The same contemporary account tells us that the bull frisked about with "Pepe Hillo"'s body held in various positions.[4] In the drawing the bull's horn has penetrated "Pepe Hillo"'s thigh and he is carried upside down by the still vital bull. A picador and other toreros rush to the rescue.

Goya's transition from drawing to print is similar to that seen in *Tauromaquia* 32. Some of the subordinate figures were repositioned, but the principal group was transferred directly to the copper plate. This plate is also a technical failure. Goya did not control the lavis properly, and it often has an accidental, blotchy appearance. The peculiar tonal effect at the upper right may have resulted from an attempt to combine lavis and aquatint. A wide black chalk border has again been added to the print.

In the print used for the published edition, Goya shows the first moment of "Pepe Hillo"'s terrible goring.

Before the matador was borne through the air like a rag doll, he was first pinned to the ground by the horns of the bull. The matador's head is slightly raised and his hands clasp the horn in a vain attempt to keep the bull from penetrating further into his body. A single torero has arrived to help him and tries to divert the bull's attention with his cape. Others scramble over the barrier into the ring. The previous plate had suggested the tumult and excitement of a critical moment. Here, there is a sense of lonely isolation. A single fine grain of aquatint tone covers almost the entire plate. The ground around the bull was burnished to silhouette him and add to the sense of motion. The etched shadows of the ground and background also serve subtly to direct one's attention to what is happening.

Goya treated the broad border line in an unusual manner. The bottom and left sides have received a coarse grain of aquatint, while the top and right side seem to have been bitten directly with acid.

2. José de la Tixera, quoted in Cossío, *Los Toros,* vol. 3, pp. 228–230; vol. 2, p. 829.

3. Reproduced by Cossío, *Los Toros,* vol. 3, p. 227.

4. José de la Tixera, quoted in Cossío, *Los Toros,* vol. 3, pp. 228–230; vol. 2, pp. 825–827.

200-202
Modo de Volar (Way of flying). 1816
D. 214, H. 260, B. 196, Hof. 135
245 × 350 mm.

JEAN BAPTISTE TILLIARD. France, 1740–1813
200
Jacob Degen in His Flying Machine
Etching, hand-colored. 235 × 180 mm.
Anonymous loan

201
Working proof, Harris I, 1
Etching.
Upper left in pen and brown ink: *4*
Watermark: Nº
Fundación Lázaro Galdiano, Madrid.

202
Posthumous proof, Harris II, ca. 1848
Etching, aquatint, and fine scratches
No watermark
Museum of Fine Arts, Boston. Lee M. Friedman Fund.
65.404

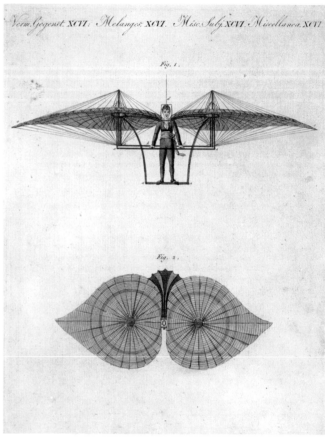

200

The mock-up copy of the *Arte de lidiar los Toros . . .
(La Tauromaquia)* that Goya gave to his friend the art
historian Ceán Bermúdez to edit for him, included a
thirty-fourth print described on Ceán Bermúdez' title
page as: *el modo de poder volar los hombres con alas*
(the way men can fly with wings) and in his table of con-
tents as *34. Modo de volar* (Way of flying). A proof of
the same print exists in the Fundación Lázaro Galdiano,
which is inscribed by Goya *Modo de volar*. Cataloguers of
Goya's work have always included it in his series of
Disparates. The plate is the same size as the others of the
series, and it is executed in the same style. But it is the
only instance of a plate for which a manuscript title
exists in Goya's hand that does not begin with the word
Disparate.

 Unlike Goya's witches and warlocks in the *Caprichos*,
who are either borne aloft on the backs of others or are
self-propelled, these men fly by means of a mechanical

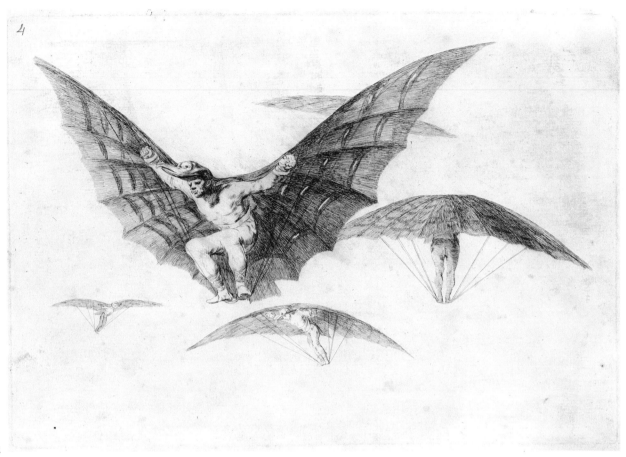

201

202

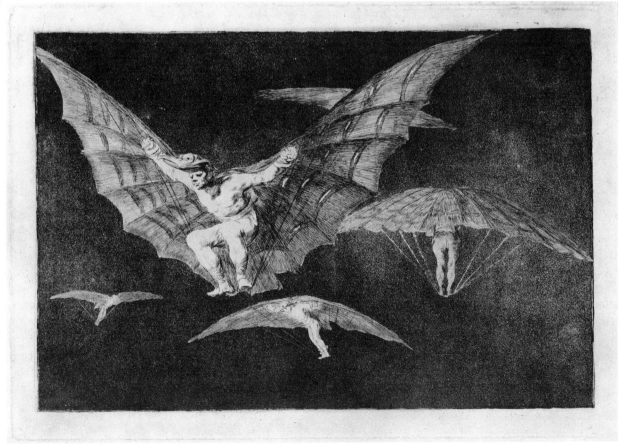

contrivance; they use their legs to pump great bird-like wings. They wear fantastic billed caps in the form of birds' heads. This invention is remarkably similar to that of the Viennese clockmaker, Jacob Degen, who "flew" with varnished paper wings twice in Vienna in 1808. In the hand-colored print by Tilliard we see Degen standing between the wings on a kind of trapeze that he could move to manipulate the wings. It must be added that Degen's flight aloft was aided in the first instance by a counterweight and in the second by a balloon.

This plate is an apt conclusion to the *Tauromaquia*. Just as common men are able to conquer through skill, knowledge, and courage one of nature's most savage creatures, the bull, so will they one day emulate the birds and conquer the air.

The etched working proof before aquatint resembles the recently rediscovered sanguine chalk and wash preparatory drawing for the print in suggesting a flight in bright daylight.[1]

The posthumous trial proof printed about 1848 in dark gray ink on grayish paper shows the addition of tone in the form of aquatint and scratches or abrasions that print with burr. In the working proof the sky seemed to extend to the plate mark. When aquatint was added the rectangle of sky was reduced in size. The sky is dark and mysterious and has a murky depth due to the modulations of the aquatint grain.

1. The drawing is in the Fundación Lázaro Galdiano, Madrid (Gassier and Wilson, 1592).

The Disparates

A number of preparatory drawings for the *Disparates* survive; for example, those for *The Dancing Giant* and *Woman Seized by a Horse* (cat. nos. 208 and 215). Most of them have platemarks or printing folds resulting from transfer to the grounded copper plate in the press. In addition, there exist a number of drawings of the same format, on the same papers, and executed in the same medium and style for *Disparates* that are not known to have been etched, such as the drawing of a drunken religious procession (cat. no. 230).

The *Disparates* drawings were executed with brush and sanguine wash over a light sketch in red chalk. They range from drawings in which the principal figures are clearly defined (cat. nos. 208 and 215) to sketchy, impressionistic drawings in which only the broad masses of light and dark are indicated (cat. no. 230).

The first *Disparates* plates were probably executed about 1816, for an impression of the etched working proof of *Modo de Volar* (Way of Flying), a print closely associated with the *Disparates* in style and format and often catalogued with them, was included in the mock-up copy of the *Tauromaquia* which Goya gave to Ceán Bermúdez to edit prior to the 1816 publication of the series. The rest of the twenty-one plates known to have been etched were most probably executed in the following years. The copper plates have the same dimensions as those used for the *Tauromaquia*.[1]

Working proofs for the *Disparates* are rare and some plates are known only from posthumous impressions *(A Man Mocked,* cat. nos. 223–224). For certain of the subjects working proofs survive inscribed with the title in Goya's hand (cat. nos. 211, 214, 219, 222, 225, and 226).

No edition was printed from these plates in Goya's lifetime.[2] About 1848 the first posthumous printing of the plates occurred.[3] These impressions are generally lightly and unevenly printed. Eighteen of the plates, including the *Modo de Volar,* were acquired by the Academia de San Fernando in 1862 and, after a few trial proofs were taken, the first edition appeared in 1864. Four plates (D. 220–223, H. 266–269, cat. nos. 225, 226–229) became separated from the others before the printing of about 1848 and were first published in the French magazine *L'Art* in 1877. Goya's working proofs are generally light, delicate, and transparent in effect, while the Academia impressions, in which a film of ink was left on the plate, are heavy and opaque.

The Academia published the eighteen plates under the title "*Los Proverbios*" (The Proverbs). The collective title, *Disparates* (Follies) is based on Goya's manuscript titles.[4] Whenever a Goya manuscript title did not exist for a print we have used a brief descriptive title in English.

The *Disparates* are among the most ambiguous and enigmatic of Goya's prints. They present a profoundly pessimistic picture of the follies of humanity that finds its equivalent in the "black" paintings Goya painted for his house.[5] Like the later prints from the *Desastres,* the *caprichos enfáticos,* they reflect the civil and social chaos of this period of Spanish history.

CLIFFORD S. ACKLEY

1. The copper plates for both series were imported from London. They bear the stamp of the manufacturers, William and Maxwell Pontifax of Long Acre, London. Harris, vol. 1, p. 27.

2. For the history of the plates and their ownership and editions see Harris, vol. 1, pp. 193–198.

3. The cover of the paper bound set owned by the Museum of Fine Arts (cat. nos. 204 and 207) is inscribed: *Madrid hacia* (about) *1848.* Two impressions acquired in 1856 by the Bibliothèque Nationale, Paris, have the date *1849* inscribed on their mounts.

We would like to thank Françoise Gardey for checking the latter for us.

4. Harris, who did not accept the manuscript titles as being from Goya's hand, retained the Academia's collective title and attempted to relate each print to traditional Spanish proverbs or sayings. He also found the word *disparate* (folly) unacceptable for the series because he considered it synonymous with "nonsense." Harris, vol. 1, pp. 193–194.

5. Gassier and Wilson 1615–1627a. They date the paintings 1820–1823.

203–206

Soldiers Frightened by a Phantom. 1816 or later
D. 203, H. 249, B. 186, Hof. 125
245 × 350 mm.

203
Working proof, Harris I, 2
Etching and burnished aquatint, number 13 in pen and brown ink upper left
Watermark: Morato
Coll.: Vindel
Fundación Lázaro Galdiano, Madrid

204
Posthumous proof, Harris II, ca. 1848
Etching, burnished aquatint, and fine scratches
Bound with a set of 18, paper cover
inscribed in pen: *GOYA Los Proverbios Madrid hacia 1848*
No watermark
Coll.: Hofer
Museum of Fine Arts, Boston. Bequest of Horatio G. Curtis, by exchange, and the Harvey D. Parker Collection, by exchange. 1973.701

205
Posthumous trial proof for the Academia edition, Harris II, 2, 1863–64
Etching, burnished aquatint, and fine scratches
Watermark: J.G.O. palmette
Museum of Fine Arts, Boston. Gift of Miss Katherine Bullard. M25705

206
First edition impression, Harris III, 1, 1864
Etching, burnished aquatint, and fine scratches
Watermark: J.G.O. palmette
Coll.: Vindel
Art Institute of Chicago. Charles Deering Collection. 1927.3311

Soldiers, tumbling over each other in their panic, flee from a giant hooded figure. A mocking mask peeping from the shadow of the spectre's sleeve reveals his falsity. It is impossible to know from what empty threat of force these soldiers flee. Goya referred again and again to the theme of human gullibility: they see what is not there.

A preparatory drawing in sanguine chalk and wash (Prado 186, not in exhibition) shows signs of transfer to the plate in the press and presents the essential elements of the completed design.

Working proofs for this series are exceedingly rare and, in certain instances, are not known to exist; see, for example *A Man Mocked* (cat. nos. 223–224). The only known working proof for this print has a delicacy and clarity altogether lacking in the posthumous editions. It is printed in a brownish ink and has been numbered in pen by an unknown hand.

The impression in black ink from one of a small number of sets of posthumous proofs of the eighteen plates that were printed about 1848 is cleanly wiped and more lightly inked than the later Academia impressions but is very uneven and cloudy. Fine abrasions or scratches that print with burr model or give tonal color to the phantom's left sleeve, the tree, and the soldier with the upraised saber. A tone above the horizon line suggests dark hills. It appears to have been brushed on to the plate and is perhaps lavis. A number of accidental scratches are also visible on the plate: see, for example, the diagonal one on the phantom's sleeve and those in the lower right corner. This set, which is bound, is printed on a buff-colored wove paper with no watermark. The plain paper cover of the set is inscribed in pen: *GOYA Los Proverbios Madrid hacia 1848* (Goya, The Proverbs, Madrid, about 1848).

The trial proof in reddish-brown ink printed for the Academia in 1863 or 1864 is much more heavily inked than the two foregoing impressions and is printed with a film of ink. There is a new strong curving horizontal scratch on the upper body of the phantom. Both this impression and the following are on the same heavy wove paper the Academia used for their edition of the *Desastres* in 1863.

The impression in black ink is from the edition published in 1864 for the Academia. The plate was even more heavily inked and a somewhat denser film of ink was left on the surface of the plate as in the 1863 edition of the *Desastres*. The long curving scratch has been burnished from the plate. The effect of this inking in the two Academia impressions is to mute contrasts and suppress

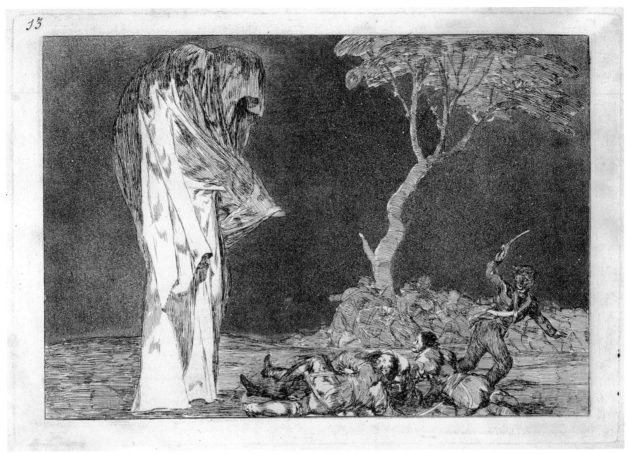

203

204

207

the highlights that drew one's attention to the towering
phantom and to the terrified faces of the soldiers in
Goya's working proof.

207
Disparate ridiculo (Extravagant folly). 1816 or later
D. 204, H. 250, B. 187, Hof. 126
245 × 350 mm.
Trial proof, Harris II, ca. 1848
Etching, aquatint, drypoint, and fine scratches
Bound with a set of 18, paper cover
Inscribed in pen: *GOYA Los Proverbios Madrid,*
hacia 1848 (Goya, The Proverbs, Madrid, about 1848)
No watermark
Coll.: Hofer
Museum of Fine Arts, Boston. Bequest of Horatio G.
Curtis, by exchange, and the Harvey D. Parker
Collection, by exchange. 1973.701

A group of witches have settled like a flock of birds
on a giant branch. Among them is a bearded male and a
fashionable young female with a muff. The latter, pos-
sibly a member of the nobility, resembles the young witch
seated in a chair at the far right in one of the "black"
paintings that once decorated Goya's house, *The Great*
He-Goat (Gassier and Wilson 1623, Prado 761, not in
exhibition). Goya's witchcraft subjects were not the crea-
tions of picturesque fantasy but rather a vehicle for
profound criticisms of the decadence of society.

A related drawing (Prado 202, not in exhibition),
executed with great freedom in red chalk and brush and
sanguine wash, is characteristic of a number of drawings
for or related to the *Disparates* in that it is difficult to
decipher but strong in power of suggestion. The figures
seem to cluster or swarm along an arch or branch that is
borne down by their weight and about to break.

The posthumous proof, printed in a dark gray ink
on buff paper, is from the same bound set printed about
1848 (cat. no. 204). Extensive use has been made of fine
scratches or abrasions with burr to shade and model
the figures.

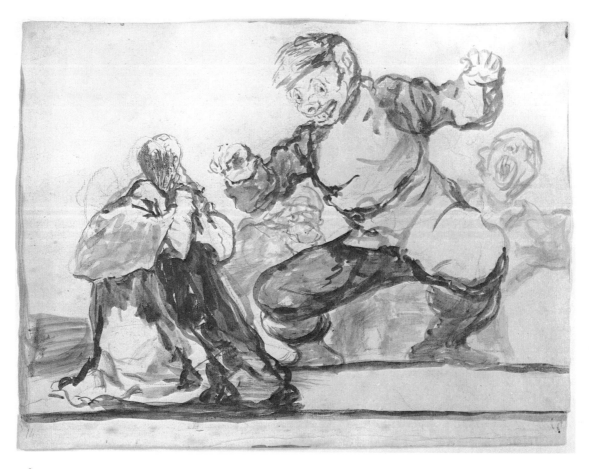

208

208–210

The Dancing Giant. 1816 or later
D. 205, H. 251, B. 188, Hof. 127
245 × 350 mm.
At left in plate: *Goya*

208
Preparatory drawing
Sanguine chalk and wash; platemark from transfer
in press
245 × 325 mm.
Watermark: Serra
Museo del Prado, Madrid. 188

209
Working proof, Harris I, 1
Etching
No watermark
Coll.: Burty, Avery
Prints Division, The New York Public Library, Astor,
Lenox and Tilden Foundations

210
Posthumous proof, Harris II, ca. 1848
Etching (twice), aquatint, and burnishing
No watermark
Museum of Fine Arts, Boston. Hezekiah E. Bolles Fund.
37.258

A figure crouches, holding a draped image which
he uses to protect himself against a childish giant, who
grins like an idiot as he dances to the rhythm of clicking
castanets. In the preparatory drawing the former is
clothed as a monk or a cleric. Is he seeking to maintain his
control over the vital but childish giant by brandishing
a holy image in front of him? Can he succeed? The
screaming and leering demons, creatures of chaos, who
peer out of the darkness from behind the powerful giant,
increase the tension of this confrontation.

The preparatory drawing in sanguine chalk and
wash shows signs of transfer in the press: a platemark is
visible in the lower margin beneath the border line. The

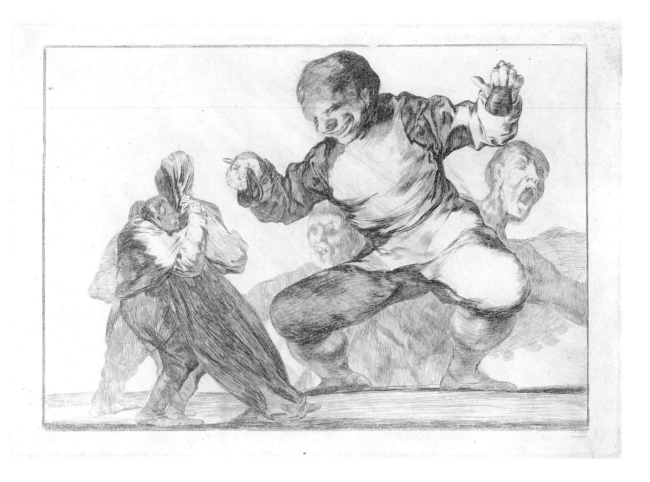

209

210

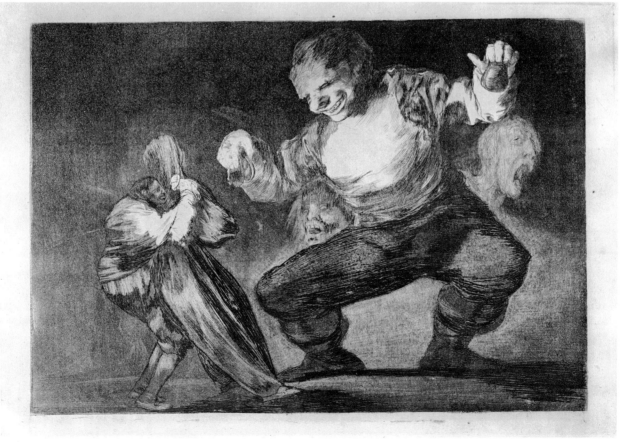

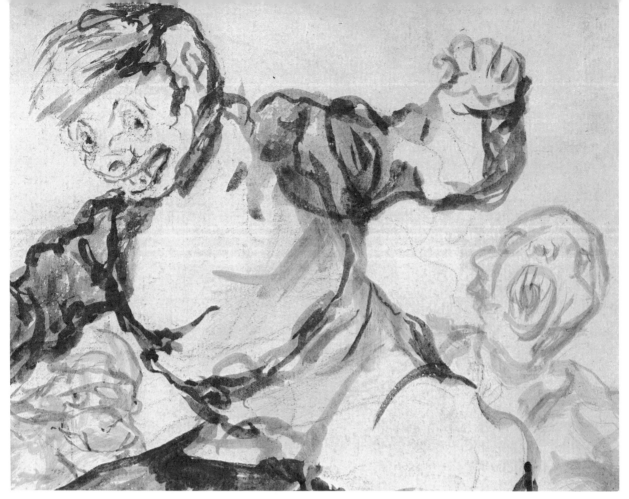

208 (detail, full size)

giant's face is demonic and mask-like, and he has a shock of unruly hair. His castanets are only summarily indicated. The demons are somewhat different in form, but are placed in approximately the positions they will occupy in the print.

The working proof, one of three, an unusually large number for this series, is printed in a brownish ink. The crouching man now wears trousers, and his dress is no longer plainly clerical: for Goya, as he so frequently did, has blurred the reference. A second person, sketchily indicated in the drawing, appears behind him. The giant's hair is cropped, and the idiotic grin convulses his features, closing his eyes. His hands now clearly hold castanets. The demons are given more definite form, and the one at the right is winged. Light streaks or scratches resulting from the wiping of the plate sweep diagonally across the impression.

No working proof with aquatint and further line work has survived. The posthumous trial proof, printed about 1848 in black ink, shows the addition of aquatint, much burnishing, and new, coarser, deeply bitten lines. These additions have considerably altered the appearance of the crouching figure, whose smaller head and more spindly legs make him appear even more insignificant in relation to the giant. Stopping-out emphasizes the arm that clutches the image. The second man is obliterated by the layer of aquatint grain. The giant is heavily shaded and modeled with aquatint and line except for the blank patches that strongly illuminate his hands, chest, and grinning face against the opaque darkness of the background. One eye is now slightly opened. His sturdy legs are strongly outlined by burnishing. The demons have again altered in form, and only their heads are visible, burnished to a ghostly phosphorescence. Throughout, burnishing of the finer, earlier etched lines has provided intermediate tones. The impression has the unevenness characteristic of many of the proofs of this edition.

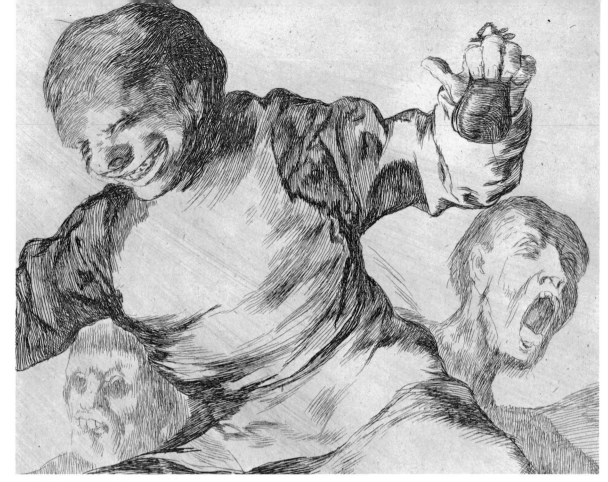

209 (detail, full size)

210 (detail, full size)

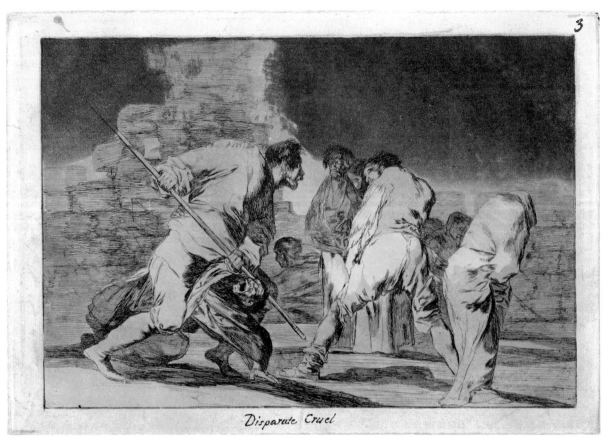

Disparate Cruel

211

211

Disparate Cruel (Cruel folly). 1816 or later
D. 207, H. 253, B. 190, Hof. 129
245 × 350 mm.
At left in plate: *Goya*

Working proof, Harris I, 2
Etching and aquatint
Inscribed in pen and brown ink, with title in Goya's
hand; number *3* pen and brown ink upper right
No watermark
Museum of Fine Arts, Boston. Bequest of W. G. Russell
Allen. 1974.251

A belligerent figure straddles a man who struggles
and cries out. The former wields a bullfighter's pic with
which he bears down on his victim's skull. He seems to
shout at a group of spectators, witnesses to this brutal
engagement, who turn away or avert their eyes: they
know but willfully choose not to see. Behind them, a
crumbling stone wall reinforces this image of civil chaos.

In the sanguine chalk and wash drawing (Prado
192, not in exhibition), the weapon is a musket and no
attack has yet occurred. The background is occupied by a
sentry box rather than the decaying wall.

The unique working proof with aquatint, printed
in a brownish ink, was not known to Harris, who lists
only two working proofs in pure line before the aquatint.
On this one Goya has inscribed the title in pen and brown
ink and probably also the number 3. Accidental streaks
and splotches that occurred during the biting of the
aquatint are visible at the top of the wall and on the
shoulder of the man with the pic. Soiling, folds, and rub-
bing of the printed surface where the sheet is buckled
testify to casual handling of this impression in the past.

212

212–214
Disparate desordenado (Disorderly folly). 1816 or later
D. 208, H. 254, B. 191, Hof. 130
245 × 350 mm.
At right in plate: *Goya*

ANONYMOUS. Spanish, early nineteenth century
212
La falsedad demostrada en barias caras (Falsity
demonstrated in various faces)
Etching, hand colored
142 × 106 mm.
Biblioteca Nacional. 17893

213
Working proof, Harris I, 1
Etching and drypoint
In pen and brown ink upper left: *ja.* Touched with pen
and gray ink on monster's breasts (not by Goya)
No watermark
Coll.: Vindel
Fundación Lázaro Galdiano, Madrid

214
Working proof, Harris I, 2
Etching, aquatint, and drypoint
Title inscribed in pen and brown ink in Goya's hand;
number 4 in pen and brown ink upper right
No watermark
Art Institute of Chicago. The Albert H. Wolf Memorial
Collection. 48.395

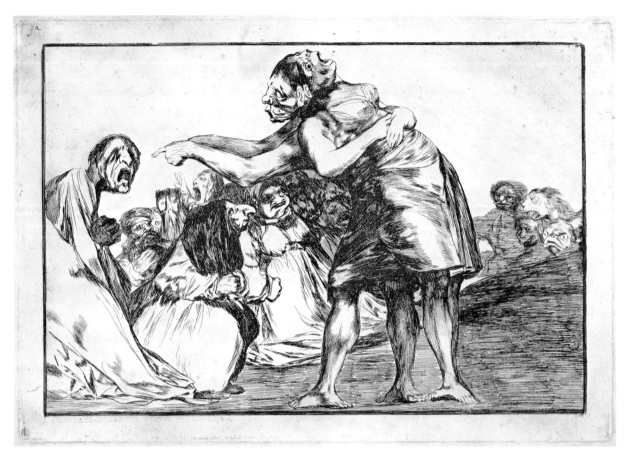

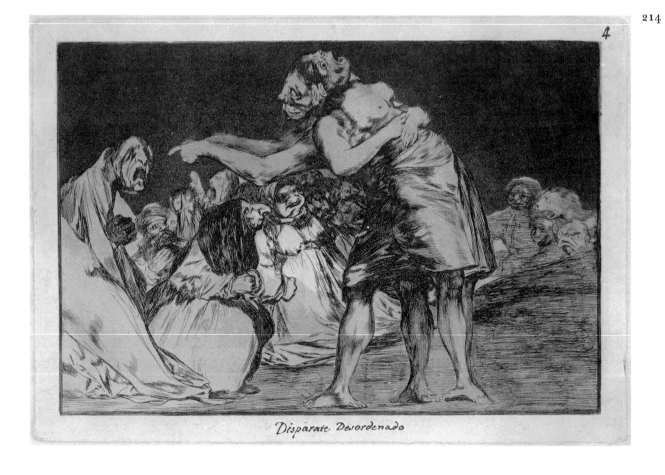

Disparate Desordenado

A group of worshippers, including a Moor, some with the heads of animals, others half-human monsters, kneel and supplicate a monstrous figure that consists of two human bodies joined back to back and head to head. Not only does this object of their adoration have two bodies and two heads but each foot consists of two feet joined at the heel. The faces of this strange idol are as monstrous as those who kneel before it.

A contemporary Spanish popular print representing *La falsedad demostrada en barias caras* (Falsity demonstrated in various faces) provides a clue to the true meaning of the print. Here falsity or duplicity is represented by figures with two, or even three faces, a device that had been used for centuries. The print is also a game in which profiles are concealed in the rocks and shrubbery while the cocked and feathered hat doubles as a landscape. Duplicity represented by two-facedness may also be seen in the unpublished capricho *Dream of lying and inconstancy* (cat. no. 92) and in the *Poor folly* (cat. no. 218).

In *Disorderly folly* we are confronted then with an image of the worship of duplicity or falsehood. Both the worshippers and that which is worshipped are equally deformed and misguided.[1]

The unique working proof, with line work only, is printed in a brownish ink. Bare patches resulting from overbiting are visible in the areas of heavier shading on the figure of duplicity. Someone, perhaps the same prudish person who retouched *Desastres* 30 (cat. no. 137) has penned in a blouse to cover the monster's bare breasts.

In the working proof with aquatint, also unique, the addition of aquatint places the scene in a symbolically appropriate twilight or half-light with a background of profound darkness. This proof, inscribed with the title in pen by Goya, and possibly numbered by him, was also printed in a brownish ink.

1. Before the Chicago proof with Goya's manuscript title was known, this print was sometimes known by the title, *Matrimonial folly*. The right-hand half of the monstrous object of veneration is indeed female, and the other half quite possibly male, but the latter is by no means certain. The image has been compared with the couple bound back to back who struggle to free themselves in *Caprichos* 75, *Is there no one to untie us?* (cat. no. 89)

215–217
Woman Seized by a Horse. 1816 or later
D. 211, H. 257, B. 194, Hof. 133
245 × 350 mm.
At right in plate: *Goya*

215
Preparatory drawing
Sanguine chalk and wash; platemark resulting from transfer, black pigment along platemark
245 × 345 mm.
Watermark: Manuel
Museo del Prado, Madrid. 189

216
Working proof, Harris I, 1
Etching and drypoint
Coll.: Burty
British Museum, London. 1876-5-10-315

217
Posthumous proof, Harris II, ca. 1848
Etching, burnished aquatint, and drypoint
No watermark
National Gallery of Art, Washington, D.C. Rosenwald Collection. B–18.900

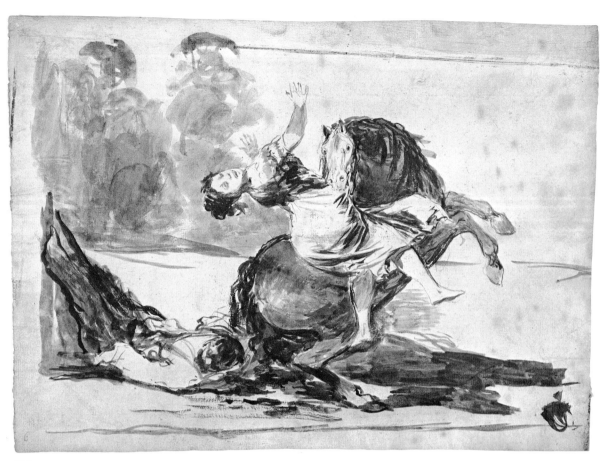

215

In the print a wild-eyed, rearing horse has seized a woman's dress with his teeth and holds her suspended, while she kicks and struggles, her arms outflung. The expression of her eyes is masked by shadow, but an ambiguous Leonardesque smile plays about her lips. In the preparatory drawing, a man lies at the left, possibly overpowered by the horse. The woman's gestures are similar to those in the print, but her features clearly express fright. The broadly indicated background suggests the edge of a wood. In the print, the background is occupied by two monstrous creatures: one porcine, half seen above the rim of the hill; the other a dog-like monster into whose maw, gaping open like the mouth of hell, a woman creeps.

These significant changes between drawing and print suggest that the final image is one in which human beings, piqued by curiosity or desire for pleasure, will-ingly yield themselves up to destructive passions.

The preparatory drawing in sanguine chalk and wash shows clear signs of transfer to the plate. In the process of transfer Goya made a compositional adjust-ment by placing the drawing on the plate at an angle. The platemark is detectable, not only because of the inden-tation made in the paper but also by traces of black, possibly from the smoked etching ground.

The posthumous proof of about 1848 in dark gray ink on a light gray paper is unevenly printed, but reveals the change in mood and setting made by the addition of aquatint. Sky and ground are dark; burnishing silhouettes the horse and woman and the two monsters like an after-glow. In this lightly inked and printed impression, pas-sages of stop-out that create highlights on the figure of the woman are scarcely visible.

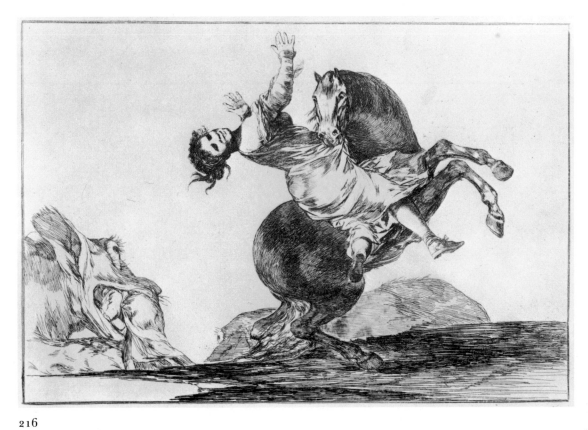

216

217

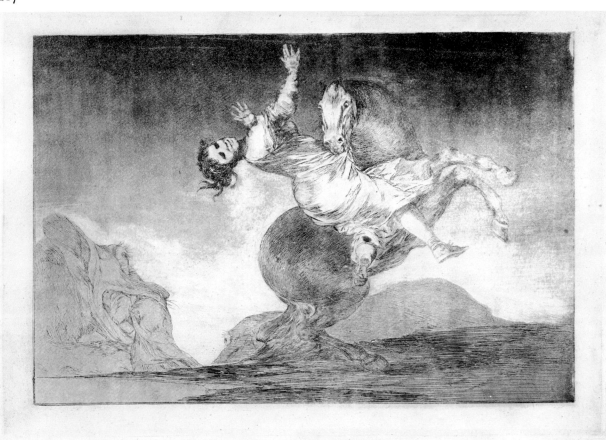

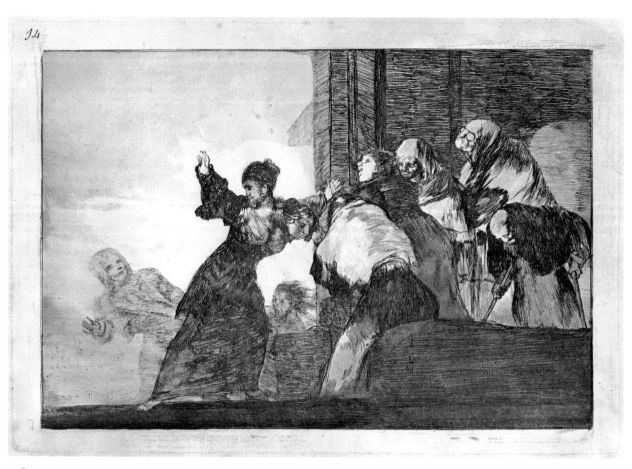

14

218

218

Disparate pobre (Poor folly). 1816 or later
D. 212, H. 258, B. 195, Hof. 134
245 × 350 mm.

Working proof, Harris I, 2
Etching, burnished aquatint, touched with graphite
or black chalk
Coll.: Vindel
Fundación Lázaro Galdiano, Madrid

At the right a group of women, wearing shawls, one
of them looking startled, emerge from a building that is
probably a church. They are confronted by a young
woman with outstretched arms and two heads. One head

bows toward the little congregation; the other stares back
at a hooded spectral figure. Behind the young woman at
the right one sees the head and shoulders of a screaming
figure with wildly streaming hair. One knows neither
who they are nor what their encounter means, and the
Disparate remains cryptic and enigmatic.

The working proof, printed in a brownish ink, has
light touches of graphite or black chalk on areas that will
subsequently receive passages of tone by means of scratch-
ing or abrasion of the plate; the women's shawls, for
example. The archway at the right is not touched but will
also be darkened by the same means. The impression has
been printed with a film of extra ink on certain areas
of the plate.

219–220
Disparate allegre (Merry folly). 1816 or later
D. 213, H. 135, B. 195, Hof. 135
245 × 350 mm.

219
Working proof, Harris I, 2
Etching, burnished aquatint, and drypoint
Inscribed by Goya with his title in pen and brown ink;
upper left penned number 8, upper right number 19
No watermark
Coll.: Hofer
Museum of Fine Arts, Boston. Gift of Mr. and Mrs.
Arthur E. Vershbow, Dorothy and Samuel Glaser,
Mr. and Mrs. Joseph Edinburg, and the M. and M.
Karolik Fund. 1973.702

220
First edition impression, 1864, Harris III
Etching, burnished aquatint, and drypoint
Coll.: Vindel
Art Institute of Chicago. The Charles Deering
Collection. 1927.3321

Six people, castanets clutched in their hands, dance in a circle. The men wear the clothing *majos* had worn some fifteen years earlier. One woman is richly dressed, with plumes in her hair, while the others are dressed as *majas*. The subject is the same as an earlier painted design for a tapestry in which young couples perform a stately dance with castanets by the Manzanares river (Gassier and Wilson 74, Prado 769). But here the dancers are old or aging and marked by life. The male dancer at the far left looks like a monkey, the bald dancer next to him has heavy legs and a swollen groin, and the one in the foreground, the physique of a dwarf. The aged noblewoman leers with an air of artificial gaiety; the two younger women have the button eyes and wooden movements of clockwork figures. One senses that they will persist in their dance until death overtakes them.

In the unique working proof with Goya's title, touches of drypoint are still fresh and strong on the dwarf's clothing and head. The delicate burnishing of the aquatint that silhouettes the figures and streaks the ground with light is still fresh and the strokes clearly defined. Although a bad stain disfigures the lower right corner, the print remains extraordinarily beautiful and compelling.

The posthumous impression from the first edition of 1864 makes one appreciate still more the qualities of the proof. The aquatint is uneven and cloudy. A film of ink over the whole plate may hide accidental scratches and other defects, but it also mutes the brighter accents and thereby interferes with the active, staccato rhythm of the dance.

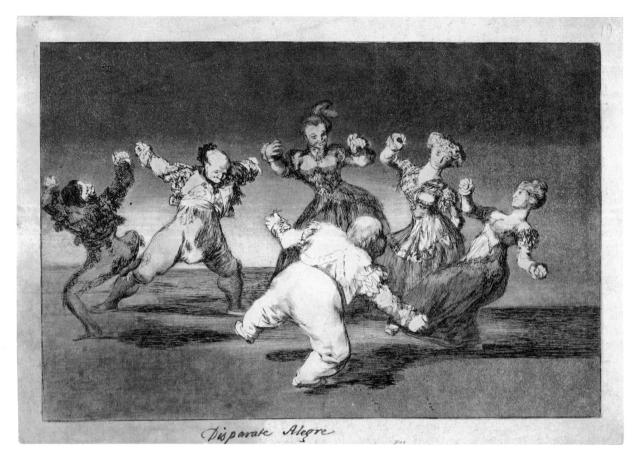

Disparate Alegre

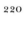

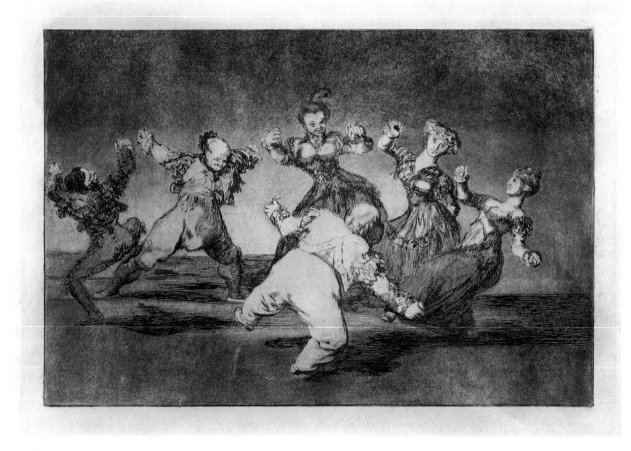

268 *The Disparates*

219 (detail, full size)

221–222

Disparate claro (Evident folly). 1816 or later
D. 216, H. 262, B. 198, Hof. 138
245 × 350 mm.

221

Working proof, Harris I, 1
Etching, touched with black chalk
Coll.: Hofmann
Graphische Sammlung Albertina, Vienna. 648–1924

222

Working proof, Harris I, 2
Etching, aquatint, lavis, fine scratches, and burnishing
Inscribed by Goya with title in pen and brown ink;
upper right penned number 7
Watermark: Morato
Coll.: Hofmann
Museum of Fine Arts, Boston. Gift of Mr. and Mrs. J.
Peabody Gardner and Museum Purchase Funds.
1973.703

The print *Evident folly* plainly alludes to the act of
letting in light (i.e., Truth) to banish the evils that
flourish in darkness. In the Albertina working proof, as
in the preparatory drawing (Prado 203, not in exhibition)
figures clamber up, sometimes standing on each other's
shoulders, in order to push up a heavy curtain and admit
the light. In the foreground other shadowy figures stand
on the brink of an abyss from which shoot up flames and
smoke, suggesting a pit of hell. A cleric, panic-stricken,
points with one hand toward the light and with the other
toward the flames of the abyss. At the right a nobleman
wearing antiquated dress kneels, eyes closed, as if in
prayer or supplication.

The same symbolism is to be found in an earlier
drawing (Prado 345, fig. 11) where, at the coming of the
light of Justice, common folk gaze up in rapture or even
dance. Monks and nuns look doubtful or appalled as light
touches their faces and a priest strides purposefully off
into the darkness.

The Albertina proof is touched with black chalk.
Strokes of chalk further define the flames of hell's blast

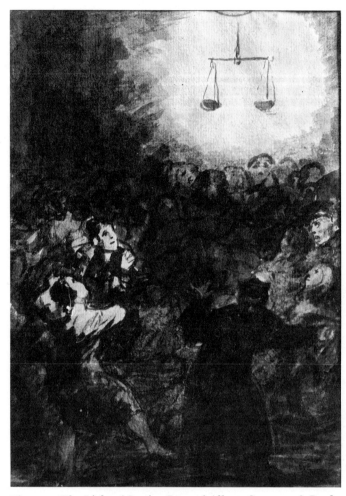

Fig. 11. *The Light of Justice,* Journal-Album C, page 118, Prado.

furnace and fill an arched window with a prison-like
grid of bars.

The working proof with Goya's manuscript title
shows further, and coarser, etched line work, as in the
final state of the *Dancing giant* (cat. no. 210). The giant
figure of a soldier with a monstrous mask now plummets
into the abyss. Aquatint and possibly lavis model the
soldier's figure and define the darkness into which he
plunges. The flames have disappeared, but smoke still
rises. Figures whose gestures indicate dismay and despair
have been added at the left of the group of onlookers.
New shading and contours have been given to the
spectators already etched.

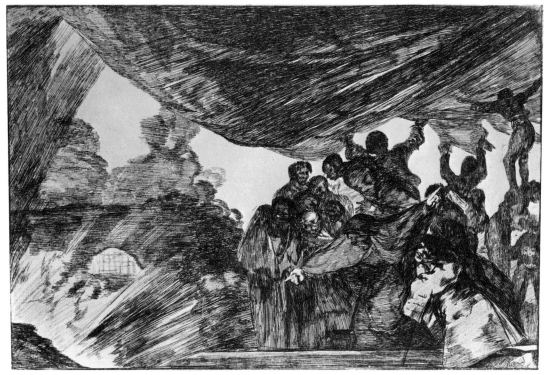

221

222

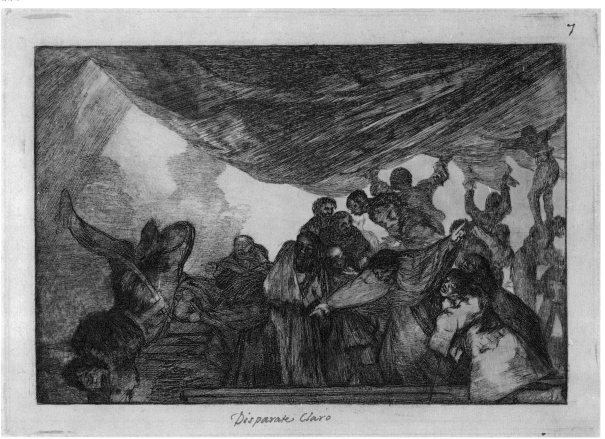

Disparate Claro

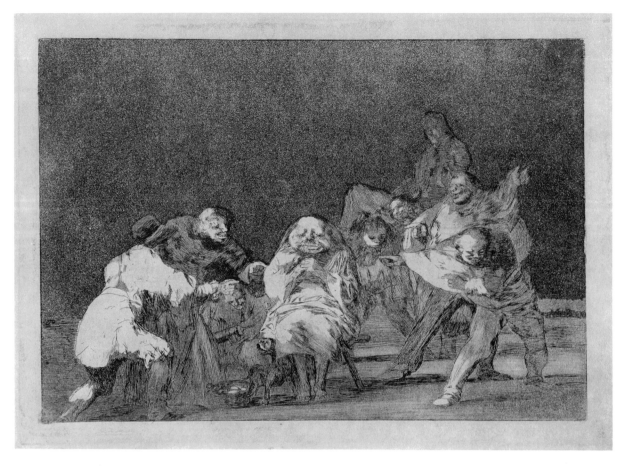

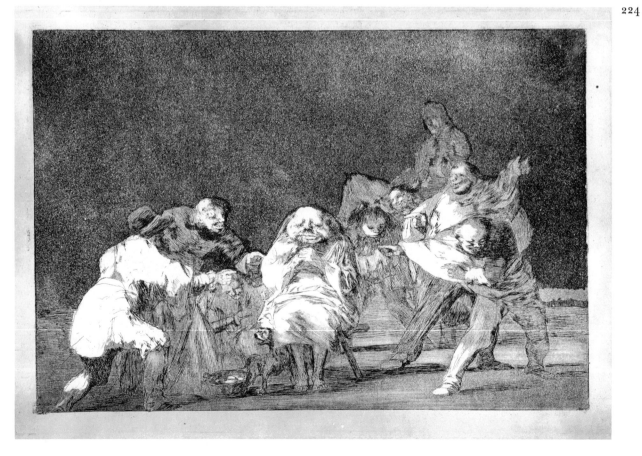

223–224
A Man Mocked. 1816 or later
D. 218, H. 264, B. 200, Hof. 140
245 × 350 mm.

223
Posthumous proof, Harris II, ca. 1848
Etching, burnished aquatint, and fine scratches
No watermark
Coll.: Burty
Museum of Fine Arts, Boston. Maria Antoinette Evans
Fund. M32621

224
Posthumous proof, Harris II, ca. 1848
Etching, burnished aquatint, and fine scratches
No watermark
Anonymous loan

An eminent man wearing a gown is seated on a bench, hands folded before him, eyes closed. He is ringed about by figures who jeer and mock at him, pointing with their fingers. His face is swollen and distorted by emotion, whether it be grief, self pity or even sanctimoniousness. His little dog loyally defends him from attack, while one of the mockers readies a syringe to purge him of his humors. Among the jeering crowd is a priest and, at the back, a shadowy figure of military or civil authority stands guard, mounted on horseback.

No working proofs are known. The early posthumous proofs, on buff or white paper in a dark gray ink, were printed about 1848. Both of the proofs exhibited here are fine, clear impressions, but the second is more effective because the white paper does full justice to the stopped-out highlights that link the mockers and the mocked. An unknown hand has written in pencil in the lower margin of this proof the ironic title, *La lealtad*—(loyalty—).

225
Disparate puntual (Sure folly). 1816 or later
D. 221, H. 267, B. 204, Hof. 143
245 × 350 mm.

Working proof, Harris I, 2
Etching, aquatint, and fine scratches
Inscribed by Goya in pen and brown ink with title;
upper left penned number 12
Watermark: Morato
Coll.: Vindel
Fundación Lázaro Galdiano, Madrid

Once again a crowd of spectators or worshippers do reverence to a feat or miracle that does not exist. Their eyes are closed in blindness or in prayer. A young woman dressed like a *maja* balances on the back of a horse. The horse in turn seems to balance on a slack rope, an impossible feat. If we look carefully we see that the rope rests on the ground: we see through the deception, the illusion, but the spectators do not.

The working proof inscribed by Goya with the title is printed in a brownish ink. Fine abraded scratches that print with a burr delicately model *maja* and horse. Similar scratches have been used to tone the crowd of spectators.

Four of the *Disparate* plates, of which this is one, had become separated from the other eighteen by about 1848, for they do not appear in the posthumous edition of that date. They were first published in the French art magazine *L'Art* in 1877.

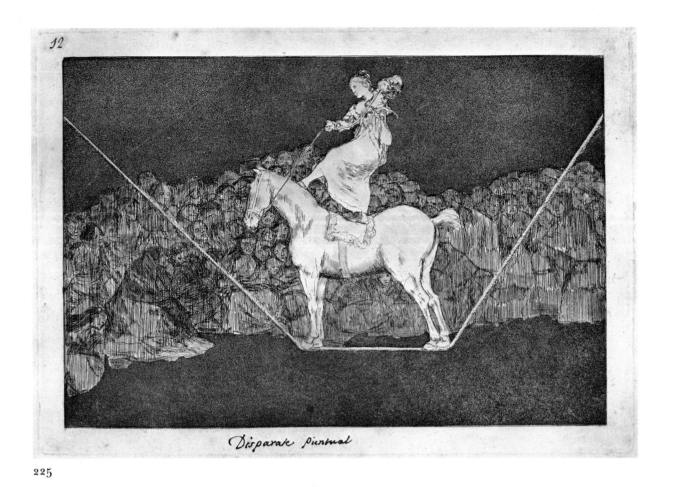

225

Fig. 12. *Buelan, buelan,* Journal-Album G, page 53, private collection.

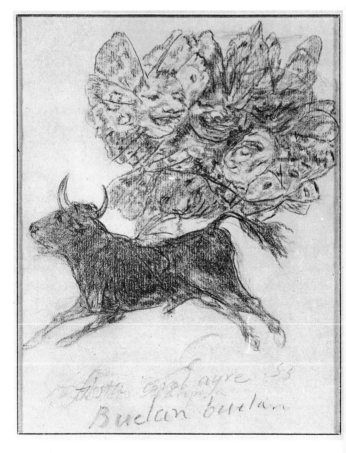

226–229

Disparate de tontos (Fools' folly). 1816 or later
D. 223, H. 269, B. 206, Hof. 123
245 × 350 mm.

226

Working proof, Harris I, 2
Etching, aquatint, and fine scratches
Title inscribed in pen and brown ink in Goya's hand
No watermark
Coll.: Vindel
Fundación Lázaro Galdiano, Madrid

227

Posthumous trial proof for *L'Art,* Harris II
Etching, aquatint, and fine scratches
No watermark, white China paper
Anonymous loan

228

Posthumous trial proof for *L'Art,* Harris II
Bound in deluxe copy of *L'Art,* 1877
Etching, aquatint, and fine scratches
No watermark, yellowish Japan paper
Anonymous loan

229

L'Art edition impression, Harris III, 1877
Etching, aquatint, and fine scratches
No watermark
Museum of Fine Arts, Boston. Gift of L. Aaron
Lebowich. 50.200

Different scholars have read Goya's inscription on
the working proof in different ways: as *tontos* (fools) or
toritos (young bulls). A cluster of bewitched bulls, a
startled look in their eyes, hover in mid-air. Some of the
world's most awesome animals, the Spanish bulls bred for
the bull ring, float helplessly in space, the very image
of uncertainty.

The image of the flying bull is seen again in a
drawing from Bordeaux album G (Gassier and Wilson
1757, private collection), where the bull is escorted by a
cluster of grinning faces surrounded by butterfly wings,
symbol of inconstancy (fig. 12). It is inscribed: *Buelan
buelan / fiesta en el ayre / El toro Mariposa* (They fly,
they fly. Fiesta in the air. The butterfly bull).

The contemporary working proof printed in a
gray-brown ink is delicate and aerial in effect. Fine
scratches with burr darken the bulls' hooves and model
their powerful bodies.

The first posthumous proof exhibited is a trial
proof on white China paper for the *L'Art* edition of 1877.
The plate, in relatively good condition, is much more
heavily inked and printed than in the contemporary
working proof. A second proof on thin, golden-toned
Japan paper is bound into a deluxe edition of *L'Art* that
has proofs on Japan as well as the ordinary edition im-
pressions on thicker white paper. Both impressions,
whether on white China or golden Japan show greater
clarity and transparency in the aquatint than does the
heavily inked, opaque edition impression on white paper.
The edition impression has the engraved title invented
for publication in *L'Art: Lluvia De Toros (Pluie
des Taureaux)* (Rain of bulls). Goya's name as inventor
and etcher and the names of the publication and the
printer, François Liénard, are also engraved on the plate.

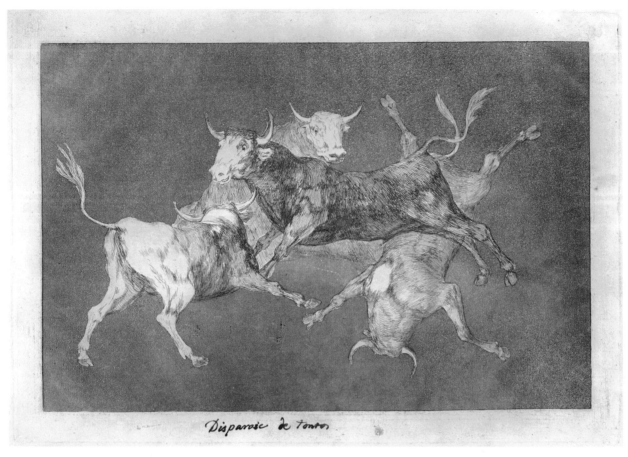

Disparate de tontos

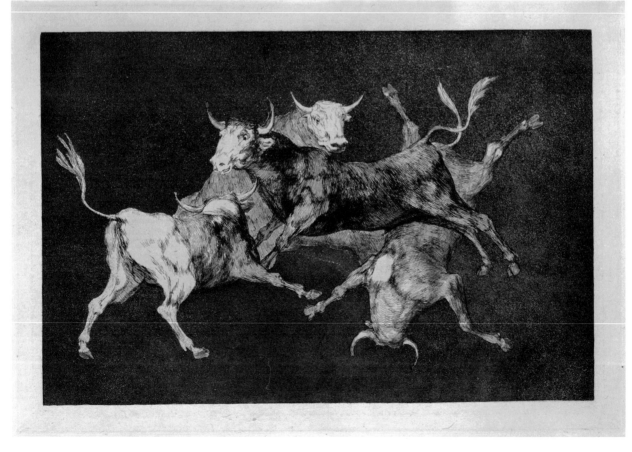

228

229

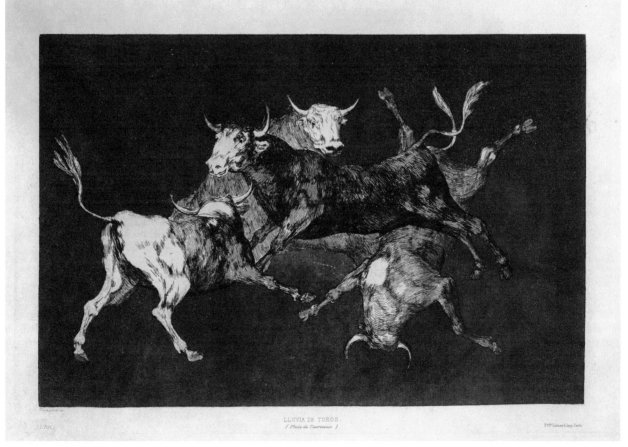

LLUVIA DE TOROS.
(Pluie de Taureaux)

230

230

Religious Procession. 1816 or later
Drawing for a *Disparate* not known to have been etched
Sanguine chalk and wash
230 × 330 mm.
Coll.: Valentín Carderera
No watermark
Anonymous loan

This is one of a group of drawings on the same two papers and in the same format and medium as the drawings for the *Disparates*. About two-thirds of these, including the present drawing, show no signs of having been put through a press. No prints of any of these compositions have survived.

Like many of the studies for the *Disparates*, such as Prado 203, *Disparate claro* (not in exhibition), this drawing is rough and impressionistic, and indicates only the broader masses of light and dark. It represents a religious procession carrying banners. Its members lurch toward us, drunken and disorderly.[1] Like some of the "black" paintings from Goya's house, it is a savage attack on the corruption of religious institutions. If the drawing had been etched Goya would have delineated faces that were as frightening and bigoted as those in the paintings executed for the walls of his house between 1820 and 1823.

1. A procession of drunken monks coming out of a church appears in an earlier drawing in the Metropolitan Museum, New York: Metropolitan 35.103.24, *De esto nada se sabe* (Nothing is known of this).

The Giant

231

The Giant. By 1818
D. 35, H. 29, B. 266, Hof. 233
285 × 210 mm.

Working proof. Harris I, 1
Burnished aquatint
No watermark
Museum of Fine Arts, Boston. Katherine Eliot Bullard
Fund. 65.1296

JACQUES GAMELIN. France, 1738–1803
232
Male nude. Study of musculature. Crayon manner
engraving after Gamelin
Nouveau receuil d'ostéologie et de myologie . . .
(Toulouse, 1779)
Coll.: Albert of Saxe-Teschen
Anonymous loan

The Giant is one of those rare prints whose imagery
is so powerful that on first seeing the aquatint one cannot
but be surprised by its small size in comparison with its
force. One other impression of the print is known in this
state and no more than four in a later state. The outline
of the giant's forearm was corrected, and villages on the
plain and mesa, originally (as here) barely suggested, were
made more explicit, so that it becomes immediately
evident that the brooding, enigmatic figure seated on the
curving earth is gigantic. The print is certainly related to
a painting now in the Prado that was listed in the 1812
inventory of Goya's house as "A giant," in which a
similar colossal figure rises from the earth to clench his
fist and spread panic throughout the countryside.[1]

No first-hand information on the print has survived.
We have nothing more than two brief statements, both
attributable to Goya's grandson Mariano. The copper
plate broke, he tells us, thus accounting for the rarity of

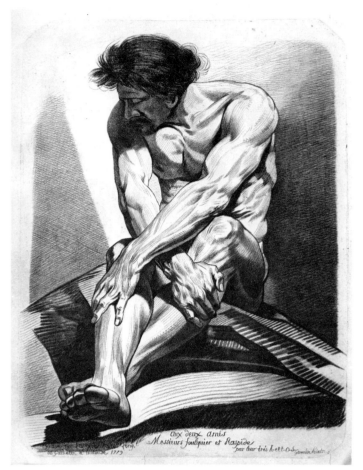

232

1. This entry was based on Eleanor A. Sayre's essay on the print in
Museum of Fine Arts, Boston, Western Art (Boston 1971), p. 208.
Prado 2785; Gassier and Wilson 946. The inventory was pub-
lished by F. J. Sánchez Cantón, "Como vivía Goya," *Archivo
Español de Arte,* vol. 19, 1946, pp. 74–109.

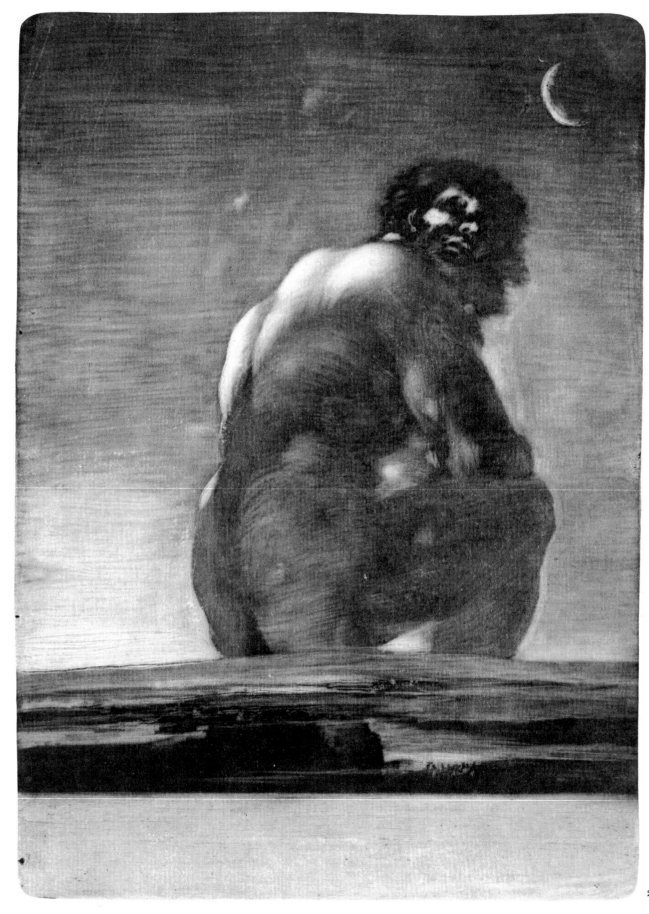

231

280 *The Giant*

the work;[2] and, during 1818, one of the appalling years that followed the Peninsular War, Goya kept an impression of *The Giant*, together with various papers, a painting, a drawing, and additional prints whose plates had also broken, in a hidden cupboard.[3]

The technique of this plate is unusual for Goya. It is entirely tonal; no lines were used. The plate was first completely covered with a fine granular tone, so that if printed it would have produced a solid dark, and Goya then scraped and burnished lights to create the design. Although he often lightened areas by burnishing, this is the only print he made entirely in this method. It has been termed a mezzotint. Indeed, the working method is similar, but the plate was not prepared with a mezzotint rocker, for the characteristic regular black dotted texture of a plate so prepared is not present under high magnification. Although the plate may have been prepared commercially, as has been suggested, it was done with a fine-grained aquatint.[4]

The academic nude study after Gamelin, although not a unique type, is by a strong and original artist whose work may have attracted Goya. The powerful, virile image is unusual for the eighteenth century. Moreover, the strong patterns of light and shade and the tonal working of the plate in broad, crayon-like lines, have an affinity with Goya's *Giant*.[5]

SUE W. REED

2. One impression of the print in the second state, in the Bibliothèque Nationale, Paris, from the collection of Mariano Goya is inscribed: *Por Goya, después de tiradas 3 pruebas se rompió la lámina.*

3. Mariano's letter, dated 1862, referring to the contents of the cupboard, is in the British Museum.

4. See Harris, vol. 1, p. 27.

5. See *Desastres* 8 (cat. nos. 102–103) for another possible link with Gamelin.

The caprichos enfáticos

For information on these prints which were included in the *Desastres de la guerra* see the introduction to that series.

233
Desastres 65 (caprichos enfáticos)
Qué alboroto es este? (What is this commotion?)
D. 184, H. 185, B. 167, Hof. 209
175 × 220 mm.

Working proof, Harris I, 1
Etching and burin
Bibliothèque Nationale, Paris

This first working proof is as enigmatic as it is brilliantly executed. Civilians confronted by barking dogs flee blindly. An official seated on a well-filled sack makes an entry on a sheet of paper.[1] There is no known preliminary drawing that might shed further light on the subject.

The etched lines have a sketchy freedom, and the small patches of parallel shading have a sureness and abstraction analagous to Goya's brushstrokes. In *Desastres* 72 (cat. no. 237) one sees more extensive use of this swift, variegated shading. The extended, triangular form of the woman in white is quite similar to the 1819 lithograph, *Espresivo doble fuerza* (cat. no. 251).

The plate would subsequently be shaded with lavis.

234
Desastres 66 (caprichos enfáticos)
Extraña devocion! (Strange devotion!)
D. 185, H. 186, B. 168, Hof. 210
175 × 220 mm.

Working proof, Harris I, 2
Etching; touched with graphite
Watermark: SERRA
Coll.: Carderera; Stirling-Maxwell
Museum of Fine Arts, Boston. 1951 Purchase Fund.
51.1686

A monk and various laymen kneel before a glass coffin containing a body alleged to have been miraculously preserved.

The content of the *caprichos enfáticos* must remain to some extent enigmatic, for we have no manuscript of explanation. Yet, insofar as Goya's imagery is recurrent in his prints, his paintings, and his drawings, it is worth relating some of them to satires in the *Caprichos*. In *What a tailor can do* (52; cat. nos. 78–80), people look with similar awe at what is plainly a false miracle. It may well be significant that in this late print of the *Desastres* the coffin is borne by a donkey, the symbol of folly, bedecked with bells and what appears to be church linen.

On his return to power in 1814 Fernando restored the church and the monastic orders to their earlier positions of power. He also took as his advisors some of the most despicable men in Spain, among them clerics.

This second working proof is touched with graphite below the donkey's head and neck where later lavis would shade the worshippers' heads as well as most of the remaining figures.

1. Lafuente, following Melida, believes it is the French despoiling Spaniards for profit or in reprisal (*Los Desastres,* pp. 179–180).

233

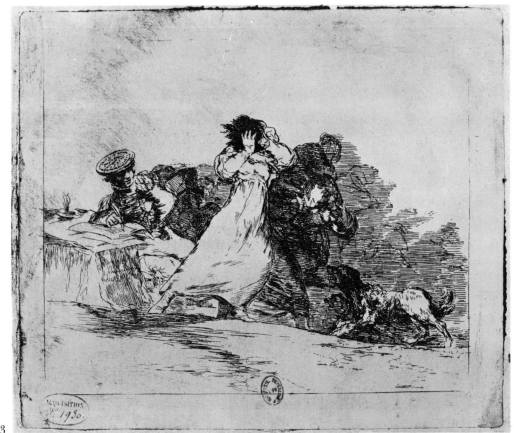

234

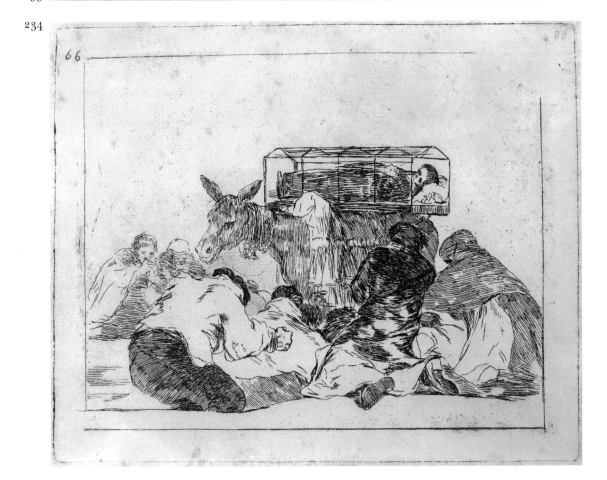

235
Desastres 68 (caprichos enfáticos)
Que locura! (What madness!)
D. 187, H. 188, B. 170, Hof. 212
160 × 220 mm.

Working proof, Harris I, 1
Etching
No watermark
Coll.: Carderera; Stirling-Maxwell
Museum of Fine Arts, Boston. 1951 Purchase Fund.
51.1687

Like *Strange devotion* (cat. no. 234), this print is anticlerical. If there had been much to deplore under Carlos IV, there was even more under Fernando VII, who, when he returned to Madrid in 1814, reopened and recompensed every possible monastic foundation, thus renewing a drain on the nation that even the Pope had recognized as unjustifiable. The king, rejecting reform, favored and supported the forces of reaction.

If we cannot specify with precision what Goya was attacking, we can recognize the components of this bitter satire. Against a background of hooded figures, a gross monk, spoon in hand, lifts his habit and squats to relieve himself. His head is turned toward a heap of masks. To the right are devotional pictures and offerings made in gratitude for cures. Below them are a pair of rampant breeches. Gross consumption of food by a useless branch of society that could be expected to give nothing more than defecation in return appears earlier in *Capricho* 4 (cat. no. 38) in a satire against the nobility. In a source drawing for the *Caprichos* a priest is shown pulling up his breeches after indulging in a sexual adventure (cat. no. 53). In *Desastres* 43 (cat. nos. 147–148) monks flee without having divested themselves of those same articles of lay clothing. Masks had been common symbols of deception for centuries.

This first working proof, in etching only, is clear and brilliant. Subsequently, two tones of lavis would be added over much of the plate.

236
Desastres 70 (caprichos enfáticos)
No saben el camino (They don't know the way)
D. 189, H. 190, B. 172, Hof. 214
175 × 220 mm.

Working proof, Harris I, 1
Etching and drypoint; touched with graphite
No watermark
Coll.: Carderera; Stirling-Maxwell
Museum of Fine Arts, Boston. 1951 Purchase Fund.
51.1689

The imagery behind this print is easy to understand. There were contemporary Spanish folk sayings such as *guiar un ciego á otro ciego* ("the blind leading the blind"). The device of blind men roped together appeared centuries earlier in Netherlandish art, and in literature it is a commonplace.

Goya's blind men, clerical and lay, some arrogant, others stupid, slowly stumble down into a hidden depth. The meaning is clear. But there is nothing that tells us who they are, and we can only speculate, as Lafuente does, on who they might be: that inner circle of despicable reactionary men who advised Fernando VII, the inept *Cortes* who would never enact the reforms desperately needed by post-war Spain, or even the Liberals, leaderless and astray.[1]

This first working proof is etched; numerous fine drypoint lines shade the figures, whose scale is unusually small for the *caprichos enfáticos* and suggests their insignificance. The proof is touched with graphite on the ground below the figures at the left and center, an area that would be shaded in drypoint in the following state. Aquatint was not added to this plate.

1. Lafuente Ferrari, *Los Desastres,* pp. 183–184.

235

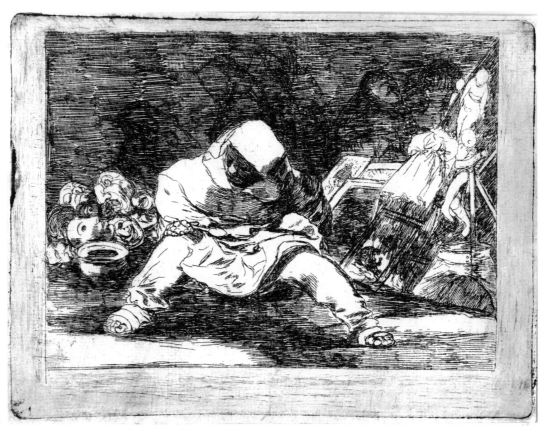

236

237

237
Desastres 72 (caprichos enfáticos)
Las resultas (The consequences)
D. 191, H. 192, B. 174, Hof. 216
175 × 220 mm.

Working proof, Harris I, 1
Etching
No watermark
Coll.: Carderera; Stirling-Maxwell
On verso, probably in Goya's hand, red chalk sketch
of the Star of the Order of Bath
Museum of Fine Arts, Boston. 1951 Purchase Fund.
51.1690

The title, as is often the case, refers back to the preceding plate, *Contra el bien general* (Against the common good; not in exhibition), where a grim and predatory power is worshipped by what appear to be clerical figures. The results are shown in this print. Vampires, nocturnal symbols of injustice, Lafuente calls them,[1] gorge themselves on the life blood of a prostrated Spaniard.

In one corner of the other side of the sheet on which this first working state was printed, there is a red chalk sketch by Goya of the English Order of the Bath, which Wellington is known to have taken with him to Spain. The decoration is barely indicated in Goya's red chalk study for the equestrian portrait of the Duke, which was exhibited in the Real Academia de San Fernando from September 2–11, 1812.[2]

Stylistically this plate is close to the "late caprichos" of 1826–28 in its variegated shading. The draughtsmanship of the face should be compared with the fragmentary *Smuggler* (cat. no. 267). Further etched shading would be added, but no aquatint or lavis.

1. Lafuente Ferrari, *Los Desastres*, p. 185.

2. *Diario de Madrid*, Tuesday, Sept. 1, p. 253. The drawing is in the British Museum (Gassier and Wilson, 898), and the painting now in the Wellington Museum, London (Gassier and Wilson, 896).

238–240
Desastres 77 (caprichos enfáticos)
Que se rompe la cuerda (Let the rope break)
D. 196, H. 197, B. 180, Hof. 221
175 × 220 mm.

238
Preparatory drawing for the print
Red chalk. 148 × 204 mm.
Watermark: crown
Museo del Prado, Madrid. 175

239
Working proof, Harris I, 3
Etching, burnished aquatint or lavis
No watermark
Coll.: Carderera; Stirling-Maxwell
Museum of Fine Arts, Boston. 1951 Purchase Fund.
51.1692

240
First (posthumous) edition, Madrid, Academia de San
Fernando, 1863. Harris III, 1, a
Etching, burnished aquatint, or lavis
Watermark: fragment of J. G. O. and palmette
Museum of Fine Arts, Boston. Harvey D. Parker
Collection (1911 Purchase). M21914

In the preliminary drawing it is clearly the pope in
his triple papal tiara who is poised on a slackened rope
above the people's heads. The Spanish church and the
papacy had long pursued separate policies. Spanish
prelates had often refused to instigate reforms dictated by
Rome, preferring to retain their traditional ways. Yet
when the Spanish church was threatened with loss of
power by reforms such as the abolition of the Inquisition
in 1813, the papacy came to its defense. Pinelli's print is a
straightforward expression of mutual support, showing
the pope and the Spanish people supporting the toppling
Catholic church.[1]

By 1815, shortly after Fernando VII returned to
power in Spain, there was a strong Catholic reaction
throughout Europe. The fall of Napoleon was seen as
more than a political event, the victory of true religion.[2]

Pius VII, able to return to Rome, began to bolster the
power of the church by drawing up concordats with
other nations, including Spain. Goya could not have
published such a drawing in Spain, and in his etching
eliminated the tiara. A priestly figure now walks
the frayed rope.

On this clean-wiped working proof, a pale, textured
tone, probably lavis, is barely discernible on the crowd
and the priest's cape.

On the 1863 edition impression this tone is clearly
visible on the cape and the crowd. If the images in the
earlier part of the *Desastres* were distorted by the
Academia's manner of printing them, the injustice done
to the images is even greater in these prints executed
when Goya was in his mid-seventies. The painterly
delicacy with which they were etched is ruinously
obscured.[3]

1. Bartolomeo Pinelli (Italy, 1781–1835), *La fede e la religione
sostenute dal Santo Padre e dagli spagnuoli* (Faith and religion sup-
ported by the Holy Father and by the Spanish people). Etching.
Plate 33 of thirty-three etchings of events ranging from 1808 to 1814
and bound as *Guerra de la Indipendenza Spagnola*, Biblioteca
Nacional, Madrid.

2. See Frederick B. Artz, *Reaction and Revolution 1814–1832*
(New York, 1934), pp. 10 ff.

3. Boston's bound set of the 1863 edition is an early printing with
all the mistakes in the titles (see Harris, vol. 2, pp. 173–174). It is
not, however, a special set, as described in cat. nos. 101, 134, 144,
and 157.

Fig. 13. Pinelli, *Faith and Religion Supported by the Holy Father and by the Spanish People,* Biblioteca Nacional, Madrid.

238

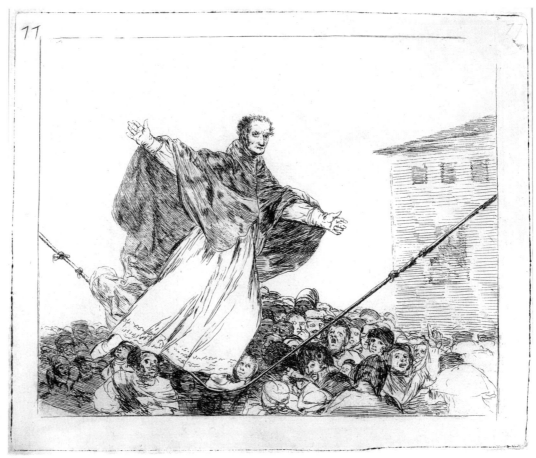

239
240

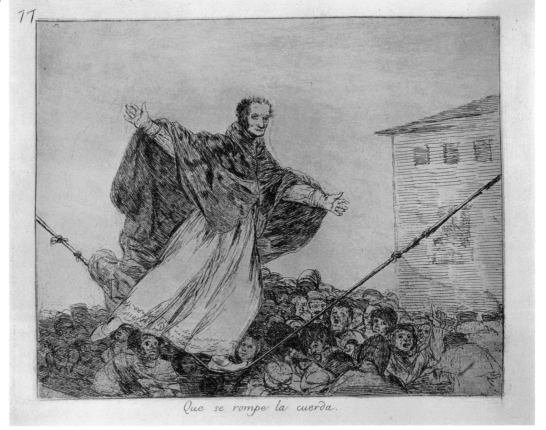

Que se rompe la cuerda.

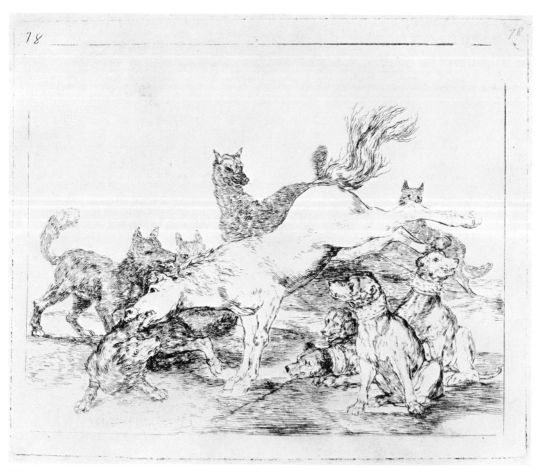

241

241

Desastres 78 (caprichos enfáticos)
Se defiende bien (He defends himself well)
D. 197, H. 198, B. 181, Hof. 222
175 × 220 mm.

Working proof, Harris I, 2
Etching, drypoint, burin, and burnishing
No watermark
Coll.: Carderera; Stirling-Maxwell
Museum of Fine Arts, Boston. 1951 Purchase Fund.
51.1693

This *capricho* is as powerful and almost as enigmatic
as *What is this commotion?* (cat. no. 233). A pack of
wolves attack a horse, who lashes back at them. Beside
him sit a group of clearly recognizable dogs wearing
collars studded with nails, who were used in the moun-
tains near Madrid to protect animals against wolves. But
they watch passively or turn their heads away and leave
the horse to fend for himself.

Although contemporary allegories and cartoons did
not use a horse as a symbol for the Spanish nation, Goya,
like Picasso, may have used it to represent her people
attacked by any one of the predatory forces that ravaged
the citizenry under Fernando VII.[1] The print is related
to *Disparate cruel* (cat. no. 211), where those who might
have been expected to halt a brutality close their eyes
or turn away.

This working proof, where the etching is comple-
mented by drypoint shading, presents the print in its
finished state.

1. For Picasso see the painting *Guernica* and the prints *Sueño y
mentira de Franco*. For a discussion of specific meanings that have
been suggested, see Lafuente Ferrari, *Los Desastres*, pp. 188–189.

242–244
Desastres 79 (caprichos enfáticos)
Murió la verdad (Truth has died)
D. 198, H. 199, B. 182, Hof. 223
175 × 220 mm.

242
Truth threatened by monks, clergy, and dark spirits
Drawing Album F, p. 45
Brush and brown wash. 205 × 142 mm.
Coll.: Carderera; Federico de Madrazo; Mariano Fortuny
Metropolitan Museum of Art, New York. Harris
Brisbane Dick Fund, 1935.

243
Preparatory drawing for the print
Red chalk. 148 × 205 mm.
No watermark
Museo del Prado, Madrid. 176

244
Working proof, Harris I, 1
Etching and burnishing
No watermark
Coll.: Carderera; Stirling-Maxwell
Museum of Fine Arts, Boston. 1951 Purchase Fund.
51.1593

The Academia edition of the *Desastres* ended with
two prints, this one, *Truth has died,* and the following,
Will she rise again? The ideological source for both
prints is to be found in Journal Album F, which had
been begun by 1819, since page 12 was used for a litho-
graph printed that year (cat. no. 253). Page 34 may also
be related to one of the *caprichos enfáticos,* No. 71,
Against the common good (not in exhibition). On page
45 (?),[1] where truth is threatened by monks, clergy, and
various dark spirits, she stands strong, beautiful, and
innocent, sending forth beams of light. She is mocked by
men and creatures who may represent the forces of
corruption and reaction that were supported by the
government.

1. Because the pages of this book are sometimes cut at the top, it is
impossible to tell whether the page is 43 or 45.

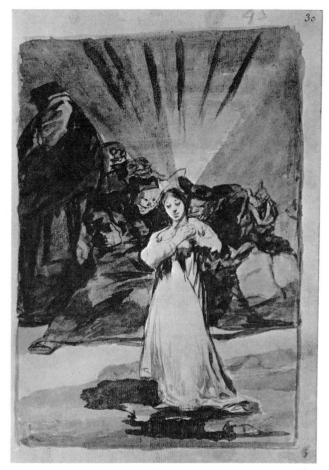

242

The red chalk preparatory drawings for this part
of the series tend to be broadly drawn, suggesting rather
than describing the design. This is characteristic of
Goya's late preliminary studies, for he had mastered
the etching medium and no longer required careful
preparatory studies. Truth now lies on the ground, emit-
ting very little light. A bishop blesses the demise, and to
the right sits weeping Justice with her scales.

In the first working proof the rays of light emanating
from Truth's recumbent form are stronger and illumi-
nate an assortment of identifiable, gloating figures. These
include two monks, who smile as they prepare to dig her
grave while a bishop chants. Justice, her pose more
dejected, covers her face with one hand. There was
to be no further work to the plate except the addition
of the number.

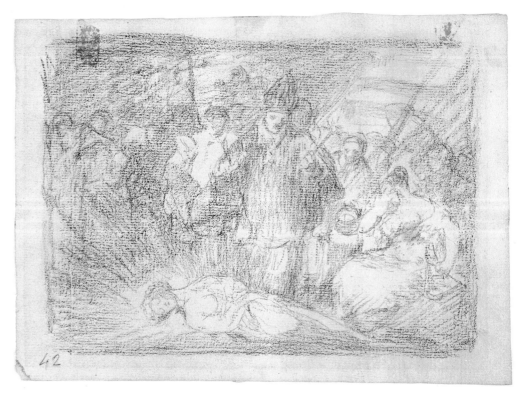

243

244

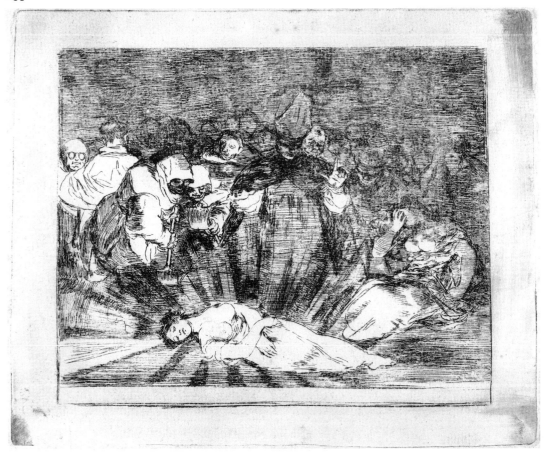

245

245–246
Desastres 80 (caprichos enfáticos)
Si resucitará? (Will she rise again?)
D. 199, H. 200, B. 183, Hof. 224
175 × 220 mm.
Lower left corner in the plate (inverted and upside
down): *Goya*
See also *Truth threatened by monks, clergy, and dark
spirits* (cat. no. 242).

245
Preparatory drawing for the print
Red chalk. 148 × 205 mm.
Museo del Prado, Madrid. 177

246
Working proof, Harris I, 1
Etching and burnisher
No watermark
Coll.: Carderera; Stirling-Maxwell
Museum of Fine Arts, Boston. 1951 Purchase Fund.
51.1695

Here the red chalk drawing is even more summary—
so much so that without the completed etching it would
be difficult to determine the subject matter. Truth, with

her ability to illuminate, is visible. Behind her, vaguely
seen creatures with book and clubs attack her, and in the
foreground one can make out a crouching cat and a bat
sweeping low, both symbols of unreason and evil deeds
that Goya had used earlier in *Capricho 43, The sleep
of reason* (cat. nos. 70–76).

In the first working proof the creatures in the fore-
ground are eliminated, and in the background, among
the anonymous monsters who fear truth, one can recog-
nize the shovel hat of a priest at the left. At the right are
two monks; one, with a club in his right hand, picks up
a rock with his left. The circle of creatures may, as
Lafuente suggests, represent that frightening inner circle
of men into whose hands Fernando gave the government
of Spain. One single person, his mouth gagged so that he
cannot be heard, does not avoid Truth's light, but
kneels behind her clasping his hands.

There was false biting over the entire plate, which
was burnished to produce the light areas. Except for some
burnishing to clean the borders of the plate and the addi-
tion of the number, the print is complete in this state.

This print is in a sense a political cartoon. Yet at the
same time the sensitive, delicate lines, the complex means
by which Goya achieved tone, and above all the beauty of
the design, lift the print into a totally different realm.

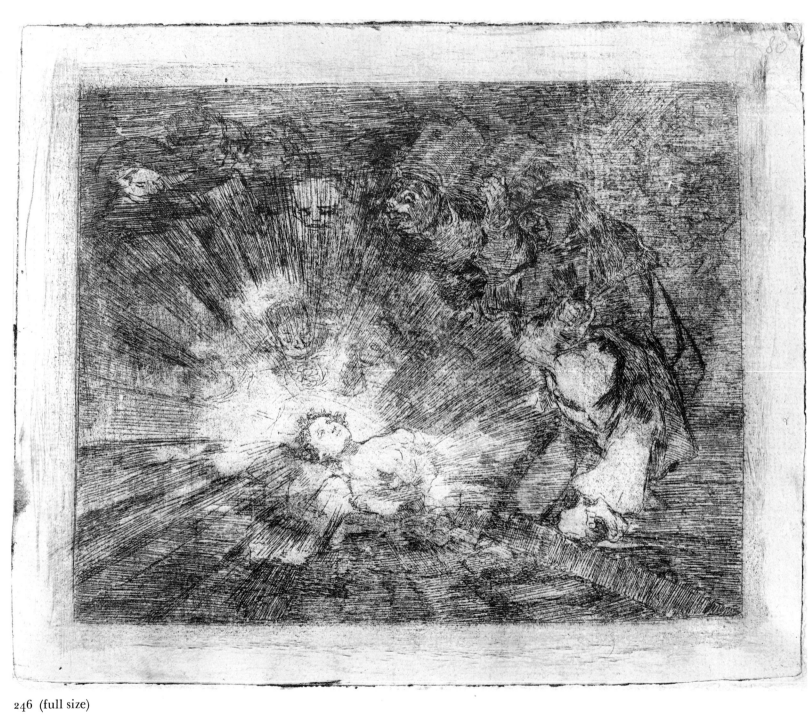

246 (full size)

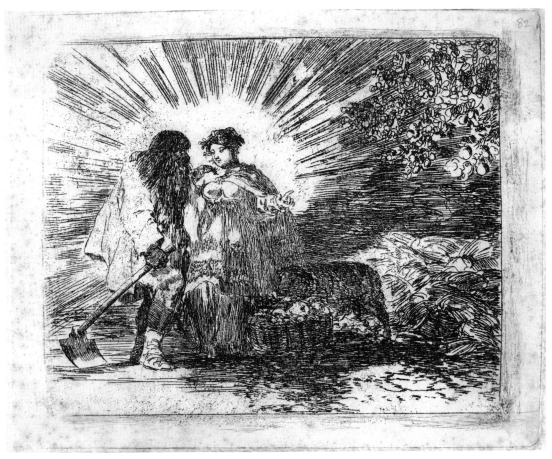

247

247

Desastres 82 (caprichos enfáticos)
Esto es lo verdadero (This is the true way)
D. 201, H. 202, B. 184, Hof. 226
175 × 220 mm.

Working proof, Harris I, 1
Etching and drypoint; touched with graphite (?)
No watermark
Coll.: Carderera; Stirling-Maxwell
Museum of Fine Arts, Boston. 1951 Purchase Fund.
51.1696

Goya intended to end the *caprichos enfáticos* with this scene in which Abundance counsels a farm laborer, mattock in hand. A sheep and a basket of vegetables stand at her side. To the right are sheaves of grain and a tree laden with fruit.

Enlightened men in Spain had been trying to bring about agricultural reforms during all of Goya's adult life. In 1798 Goya's friend Gaspar Melchor Jovellanos wrote for the government his famous report on agricultural law.

The sense of hope in this print suggests that period when the Constitution of Cádiz, which included agricultural reforms, was reenacted in 1820. It was then that Goya numbered all eighty-two plates of the *Desastres* in preparation for publishing them. He never did so because he was all too aware that Fernando VII, false hearted, unenlightened, and intolerant, would rule as a constitutional monarch only as long as he could be forced to do so. The Constitution was annulled in 1823 after Fernando had invited the French to reinvade Spain in his behalf.

This working proof is touched with graphite (?) to indicate a flock of sheep behind the etched one. In the finished print extensive work would be added in burin to the two people and to the sheep, and a tone of aquatint applied over much of the plate.

The copper plate for this print and *Bloodthirsty monster* (81, not in exhibition) were not acquired with the other eighty by the Academia in 1862, but were posthumously and sympathetically printed possibly by the Calcografía but more probably for Paul Lefort, from whom they acquired the plates.

The Madrid Lithographs

The first lithographs Goya executed were made in Madrid in 1819 when the artist was seventy-three years old. They were experimental; not one was technically sound, nor was any stone printed in an edition. Nevertheless they provide interesting evidence of the artist's ceaseless curiosity about new techniques that was to last until the end of his life.

Lithography had been invented twenty-three years before by Aloys Senefelder in Munich but had only begun to come into common usage about 1815. Madrid's first lithographic establishment, founded in 1819, was that of José María Cardano. It was the project of Don Felipe Bauzá, head of the Hydrographic Bureau, who persuaded the government to send a man to the two important lithographic centers, Paris and Munich, with the idea of importing this quicker and less expensive printing method to Spain. Bauzá's intention was that the press should be used primarily for printing naval charts. He chose Cardano, a graduate of the Cartagena pilot school who had learned to engrave maps in France.[1]

In late 1818, after a year in Paris and several months in Munich with Senefelder, Cardano returned to Madrid. On March 16, 1819, Fernando VII signed a decree to found in Madrid, not a press for the Navy's exclusive use, but a "public institution for lithography . . . under the directorship of Don José Cardano" whom the king named court lithographer "in recognition of his constant and profitable application, and also to encourage others."[2]

It is likely that all of Goya's Madrid lithographs were printed at Cardano's press, for proofs of two appear on the versos of prints that are inscribed *J. Cardo* and *Impr. Lithogr. de Cardano* (see cat. no. 251). These crayon lithographs, technically competent, dry, and precise, are the antithesis of Goya's own.

Print and drawing techniques were closely related in Goya's work, and this is never more visible than in his first experiments with lithography. *Two duelers,* a drawing from Journal-Album F (cat. no. 252) is typical of his drawings around 1819, which were executed primarily with the brush. He first made a sketch in broken strokes and with a transparent wash so that whatever would not be incorporated into the final drawing would not be disturbing. Over this he built up his figures with denser ink in various intensities. Where special effects were needed he used either a very wet or dry brush, and often scraped or scratched to lighten areas or add highlights.

It was this kind of drawing, but executed in greasy lithographic ink (tusche), that was used to transfer the image to the lithographic stone. The sheet was laid on the stone and run through the press. The grease adhered to the stone and made the image receptive to printing ink.

Several technical problems were encountered by Goya. Instead of using special, non-absorbent transfer paper, he drew on ordinary paper. Too much of the greasy tusche penetrated the sheet, and the image did not fully transfer to the stone. Moreover, Goya's drawing style, using brush and thin washes, posed further difficulties, for the pale brushstrokes did not contain sufficient grease to transfer well (see cat. no. 251). The press seems sometimes to blame, for the *Inferno* transfer drawing (cat. no. 249) appears to have been improperly transferred to the stone, evidently because the pressure of the scraper-bar was not evenly adjusted.

The subject matter of the Madrid lithographs varies. There is no indication, in either scale or subject matter, that a series of prints was intended. Goya's real achievements in the lithographic medium were to be made some five years later in Bordeaux.

SUE W. REED

1. This introduction is based on notes on Goya's lithographs by Eleanor Sayre, who, in turn, relied on Félix Boix, "La litografía y sus orígenes en España," *Arte español,* 7 (1925), 279–302.

2. Boix, "La litografía," p. 283.

248

248–250
Inferno. Damned man dragged by the heels into hell.
1819
D. 271, H. 272, B. 271, Hof. 271
120 × 240 mm.

248
Related drawing
Brush and tusche
187 × 267 mm.
Inscribed, not in Goya's hand: *Camino de los infiernos*
(The way of the damned)
Watermark: N (probably HONIG)
Biblioteca Nacional, Madrid. B1252

249
Preparatory transfer drawing
Brush and tusche
156 × 233 mm.
Watermark: H N (probably HONIG)
Coll.: Lefort; Burty
British Museum, London. 1876–5–10–374

250
Transfer lithograph. Unique proof
Transferred from the above drawing
Watermark: J HO (NIG & ZOONEN)
Coll.: Carderera
Biblioteca Nacional, Madrid. 45629

249

Images of hell occur frequently in Goya's last works executed in Spain. In the first state of *Disparate claro* (cat. no. 221) hellish flames shoot up from the lower left corner. In the powerful drawing from the Biblioteca Nacional intertwined bodies are swept along toward hell's fiery opening. The drawing was executed in a wash that shows characteristics of lithographic ink (tusche).

In the British Museum's drawing, a devil drags a damned man off to the flames of hell by the rope that binds his feet. Rather than merely looking on as they do in the previous drawing, the bestial demons seem to be escorting the damned and pushing them along. This drawing was executed with brush and lithographic ink.

The fragmentary image of the lithograph corresponds exactly to the drawing, confirming that the drawing was transferred directly to the stone. However, too much of the greasy ink required to transfer the image to the stone was absorbed by the ordinary drawing paper and the paler washes were not picked up. Moreover, the scraper-bar of the press applied pressure neither fully nor evenly across the paper surface, so that the bottom part of the drawing did not transfer at all and other areas transferred weakly.

250

251

Espresivo doble fuerza (Expressive of double strength)
1819
D. 272, H. 274, B. 272, Hof. 268
80 × 115 mm. (image)
Transfer lithograph. Proof
Touched with black crayon
Inscribed in chalk in Goya's hand: title; below in pencil
(not autograph): *letra y litogᵃ por Goya*
No watermark
Printed on the verso of a lithograph inscribed in the
stone: *Impr. Lithog. de Cardano*
Coll.: S. P. Avery
Prints Division. The New York Public Library. Astor,
Lenox and Tilden Foundations

This is one of two impressions known of this lithograph.
Both are on the versos of lithographs printed by Cardano,
who set up the first lithographic press in Madrid in 1819.

Goya's lithograph was transferred from a brush
and tusche drawing (London, private collection, not in
exhibition). The technique of the drawing, using brush
and heavy and light washes is found among Goya's draw-
ings of this time. Moreover, the style is comparable to the
brush and brown ink drawings of Journal-Album F, one
of which served as a preliminary study for another early
lithograph (cat. no. 253). As with the *Inferno* drawing
(cat. no. 249) the thinner washes only partially transferred
to the stone. Both surviving impressions were touched by
Goya to complete the image. On this one, portions of the
woman's dress, the man's legs, and the ground are
drawn in black crayon.

The emotional intensity of this image, conveyed
by the long, swift brush strokes, corresponds to one of the
caprichos enfáticos of about 1820, *Que alboroto es este?*
(cat. no. 233).

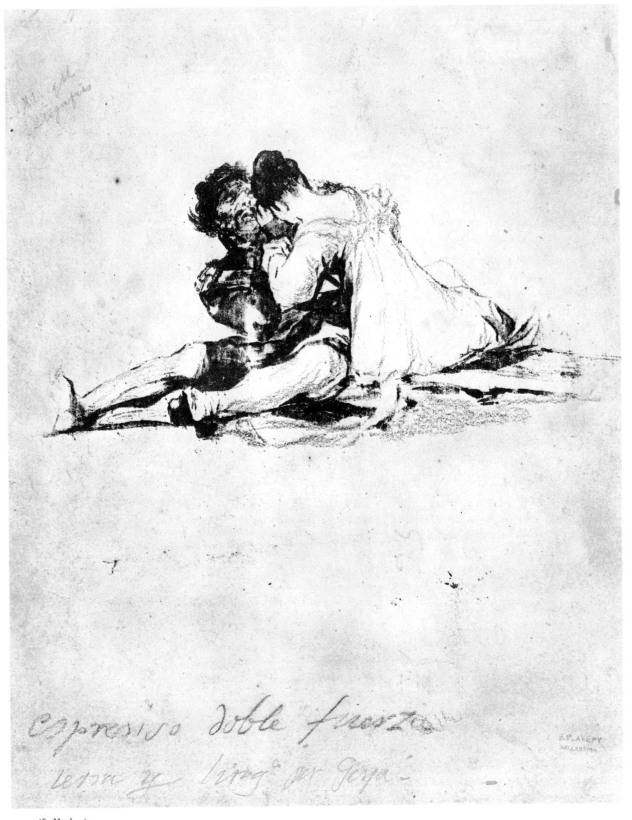

251 (full size)

252–253
Old Style Duelers. 1819
D. 269, H. 271, B. 269, Hof. 267
130 × 230 mm. (image)

252
Related drawing
Brush and brown wash
205 × 145 mm.
Journal-Album F, page 12
Watermark: M surrounded by ornament ending in
a heart
Coll.: Javier Goya; Mariano Goya; Román Garretta
Museo del Prado, Madrid. 286

253
Transfer (?) lithograph. Proof
Touched with brush and wash
Coll.: Galichon
British Museum, London. 1876–5–10–355

One impression of this lithograph is inscribed
Madrid. Marzo 1819 (Madrid. March 1819), which coin-
cides with the fact that Cardano's press was set up shortly
before that time.[1] For the source of this image Goya
turned to a drawing, page 12 of Journal-Album F. It was
one of six scenes of old-fashioned duels, each executed in
brush and brown wash, probably in late 1818 or
early 1819.

The force of the drawing is in the counterpoise of
the dying man, bathed in brilliant light, with the strong,
dark shadow toward which he falls. These two elements,
the sunlit man and the darkened earth, form a fateful
unity of their own from which the second dueler is ex-
cluded. In the print, although Goya improved the
anatomy of the dueler on the left, made the sword thrust
fiercer, and gave an almost classical pose to the wounded
man, none of these factors served to keep it from appear-
ing somewhat clumsy beside the drawing.

The lithograph was almost certainly transferred
from another drawing made with pen and tusche, not

1. The dated impression was formerly Paris, Lefort Collection;
repr. *Gazette des Beaux-Arts,* vol. 25, 1868, p. 177.

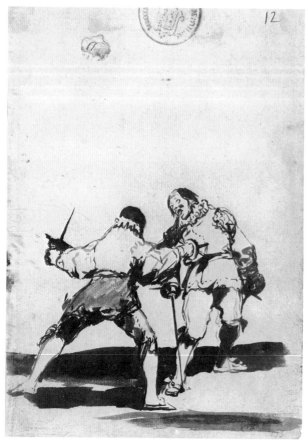

252

known to have survived. There is one other lithograph of
an old woman spinning (not in exhibition) that was also
apparently transferred from a pen drawing. Probably
because the greasy ink of the finer pen lines was denser,
the drawing transferred more successfully than the brush
drawings for *Espresivo doble fuerza* or for the *Inferno*
(cat. nos. 249–251). The lines did not print entirely to
Goya's satisfaction, however, for he retouched each of the
five known impressions to complete the image. On this
impression he added wash below the sideburn of the
dueler on the right, and between his coat skirt and his
opponent's sleeve.

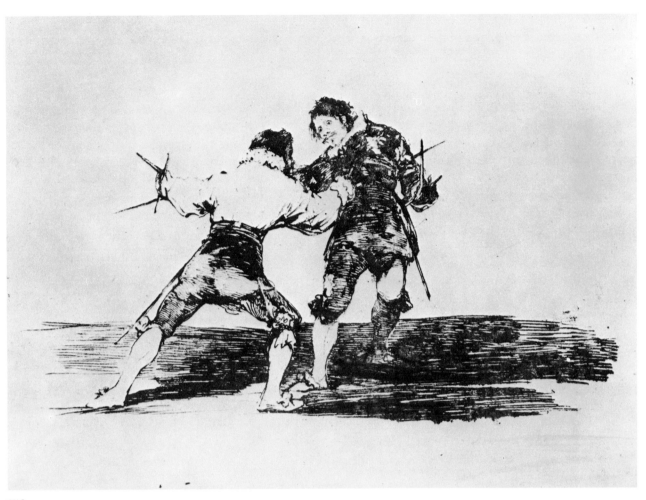

253

The Bordeaux Prints

Goya received permission to travel to France in June 1824, ostensibly to consult doctors and take curative waters. He stopped briefly in Bordeaux and then continued on to Paris, where he stayed for two months. There he was under police surveillance, for the French monarchy, controlled by the Rightists during the last months of Louis XVIII's reign, kept an official and wary eye on Spaniards who entered the kingdom after the fall of Spain's liberal constitutional government of 1820–1823 and the reestablishment of absolutist government by Fernando VII.

In September Goya returned to Bordeaux and settled there. Bordeaux, like Paris, was a center for Spanish emigrés, including the playwright Don Leandro Fernández de Moratín and the young painter Antonio Brugada, who later told Goya's biographer Laurent Matheron many details of the old artist's life there. Apart from two brief journeys to Spain in 1826 and 1827, Goya seems to have remained in Bordeaux until his death on April 16, 1828.[1]

Letters written by Goya and by those who knew him provide brief, vivid glimpses of the old man's enjoyment of the city, his life with the outspoken Doña Leocadia, the failings of his old age, and his artistic activity. Moratín remarked, "He is very arrogant, and paints what he feels with great vehemence, being unwilling ever to correct anything that he paints."[2]

By the fall of 1825 Goya had made the acquaintance of a neighbor, Cyprien Charles Marie Nicolas Gaulon, a calligrapher whose lithographic establishment was founded in 1818. In November and December Gaulon registered an edition of one hundred impressions each from four stones depicting bullfights, the so-called *Bulls of Bordeaux* (cat. nos. 257, 258).[3] Goya also drew a handsome lithographic portrait of Gaulon (cat. no. 256). These and other lithographs printed in Bordeaux were executed by drawing directly on the stone with a lithographic crayon. Matheron gives us a description of Goya at work, standing before an easel and working on the stone as if on a canvas. The writer somewhat oversimplifies the extent to which the Bordeaux lithographs are worked from dark to light, but his description is vivid: "Usually he covered the whole stone with a uniform gray tone, and then removed the parts which were to be light with a scraper: here a head, a person; there a horse, a bull. The crayon was then brought back to use for reinforcing the shadows, for strengthening or for indicating figures and giving them movement."[4] There is a distinct unity of style and technique to be seen in Goya's work at this time, extending through his prints, paintings, miniatures on ivory, and his drawings.

On December 6, 1825, Goya wrote to Joaquín María Ferrer, a Spanish emigré in Paris, and sent him a lithograph of bulls, inquiring as to whether a set of the art of bullfighting would be saleable in Paris. We recognize these prints as the first great works of art in a new medium, but they were totally unlike what was admired in 1825, and Ferrer discouraged Goya from continuing. He suggested instead that Goya reprint the *Caprichos* of 1799, and on December 20 Goya replied, "What you tell me about the *Caprichos* cannot be, because like most of the things I etched which are in His Majesty's chalcography, I gave the plates to the King over twenty years ago and despite that they denounced me to the Holy [Office, i.e., Inquisition]: nor would I copy them because right now I have better ideas [for *Caprichos*]."[5]

1. This introduction is largely based on Eleanor A. Sayre, *Late Caprichos of Goya* (Philip Hofer Books, Walker and Company, New York, 1971). The author notes that Laurent Matheron's book, *Goya* (Paris, 1858) is romantic and unreliable except for the last chapter (11), which was dependent on Brugada's information. The style of the Bordeaux period works is discussed at length in Eleanor A. Sayre, "Goya's Bordeaux Miniatures," *Boston Museum Bulletin*, vol. 64, 1966, pp. 84–123.

2. Leandro Fernández de Moratín, *Obras póstumas* (Madrid, 1867), vol. 3, pp. 54–56, as quoted in Sayre, *Late Caprichos*, p. 14.

3. On Goya and Gaulon see Eugène Bouvy, *L'Imprimeur Gaulon et les origines de la lithographie à Bordeaux* (Bordeaux, 1918).

4. Matheron, *Goya*, chapter 11 (unpaged), as quoted in Sayre, "Goya's Bordeaux Miniatures," p. 106.

5. Lo que me dice V. de los caprichos no puede ser, por que las laminas las cedi al Rey mas ha de 20 años como las demas cosas qe ha grabado qe estan en la calcografia de S. M., y con todo eso me acusaron a la Santa ni yo las copiaria p. qe tengo mejores ocurrencias. Quoted in Sayre, *Late Caprichos*, p. 15 and p. 29, note 38. Text and translations of Goya's several letters to Ferrer are to be found in Sayre, "Goya's Bordeaux Miniatures," pp. 112–114.

Goya seems to have done more than merely consider a new suite of *Caprichos,* for various prints executed in Bordeaux fall into this category. Since he left them untitled we cannot be certain whether he intended them for a French or Spanish audience. Many of the criticisms to be found in the earlier *Caprichos* were relevant to both France and Spain in 1825. Both nations routinely exercised heavy censorship. If, in the new prints, any attack on the wrongs committed by church, state, or the nobility is intended, we cannot expect them to be explicit.

In Goya's iconography, all who indulge in folly or evil repeatedly, or choose to court either, may appear in the guises of warlocks, witches, animals, or demons. But in order to identify a specific evil, for example, malpractice, in a drawing of two donkeys by the bed of a sick man, one needs the inscription, *Brujas disfrazadas en fisicos comunes* (Witches disguised as ordinary physicians, Prado 26, not in exhibition). This *sueño* drawing was revised as *Capricho* 40 (not in exhibition), *De que mal morira?* (Of what will he die?), the answer being "Of the doctor." If one is to know what professions were practiced by those demons who preferred truth dead in corrupt postwar Spain, one needs to recognize the telltale shape of an official's hat, a tonsure, cowl, or miter in such *caprichos enfáticos* as *Truth has died* and *Will she rise again?* (cat. nos. 244, 246). Besides having no titles, the new *caprichos* also lack revealing details that might have caused trouble. Moreover, since we have only the fragmentary beginnings of a series, we shall probably never know how great a risk the old artist intended to take.

In his letters to Ferrer, Goya had mentioned that he was working on a set of lithographs on bullfighting, and had better ideas for *caprichos.* One would not expect to find him working on two major sets simultaneously. When he received no encouragement to work further on the bullfight series, he may have turned to the new *caprichos* in 1826.

Two series seem to have been begun, one in lithography, the other in etching. Three lithographs, existing in trial proofs only, include a duel whose outcome is death, and an old crone casting a love spell on a young woman (cat. nos. 260, 261). It seems likely that Goya began the lithographs first, for two of these prints relate to a final page in Journal-Album G and a middle page from Journal-Album H (cat. nos. 259, 260). On the other hand, the etched *caprichos* derive in content or motif from entries scattered throughout Album H (pages 11, 19, 22, 31, and 58). This book, partly because it records the Bordeaux fair of 1826 on pages 39–41 and 45, and partly because the figures are predominantly more gigantic, is assumed to be the later of these two Journal-Albums.[6]

The subjects of the etchings are a witch, a warlock, a smuggler, a *maja,* and an evil guitarist (see cat. nos. 261–268). Only three working proofs of two of these subjects are recorded. The remainder of the subjects are known only from posthumous impressions. There were four plates, three of which are etched on both sides. The plate for the guitarist was separated from the others in the nineteenth century. The three remaining double-sided plates were acquired in Spain around 1859 by John Savile Lumley, an English diplomat who had impressions printed from all but one side, which he probably considered ruined (see cat. no. 267). These three plates are now in the collection of the Boston Museum (see cat. no. 264).[7]

It is a pity that the aged but vigorous and inventive artist was to leave incomplete this late series of *caprichos,* which he had started a year or so before his death. Despite his failing eyesight, he had lost none of his hard-earned power to etch lines of an extraordinarily expressive and incisive delicacy or to combine them with aquatint applied in so individual a manner that the means are now hard to determine. And it is frustrating that we shall never know the full scope of the set—which personal follies and vices, which evils of state or church a great artist, some eighty years old, would have found important enough to attack with satire.

SUE W. REED

6. Sayre, *Late Caprichos,* pp. 19–20.

7. For a full history of the plates see Sayre, *Late Caprichos* pp. 9–11.

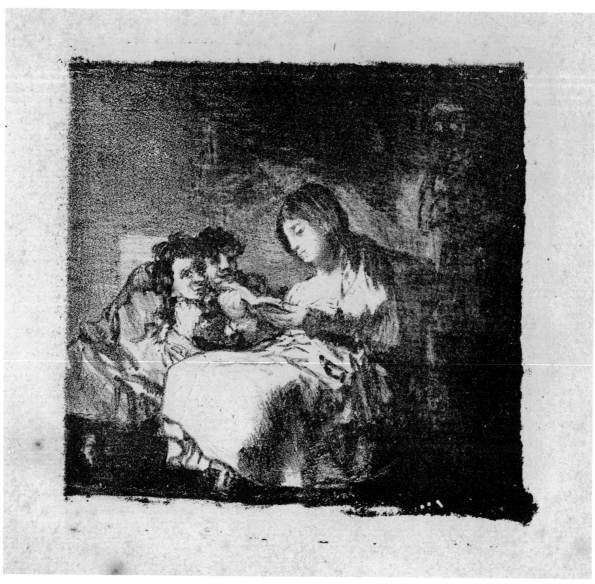

254 (full size)

254–255

Woman Reading to Two Children. About 1824
D. 276, H. 276, B. 280, Hof. 270
115 × 125 mm. (image)

254

Crayon lithograph. Proof
No watermark
Museum of Fine Arts, Boston. Katherine Eliot Bullard
Fund. 1970.469

255

Two Children Reading. About 1824
Miniature on ivory. Watercolor (black and red)
(Varnished by a later hand)
52 × 53 mm.
Coll.: Edward Habich (?); Gustav Radeke
Museum of Art, Rhode Island School of Design. 21.139

The subject of both miniature and lithograph may
be taken from Goya's domestic setting in Bordeaux. His
household included Doña Leocadia Zorrilla de Weis(s)
and her two children, Guillermo and ten-year-old María
del Rosario or "Mariquita" (Ladybug). Goya proudly
mentions "Mariquita" in letters, and it was from him that
she learned to write and to draw.[1] Whether or not she is
one of the two attentive children in this darkened room,
the small scale and the initimate treatment evoke a
strong sense of personal involvement.

This crayon lithograph is related in style to the
drawings made in Bordeaux and to Goya's technique in
his late miniatures in watercolor on ivory. The use of this
technique may be observed in *Two Children Reading*,
where Goya worked from dark to light, using black water-
color pigment, which he could easily thin down or remove
from the smooth ivory surface. The children's faces,
the shirt, and the book were drawn out of the dark back-
ground while the paint was still wet by absorbing the
pigment with a clean brush. Goya then added dark
accents for further definition. He used a sharp point to
scratch highlights on the shirt, the book, and the hand

255 (full size)

holding it. This highly individual, hasty graffito is com-
mon to the miniatures and to most of the Bordeaux
lithographs.[2]

In the lithograph, Goya drew fairly densely with
a crayon and then scratched out fine highlights on the
woman's arm, her skirt and mantilla, and around
her head.

1. See Eleanor A. Sayre, *Late Caprichos of Goya* (New York, 1971),
p. 15, note 37.

2. Eleanor A. Sayre, "Goya's Bordeaux Miniatures," *Boston
Museum Bulletin*, vol. 64, 1966, pp. 84–123.

256

Portrait of Gaulon (Cyprien Charles Marie Nicolas
Gaulon). About 1825–1826
D. 284, H. 282, B. 285, Hof. 281
270 × 210 mm.
Lower left in the stone: *Goya*

Crayon lithograph. Proof
Wove paper
Coll.: Nicolas-Toussaint Charlet (?). The proof was
discovered in a scrapbook that apparently belonged to
this French lithographer
Davison Art Center, Wesleyan University, Middletown,
Connecticut

Goya had etched and aquatinted his own self-portrait
as a frontispiece to the 1799 *Caprichos*. This lithograph
is the only other printed portrait definitely from Goya's
hand.[1] The handsome features and proud bearing are
those of Cyprien Charles Marie Nicolas Gaulon (1777–
1858), a calligrapher who had set up his lithographic
establishment in Bordeaux in 1818. Goya had extensive
contacts with Gaulon, for it was he who printed the edi-
tion and registered for publication the four lithographs
known as the *"Bulls of Bordeaux"* (cat. nos. 257, 258). It
was undoubtedly at his shop that Goya's other Bordeaux
lithographs were printed.[2]

The same marvelous vision the old painter brought to
his late oil portraits is seen here. Simplicity and strength
of forms are enlivened by the inventive use of technique.
After drawing the image on the stone Goya scraped away
at it, creating highlights to model the face. On the lapels
and shoulders of the jacket he scratched fine lines that
soften the contours. Through broader scraping the vest
gains pattern and texture and the cravat sparkling white
accents. In this lithograph Goya does full justice to the
sitter, who helped the artist realize to the fullest his
potential in this medium.

1. The lithograph identified as being the son of Gaulon (Harris
292) does not exhibit Goya's characteristic working methods. There
are no scraped highlights, and the strokes of the crayon are rather
regular.

2. For a history of Gaulon's life and work see Eugène Bouvy,
L'Imprimeur Gaulon et les origines de la lithographie à Bordeaux
(Bordeaux, 1918), extract from *Revue Philomathique de Bordeaux
et du Sud-Ouest*, 20th year, no. 6, Nov.-Dec. 1917. He reproduces a
profile portrait of Gaulon by Galard; the facial proportions are
very like Goya's portrait, and would seem to strengthen the tradi-
tional identification, which is otherwise undocumented.

257

257

"Bulls of Bordeaux"
Dibersion de España (Spanish diversion). 1825
D. 288, H. 285, B. 289, Hof. 279
300 × 410 mm.
Lower left in the stone: *Goya*

Crayon lithograph
Proof before letters. Harris I
Wove paper without watermark
Anonymous loan

On November 17 and 29, and on December 23, 1825, the lithographer Gaulon registered an edition of one hundred impressions from four stones, each described as *"une course de taureaux."* These were Goya's magnificent large lithographs of Spanish bullfights drawn from memory.

This is a very strong impression of *Dibersion de España* taken before the addition of the title that appears on the published impressions. In a wild amateur free-for-all, five bulls run about in the ring with numerous human opponents armed only with capes. Undaunted by the trampled body in the center of the ring, the participants grin with amusement. Their broad, humorous faces and stocky bodies are also to be found in the drawings from Journal-Album H of the same time. Then in his eightieth year, Goya had an undiminished appetite for life, and the ability to convey it on paper or stone.

He hoped that the prints would find an appreciative audience in Paris. On December 6 he wrote to his friend Joaquín Ferrer in that city: "My estimable friend; on the occasion of Señor de Baranda's going to Paris, I sent you a lithographic proof representing a fight with young bulls so that you and our friend Cardano[1] might see it; and if you thought it saleable I would send all those you might wish; this note I put with the print. Having received no answer, I pray you again to let me know, because I now have three others of the same size and subject of bulls . . ." The response cannot have been very favorable, for again on December 20 Goya writes Ferrer: "I am advised and agree with what you tell me about the prints of bulls; but

as I did think rather of the art connoisseurs which abound in that great capital, and also of the many people who would have seen them (without taking into account the number of Spaniards) I thought that it would be easy to give them to a printseller without telling my name, and this could have been done at a small price . . ."[2]

Goya's method of working directly on the stone is evident in various parts of the print. For example, he corrected the original, elongated left foreleg of the light-colored bull in the center of the ring by partially scraping away the crayon covering the stone and redrawing the leg in a new position.

1. Cardano, the Madrid lithographer who printed Goya's work there, had emigrated to Paris.

2. Original Spanish and full text of both letters in *Boston Museum Bulletin*, vol. 64, no. 337, 1966, pp. 113–114.

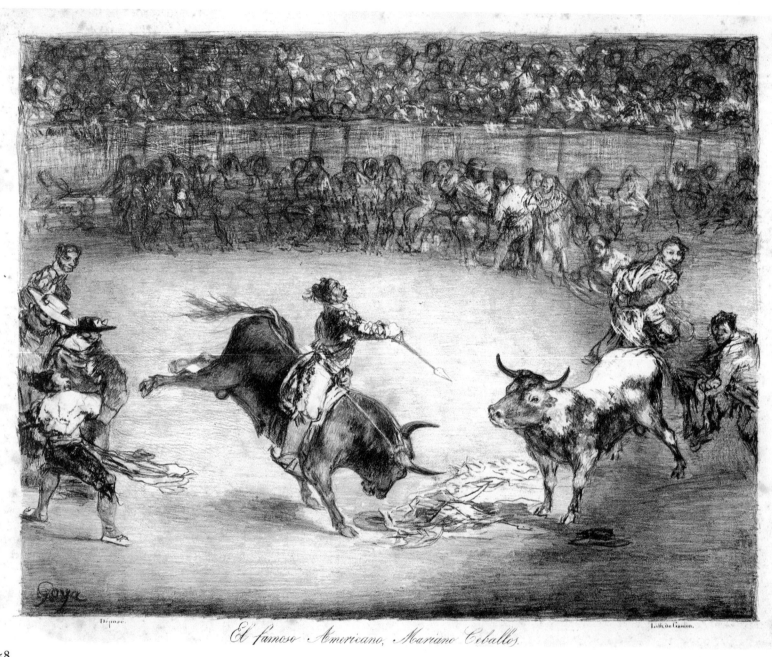

El famoso Americano, Mariano Ceballos.

258

258 (full size detail)

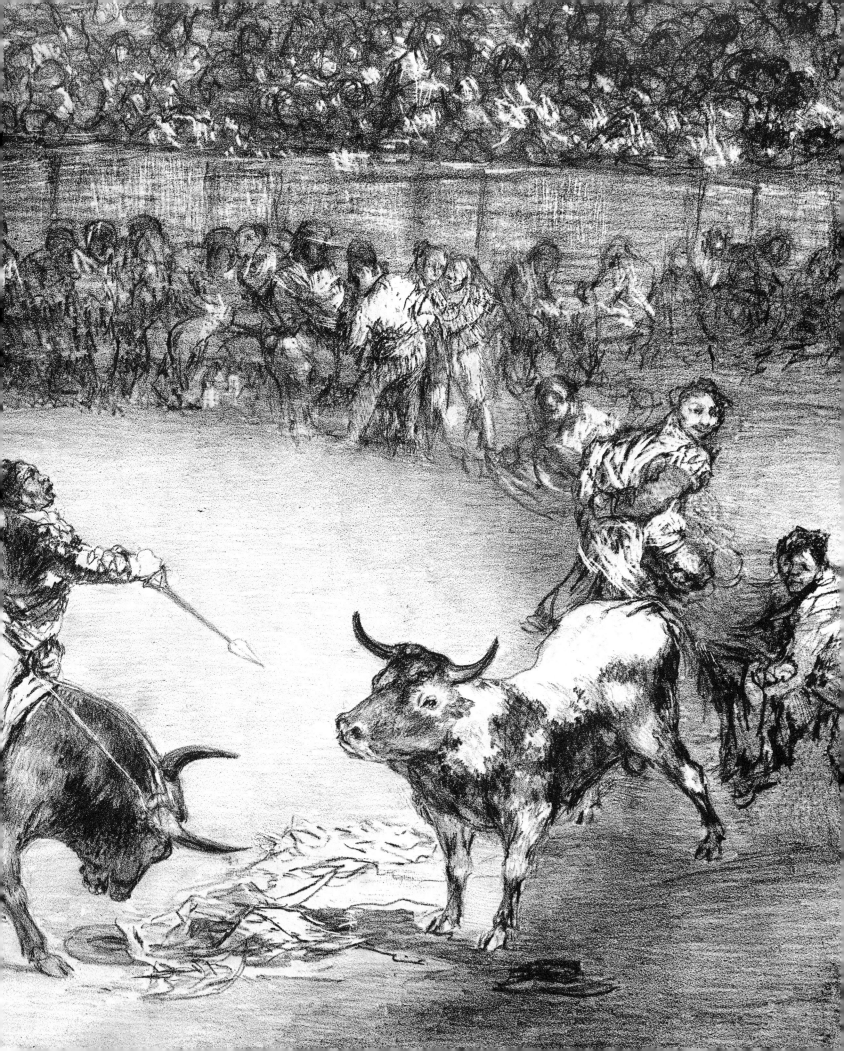

258

"Bulls of Bordeaux"
El famoso Americano, Mariano Ceballos (The famous
American, Mariano Ceballos). 1825
D. 286, H. 283, B. 287, Hof. 277
305 × 400 mm.
Lower left in the stone: *Goya*

Crayon lithograph
Published edition. Harris II
With title and *Lith. de Gaulon*
Wove paper without watermark
Museum of Fine Arts, Boston. Samuel P. Avery Fund.
M28580.

This lithograph represents Mariano Ceballos, prob-
ably of Argentinian origin, whose daring feats on horse-
back were represented in the *Tauromaquia* of 1816 (cat.
nos. 185–187). Here, mounted on a rearing bull, and
surrounded by assistants, Ceballos prepares to kill the
bull with a *rejón* (short sword).

With his crayon Goya carefully delineated the
main theme. He then scratched white lines under the
belly and hind leg and above the neck of the matador's
mount. The blurred contours thus produced contribute
to the animal's sense of motion. The handling of the back-
ground is extremely painterly. With scarcely any contour
lines the entire audience is described in terms of flicker-
ing lights and shadows, produced by scraping out high-
lights from the crayon covering the stone. Matheron's
vivid description of the aged Goya standing before a
stone set up on an easel, and drawing and scraping as if
into the wet oil pigments of a canvas,[1] is nowhere more
pertinent than in this startlingly impressionistic image.

259

Young Woman in a Trance. About 1825–26
D. 277, H. 279, B. 278, Hof. 272
130 × 160 mm. (image)

Crayon lithograph. Proof
Watermark: CRIM[D] No. 13
Museum of Fine Arts, Boston. Katherine Eliot Bullard
Fund and Gift of Landon T. Clay. 1971.622

It is possible that three of the Bordeaux lithographs,
this one, *Conclusion of a Duel with Swords* (cat. no. 260),
and *The Andalusian Dance* (not in exhibition) were con-
ceived as part of a series of allegorical prints by Goya. The
meanings of the lithographs—the follies of unnecessary
bloodshed, of love spells, or of lustful abandonment—
would categorize them, as well as the five etched subjects
(see cat nos. 261–268), as new *caprichos*.[1]

Here, unrequited love causes a young woman
to put herself into the hands of an old woman who casts
spells. The preliminary drawing (Strölin, Paris, not in
exhibition), page 25 of Journal-Album H, shows a girl in
a trance, supported by several evil-looking women. In the
lithograph a girl, clearly out of her senses, rests her head
on the lap of an old crone, whose evil fingers comb
through her hair. The print was drawn in a technique
very close to that used for the black chalk drawings of
Album H. Painterly tones, enlivened by dark accents and
highlights, describe the gently rounded forms of the
women. Fine scratches lighten the areas above the out-
stretched girl's thigh, silhouetting her form. With a few
strokes of the crayon Goya specified each woman's emo-
tions: the abandon of the young woman; the gloating
success of her bewitcher; and the three observers, one
contemplative, one satisfied, and one fearful.

1. Laurent Matheron, *Goya* (Paris, 1858), unpaged.

1. Eleanor A. Sayre, *Late Caprichos of Goya* (New York, 1971),
pp. 19–20.

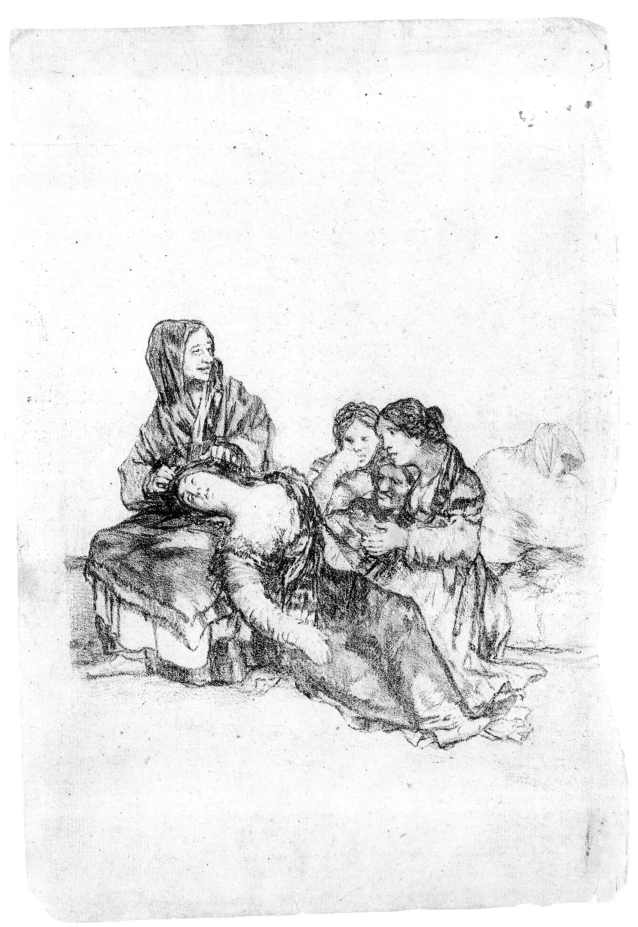

259 (full size)

260

260

Conclusion of a Duel with Swords. About 1825–26
D. 279, H. 276, B. 276, Hof. 276
120 × 200 mm. (image)
Lower left in the stone: *Goya*

Crayon lithograph. Proof
Touched with graphite
Wove paper
Coll.: Berolzheimer
Art Institute of Chicago. The Clarence Buckingham
Collection. 1944.1396

The stocky proportions of these duelers are characteristic of Goya's Bordeaux period drawings, and indeed a first thought for this print is found in a black chalk drawing, page 58 of Journal-Album G (Hermitage, Leningrad, not in exhibition). Although they lack the verve of the old-style pair dashingly portrayed in the Madrid lithograph of 1819 (cat. no. 253), the scene has a strong sense of reality and immediacy, as if a camera had stopped it in action.

Like the preceding print, this may have been intended as part of an allegorical series of *caprichos*. The drawing was entitled by Goya *Quien bencera?* (Who is going to win?). The only answer is Death.[1]

The artist drew broadly on the stone and then made strong black accents with his crayon that draw our attention both to the swords and to the gouts of blood issuing from the mouth of the mortally wounded man. This impression, one of five known, has been extensively touched with graphite, apparently by Goya himself. He shaded the white trouser legs and darkened most of the ground below the duelers. Their shadows thus become less pronounced and the ground more level.

1. Sayre, *Late Caprichos*, p. 19.

261–265
Warlock on a Swing among Demons. About 1826–1828
D. 25, H. 32, B. 256, Hof. 234
185 × 120 mm.

261
Young Witch Flying on a Rope Swing
Black chalk
191 × 155 mm.
Journal-Album H, page 19. Lower right: *Goya*
Watermark: St .Andrew's cross between two lions
Coll.: John Savile Lumley; John Savile
The National Gallery of Canada, Ottawa

262
Proof. Harris I, 2
Etching and burnished aquatint
Thin, wove paper
Coll.: Boix
Staatliche Museen Preussischer Kulturbesitz,
Kupferstichkabinett, Berlin. 793-1906

263
Copper plate (On the verso is *Witch on a Swing,*
Harris 33)
Coll.: Philip Hofer
Museum of Fine Arts, Boston. Gift of Philip Hofer in
honor of Eleanor A. Sayre. 1970.608

264
Posthumous impression, 1954. Harris IV, 1a
Etching and burnished aquatint
Museum of Fine Arts, Boston. Gift of Philip Hofer.
54.915

RUPEREZ(?)
265
Electrotype facsimile
With posthumous work, as Harris III
No watermark
Museum of Fine Arts, Boston. Bequest of W. G. Russell
Allen. 1974.239

This print and *The Andalusian Smuggler* (cat.
nos. 266–268), as well as three other subjects, a *maja*, a
guitarist, and an old witch, may be prints Goya completed
for a new series of *Caprichos* conceived in the eightieth
year of his life.[1] In the earlier *Caprichos* of 1799 Goya
used witches allegorically to represent various evils
abroad in the world.

The drawing of a young witch flying on a rope
swing, made in Bordeaux as part of Journal-Album H, is
not directly related to, but sheds light on the etching of
the *Warlock.* Wearing a charmingly wicked smile and in
bat-wing slippers, she holds the ends of the rope on which
she stands as she glides through the air.

The *Warlock on a Swing among Demons* is based on
a preliminary drawing also from Journal-Album H, page
58 (Hispanic Society, not in exhibition) , that shows the
ends of the rope extending to the edge of the sheet. In
the print, Goya took care to place aquatint over the ends
of the rope so that they are obscured by darkness. From
this murky background two demons watch, and from
below a large hand reaches up toward the old man. Sim-
ilarly, in *Capricho* 62, *Who would believe it?* (not in
exhibition), a hairy, catlike creature holds up its paws to
receive the evil, struggling pair suspended in the air.

A few posthumous impressions of the *Warlock*
were made around 1859 for John Savile Lumley, an Eng-
lish diplomat in Spain, who purchased the plate at that
time. These impressions show further work on the plate,
perhaps by Lumley, an amateur etcher himself. The
legible, orderly outlines that lengthen the sleeves give the
old man's figure a static weight and negate the freedom
of that earlier, gleeful, evil swinging.

These posthumous changes are still visible on the
copper plate. In the early 1930's three double-sided cop-
per plates, including that with the *Warlock,* were
purchased from Colnaghi's in London by Philip Hofer.
A few impressions were printed in 1954 and again in
1970, at which time the plates were given to the Boston
Museum. The impression exhibited here, from the 1954
printing by the late Ture Bengtz of the Boston Museum
School, shows the additional posthumous work.

A deceptive, electrotype facsimile of this later state
is identifiable by the fact that the corners of the plate are
rounded, the plate bevelled, and only one demon can be
seen above the warlock's knee.

1. For a complete discussion of these late prints, the plates, and
their printing history, see Eleanor A. Sayre, *Late Caprichos of Goya*
(New York: Philip Hofer Books, Walker and Company, 1971).

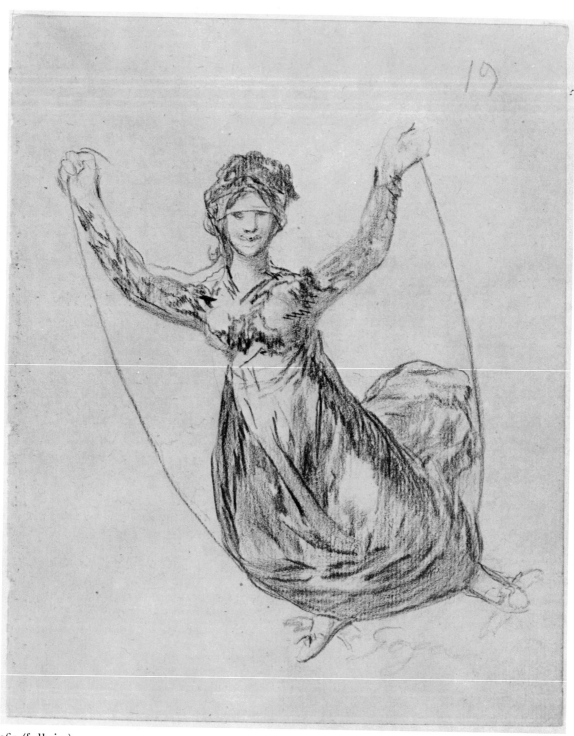

261 (full size)

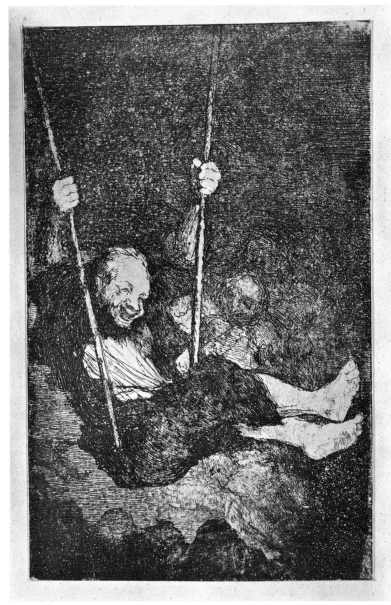

262

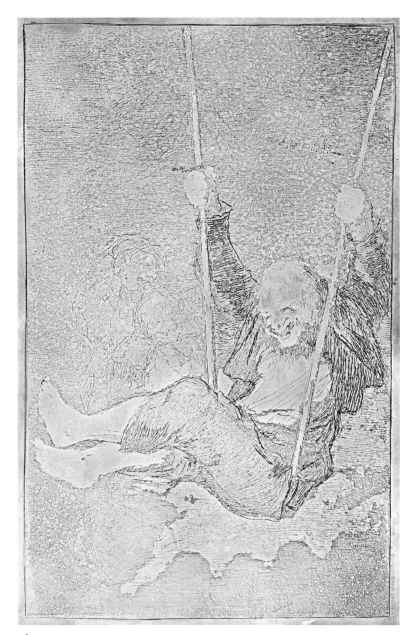

263

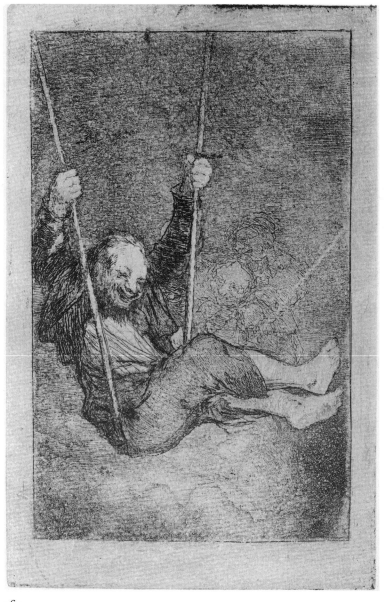

264

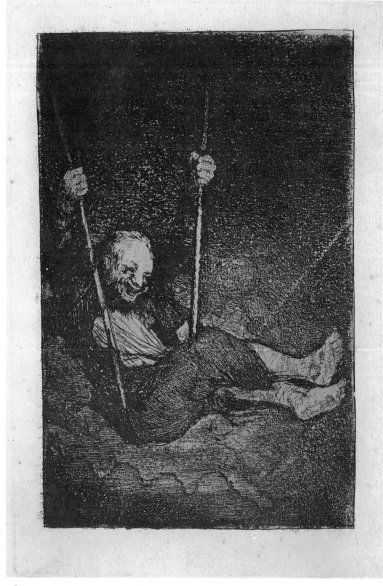

265

266–268
The Andalusian Smuggler. About 1826–1828
D. 27b (Not in H., B., or Hof.)
190 × 120 mm.

266
Preparatory drawing
Black chalk
191 × 151 mm
Journal-Album H. page 31
No watermark
Lower left: *Goya*
Museo del Prado, Madrid. 319

267
Posthumous impression, 1954
Etching and aquatint
Museum of Fine Arts, Boston. Gift of Philip Hofer.
54.920

Anonymous Etcher, After Goya
268
The Smuggler
D. 27, H. 34, B. 258, Hof. 236
Impression printed in 1859 for Lumley. Harris III
Etching and drypoint
Coll.: Gottfried Eissler; W. G. Russell Allen
Museum of Fine Arts, Boston. Bequest of W. G. Russell
Allen. 1974.242

Goya's criticism of greed and its consequences is to be
found in this subject, which may be more readily
comprehended by comparison with *Capricho* 11 (not in
exhibition). There Andalusian smugglers, turned to
highway robbery, sit smoking cigarettes. Their chief
commodity was tobacco. The Spanish government set the
price of tobacco, which it imported from Cuba and
processed in Sevilla, much too high, so that enormous
quantities of Brazilian tobacco were smuggled in from
Portugal. As the Spanish prices rose, the numbers of
smugglers increased, and they turned to brigandage
and murder.[1]

The black chalk drawing is from the same Journal-
Album that inspired the *Warlock on a Swing among
Demons* (cat. nos. 262–265). The Andalusian's envelop-
ing cloak, originally sketched with more folds at the
left, hides from view all but the muzzle of his gun.

A modern impression from the plate is exhibited here,
taken in 1954 at the same time as that of the *Warlock*
(cat. no. 264). No impressions printed by Goya are known
to have survived, nor did Lumley, who acquired the
plate around 1859, have any impressions pulled from this
side of the plate, which he may have considered incom-
plete or damaged. Indeed, Goya's print was imperfectly
bitten, but the authorship is secure. Facial type and
draughtsmanship are similar to *Las resultas* of about
1820 (cat. no. 237), while the dark and suggestive back-
ground of coarse-grained aquatint is found also in the
Warlock. Despite its technical difficulties, the print is
characteristic of Goya's late etching style.

The author of the etching on the verso of the plate was
probably not Goya. The thin, sharp lines are not charac-
teristic of Goya's painterly Bordeaux manner of work-
ing, as seen in the print from the recto of this plate. He
certainly did not execute the bull that was added in
drypoint, for it reveals a misunderstanding of the subject.
No Spaniard would stand nonchalantly in the pasture of
fighting bulls, nor if he were a guard, as has been sug-
gested, would he conceal his weapon. Goya's original
drawing was indeed the source for this print. The draw-
ing remained in private hands in Spain until it was
acquired by the Spanish government in 1866.[2] Its sheet
shows incised lines that indicate it was traced with a
stylus. The print is a mirror image, which would be the
case if the drawing had been traced onto the grounded
copper plate, rather than being transferred to the plate in
the press, as was Goya's usual working method.

1. Sayre, *Late Caprichos*, p. 22. A thorough study of this print is
found in this publication.

2. Ibid., p. 23.

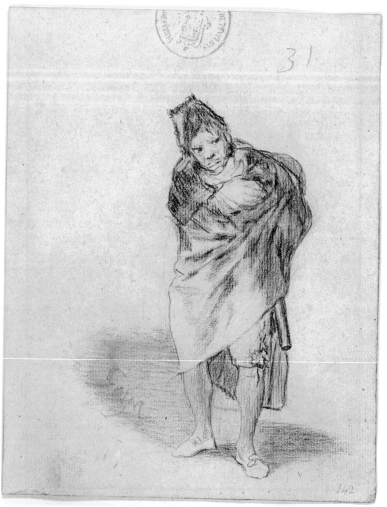

266

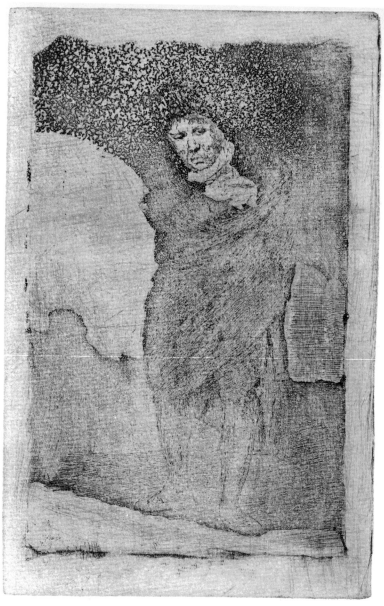

267

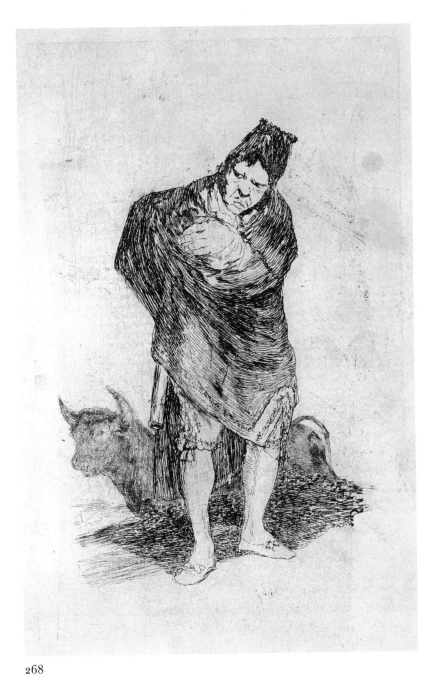

268

Glossary

In the **etching** process, the copper plate is covered with a waxy ground that is impervious to acid. With an etching needle the artist lightly scratches away the ground to delineate the image. Sometimes the grounded plate is darkened with soot from a candle flame so that the bright copper lines are more visible. The uncovered copper is then exposed to acid; it is this **biting** or etching by acid that produces the grooves that will hold the printer's ink.

The size of the line is determined by the breadth of the needle and the duration of biting time. **Overbiting** causes the etched work to break down, forming hollows in the plate that will not retain ink and print as gray patches. **Foul biting** occurs when the protective ground is penetrated and an area is accidentally etched.

The corrosive action of the acid may be controlled by **stopping-out** or masking of areas of the plate with a varnish or waxy substance. Work that is completed may be covered up or stopped out to resist the acid. By alternating the stopping-out and etching stages, a variety of line and tone can be produced. Goya was able to use the white of the paper to create brilliant highlights by reserving areas with a stop-out medium when a tone was bitten.

Drypoint lines are incised into the plate with a sharp needle. Held at the proper angle, the point displaces a fine shaving of metal which forms a ridge or **burr** on either side of the line. When the plate is inked for printing, the ink clings to the burr, giving a velvety softness to the printed line. The burr is very fragile and rapidly disappears with repeated printing. Goya also used the drypoint needle to scratch lines without raising a burr. Unlike engraved lines, these strokes tend to be very fine. Drypoint was often used in combination with etching to elaborate etched passages or to make small additions and corrections without regrounding and rebiting the plate.

Engraved lines are achieved by gouging out the line with a **burin** (a lozenge-shaped steel bar, cut on the bias at the point, and set in a wooden handle). The thin ribbon of displaced metal is scraped away to maintain the clarity of the line. Goya used the burin to supplement his etched lines or to shade and model forms further.

The **aquatint** method is a means of etching a continuous tone. A porous ground of powdered resin is dusted onto the copper plate and fused to it by heat. The metal that remains exposed around these droplets of acid-resistant resin is bitten, creating a reticulated pattern of crevices. These crevices hold the ink and print as a tone. The variety of aquatint tones that can be achieved depends upon the type of resin, the size of the grains (from fine to coarse), their density, the duration of biting time, and the amount of stopping-out that is employed. In many of Goya's prints, the stopped-out white areas are in sharp contrast to areas that have been aquatinted.

Lavis (French for "wash"), simulates the effect of an ink wash on paper and is another means of achieving continuous tone. This tone is produced by the direct application of acid to an unprotected area of the copper plate; the finely pitted surface holds ink and prints as a pale gray tone. Passages may be stopped out and the plate briefly exposed to acid or the acid may be brushed onto the plate.

Changes on the plate can be made by scraping the copper to remove the unwanted work. A sharp blade or **scraper** removes the copper from the surface of the plate, thereby reducing the depth of the lines. This roughened area is then smoothed and polished with a rounded, finger-like steel tool or **burnisher**. Goya used scraping and **burnishing** to correct passages, to produce halftones, and to extract highlights from a dark bitten tone.

The **roulette** produces a tone or dotted line by scoring the plate with a spiked wheel mounted on a wooden handle. Goya used this technique in some of his earliest prints to supplement the etched lines.

When a plate is inked for printing, the excess ink is removed and the plate **cleanly wiped**. Sometimes a **film of ink** may intentionally be left on the surface of the plate and will print as a tone.

When the inked plate is run through the press with a sheet of paper, the copper plate embosses the paper, leaving a **platemark**.

Lithography is a process that is dependent upon the antagonism of oily substances and water. The artist draws upon a specially prepared limestone with a **lithographic crayon** or greasy **lithographic ink** (**tusche**). During printing, the stone is kept wet. The greasy areas of the design resist water; instead they absorb the stiff ink, which is rolled onto the wet stone for printing.

A sheet of paper is laid on the stone and both are run through a lithographic press. The pressure of a scraper-bar causes the ink to adhere to the sheet.

A **transfer lithograph** is one that was first executed on paper with lithographic crayon or ink and then transferred to a stone. Goya encountered problems with this process because he used ordinary paper that absorbed the grease and prevented the image from transferring properly.

Goya used a variety of drawing materials. **Graphite** is a natural black carbon material that differs in texture from the synthetic graphite that is used today in the manufacture of pencils. **Red (or sanguine) chalk,** also a natural material, was frequently used by Goya; its modulations of hue ranged from orange to purplish-red. **Red or sanguine wash**, a solution of red chalk, was applied with a brush. Goya also employed a brown-hued **sepia** ink for both pen and brush drawings.

To **transfer a drawing** to the copper plate, the sheet was placed face down on a grounded plate and run through the press. Traces of the drawing medium offset onto the receptive ground and served as a guide for the etching needle. The appearance of platemarks, the existence of **printing folds** and creases resulting from pressure, and the fact that numerous preparatory drawings are in the same direction as the prints all give evidence that Goya frequently employed this method to transfer his drawn designs to the copper plate. In some instances Goya shifted the sheet on the plate to alter the compositional arrangement.

A drawing could also be transferred by covering the verso of the sheet with chalk and tracing the design on the recto with a stylus onto a prepared plate. The image in the print appeared in reverse.